2025

J.P.Morgan

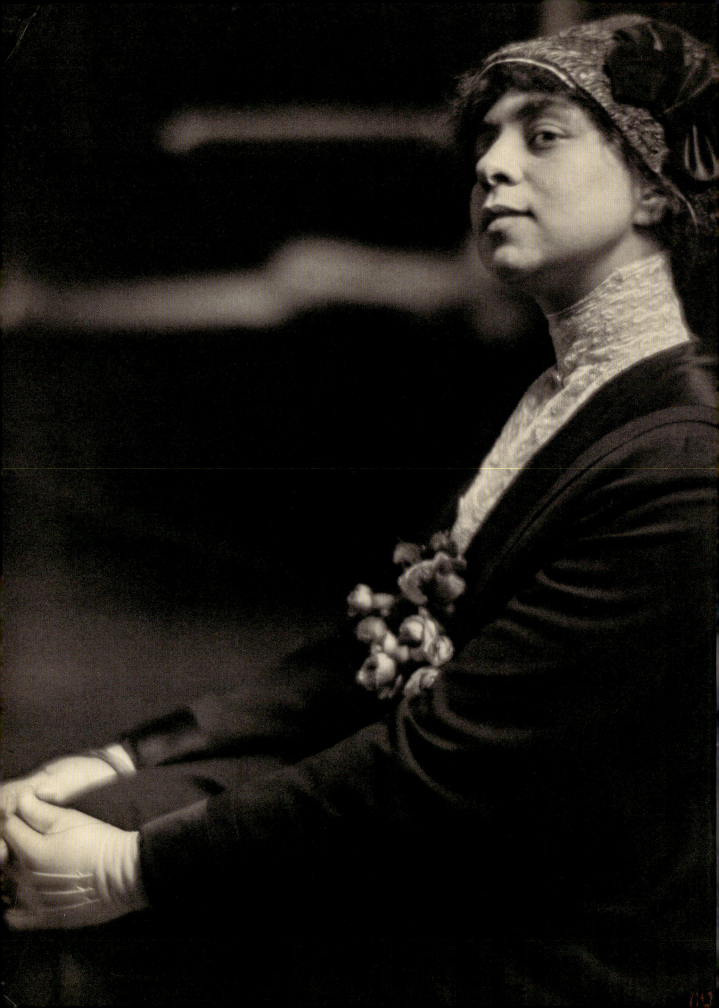

BELLE DA COSTA GREENE

A Librarian's Legacy

Edited by
Erica Ciallela and
Philip S. Palmer

Foreword by
Colin B. Bailey

Afterword by
Tamar Evangelestia-Dougherty

Essays by
Julia S. Charles-Linen
Erica Ciallela
Rhonda Evans
Anne-Marie Eze
Daria Rose Foner
Gail Levin
Philip S. Palmer
Deborah Parker
Deborah Willis

The Morgan Library
& Museum
New York

DelMonico Books · D.A.P.
New York

CONTENTS

7

Director's Foreword
Colin B. Bailey

13

Curatorial Acknowledgments
Erica Ciallela
and Philip S. Palmer

17

Introduction
Philip S. Palmer

45

The Education of Belle da Costa Greene
Daria Rose Foner

69

The Cleverest Girl: Strategic Racial Performance and the Making of Belle da Costa Greene
Julia S. Charles-Linen

85
Becoming or Belonging: Belle's Camera Portraits
Deborah Willis

101
Belle Greene and Literature
Philip S. Palmer and Deborah Parker

117
**PLATES
Highlights of Belle Greene's Acquisitions for the Morgan Library**

133
The Ballad of Belle da Costa Greene: Librarian as Medievalist
Anne-Marie Eze

173
Belle da Costa Greene, the Stieglitz Circle, and Modern Art
Gail Levin

191
**PLATES
Belle Greene's Personal Collection**

219
Belle Greene as Director: Transitions
Erica Ciallela and Philip S. Palmer

249
Black Librarianship and the Legacy of Belle da Costa Greene
Rhonda Evans

265
Belle Greene as Director: Endings
Philip S. Palmer

283
Afterword
Tamar Evangelestia-Dougherty

Checklist of the Exhibition 289
Index 297
Contributors 300

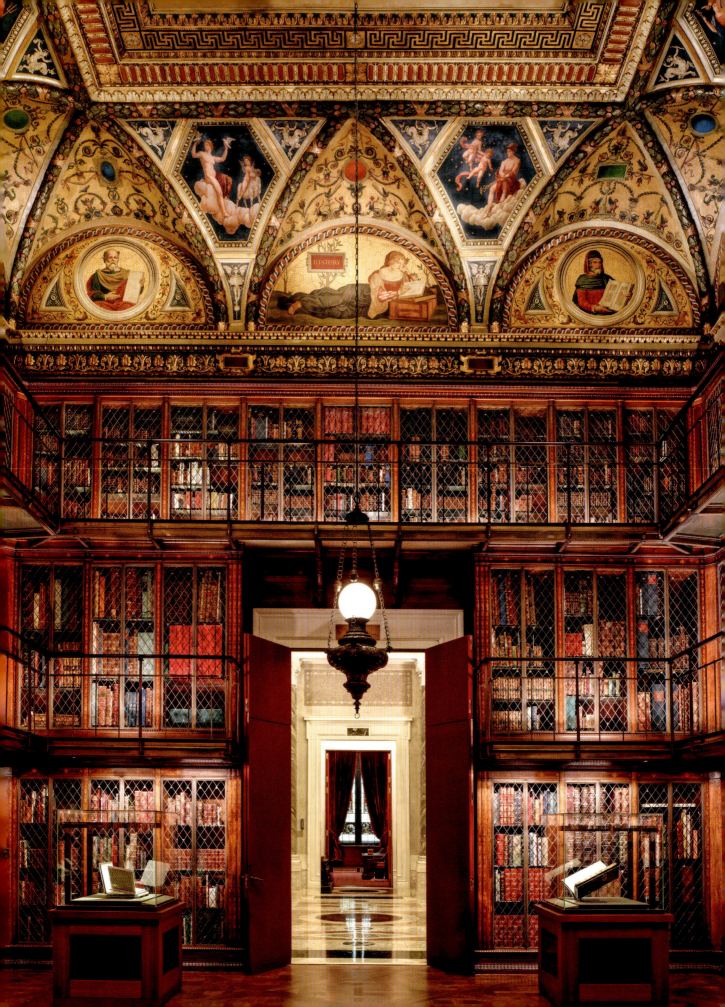

Director's Foreword

One aim is to make the Library pre-eminent....
I hope to be able to say some
day that there is neither rival nor equal.
—Belle da Costa Greene, 1909

A little less than four years after J. Pierpont Morgan hired her as his librarian, Belle da Costa Greene wrote these prescient and ambitious words about the future of the institution she frequently described as "her" library. She was there from the beginning, unpacking and bookplating volumes in the summer of 1905 when Morgan's library was being stored on Fifth Avenue at the Lenox Library, now the site of the Frick Collection. Once the library building designed by McKim, Mead & White was completed on 36th Street near Madison Avenue a year later, she presided over and built holdings of books, manuscripts, and art in collaboration with the Morgan family: first with Pierpont, until his death in 1913, and then with his son, J. P. Morgan Jr., known as Jack. Together they transformed the private collection into a world-renowned museum and research library—beginning in 1924 as the Pierpont Morgan Library, and known today, a century later, as the Morgan Library & Museum. Belle da Costa Greene was its first director.

As the fifth director to run the institution since Belle da Costa Greene retired in 1948, I am delighted to present *Belle da Costa Greene: A Librarian's Legacy*. In July 2017, a couple of years after assuming my position, I convened a gathering of curatorial department heads to brainstorm an interdepartmental project devoted to the Morgan's first director. I remember being intrigued (and excited) at the range of her taste and influence in so many different areas. Thanks to the energy and commitment of Philip S. Palmer, the Morgan's Robert H. Taylor Curator and Department Head of Literary and Historical Manuscripts, and Erica Ciallela, Exhibition Project Curator and former Belle da Costa Greene Fellow, the project has been realized with an ambition and care that have more than fulfilled our initial expectations.

This book and its complementary exhibition, the first major museum presentation to consider the full arc of Belle Greene's remarkable career, share new research and offer fresh perspectives on the study of her life. Building on the foundational scholarship of Jean Strouse and Heidi Ardizzone, the co-curators and their fellow catalogue contributors have revealed a clearer picture than ever

The East Room of the Morgan Library.

before of Belle's family, education, library work, personal art and book collections, and social life, as well as her far-reaching and complex legacy. This legacy is felt at the Morgan every day. From the pencil notes she added to the inside covers of books to the important work of our Belle da Costa Greene Curatorial Fellows, her presence has been nothing short of transformative at this institution—once earning her the epithet "the soul of the Morgan Library." Yet Greene has also become more widely known to communities outside of the Morgan and around the world. She is considered a "patron saint of medievalists of color," in the words of essay contributor Anne-Marie Eze, and regularly inspires students and young professionals to pursue career paths in information science and museum studies. She is widely known to readers of historical fiction in both the United States and Europe through the popular books *The Personal Librarian*, coauthored by Marie Benedict and Victoria Christopher Murray, and *Belle Greene* by Alexandra Lapierre. The Morgan has become a pilgrimage site for such readers seeking to capture the aura of the place where she worked for over forty years.

Despite such veneration, Belle da Costa Greene does not need a hagiography. She lived her life in uncompromising fashion and on her own terms, embracing the contradictions inherent in the life of a Black woman passing as white in the privileged world of "bookmen." Though frequently grouped together with early twentieth-century librarians who identified as Black, Belle Greene did not share the same connections to the African American community in New York as contemporaries like Catherine Latimer and Arturo Schomburg. Unlike figures such as the actor Fredi Washington or the writer Charles W. Chesnutt, both of whom could have passed as white, with their light-skinned complexions, but chose instead to embrace their Blackness, Greene crossed the color line with her mother and siblings and did not turn back. But as the book and exhibition forcefully argue, the systemic racism embedded in the fabric of the United States put Greene in an impossible position. Her choice to live the way she did was as much an individual decision as a survival strategy.

The story of Belle da Costa Greene is not an easy one to tell, and it cannot be told in a single voice. From the beginning this project has been deeply collaborative. Our co-curators and coeditors Erica Ciallela and Philip S. Palmer, with the assistance of Research Associate Jathan Martin, assembled an Advisory Committee to guide their thinking, writing, and selection of objects. The group comprises Carla Hayden, the Librarian of Congress, along with an august collection of scholars, museum professionals, curators, and collectors: Lisa Unger Baskin, Julia S. Charles-Linen,

Tamar Evangelestia-Dougherty, Rhonda Evans, Anne-Marie Eze, Dominique Jean-Louis, Tracy Sharpley-Whiting, and Deborah Willis, along with the Morgan's own Astor Curator and Department Head of Printed Books and Bindings, Jesse R. Erickson. Many of these committee members have also written essays for this volume, and I would like to extend my thanks to our additional essay contributors Daria Rose Foner, Gail Levin, and Deborah Parker for their work on the book.

Though the Morgan is the main repository of artifacts and archives documenting Belle da Costa Greene's career, this exhibition would not have been possible without the generosity of our lenders, who hail from Colorado to Tuscany, from private prep schools to major museums. I am grateful first and foremost to colleagues at I Tatti, the Harvard University Center for Italian Renaissance Studies, for lending a beautiful series of photographs of Belle da Costa Greene to the exhibition, as well as two of her letters written to Bernard Berenson—the subject of a major new digital resource, "The Letters of Belle da Costa Greene to Bernard Berenson," developed in collaboration between the Morgan and I Tatti and directed by Philip S. Palmer. I would also like to single out three preparatory schools that have been supportive of our efforts to tell the story of the education of Greene and her nephew, Robert "Bobbie" MacKenzie Leveridge, lending key objects to that end: the Northfield Mount Hermon School, St. Paul's School (Concord, NH), and the Fountain Valley School of Colorado. I am equally grateful to our other lenders, all of whom have generously allowed their treasures to grace our galleries for six months so we can tell the fullest possible story about Belle da Costa Greene: Amherst College, the Archives of American Art, Dumbarton Oaks, Fisk University Museum of Art, Harvard University Archives, the Houghton Library at Harvard University, the Library of Congress, the Metropolitan Museum of Art, Michael Rosenfeld Gallery, Elisabeth Morgan, the Museum of the City of New York, the National Gallery of Art, the National Museum of African American History and Culture, the National Museum for Women in the Arts, New-York Historical Society, the New York Public Library's Schomburg Center for Research in Black Culture, the Portland Museum of Art, Princeton University Art Museum, and Princeton University Library.

Like all our exhibitions and publications, *Belle da Costa Greene: A Librarian's Legacy* has been a major cross-departmental collaboration at the Morgan. I am grateful to Karen Banks, Publications Manager, and Ryan Newbanks, Editor, for their leadership in bringing this book to fruition. Marilyn Palmeri and Eva Soos obtained the illustrations, many of which are from photographs by Janny Chiu and Carmen González Fraile. Conservators Maria Fredericks, Frank Trujillo, Reba Snyder, and Rebecca Pollak prepared material for the installation. I owe particular thanks to Elizabeth Abbarno, Director of Exhibition and Collection Management, for her management of the physical installation, and her colleagues

Erika Hernandez Lomas, Exhibitions Registrar; Alex Félix, Exhibition Coordinator; and Walsh Hansen, Head of Exhibitions Preparation; as well as our skilled team of art handlers. The exhibition was designed by Amy Forman, the graphics were produced by Miko McGinty Inc., and the gallery lighting was provided by Anita Jorgensen. Barbara Glauber, of Heavy Meta, is responsible for the elegant design of this catalogue.

This two-gallery exhibition, featuring over a dozen lenders, was a major logistical undertaking, and we could not have been successful in this project without the generosity of our supporters. *Belle da Costa Greene: A Librarian's Legacy* is made possible by lead support from Agnes Gund. Major support is provided by the Ford Foundation; Mr. and Mrs. Benjamin M. Rosen; Katharine J. Rayner; Denise Littlefield Sobel; the Lucy Ricciardi Family Exhibition Fund; Desiree and Olivier Berggruen; Gregory Annenberg Weingarten, GRoW @ Annenberg; and by a grant from the National Endowment for the Humanities: Democracy demands wisdom. Assistance is provided by the Franklin Jasper Walls Lecture Fund, the Friends of Princeton University Library, Elizabeth A. R. and Ralph S. Brown Jr., and the Cowles Charitable Trust.

Belle da Costa Greene: A Librarian's Legacy celebrates the life of one of the most prominent librarians in American history. As readers of this book and visitors to the exhibition will learn, Greene's legacies are many: today she is remembered as a curator, cultural heritage executive, philanthropist, collector, scholar, New Yorker, socialite, and friend. To her grandnephew Robert Leitner, whom it has been a delight to meet during this project, she was known as "Aunt Bull." To her colleagues at the Morgan, she was always "Miss Greene." Despite all of the changes to her title and name over the years, she would have most consistently identified herself as a librarian. One hundred years since Belle Greene's appointment as the Pierpont Morgan Library's first director, her influence as a librarian and museum leader shows no signs of diminishing. On the contrary, her commitment to providing access to the Morgan's unparalleled holdings is now an article of faith for our institution.

Colin B. Bailey
Katharine J. Rayner Director,
The Morgan Library & Museum

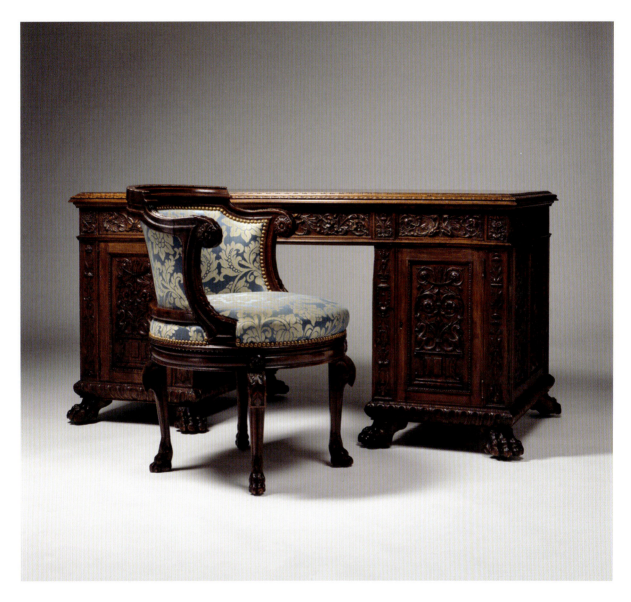

Cowtan & Sons, Desk and swivel chair used by Belle da Costa Greene, 1906–7. The Morgan Library & Museum, New York.

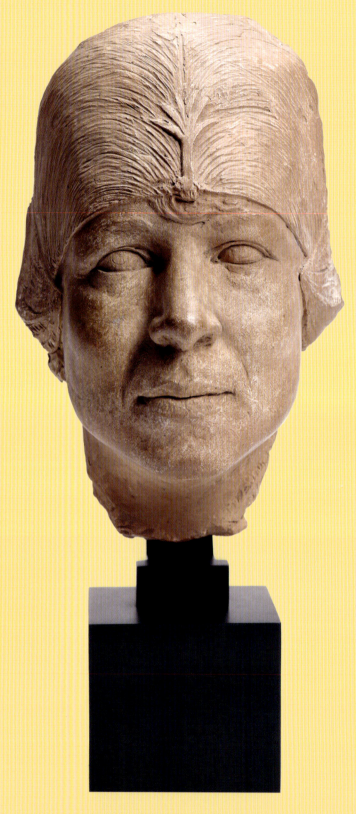

Jo Davidson (1883–1952), *Belle da Costa Greene*, 1925. Terra-cotta; 11 × 7 × 5¾ in. (27.9 × 17.8 × 14.6 cm). The Morgan Library & Museum, New York, purchased on the Charles Ryskamp Fund, 2018; AZ205.

Curatorial Acknowledgments

Belle da Costa Greene, A Librarian's Legacy has been a deeply collaborative undertaking from the beginning, and the curatorial team is thankful to so many people for their time, knowledge, and support over the course of writing this book and developing the exhibition. First and foremost, we want to thank Belle Greene's grand-nephew Robert Leitner as well as his wife, Toni. Thank you for sharing your memories of "Aunt Bull" with us. Her story has touched so many, and we are grateful for your support in allowing us to tell a part of your family history. On the Morgan side, we are grateful to Miles Morgan for sharing family stories.

Exhibitions and books are not solo endeavors, and we could not have brought this project to fruition without the expertise, generosity, friendship, and patience of the wonderful staff, past and present, of the Morgan Library & Museum. We appreciate your dedication in sharing Belle Greene's story. We especially want to thank our visionary director, Colin Bailey, for his support and leadership on this project. Special thanks must also be extended to former Morgan curator Christine Nelson, who with her characteristic brilliance stewarded the Morgan Archives and Belle Greene's story for many years before our arrival, and editor Ryan Newbanks, who spent countless hours shaping this book into its final form. Former members of the curatorial team Jathan Martin and Daria Rose Foner contributed much to our thinking and planning. Thanks as well to colleagues Sal Robinson, Joshua O'Driscoll, Roger Wieck, Bill Voelkle, Sidney Babcock, John McQuillen, Sheelagh Bevan, Jennifer Tonkovich, Joel Smith, Olivia McCall, Elizabeth Abbarno, Walsh Hansen, Alex Félix, Erika Hernandez Lomas, Karen Banks, Michael Ferut, Yuri Chong, Marilyn Palmeri, Eva Soos, Janny Chiu, Carmen González Fraile, Maria Fredericks, Frank Trujillo, Reba Snyder, Rebecca Pollak, Elizabeth Gralton, Christina Ludgood, Chie Xu, Noreen Khalid Ahmad, Kirsten Teasdale, María Isabel Molestina, Polly Cancro, Katie Graves, Sylvie Merian, Maria Oldal, Sandra Carpenter, Peter Gammie, and, last but not least, our indefatigable team of senior administrators, Jessica Ludwig, Kristina Stillman, Lauren Stakias, and John Marciari.

When we began this project, it was clear that assembling an outside group of collaborators would be necessary to steward the exhibition's development. The advisory committee took time out of their extremely busy schedules to help us think through the object checklist, design, themes, programming, and didactics. They were crucial in ensuring that Greene's story was told thoughtfully and

with the utmost care. With humility and gratitude, we thank Lisa Unger Baskin, Julia S. Charles-Linen (Arizona State University), Jesse R. Erickson (Morgan Library & Museum), Tamar Evangelestia-Dougherty (Smithsonian Libraries & Archives), Rhonda Evans (New York Botanical Garden), Anne-Marie Eze (Houghton Library, Harvard University), Carla Hayden (Library of Congress), Dominique Jean-Louis (Center for Brooklyn History), Tracy Sharpley-Whiting (Vanderbilt University), and Deborah Willis (New York University).

Several of our advisory committee members have also contributed essays to this catalogue, and we are deeply indebted to all of the historians and scholars who have brought her story to the world. It is thanks to Jean Strouse, who believed in the importance of highlighting Belle Greene in her biography of J. Pierpont Morgan, that we started to understand Greene's complex and trailblazing legacy. Thank you, Jean, for all of your support and advice over the years. Heidi Ardizzone's full-length biography built on Jean's research and has been a guide for us as we navigated the archival traces of Belle Greene, particularly her letters to Bernard Berenson. Finally, we would like to thank our catalogue contributors for exploring the many sides of our subject and contributing new knowledge to the study of her life. They, like Strouse and Ardizzone, will inspire the next generation of scholars to continue uncovering the past. Thank you, Juliana Amorim Goskes, Araceli Bremauntz-Enriquez, Julia S. Charles-Linen, Tamar Evangelestia-Dougherty, Rhonda Evans, Anne-Marie Eze, Daria Rose Foner, Jiemi Gao, Gail Levin, Deborah Parker, and Deborah Willis.

Much of this scholarship would not have been possible without the support and cooperation of colleagues at I Tatti, the Harvard University Center for Italian Renaissance Studies, where Greene's important letters to Berenson are held. The "Letters of Belle da Costa Greene to Bernard Berenson" has benefitted from the support of I Tatti colleagues Michael Rocke, Ilaria della Monica, Lukas Klic, and Daniele Fratini, along with the project's web designer, Francesco Cipriani. The tireless work of transcribing these letters could not have happened without the efforts of Daria Rose Foner, Sam Mohite, Lauren Davis, Nic Caldwell, Serena Pellegrino, Zoe Braccia, Ariana Joubert, Kelsey Malanowski, Meghan Fletcher, Maya Wilson, Isabelle Halsey, Clara Guzman, Alysha Colon, James Donchez, and Alison Bleznick.

We would also like to recognize the many curators, archivists, librarians, gallerists, and scholars who went above and beyond to facilitate our research, including Peter Weis (Northfield Mount Hermon School); Jake Emery (Fountain Valley School); Deanna Parisi (St. Paul's School); Leslie Fields (Mount Holyoke College, now Smith College); Christina E. Barber and Mike Kelley (Amherst College); Daniel C. Prebutt (Manhattan Sites, National Parks Service); Louisa Hoffman (Oberlin College); Stephen Ferguson, Eric White, Emma Sarconi,

Mireille Djenno, and April Armstrong (Princeton University Library); Pamela Patton, Mathilde Sauquet, and Anne McCauley (Princeton University); Paige Roberts (Phillips Academy); Robyn Asleson (National Portrait Gallery); Paul Civitelli (Beinecke Rare Book & Manuscript Library, Yale University); Conrad Lochner (Teachers College, Columbia University); Kristi L. Finefield (Library of Congress); Elyse Nelson, Tracy Yoshimura, and Julie Lê (The Metropolitan Museum of Art); Ronald Patkus (Vassar College); Barrye Brown, Maira Liriano, and Alex Garcia (Schomburg Center for Research in Black Culture, New York Public Library); Ashley Barrington (Harvard Art Museum Archives); Charice Thompson (The Moorland-Spingarn Research Center, Howard University); Elizabeth Botten (Archives of American Art); Jerry McCoy (Peabody Room at the Georgetown Branch of the DC Public Library); Jamaal B. Sheats (Fisk University Art Galleries); Elizabeth Dospel Williams (Dumbarton Oaks); halley k. harrisburg (Michael Rosenfeld Gallery); Elizabeth E. Fuller (The Rosenbach); Hannah Kaufman and Monica Blanchard (Catholic University of America); Shelly Buring (The George Washington University); Elizabeth Garver (Harry Ransom Center); Meghan Constantinou (formerly of the Grolier Club Library) and Scott Ellwood (Grolier Club Library); Anita Clary (Kent State University); Kate Long (Smith College); and Tal Nadan (New York Public Library).

Belle Greene's life has sparked curiosity in so many and we are thankful to those who were inspired by her story. With gratitude to Marie Benedict, Victoria Christopher Murray, Alexandra Lapierre, Epiphany "Big Piph" Morrow, Andrena Crockett, Robyn Smith, and Denise Johnson.

In closing, we would especially like to acknowledge the essential work of librarians. Thank you for your dedication to access, your commitment to knowledge, and your defense of intellectual freedom. As we look back and celebrate the legacy of Belle da Costa Greene, we honor your work.

Erica Ciallela
Exhibition Project Curator, The Morgan Library & Museum

Philip S. Palmer
Robert H. Taylor Curator and Department Head, Literary and Historical Manuscripts, The Morgan Library & Museum

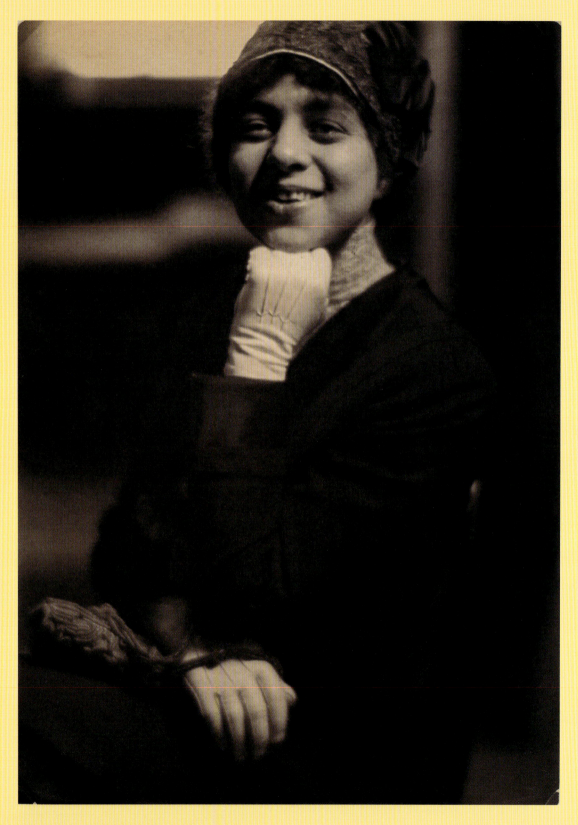

Clarence H. White (1871–1925), *Belle da Costa Greene*, 1911. Platinum print; 9⅜ × 6¾ in. (23.8 × 17.1 cm). Princeton University Art Museum, The Clarence H. White Collection, assembled and organized by Professor Clarence H. White Jr., and given in memory of Lewis F. White, Dr. Maynard P. White Sr., and Clarence H. White Jr., the sons of Clarence H. White Sr. and Jane Felix White; x1983-447.

Philip S. Palmer

INTRODUCTION

*My friends in England suggest that I be called "Keeper of
Printed Books and Manuscripts"... but you know
they have such long titles in London. I'm simply a librarian.*
—Belle da Costa Greene, 1912[1]

When asked for her job title in a 1912 *New York Times* interview, Belle da Costa Greene answered, with a characteristic dose of affected modesty, "I'm simply a librarian." Through all of her shifts in circumstance and self-transformations, "librarian" is the word that most consistently defined Greene's identity. It was in her family's DNA: her father, Richard T. Greener, after becoming the first Black student to graduate from Harvard College, became a librarian and professor at the University of South Carolina before the collapse of Reconstruction in 1877.[2] When she applied to the Northfield Seminary for Young Ladies in 1896, she indicated on her application that she "would like to fit for Librarian."[3] Four years later the 1900 United States Census noted her profession as "libaryberian" [*sic*], and in 1905, when she was working at Princeton University, the New Jersey state census indicated she was employed with "Library Work." Her first appearance as the head of household in a New York City directory, in 1912, lists her under "Green" as "Bella librarian."[4] For most of her career her signature and sign off in business letters read, "Belle da Costa Greene Librarian," or, in the case of the unsigned carbon copies of her letters, "Very truly yours... Librarian." Even after becoming director and "keeper of manuscripts" in 1924, when the private library formed by J. Pierpont Morgan and inherited by his son, J. P. "Jack" Morgan Jr., became the public educational institution known as the Pierpont Morgan Library, "librarian" often still suited her. After Greene's death, the book collector

Anne Lyon Haight began writing an account of her good friend's life, drawing on unpublished letters and interviews with people who knew her. Her working title? "The Training of a Librarian."[5]

But even a passing familiarity with Belle da Costa Greene's life and career shows that her "simply a librarian" quote is a massive understatement. This was a librarian who spent fortunes at rare book auctions, instilling fear in the hearts of rival bidders when they spied the feathered plume of her hat across the room.[6] This was a librarian who dazzled and charmed the male-dominated world of rare books and manuscripts, commanding respect and awe from Sir Sydney Cockerell, Charles Hercules Read, and other prominent European curators and cultural heritage professionals. This was a librarian regularly featured in newspaper articles on the best-paid women in America (fig. 1), someone who collected fine art and Chinese sculpture for herself.[7] This was a librarian who drove a convertible and cavorted with aristocrats, who dined with avant-garde artists and parodied Gertrude Stein.[8] This was a librarian, in other words, with verve and style uniquely her own. The substance of her most famous and oft-cited quote—"Just because I am a librarian doesn't mean I have to dress like one"—comes to life in the words of her colleague and protégé Meta Harrsen, who recalled the surprised delight she felt upon first meeting Greene in 1922, when "she wore a dress of dark red Italian brocade shot with silver threads, a gold braided girdle, and an emerald necklace."[9]

In a tribute to Greene written on the occasion of her retirement in 1948, her friend and fellow library professional Lawrence C. Wroth remarked:

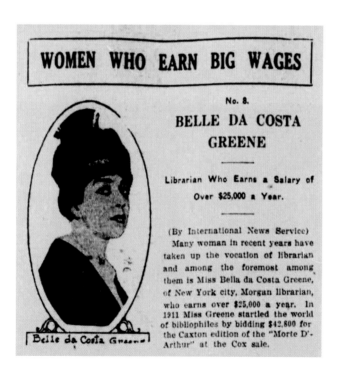

FIG. 1
"Women Who Earn Big Wages," *Asbury Park Evening Press*, March 10, 1921.

Never has there been a librarian so little like the conventional librarian of fiction, gliding, rubber-heeled, with finger to lips, among tables and files and shelves. Miss Greene's work was carried on heartily, noisily, in a whirl of books and papers disturbing to one who could not perceive the cosmic orderliness of purpose which underlay the surface confusion. Wherever she might be found in the building there was a living matrix of ideas, a nucleus of constructive forces constantly released for the greater good of her Library.[10]

As Wroth reminds us, despite Greene's unconventional style she was also a librarian who expressed a strong commitment to "the greater good" and the bedrock principles of librarianship—access, education, and the freedom of information (fig. 2). She promoted the extensive use of photostat technology, creating remotely accessible copies of rare materials in a method that prefigured the democratized access afforded by today's digital humanities. She believed in the Library's educational mission, ensuring that students were given every opportunity to visit the Morgan and view its many exhibitions, often during special opening hours reserved for high schools and junior high schools.[11] She eschewed giving traditional lectures, at the time de rigueur for scholarly presentations, in favor of offering hands-on experiential learning with real books and manuscripts—now the standard in modern special collections pedagogy.[12] She was an indefatigable scholar and student of the Morgan's vast collections, specializing in medieval illuminated manuscripts (fig. 3) and fifteenth-century printed books but also becoming adept at researching and acquiring literary manuscripts, historical documents and letters, and old master drawings and prints. Greene undoubtedly enjoyed the heady nightlife of 1910s New York City, but she was also someone who would cancel evening plans to read *The Thousand and One Nights*, pore over specialist bibliographies and catalogues, and answer the "mountains of mail" she received as chief executive of one of the world's great research libraries.[13]

It is as a woman of color that she arguably leaves her most compelling and complicated legacy, a story she herself did not tell in writing but that has become widely known through the scholarship of Jean Strouse and Heidi Ardizzone, as well as through the fictionalized accounts of Marie Benedict and Victoria Christopher Murray, and Alexandra

FIG. 2
Cowtan & Sons, Card catalogue cabinet from the North Room of J. Pierpont Morgan's Library, ca. 1907. The Morgan Library & Museum, New York.

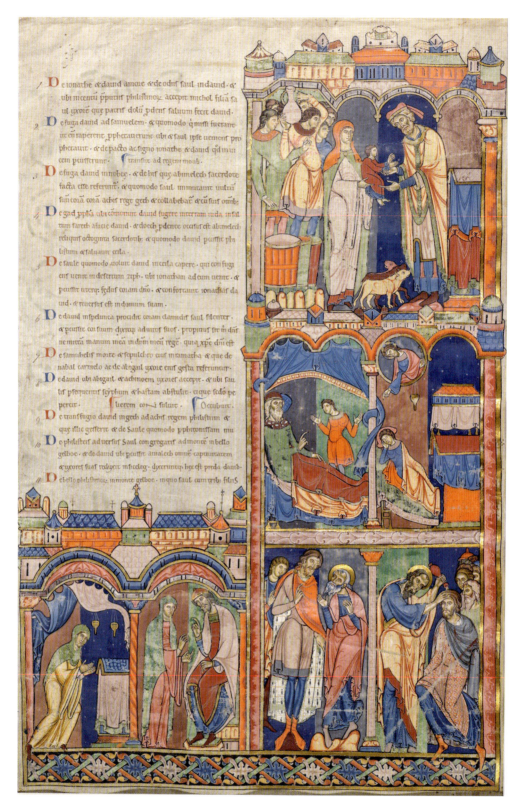

FIG. 3
Single leaf from the Winchester Bible, Winchester, England, between 1160 and 1180. The Morgan Library & Museum, New York, purchased by J. Pierpont Morgan in 1912; MS M.619, recto.

Lapierre. Born Black as Belle Marion Greener, she passed as white as Belle da Costa Greene. The archival silences and gaps left in her wake—she burned her personal papers and diaries—leave much of her personal history unknowable, and intentionally so. But the transformation of her identity, and the conflicted language she often used to express it, evokes the broader vexed histories of race and racism in the United States. In 1879—the same year she was born into a prominent Black family whose ancestors enjoyed liberated lives in Georgetown since the 1820s—a Black man named James Carroll was arrested in Georgetown near the Chesapeake and Ohio Canal before being lynched downriver for allegedly attacking a white woman in Maryland.[14] Racial violence, in other words, was never too far distant from racial uplift. The "aristocrats of color" that made up the social world of Greene's parents would have included figures like Blanche K. Bruce, the first African American senator to serve a full term in the US Senate.[15] Bruce and the Greeners formed part of the social orbit of Francis J. Grimké and the Fifteenth Street Presbyterian Church, in Washington, where Greene was baptized (fig. 4). These connections are vital for understanding the ways that colorism and elitism influenced Greene's upbringing and arguably readied her to work at the privileged white institutions where she was employed.[16] When Belle Greene started working for J. Pierpont Morgan in 1905 at the nearly finished Library designed by McKim, Mead & White to house Morgan's collection, most New York inhabitants were well aware of plans for the construction of Penn Station only a few blocks away. Also designed by McKim, Mead & White, the train terminal would finish the displacement of the Black community in Midtown that began with the New York Race Riot of 1900 (in the Tenderloin) and another anti-Black riot in 1905.[17] Greene left behind no indication of her thoughts about these violent events that deeply affected the lives of Black New Yorkers. But their physical and temporal proximity to the beginning of her new career serve as stark reminders of the dangers posed to African Americans in the early twentieth-century United States, and may have steeled her resolve not to disclose her Black ancestry.

And yet Greene's "crossing of the color line" was not a complete and irreversible transformation from Black to white, but rather the story of a Black person with mixed-race ancestry making individuated, sometimes deeply conflicted decisions about how to live her life. Critically intersectional, her identity cannot be understood exclusively along the binary of Black/white but must also be viewed through the lens of gender, class, and socioeconomic status. She was a socially elite Black woman living as white in a man's world of unimaginable wealth and privilege. But for all of her hiding she was undoubtedly authentic, uncompromising in her methods, and singular in her personality and style. It is hard to think of another librarian who captures one's imagination so completely.

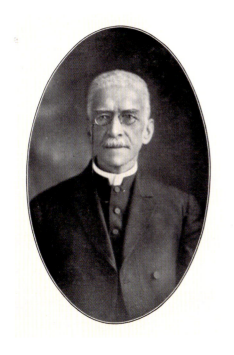

FIG. 4
Rev. Francis J. Grimké, Head-and-shoulders portrait, n.d. Photographic print; 13 3/8 × 8 11/16 in. (34 × 22 cm). Library of Congress, Photographs and Prints Division; BIOG FILE [item] [P&P].

A GROWING CONVERSATION AROUND BELLE GREENE

This book was written to mark the occasion of the first major museum exhibition devoted to the life and career of Belle da Costa Greene. A much smaller installation of material was displayed in 1983–84 at the Pierpont Morgan Library, celebrating the centennial of (what was then believed to be) Greene's birth. There have been a few smaller exhibitions in the interim: *Almost a Remembrance: Belle Greene's Keats* (2021) and *Belle da Costa Greene and the Women of the Morgan* (2022–23, both at the Morgan) and *The Reinvented Life of Belle da Costa Greene* (2023, at Vanderbilt University Special Collections). Several other books have focused on Greene. The first biographical notice about her appeared in *Notable American Women* (1971), where her year of birth is listed as 1883 and her birthplace Alexandria, Virginia.[18] But her story first appeared in biographies of the great men in her life: J. Pierpont Morgan and Bernard Berenson.[19] It was in the definitive biography of Morgan—Jean Strouse's *Morgan: American Financier* (1999)—that the fullness of Greene's life came into focus. Her chapter "Singular Women," along with her 1999 *New Yorker* article, "The Unknown J. P. Morgan," for the first time revealed the real story of Greene's background: that she was born Belle Marion Greener and was a Black woman. Strouse's research in the Morgan Archives, Harvard's I Tatti research center in Florence, and elsewhere provided the groundwork for a full-length biography of Greene, published in 2007 by the historian Heidi Ardizzone. Still the definitive biography, *An Illuminated Life: Belle da Costa Greene's Journey from Prejudice to Privilege* tells her story primarily through the nearly six hundred personal letters Greene sent to Bernard Berenson from 1909 to 1949, while also delving into the Morgan Archives to reveal her work as librarian and director.

Other scholars have written on various aspects of Greene's life and career, including Flaminia Gennari-Santori (her role in the art world),[20] William Voelkle, Christopher de Hamel, and Opritsa D. Popa (her acquisitions of medieval manuscripts for the Morgan),[21] Stephanie Smith (Belle Greene and passing),[22] Dorothy Kim and Sierra Lomuto (her position at the intersection of race and medieval studies),[23] and Karen Winslow (her interest in Islamic art),[24] as well as Laura Cleaver and Danielle Magnusson (her role in the rare book trade).[25] At the time the present volume was published, several scholars were writing works-in-progress about Greene, including Lori Salmon, Deborah Parker, and Olivier Berggruen.[26] Best known to general audiences are two adaptations of Greene's life as historical fiction: *The Personal Librarian* by Marie Benedict and Victoria Christopher Murray (2021) and *Belle Greene* by Alexandra Lapierre (first published in French, 2021; then in English translation, 2022). The first has seen tremendous popularity in the United States but is virtually unknown in Europe, while the second is popular in Europe but less commonly read by Americans. Both books have captivated the imaginations of readers and stand as the two most prominent fictional adaptations of her life. Other adaptations have included a stage

play (Juliane Hiam's *Revels and Revelations: Belle da Costa Greene and the Making of the Morgan Library*, 2010) and a hip-hop track (Big Piph's "The Ballad of Belle da Costa Greene," 2018).

This volume offers a companion publication to the exhibition while also presenting new research about Greene's family, education, personal art collection, acquisitions, reading interests, career, and writing. The essays are thematic in nature, and the book's structure follows a loose chronology but largely focuses on three main areas of interest: identity, collections, and leadership. This book does not present a revised biography of Greene, nor offer a comprehensive study of any of the themes covered therein. Rather, it aims to foster curiosity and provoke thought among readers who are interested in learning more about this extraordinary librarian and woman. For the sake of orienting readers to her life and career, however, what follows is a brief biographical sketch that covers the principal events of her life and touches on each of the ensuing essays.

Belle da Costa Greene was born Belle Marion Greener in Washington, DC, on November 26, 1879, the daughter of Richard T. Greener and Genevieve Ida Fleet Greener. Her mother, a music teacher, came from an elite Black family in Washington (fig. 5), the Fleets, while her father was a prominent civil rights activ-

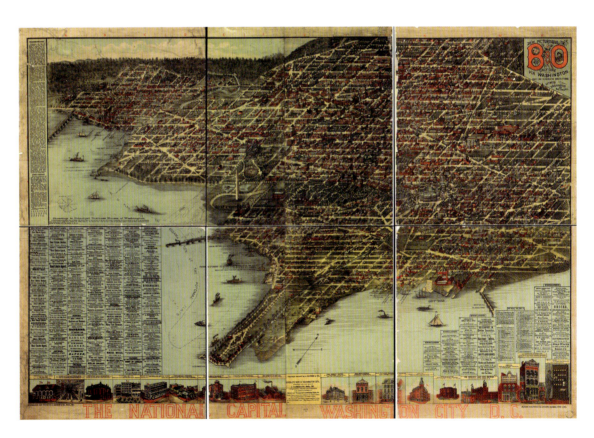

FIG. 5
Adolph Sachse, *The National Capital, Washington, D.C. Sketched from Nature by Adolph Sachse, 1883–1884* (Baltimore: A. Sachse & Co., 1884). Library of Congress, Geography and Map Division; G3851.A3 1884 .S3.

ist, educator, and lawyer. Most of the information we have about Belle Greene's mother is fragmentary, sourced from census records, city directories, and newspaper articles. But we know that her family had held a prominent place among the free Black communities living in Georgetown from the early nineteenth century. Her great-great-grandfather Henry Fleet was a shoemaker and would purchase the freedom of his family members. His son Henry Fleet Jr. worked in the same profession and married Sarah Carter Fleet. Their children included James Fleet, who became a music teacher.[27]

According to the 1850 US Census, James Fleet had a son, also named James, listed as "J. H. Fleet."[28] The family members' race is designated "M" for "Mulatto," a category that would have applied to the mixed-race ancestry of many free Black people descended from enslaved ancestors. James H. Fleet studied medicine but was not permitted to become an acting physician, instead opening two different schools in DC, one of which was destroyed by arson.[29] Around this time he also attended the Fifth Annual Convention for the Improvement of the Free People of Color in the United States, held in Philadelphia, where he motioned to recommend "to the free people of color throughout the United States, the propriety of petitioning Congress and their respective State legislatures to be admitted to the rights and privileges of American citizens."[30] Fleet and his wife, Hermione Peters Fleet, were also well-known musicians in Georgetown. They were associated with the choir of the Fifteenth Street Presbyterian Church, and together performed in the first instrumental concert held at an African Methodist Episcopal church in the United States. An account of this concert characterizes James H. Fleet as "the ablest colored musician then in the District of Columbia," and describes "Mrs. Hermion[e] Fleet, a pianist, the wife of Mr. Fleet, who played on the flute and the guitar, as well as the piano, with great skill."[31]

FIG. 6
Fleet family residence, 1208 30th Street NW (formerly 109 Washington).

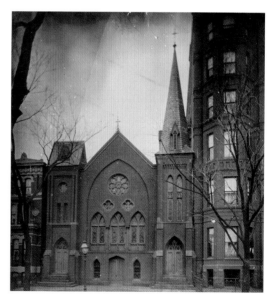

FIG. 7
Negro Churches—Presbyterian Church, Wash., D.C., 1899? Photographic print; 6 5/16 × 5 7/8 in. (16 × 15 cm). Library of Congress, Photographs and Prints Division; LOT 11303 [item] [P&P].

Over the second half of the nineteenth century, Belle's mother's family enjoyed a rise in social prominence and corresponding increase in wealth, as registered in federal census records. While in 1850 James owned $900 in real estate, by 1860, a year before his death, that value had grown to $1,000 in real estate and $600 in personal property. In 1870 his widow, Hermione, owned $2,500 in real estate and $500 in personal property. Twenty-seven years earlier, her husband had acquired this real estate, a federal style home in Georgetown, for $800 (fig. 6).[32] Even after James H. Fleet's death in 1861, Genevieve, her mother, and siblings were living at that address, but in 1873 Hermione was forced to sell the house to make ends meet for her family.[33] In the mid-1870s they moved into Washington, DC, proper, to 1713 M Street, where Genevieve lived until she married Richard T. Greener, Belle's father, in 1874. At this address, which was not far from the Fifteenth Street Presbyterian Church, Hermione Fleet picked up work as a dressmaker. Genevieve's mother and siblings continued to live on M Street until 1878, when they moved north to T Street, where the Fleet and Greener families settled.[34]

Daria Rose Foner's essay on "The Education of Belle da Costa Greene" will delve more deeply into the lives of Greene's parents, whose relationship probably developed through their mutual association with the Fifteenth Street Presbyterian Church (fig. 7). Greener moved from Harvard to DC in 1873 to become principal of the Preparatory High School for Colored Youth, the first high school for nonwhite students in the city, which was founded in the basement of the Fifteenth Street Presbyterian Church.[35] After their marriage in 1874, Genevieve and Richard moved south for his position as professor and librarian at the University of South Carolina. The collapse of Reconstruction brought the couple back to Washington, where they began raising a young family. Back in DC, Greener worked at various times as a government clerk, dean of the Howard University Law School, civil rights activist, and lawyer (fig. 8).[36] In 1885 he moved to New York City to take a job as secretary of the Grant Monument Association, charged with building a memorial for Ulysses S. Grant on the West Side of Manhattan.[37] The rest of the Greener family moved to New York City in 1888. Around 1894–96 three events occurred that would change Belle Greene's life forever: her parents would separate, she would leave the city to attend boarding school in Massachusetts, and she would begin to pass as white with her mother and siblings. All three of these transitions are recorded in an extraordinary file of material preserved at the Northfield Mount Hermon School, then known as the Northfield Seminary for Young Ladies (1879), which Daria Rose Foner discovered in 2021 and will explore more fully in her essay.

The story of Belle Marion Greener passing to Belle da Costa Greene is a complex one, marked significantly by gaps in the archives, whispered gossip, and unspoken acknowledgments. It is very likely that Greene destroyed her personal papers, which we know included several volumes of diaries, before her death.[38] Rumors circulated about her racial identity during her lifetime, and she sometimes fed these rumors with statements made in private correspondence

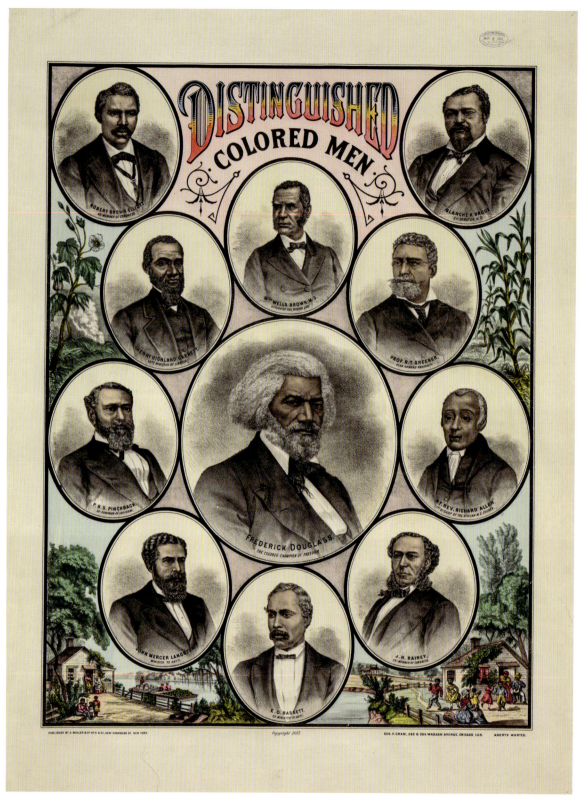

FIG. 8
Distinguished Colored Men (New York: A. Muller & Co.;
Chicago: Geo. F. Cram, ca. 1883). Library of Congress, Prints
and Photographs Division; PGA – Muller—Distinguished
colored men (D size).

or social situations. Passing is a deeply private and personal decision. People did not usually talk about passing openly, and they certainly did not typically leave written records about it. Despite the many archival silences around this aspect of Greene's life, one established fact is that she did not go about it alone. Crucially, it was her mother, Genevieve, as well as Belle's siblings who passed together in New York City. Genevieve would adopt a new middle name, "Van Vliet," in an attempt to align herself with the old Dutch names used among New York's upper classes. Both Belle Greene and her brother, Russell, adopted the middle name "da Costa," connecting it directly to a fictional Portuguese heritage that would help explain their darker complexions. Belle Greene's other siblings, her older sister, Mary Louise, as well as her younger sisters Ethel (or Alice Ethel) and Theodora (also known as "Teddy") had lighter complexions and did not adopt "da Costa" in their names. Though documentation is scarce from this part of her life, a book inscription reading "Belle da Costa Greene" from 1903 shows that she was using her new middle name by at least that year (fig. 9).[39] The family's decision to pass as white and use these invented names was a possible response to the major changes in the legal status of Black Americans in the United States near the end of the nineteenth century. In 1896 *Plessy v. Ferguson* put before the country the question, what is Blackness? Should Plessy, a white-passing individual, be categorized as Black? The ruling not only formalized segregation through the formulation "separate but equal," but also noted that an individual need not appear Black to be considered Black. This concept—known as the One-Drop Rule or the Hypodescent Rule—would play a pivotal role in shaping the contours of race and racism in the early twentieth-century United States.[40] Julia S. Charles-Linen's essay, titled "The Cleverest Girl: Strategic Racial Performance and the Making of Belle da Costa Greene," will more fully contextualize the passing of Belle da Costa Greene within these larger histories of race and passing literature in the United States.

The beginning of Greene's career as a librarian can be traced to Princeton University, where she began working in 1901 after leaving Northfield in 1899 and attending a summer library school program at Amherst College in 1900. Princeton's institutional archives contain very little about Greene's work for the library. A list of library employees from 1903 includes a "Greene, B." earning $40 per week and $480 per year.[41] Several handwritten accession ledgers from the Princeton University Library contain sections in handwriting that matches the formal hand Greene would later use at the Morgan in certain letters and documents, as well as library catalogue cards.[42] One of the ledgers documents her accessioning of the John Shaw Pierson Civil War Collection, including many titles about slavery, antislavery, and race in America.[43]

FIG. 9
Book inscribed "Belle da Costa Greene from Craven Langstroth Betts 1903." Pierre Jean de Béranger (1780–1857), *Songs from Béranger*, translated by Craven Langstroth Betts (New York: F. A. Stokes Co., 1893). The Morgan Library & Museum, New York, gift of the Estate of Belle da Costa Greene; PML 45820.

Her work on this collection is interesting in part because she was passing as white at this time while working at an institution helmed by the notoriously racist Woodrow Wilson, later the US president. One of the titles she recorded in the accession books is the *Speech of Salmon P. Chase in the Case of the Colored Woman, Matilda* (1837), which recounts the story of a mixed-race woman named Matilda who escaped from enslavement and passed as white to live in Cincinnati before being caught and returned to her owner.[44] Her case, taken up by Salmon P. Chase, later Chief Justice of the United States, became a galvanizing force in the abolitionist movement. It is interesting to consider the question of how Belle Greene would have reacted to this pamphlet as someone newly passing as white at Princeton. The book about Matilda told the story of a mixed-race woman, like Greene, belonging to her grandparents' generation—a woman who also had to pass to live her life.

At Princeton she would meet Junius Spencer Morgan, J. Pierpont Morgan's nephew and associate librarian at the Princeton University Library. Junius was a bibliophile like his uncle, specializing in early printed editions of the Roman poet Virgil, and advised Pierpont on his early book and manuscript purchases.[45] It was Junius who brought Greene to the attention of his uncle, who would hire her to work at his private library in New York at some point during the summer of 1905 (fig. 10). A letter from Junius to his wife, Josephine, contains the earliest description of Greene working with Morgan's library: "Miss Greene telephoned me the other day about her work at the Lenox & said she was having the time of her life! She is putting in book plates dusting the books & packing them."[46] In the summer of 1905 Morgan's great Library, designed by McKim, Mead & White, was not yet finished, and his book collection was stored in three locations: his Madison Avenue brownstone; his London home; and the Lenox Library on Fifth Avenue, the site of which is now the home of the Frick Collection. By the end of the year Greene was earning $75 a month in her job, as indicated in one of Pierpont Morgan's diaries—roughly $2,500 a month in 2024 dollars.[47] Once the Library was completed she drafted inventories of the collection and catalogued individual books and manuscripts. Greene enjoyed a beautifully appointed office,

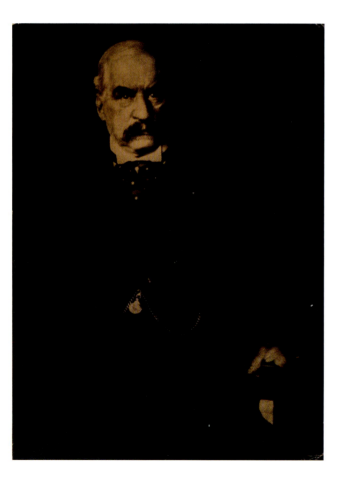

FIG. 10
Edward J. Steichen (1879–1973), *Photographic Portrait of Pierpont Morgan*, 1903. Platinum print; 16 1/16 × 11 15/16 in. (40.8 × 29.7 cm). The Morgan Library & Museum, New York; AZ182.

the North Room, located diagonally across the Rotunda from Pierpont Morgan's study. A staged photograph of the North Office shows two catalogue card cabinets flanking the room (fig. 11), while an early etching of Greene depicts her in the middle of answering a reference question, sitting with "half the Library" on her desk. This was a time in her career, unlike later years, when Greene frequently sat for portraits by photographers and artists. Deborah Willis's essay will engage

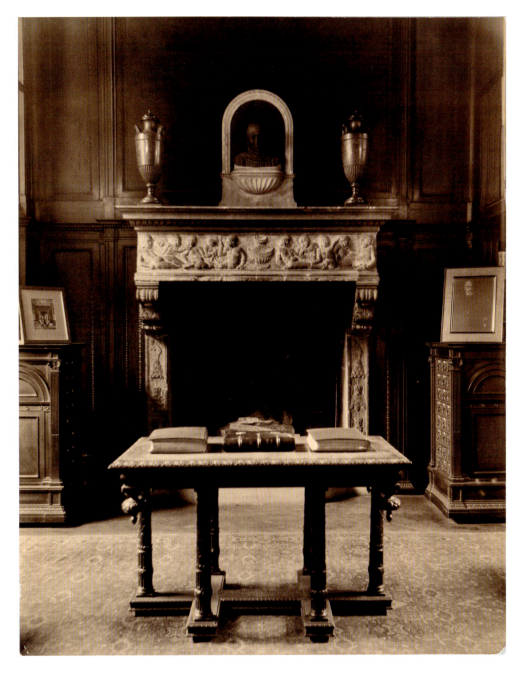

FIG. 11
Tebbs & Knell, North Room of J. Pierpont Morgan's Library, between 1923 and ca. 1935. Gelatin silver print; 13½ × 10⁷⁄₁₆ in. (34.2 × 26.5 cm). The Morgan Library & Museum, New York; ARC 1600.

with the rich variety of surviving Belle Greene photographs and interpret these images against the backdrop of the New Woman and New Negro movements.

Greene's first major acquisition as Morgan's representative was her much-lauded coup at the 1908 sale of the library of William Tyssen-Amherst, first Baron Amherst of Hackney. There she negotiated the purchase of sixteen incunabula printed by William Caxton, including the first book printed in English— *The Recuyell of the Historyes of Troye* (1473; PML 771). Famously, Greene offered to purchase the collection outright from Lord Amherst before the public sale, promising not to bid against one of her British colleagues.[48] Though correspondence with the British bookseller Bernard Alfred Quaritch and his associates indicates that negotiations had begun even before Greene's arrival in England that December, the story is legendary for establishing her acumen as a negotiator and reputation as a major force in the world of rare book collecting.[49] Her efforts at collection development were at once smart and sensational. Essays in this volume about Greene's interest in literature, as both a reader and collections curator, as well as her work as a medievalist, shed additional light on her approach to building collections. She had a particularly keen eye for developing Morgan's collection of Rembrandt etchings, one of the finest in the world, and she was always on the lookout for rare editions of early printed books. The holy grail in that respect was Thomas Malory's *Le Morte d'Arthur*, printed by William

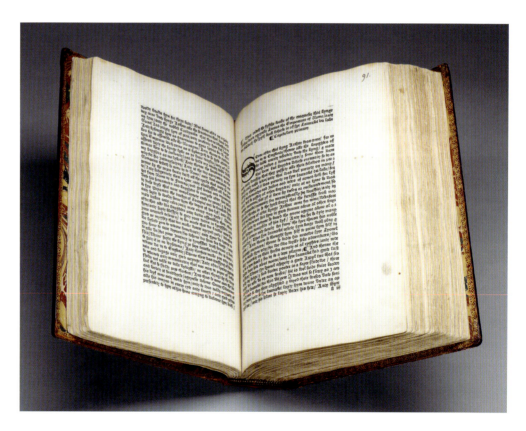

FIG. 12
Sir Thomas Malory (active fifteenth century), *Thus endeth thys noble and joyous book entytled le morte Darthur* (Westmestre: [William Caxton], the last day of Juyl [sic] the yere of our lord /M/CCCC/lxxxv [July 31, 1485]). The Morgan Library & Museum, New York, purchased by J. Pierpont Morgan, 1911; PML 17560, fols. 90v–91r.

Caxton in 1485 and surviving in only a single complete copy (fig. 12). Sold at the auction of Robert Hoe's library in 1911, this book is arguably her most famous acquisition. Morgan was willing to pay up to $100,000, and the high threshold was necessary because of a new kid on the block, the book collector Henry E. Huntington, who had been driving book prices into the stratosphere. Greene and Morgan won out in the end, successfully bidding at under $50,000. The press was enthralled: "Fifty thousand dollars for that book!" read a magazine headline (fig. 13).[50] Greene's greatest acquisitions lay in the field of medieval illuminated

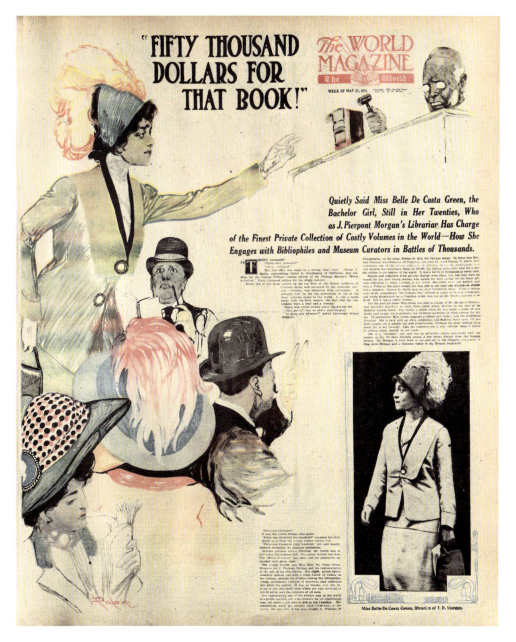

FIG. 13
Color-printed illustration by Alexander Popini imagining Belle da Costa Greene at the Robert Hoe sale. "Fifty Thousand Dollars for That Book!" *World Magazine*, May 21, 1911.

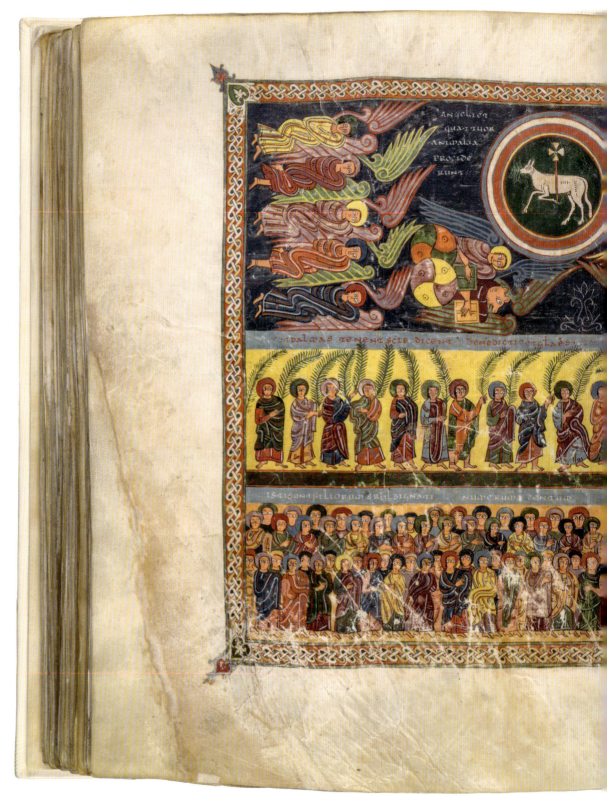

FIG. 14
Beatus of Liébana (d. 798), *Commentary on the Apocalypse*, San Salvador de Tábara, Spain, ca. 945. The Morgan Library & Museum, New York, purchased by J. P. Morgan Jr., 1919; MS M.644, fols. 117v–118r.

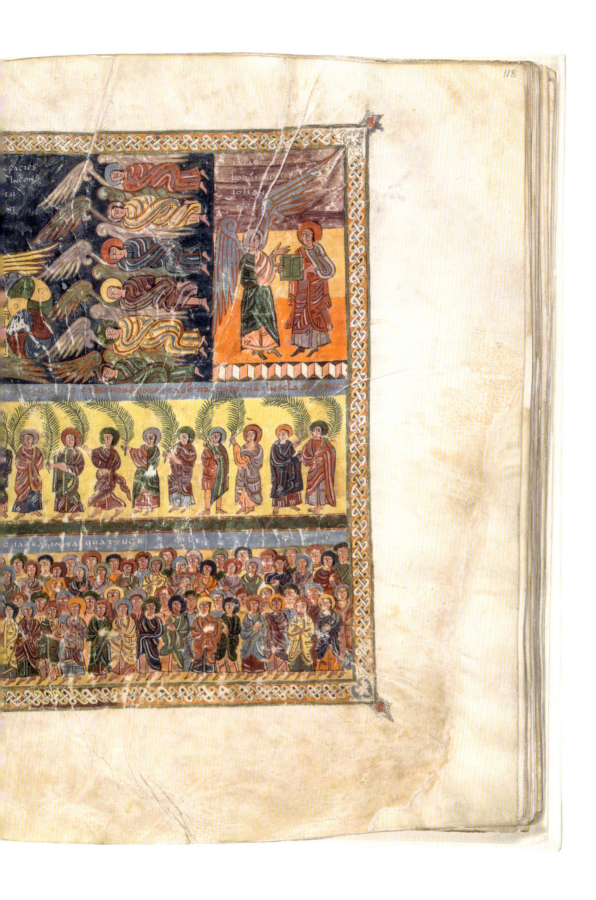

manuscripts (fig. 14), and as Anne-Marie Eze shows in her essay, she was deeply connected in the international network of medievalist scholars and professionals. But her expertise was not limited to early printed books and medieval manuscripts. She also continued to develop the collections of drawings and prints (fig. 15) and literary and historical manuscripts formed by Morgan. Since Greene was an avid reader, theatergoer, and friend of writers, her interest in developing the literary manuscripts collection emerged naturally from her immersion in the fictional world of books. "Greene and Literature," cowritten by Deborah Parker and myself, explores Greene's reading of literary texts and acquisition of authors' manuscripts. A special section of plates includes more information about other acquisitions made by Greene for the Morgan's collection.

By 1911 Morgan had placed so much trust in Greene that she noted he "is so well trained now that he rarely ever buys a book or [manuscript] without consulting me by cable or letter first."[51] A big raise in 1911 made her one of the best-paid women in the United States. The relationship between Pierpont and Belle is, of course, central to the story of her work at the Library. He was her employer, friend, and strongest advocate.[52] At other times she bristled at his temper and authoritarian demands. In her letters to Berenson, she defends him one day and criticizes him the next. But it is abundantly clear that despite occasional ten-

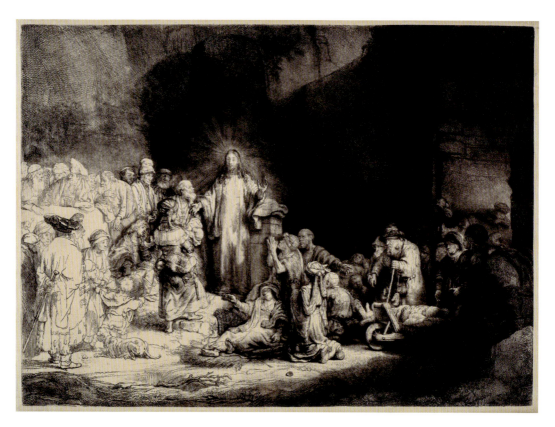

FIG. 15
Rembrandt Harmenszoon van Rijn (1606–1669), *The Hundred Guilder Print*, ca. 1648. Etching, engraving, and drypoint; 11⅛ × 15⅝ in. (28.3 × 39.5 cm). The Morgan Library & Museum, New York, purchased, 1925; RvR 116.

sions, Greene deeply admired her boss. We see an outpouring of emotion when he died suddenly in March 1913; as she writes to Sydney Cockerell, a British curator and director of the Fitzwilliam Museum at Cambridge University,

> I feel as if Life had stopped for me and it is all I can do to "go on" without him. He was so much more than my "boss." He was almost a father to me—very often I felt like a son—and always the staunchest [and] truest of friends, and his never-failing sympathy, his understanding and his great confidence and trust in me bridged all the differences of age, wealth and position. So you can see I feel stranded and desolate.[53]

Pierpont's son, Jack, would inherit the bulk of his father's estate, including the Library, and Belle Greene would receive a bequest of $50,000—an enormous sum in 1913. Morgan also indicated that he wanted his son to keep Greene employed as librarian. But the early days under Jack were a bit rocky for Greene: she feared he would sell the entire collection and he made some acquisitions that confounded her. Despite these disagreements Greene would help Jack assess his father's collection, part of which was sold or donated. But the works on paper—especially Greene's prized books and manuscripts—were kept intact within the Library's walls and comprise the core of the institution's modern holdings. In 1924 Jack Morgan (fig. 16) signed a deed of trust to create the Pierpont Morgan Library as a memorial to his father. Together, Belle Greene and Jack Morgan collaborated to open the Morgan Library as a public research library and museum in 1928, when the Annex building designed by Benjamin Wistar Morris and located adjacent to the Library opened to visitors and researchers. One of the essays in this volume, Erica Ciallela and my "Belle Greene as Director: Transitions," will discuss her working relationship with Jack Morgan and Morgan family board members in greater detail.

Another figure who played an outsize role in Belle Greene's life was the art historian Bernard Berenson, Greene's friend, colleague, and sometime lover.

FIG. 16
Frank Owen Salisbury (1874–1962), *J. Pierpont Morgan Seated, Half-Length*, 1928. Charcoal and white chalk with fixative; 22 5/16 × 19 in. (59.7 × 48.5 cm). The Morgan Library & Museum, New York, purchased on the Acquisitions Fund; 1973.8:3.

Their lively correspondence, though one-sided (Greene burned Berenson's letters before her death), spanned four decades (1909–49) and comprises arguably the most important surviving body of Greene's writing. Her personality and imagination sparkle in these letters, nearly six hundred in all, which are now preserved at I Tatti, the Harvard University Center for Italian Renaissance Studies.

Greene and Berenson first met in New York in January 1909. Berenson was there with his wife, Mary (fig. 17), and together they visited the Morgan Library to view its treasures. She records one of her earliest impressions of Belle Greene in a letter to her daughter Rachel, where she calls her "a most wild and woolly and EXTRAORDINARY young person."[54] Belle and Bernard's relationship emerged initially from a shared love of art and culture but soon blossomed into a sweep-

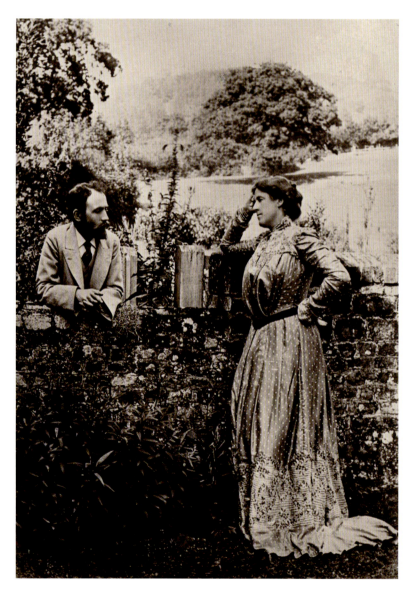

FIG. 17
Bernard Berenson and Mary Berenson at Friday's Hill, 1901. Gelatin silver print; 8 × 5⅞ in. (20.4 × 15.1 cm). Biblioteca Berenson, I Tatti, the Harvard University Center for Italian Renaissance Studies; Bernard and Mary Berenson Papers, Personal Photographs, Box 1, Folder 8.

ing romance that for many years stood the test of space and time. While it is misleading to describe their correspondence, which regularly veers into art historical topics, as a group of "love letters," Belle and Bernard nonetheless expended a great deal of ink expressing their affection for one another. They enjoyed each other's company in Europe on a few occasions but their relationship was largely expressed through handwritten letters. The romance had cooled by the 1920s but they remained correspondents until 1949.[55]

Through Berenson, Greene met many key figures in the early twentieth-century art world, and she details this wide social circle in her many letters to him. Her rich network included names related to modernist movements in art and literature, such as Edward Steichen, Alfred Stieglitz, Abraham Walkowitz, and Francis Picabia. Gail Levin's essay on "Belle da Costa Greene, the Stieglitz Circle, and Modern Art" considers Greene's published contribution to *Camera Work* and her entry into the world of Stieglitz's 291 gallery, where she purchased her first piece of modern art, a drawing by Matisse. Greene's personal interests in collecting art and books is treated in a special section of plates and catalogue entries.

One also catches in Greene's letters to Berenson a glimpse of her social involvement in the world of politics, particularly her position on women's suffrage. She was infamously against women's suffrage early in her career, but eventually would become engaged with the Women's City Club of New York, an organization of suffragettes, as one of its officers.[56] She also worked against the incumbent Woodrow Wilson's presidential bid in 1916 in support of the Republican candidate, Charles Evans Hughes, who sought to extend the vote to women.[57] Her role in the Women's Roosevelt League for Hughes (fig. 18) alongside women like Alice Carpenter is interesting in part because Wilson was the president of Princeton when Greene worked there, and was notorious for his anti-Black racism.

FIG. 18
Members of the Women's Roosevelt League for Hughes. Left to right: Mrs. Jos G. Deune, Sec'y., Miss Alice Carpenter, Pres., Miss Belle Greene, Treas., ca. 1916. Photographic print; 5 × 4 in. (12.7 × 10.2 cm). Library of Congress, Photographs and Prints Division; BIOG FILE [item] [P&P].

FIG. 19
Library card issued by the Pierpont Morgan Library to Harold Strong Gulliver, ca. 1934. The Morgan Library & Museum, New York; ARC 3291, Box 77, Folder 7.

Of course, the greatest act of philanthropy in Greene's world was the creation of the Pierpont Morgan Library in 1924, when she was appointed as both director and keeper of manuscripts. Once the institution was established there was much work to do. Greene developed protocols for accessing the Library, including the creation of reader's cards and Reading Room regulations, often in consultation with other cultural heritage institutions (fig. 19).[58] She was involved in expanding the Morgan's campus in 1928, overseeing the addition of an exhibition space and dedicated Reading Room. She would ramp up the education program at the Morgan, hosting hundreds of visiting classes from colleges and universities around the Northeast. She established the widely regarded series of public educational and scholarly programs the Morgan Library & Museum is known for today—its lectures and symposia, its educational outreach to students in greater New York City, and its memorable exhibitions of books, manuscripts, and art. She would continue and expand the great work she had begun when the Library was in private hands, ultimately attaining for the Pierpont Morgan Library a level of international recognition that she only dreamed about in the early days of her career. In 1949, a year after Greene retired, her colleagues would honor her with an exhibition commemorating the first twenty-five years of the Library, celebrating the many incredible treasures she acquired during

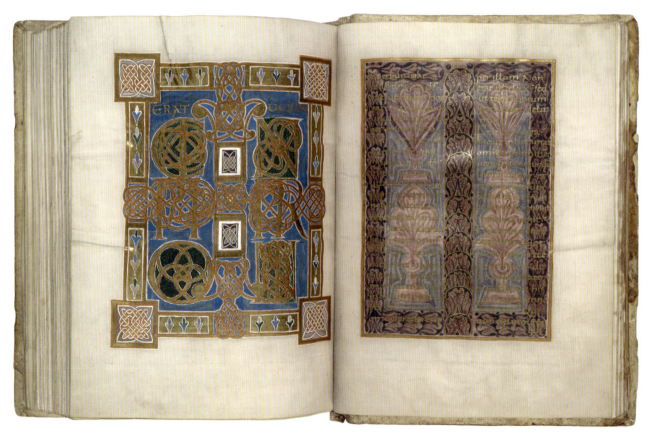

FIG. 20
Illuminated Gospel Book acquired by Belle da Costa Greene in 1929. Quedlinburg Gospels, Westphalia, Germany, mid-tenth century. The Morgan Library & Museum, New York, purchased, 1929; MS M.755, fols. 157v–158r.

her time as director (fig. 20). She would continue to make acquisitions until the very end of her career, culminating in an illustrated Ethiopian Gospels commissioned for Princess Zir Ganela, acquired in 1948 (pp. 152–53). The last decade of her life was marked by such professional honors but also much personal tragedy, as my essay on "Belle Greene as Director: Endings" explores in more depth. Even though her health was failing from lung cancer, Greene would continue to come into the Library regularly to write a memoir about her life with the Morgans.[59] She would die on May 10, 1950, at the age of seventy.

 Gone, but not forgotten, for the vestiges of Belle Greene's work and personality are keenly felt at the Morgan today, nearly seventy-five years after her death. Her handwritten notes in pencil, customarily added to the blank endpapers of books and manuscripts, or to the empty margins of album leaves, are a reminder of her many decades of tireless work and dedication. Such notes are encountered on a daily basis by Morgan staff as they browse the collection, research material for exhibitions, and page books and manuscripts to the Reading Room. The Library is truly a living testament to Belle da Costa Greene's ambition, creativity, and labor. Today she is widely recognized as an important figure in the history of Black American librarianship, and she is often put in the same context as contemporaries and near-contemporaries such as Catherine Latimer, Dorothy Porter Wesley, and Vivian G. Harsh. An essay by Rhonda Evans considers the disparate biographical and professional trajectories of these women and explores what it means to identify Belle Greene as a Black woman librarian.

 Twenty-five years after her death, in response to then-Director Charles Ryskamp's request for reminiscences of "Miss Greene," as she was known to Morgan staff, Meta Harrsen typed up a series of anecdotes about her former mentor and boss. She titled it "Memories of Belle Greene, or Never a Dull Moment." As evinced by the contents of this book and exhibition, Belle da Costa Greene's life and career were anything but dull. In the 1940s she remarked to Berenson that "after all we knew a grand time and lived a grand life"—and what a grand life it was.[60]

NOTES

1
"Spending J. P. Morgan's Money for Rare Books," *New York Times*, April 7, 1912.

2
Katherine Reynolds Chaddock, *Uncompromising Activist: Richard Greener, First Black Graduate of Harvard College* (Baltimore: Johns Hopkins University Press, 2017), 48–73; Michael Robert Mounter, "Richard Theodore Greener: The Idealist, Statesman, Scholar, and South Carolinian," PhD diss. (University of South Carolina, 2002), 112–88.

3
Belle Marion Greener, Application for Admission to Northfield Seminary, June 28, 1896, Northfield Mount Hermon Archives.

4
Trow's General Directory of the Boroughs of Manhattan and Bronx City of New York for the Year Ending August 1, 1913 (New York: Trow Directory, Printing and Bookbinding Company, 1912), 603.

5
Meta Harrsen to Bernard Berenson, September 18, 1953, Bernard and Mary Berenson Papers, Box 68, Folder 3, Biblioteca Berenson, I Tatti, the Harvard University Center for Italian Renaissance Studies.

6
"Bidding at Great Library Sale," *New York Evening Post*, May 13, 1911, Archives of the Morgan Library & Museum, ARC 3291, Box 94, Folder 2. (Archives of the Morgan Library & Museum material hereafter cited as "ARC.")

7
"Women Who Are Big Money Makers," *Atlanta Constitution*, December 28, 1913; "Women Who Earn Big Wages," *Asbury Park Evening Press*, March 10, 1921; "The Growing Army of Women Who Earn $10,000 a Year or More in Business," *St. Louis Post-Dispatch*, March 13, 1921.

8
A manuscript titled "Gertrude Stein" and signed "B. G. Picasso," entirely in Greene's cursive hand, is preserved at Yale. Alfred Stieglitz / Georgia O'Keeffe Archive, YCAL MSS 85, Box 99, Folder 2013, Beinecke Rare Book and Manuscript Library, Yale University.

9
Meta Harrsen, "Memories of Belle Greene, or Never a Dull Moment" (ca. 1973), 1, Unprocessed Director's Papers (Charles Ryskamp), ARC.

10
Lawrence C. Wroth, "A Tribute to the Library and Its First Director," in *The First Quarter Century of the Pierpont Morgan Library: A Retrospective Exhibition in Honor of Belle da Costa Greene*, exh. cat. (New York: Pierpont Morgan Library, 1949), 17–18.

11
ARC 3291, Box 52, Folder 2.

12
Letters exchanged between Margaret Jackson of the NYPL Library School and Greene, December 10, 16, and 19, 1919, and January 16, October 23, and 29, 1920, ARC 1310, "NYPL."

13
For *The Thousand and One Nights* and "mountains of mail," see Greene to Berenson, April 9 and June 21, 1909, Berenson Papers, Box 60, Folders 2 and 3, respectively.

14
Dean Herrin, "The 'Mob Fairly Howled': Lynching in Frederick County, Maryland 1879–1895," *African American Resources Cultural and Heritage Society*, accessed September 13, 2023, https://aarchsociety.org/wp-content/uploads/History-of-Lynching-Frederick-County-MD_Dean-Herrin.pdf. I am grateful to Rex Carnegie, director of education and partnerships for Georgetown Heritage, for his fascinating talk on the Chesapeake and Ohio Canal, which touched upon Carroll's lynching, among other topics. "Georgetown African American History" panel held at Holy Trinity Church, Georgetown, February 1, 2023.

15
See Willard B. Gatewood, *Aristocrats of Color: The Black Elite, 1880–1920* (Bloomington: Indiana University Press, 1990).

16
For more on the Grimké family and the Fifteenth Street Presbyterian Church, see Kerri K. Greenidge, *The Grimkes: The Legacy of Slavery in an American Family* (New York: W. W. Norton, 2022).

17
For more on these events, see James Weldon Johnson, *Black Manhattan* (New York: Alfred A. Knopf, 1930); Saidiya Hartman, *Wayward Lives, Beautiful Experiments: Intimate Histories of Social Upheaval* (New York: W. W. Norton, 2019); and "New York City Race Riot: Topics in Chronicling America," Library of Congress, accessed March 1, 2024, https://guides.loc.gov/chronicling-america-new-york-city-race-riot.

18
Dorothy Miner and Anne Lyon Haight, "Greene, Belle da Costa," in *Notable American Women: 1607–1950* (Cambridge, MA: Belknap Press, 1971), 2:83–85. Miner worked at the Morgan under Greene, who recommended her for a position at the Walters Art Gallery. Anne Lyon Haight was a book collector who embarked on a biography of her friend Belle Greene, but illness prevented her from finishing the project (and her draft biography is not extant). See also Marilyn Domas White, "Greene, Belle da Costa," in *Dictionary of American Library Biography*, ed. Bohdan S. Wynar (Littleton, CO: Libraries Unlimited, 1978), 216–18.

19
Herbert L. Satterlee, *J. Pierpont Morgan: An Intimate Portrait* (New York: Macmillan, 1939); Cam Canfield, *The Incredible Pierpont Morgan: Financier and Art Collector* (New York: Harper & Row, 1974); Meryle Secrest, *Being Bernard Berenson: A Biography* (New York: Holt, Rinehart & Winston, 1979).

20
Flaminia Gennari-Santori, "'This Feminine Scholar': Belle da Costa Greene and the Shaping of J. P. Morgan's Legacy," *Visual Resources* 33, no. 1–2 (2017): 182–97.

21
William M. Voelkle, "Provenance of the Manuscript," in *Beato de Liébana San Miguel de Escalada: Manuscrito 644 de la Pierpont Morgan Library de Nueva York* (Madrid: Club Internacional del Libro, 2005), 1–3; Voelkle et al., *Biblia de los Cruzados* (Valencia: Scriptorium, [2013]); Christopher de Hamel, "The Curator: Belle da Costa Greene," in *The Posthumous Papers of the Manuscripts Club* (London: Allen Lane, 2022), 456–505; Opritsa D. Popa, "Belle of the Books," in *Bibliophiles and Bibliothieves: The Search for the Hildebrandslied and the Willehalm Codex* (New York: Walter de Gruyter, 2003), 96–110.

22
Stephanie Danette Smith, "Passing Shadows: Illuminating the Veiled Legacy of Belle da Costa Greene," PhD diss. (Dominican University Graduate School of Library and Information Science, 2015).

23
Dorothy Kim, "Belle da Costa Greene, Book History, Race, and Medieval Studies," *Quimbandas* 1, no. 1 (December 2020): 43–61; Sierra Lomuto, "Belle da Costa Greene and the Undoing of 'Medieval' Studies," *boundary 2* 50, no. 3 (2023): 1–30.

24
Karen Deslattes Winslow, "The Reluctant Collector and His Librarian: John Pierpont Morgan and Belle da Costa Greene," in "Moguls Collecting Mughals: A Study of Early Twentieth-Century European and North American Collectors of Islamic Book Art," DPhil thesis (University of London School of Advanced Studies, 2023), 126–75. See also William M. Voelkle, "History of the Collection," in Barbara Schmitz, *Islamic and Indian Manuscripts and Paintings in the Pierpont Morgan Library* (New York: Pierpont Morgan Library, 1997), 1–5.

25
Laura Cleaver and Danielle Magnusson, "American Collectors and the Trade in Medieval Illuminated Manuscripts in London, 1919–1939: J. P. Morgan Junior, A. Chester Beatty and Bernard Quaritch Ltd.," in *Collecting the Past: British Collectors and Their Collections from the 18th to the 20th Centuries*, ed. Toby Burrows and Cynthia Johnston (London: Routledge, 2018).

26
Lori Salmon is the head of the Institute of Fine Arts Library at New York University and is working on Greene as part of a larger book project on Black women art librarians of the twentieth century. Deborah Parker, who has contributed a cowritten essay in this catalogue, has completed a book manuscript titled *Becoming Belle da Costa Greene: A Visionary Librarian through Her Letters*. The art historian Olivier Berggruen is completing a book on the psychology of art collectors,

including a chapter on Morgan and Greene.

27
Ardizzone, *Illuminated Life*, 14, 23–27; Dorothy S. Provine, ed., *District of Columbia Free Negro Registers, 1821–1861* (Bowie, MD: Heritage Books, 1996), Registration, no. 192, Manumission, November 2, 1822; Robyn Smith, "The Fleet Family of Washington, D.C.," *Reclaiming Kin: Taking Back What Was Once Lost*, August 29, 2013, https://reclaimingkin.com/fleet-family/. As is not uncommon with genealogical records of early nineteenth-century African American communities, there are contradictions in the records about the exact relationships among Belle Greene's ancestors.

28
1850 United States Census.

29
Andrena Crockett, "D.C. Mondays: Georgetown African American Historic Landmark Project," The George Washington University Museum and the Textile Museum, accessed January 12, 2023, https://vimeo.com/699098007.

30
Review of "Minutes of the Fifth Annual Convention for the Improvement of the Free People of Color in the United States," *The Liberator*, August 1, 1835.

31
Daniel Alexander Payne, *History of the African Methodist Episcopal Church* (Nashville: Publishing House of the A. M. E. Sunday School Union, 1891), 456.

32
The house, now a private residence, is located at 1208 30th St. NW in Georgetown. The address was formerly known as 109 Washington, as Georgetown was an independent municipality before 1871. For Fleet's purchase of the house, see Deed, November 22, 1843, recorded May 14, 1844, in Liber WB 108 folio 86, Oscar Alston to Joseph [*sic*] H. Fleet, cited in "Georgetown Residential Architecture—Northeast," *Historic American Survey Selections* 5 (n.d., after 1950): 18.

33
Deed, May 22, 1873, recorded May 24, 1873, in Liber 722 folio 19, H. C. Fleet to James Goddard, cited in ibid., 19.

34
For the M Street address, see *Boyd's Directory of the District of Columbia* for 1874, 1875, 1876, and 1877. *Boyd's* 1878 lists Hermione at 1452 T Street.

35
Chaddock, *Uncompromising Activist*, 42; Mounter, "Richard Theodore Greener," 87–89; Ardizzone, *Illuminated Life*, 22–23.

36
Chaddock, *Uncompromising Activist*, chapters 5–7; Mounter, "Richard Theodore Greener," chapters 6–15; Ardizzone, *Illuminated Life*, 28–37.

37
Chaddock, *Uncompromising Activist*, chapter 9; Mounter, "Richard Theodore Greener," chapter 16; Ardizzone, *Illuminated Life*, 40–43.

38
Greene describes these diaries in eight letters to Berenson. See Greene to Berenson, September 12, October 5, and November 26, 1909; January 18, February 24, March 1, and July 29, 1910; July 18, 1914, Berenson Papers, Box 60, Folders 5, 6, and 8, respectively; Box 62, Folder 4.

39
Pierre Jean de Béranger, *Songs from Béranger*, trans. Craven Langstroth Betts (New York: F. A. Stokes, 1893). The Morgan Library & Museum, gift of the Estate of Belle da Costa Greene; PML 45820.

40
For one of many books that touches upon the impact of *Plessy v. Ferguson*, see Yaba Blay, *One Drop: Shifting the Lens on Race* (Boston: Beacon Press, 2021).

41
Board of Trustees Records, AC 120, Box 22, Princeton University Archives.

42
Princeton University Library Records, AC 123, Boxes 496–97, Princeton University Archives. I am grateful to Mathilde Sauquet, Pamela Patton, Eric White, and April Armstrong for sharing their research on traces of Greene at Princeton.

43
Accession Book 37, October 1904–March 1905, Princeton University Library Records, AC 123, Box 497, Princeton University Archives.

44
Speech of Salmon P. Chase in the Case of the Colored Woman, Matilda, 1837, Princeton University Library Special Collections, W17.251q Oversize.

45
Colin B. Bailey and Daria Rose Foner, "J. Pierpont Morgan: Becoming a Bibliophile," in Bailey et al., *J. Pierpont Morgan's Library: Building the Bookman's Paradise*, exh. cat. (New York: Morgan Library & Museum; London: Scala, 2023), 17–61.

46
Junius Spencer Morgan to Josephine Perry Morgan, August 25, 1905, Morgan Family Papers, C0553, Manuscripts Division, Department of Special Collections, Princeton University Library.

47
J. Pierpont Morgan, Excelsior daily journal for 1905, ARC 1196, Box 28, Folder 3.

48
New York Times, April 7, 1912, quoted in Ardizzone, *Illuminated Life*, 99–100.

49
Bernard Quaritch to Greene, September 3, 1907; Greene to Quaritch (photocopy), September 9, 1907; Quaritch to J. Pierpont Morgan, September 23, 1907 and October 2, 1908; E. H. Dring to Belle da Costa Greene, September 24, 1907; cable dated October 3, 1907, and receipt dated December 1908, ARC 1310. The correspondence documents that Lord Amherst had offered his entire library to Morgan for £150,000 and would not sell off the Caxtons individually (Greene had originally preferred to purchase only nine of the sixteen). In the end Amherst decided to sell the Caxtons as a group for £24,000, with Quaritch as the agent. The evidence suggests that Greene's negotiation for the books was achieved in collaboration with Quaritch.

50
"Fifty Thousand Dollars for That Book!" *World Magazine*, May 21, 1911. The copy of Caxton's *Morte d'Arthur* is now PML 17560. For more on the Robert Hoe sale and Greene's acquisition of the Caxton *Morte d'Arthur*, see Ardizzone, *Illuminated Life*, 243–50.

51
Greene to Berenson, February 21, 1911, Berenson Papers, Box 60, Folder 15.

52
There were rumors that the two were lovers, but this speculation is completely unfounded. Ardizzone, *Illuminated Life*, 4. A well-known scene in *The Personal Librarian* dramatizes a romantic kiss between Morgan and Greene, though the ultimate source for this invention suggests it was merely a kiss in greeting and unromantic in nature (Ardizzone, *Illuminated Life*, 171: "she allowed him to kiss her in greeting").

53
Greene to Sydney Cockerell (copy in Cockerell's hand), April 29, 1913, Add MS 52717, British Library.

54
Mary Berenson to Rachel Costelloe, February 18, 1909, "Correspondence: Berenson," Hannah Whitall Smith MSS, Lily Library, Indiana University, quoted in Ardizzone, *Illuminated Life*, 123.

55
"The Letters of Belle da Costa Greene to Bernard Berenson" is a web resource collaboratively built by Harvard's I Tatti Center and the Morgan Library & Museum. It features high-resolution images, full-text transcriptions/search, and rich metadata for discovering all of the letters from Greene to Berenson. See https://bellegreene.itatti.harvard.edu.

56
Ardizzone, *Illuminated Life*, 362–63.

57
"Women's Roosevelt League Will Work for Hughes's Election," *New York Times*, July 13, 1916.

58
ARC 3291, Box 97, Folder 4.

59
Greene to Berenson, June 2, 1947, Berenson Papers, Box 63, Folder 34; Ardizzone, *Illuminated Life*, 460.

60
Greene to Berenson, April 28, 1945, Berenson Papers, Box 63, Folder 34.

NOTE TO THE READER

Many of the essays in this volume engage with the histories of enslavement, racial violence, mental health, racist stereotyping and slurs, racial passing, and colorism. The authors have been deliberate in approaching these topics with the utmost care and honesty in order to convey a multifaceted and full portrait of Belle da Costa Greene that frequently challenges popular notions of who she was as a person. Presenting the broadest possible picture of Greene entails using thoughtful language to characterize her racial identity. In *One Drop: Shifting the Lens on Race*, Yaba Blay writes that stories of individuals of mixed-race ancestry "highlight the precariousness of language to define and describe race and racial identities."* To think intentionally with such precarity, in this book we identify Belle da Costa Greene as a Black woman of mixed-race ancestry. This specific language not only acknowledges that Belle Greene's parents were Black, but also that the light complexion of her family can be attributed to the legacies of slavery.

 Greene's name changed throughout her life, from Belle Marion Greener to Belle Marion Greene to Belle da Costa Greene. Colleagues at the Morgan called her "Miss Greene" and she would sign letters in variable fashion as "Belle Greene," "Belle da Costa Greene," or "B.G.," reserving "Belle" only for personal letters to correspondents like Bernard Berenson. For references to her name in this book, there is a marked preference for "Greene," though each of the above forms appear throughout the essays, depending on context and individual author's preferences.

*Yaba Blay, *One Drop: Shifting the Lens on Race* (Boston: Beacon Press, 2021), 128.

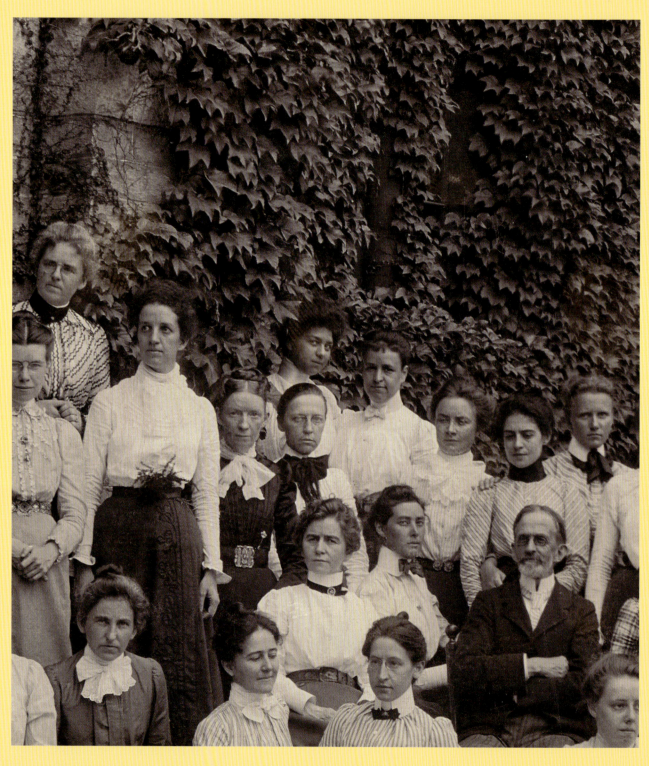

Amherst College Summer School, Fletcher Course in Library Economy, Class of 1900, with Belle da Costa Greene in the back, center-left (detail, fig. 9).

Daria Rose Foner

THE EDUCATION OF BELLE DA COSTA GREENE

Belle Greene's education began at home. Like innumerable African American families in the Reconstruction era, hers placed great emphasis on learning, which she continued to foster for the rest of her life. Greene decided early to be a librarian. According to friends, she could not "remember when she hadn't an interest in books," and that her "determination to be one of the great librarians of the world took form within her precocious brain at the age of thirteen."[1] Utilizing newly discovered archival sources, this essay revises our understanding of the experiences that shaped her early life and led to her eventual employment as J. Pierpont Morgan's librarian.

Born Belle Marion Greener on November 26, 1879 (fig. 1), she was the fourth child of Genevieve Ida Fleet and Richard Theodore Greener, light-skinned African Americans whose accomplishments foreshadowed some of Belle's own.[2] Both were well-educated, culturally engaged, and intellectually ambitious. Her father, who in 1870 had become the first Black graduate of Harvard College, went on to become one of the most prominent Black intellectuals and political figures of the late nineteenth century. Her mother, a "Washington belle," worked as a teacher and music instructor in the nation's capital.[3]

At the time of Belle's birth, the Greeners lived in Washington, DC, on T Street, a tree-lined block situated between the Adams Morgan neighborhood and Howard University.[4] Belle, like her siblings, was baptized at the Fifteenth Street Presbyterian Church by Reverend Francis J. Grimké, a staunch activist for equal rights, regardless of race.[5] (Grimké, like many of Washington's Black

elite, had parents of different races: his father had been a plantation owner and his mother an enslaved woman.)[6] A gathering place for the "Elite of Our Colored Society," the church's congregation included many of Washington's most prominent Black residents, including Blanche K. Bruce, who during Reconstruction had been the first Black man to serve a full term in the United States Senate.[7] The Greeners seem to have been firmly embedded within this elite community. Grimké married Belle's parents, Genevieve and Richard, at the Fifteenth Street Presbyterian Church in September 1874, and Genevieve often volunteered at church functions.[8] One of her brothers, Bellini Fleet, though a printer by profession, served as a church organist.[9]

Genevieve grew up in Georgetown in a musically oriented family. Her mother, Hermione Fleet, and father, James H. Fleet, attended the Fifteenth Street Presbyterian Church and sang in its choir, which James also conducted.[10] Three of Genevieve's brothers were named after composers: Bellini, Mozart, and Mendelssohn.[11] After James died in 1861, Genevieve's mother headed the household, which was comfortably upper middle class by African American standards. In 1866 and 1867 Genevieve attended a two-year college preparatory course at Oberlin, an institution well known since its founding in 1833 for its abolitionist connections and progressive attitudes on educating African American and female students.[12] Returning to Washington in 1867, Genevieve found employment at a Freedmen's Bureau school called the Observatory (because of its proximity to the city's naval observatory), where she taught reading, arithmetic, and geography.[13] She became principal of the all-Black Thaddeus Stevens School (named after the Radical Republican leader) and eventually

FIG. 1
"Return of a Birth to the Office of Health Officer, 212 4½ Street NW, Washington, D.C.," no. 20945, District of Columbia, Births and Christenings, 1830–1955. District of Columbia Office of Public Records.

oversaw musical instruction at all of the schools for African American students in Washington's Western District.[14] An active member of Washington's Black social circuit, Genevieve Greener devoted time and energy to charitable causes and attended society events. After one such occasion in 1874, a local Republican newspaper contrasted the guests "of the highest social position and literary culture" with "the people in Congress who oppose our having civil rights," a reference to the refusal of that body to enact the Civil Rights Bill introduced by Senator Charles Sumner.[15]

Although in the late nineteenth century Washington was "the center of black aristocracy in the United States," the specter of racism was ever-present.[16] Music was not, for example, the chosen profession of Belle's maternal grandfather, James Fleet. As a young man in the early 1830s, he was among three aspiring physicians who had enrolled at Columbian Medical College (today the George Washington University School of Medicine and Health Sciences).[17] The American Colonization Society sponsored their studies on the condition that upon receiving their degrees, they emigrated to Liberia to work as doctors in the nation the Society had established on Africa's West Coast. Fleet, though "desirous of becoming Eminent" in the field, ultimately refused to leave for Liberia after being prohibited from attending regular medical lectures and laboratory demonstrations, preventing him from obtaining "a proper education."[18] Banned from practicing medicine in the United States, only then did he turn to music.[19] As "a universally respected and regarded" music teacher, he opened two schools and offered lessons in "Piano Forte, Guitar, Flute, Thorough Bass, and Singing."[20]

A civil rights activist, lawyer, diplomat, and educator, Richard T. Greener (fig. 2) was part of a generation of Black members of the Republican party who felt that established leaders like Frederick Douglass, who had led the fight against slavery, had not achieved full equality for the emancipated slaves.[21] Like his daughter Belle, Greener was (at least briefly) a librarian: at the University of South Carolina he rearranged the 27,000 volumes in its collection and created a new catalogue.[22] There, as a professor during the school's brief period of racial integration in the era of

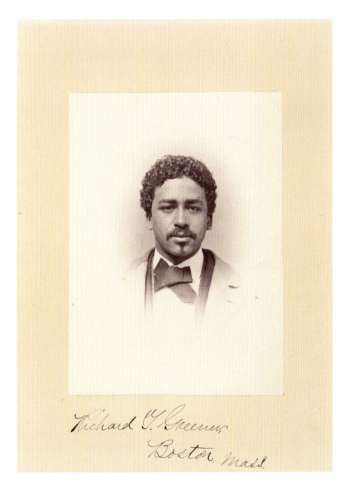

FIG. 2
Class Album, Harvard 1870, with photographs by George Kendall Warren (1834–1884) (Cambridge, MA: Harvard College, 1870). The Morgan Library & Museum, New York, purchased on the Horace W. Goldsmith Fund for Americana, 2021; ARC 3270.

Reconstruction, he taught philosophy, classical languages, and constitutional law. Greener later worked in the United States Treasury department, served as dean of Howard Law School, and defended Cadet Johnson Chesnut Whittaker before a court of inquiry at the United States Military Academy at West Point, after Whittaker, the Academy's only Black cadet, was brutally attacked by his fellow cadets, then charged with staging the assault.[23] Greener went on to hold diplomatic posts overseas, notably in Vladivostok.

A self-described "literary man," Greener was devoted, as his daughter would be, to "art, books, and esthetics."[24] While a Harvard undergraduate, Greener was invited by Charles Sumner, who had an impressive collection of art and books, to "converse on art," an occasion that likely included viewing the senator's fifteenth-century manuscript of Cicero's *De Officiis*. Such humanist illuminated manuscripts, which Belle would collect for Morgan so assiduously, would have impressed both father and daughter alike.[25] A polyglot, Greener learned Russian when stationed in Vladivostok, translating "The Poet" by Pushkin, "the greatest Russian author…dramatist, poet, and novelist."[26] Greener also assembled a collection of significant documents of African American history, writings by Black authors that he referred to, perhaps jokingly, as "negromania."[27] When thanking Arturo Alfonso Schomburg, the historian and founder of the New York Public Library's branch devoted to African American history, for a "checklist on American Negro poetry," Greener exclaimed, "How I admire your real bibliomaniac spirit!"[28] (fig. 3).

In 1885 Greener moved to New York City, where he had been appointed secretary of the Ulysses S. Grant Monument Association, which created what is popularly known as Grant's Tomb (fig. 4). As secretary, Greener had to raise the necessary funds—through public, private, and corporate subscriptions—to erect, as he wrote, "a fitting tribute to the greatest soldier of modern times."[29] Greener was one of the twenty men who made up the Monument Association's executive committee. Another was Belle Greene's future employer, J. Pierpont Morgan, who served as the organization's treasurer.[30] At the time, Morgan was a partner in the Drexel, Morgan & Co. banking house (a predecessor to J. P. Morgan & Co.), which held the asso-

FIG. 3
Richard T. Greener (1844–1922), Autograph letter signed to Arturo Schomburg, June 4, 1918. New York Public Library, Schomburg Center for Research in Black Culture, Manuscripts, Archives and Rare Books Division; Richard T. Greener Papers, Sc MG 107.

ciation's funds. When Morgan stepped down from his role in February 1889, Greener noted in the association's minutes that "through him and his banking house, much has been done toward augmenting our Fund."[31] Thus, years before Morgan had any contact with Belle, he had worked with her father on a widely publicized project.

In early 1888, when Belle was nine years old, the rest of the Greener family, which now included her siblings Mary Louise, Russell, Ethel (or Alice Ethel), and Theodora (or "Teddy"), joined Richard in New York. They initially lived on West 58th Street, between Eighth and Ninth Avenues, a block of row houses quite different from T Street NW in Washington, DC.[32] Belle attended Public School 69 on West 54th Street,[33] then in early 1893 attended a year of high school at the Horace Mann School for Girls, at the time located in Upper Manhattan and affiliated with Teachers College.[34] By the time she left Horace Mann, she had studied algebra, grammar, geography, and American history.[35] She had also taken advanced courses in French, Greek history, and English composition, and had begun studying Latin and geometry.[36]

Between 1887 and the early 1890s, the Greeners moved several times, eventually settling on West 99th Street, home to prominent Black residents such as Schomburg, the writer James Weldon Johnson, and Granville T. Woods, an inventor known as "the Black Edison."[37] With the family's move north, Genevieve began passing as white. In May 1894, the African American journalist, lawyer, and educator Thomas J. Calloway wrote to Booker T. Washington that Genevieve

FIG. 4
Byron Company, *Seven African-American Men on the Steps of Grant's Tomb on Riverside Drive*, ca. 1903. Gelatin silver print; 8 × 10 in. (20.3 × 25.4 cm). Museum of the City of New York, Prints & Photographs collection; 93.1.1.7009.

PLEASE FILL OUT THIS BLANK AND RETURN TO THE PRINCIPAL OF NORTHFIELD SEMINARY,
EAST NORTHFIELD, MASS.

1. Name of Candidate. *Bell Marion Greener*
2. Birthplace. *New York*
3. Send a physician's certificate as to health, specifying any weakness.
4. What schools has she attended, and how long? *Teachers College 1 year and a graduate of public schools*
5. State the amount of work done in the following studies, giving rank if possible:

 Arithmetic. *through cube root — excellent*
 Grammar and Analysis. *through Barnes grammar*
 Geography. *finished Harpers school geog.*
 U. S. History. *Barnes Hist. U.S. Not good*
 Civil Government. *None*
 Physiology. *None*
 Physical Geography. *but little*
 Algebra. *None*

6. If higher branches have been taken, state the amount of work done in each. *French (elem) begun Latin, Grecian Hist, begun Geometry, english*
7. Has she any marked preference in study, reading and occupation? *Mathematics & long would like to fit for Librarian*
8. Has she done anything toward self support? *Yes — one year as clerk Office of the Registrar of Teachers College —*
9. Has she formed any object in life? *Not pronounced*

FIG. 5
Belle da Costa Greene (1879–1950), Application for Admission to Northfield Seminary, June 1896. Northfield Mount Hermon Archives; Greene, File 2052N.

10. What are her prominent traits of character? generous & affectionate

11. Has she had any bad companionships or bad habits? No.

12. In what religious belief has she been educated? Protestant

13. Is she a member of any Church? No —
 If so, of what denomination?

14. If not a member of the Church, has she shown any interest in religion? Yes, has been a worker in S. School and King's daughters

15. Are her father and mother in any Church-membership? Yes — Presbyterian

16. State their occupation and means. Mother a teacher — family of five dependent children on her efforts

17. Who will be responsible for the pupil's board and tuition? Miss Grace H. Dodge, of 262 Madison Ave. N. Y. City —

18. Why do you wish to send her to this school? For the sake of its excellent religious training —

19. Send the address of her pastor. Dr. Malcom Shaw, West End Presbyterian Church, 105th + Amsterdam Ave. City

20. Send the address of the teacher in charge of the school which she last attended. Miss M. Hoffman. G. S. No 69. City —

21. Please send a photograph of the candidate.

Will have one taken —

"associates only with whites in New York." He added that the family was "poor and in very straightened circumstances."[38] Amid the backdrop of an economic depression, Greener struggled to find work after his 1892 departure from the Grant Monument Association. He traveled almost continuously, spending months at a time on the road as an itinerant lecturer, and had no regular source of income.

Following their relocation uptown, the family joined the West End Presbyterian Church, where Belle and her siblings attended Sunday school.[39] At the time, the church's pastor, John Balcom Shaw, knew them to be children of "the noted Colored man (Mulatto, I suppose)," Richard T. Greener.[40] However, Shaw believed Genevieve to be "a white woman, most intelligent and industrious," who due to "unusually unfortunate" circumstances had to offer music lessons in an attempt to "provide entire support for the family."[41]

Against the background of an increasingly strained home life, Belle withdrew from Horace Mann and in 1894 began working as a messenger and clerk for Lucetta Daniell, the registrar of Teachers College. Belle impressed Daniell, and within two years, the teenager had become her assistant. Daniell found Belle "bright, intelligent...capable, industrious, and faithful in her office-work." The registrar mentioned qualities that would serve Belle well throughout her life— determination, grit, steadfastness, and constant striving for improvement— Belle "shows good judgment and executive ability," is "strong in her likes and dislikes...and if she feels that she is trusted, meets and merits that trust." Daniell concluded: "She has a strong will, and shows much resolution about overcoming a fault when she is persuaded of it." Even as Belle excelled in her work at Teachers College, her home life must have been turbulent. In 1896 Daniell (who referred to Genevieve as "Mrs. Greener" but made no mention of Richard) believed that "Belle should be away from it all for a time, and have some of the happy girlhood which her nature, especially, needs for its best development."[42]

It was almost certainly through Daniell that Belle met the philanthropist and social welfare advocate Grace Hoadley Dodge, a founder of Teachers College who promoted vocational training and educational programs for young women.[43] Like Daniell, Dodge encouraged Belle to resume her studies and supported her application in the summer of 1896 to the Northfield Seminary for Young Ladies in rural Massachusetts.[44] Belle's application, submitted under the name "Bell Marion Greener," underscores her early aspiration to become a librarian (underlined for added emphasis) (fig. 5).[45] In a revelatory letter to Emma Charlotte Moody, the wife of Northfield's founder, Dwight Lyman Moody, Dodge urged her to admit Belle:[46]

> The family has a sad history[.] The Mother was a Mt Holyoke Graduate,
> a teacher—She married a man, with Spanish Cuban & Negro blood a lawyer
> who graduated the head of his class at Harvard! He turned out clever
> but bad and after terrible experiences she left him & has been supporting
> her five children with terrible struggle—Belle is bright, quick to learn,

easily influenced full of fun & energy.... While the trace of Negro blood is noticeable Belle has always associated intimately with the best class of white girls & at the College was a great favorite with many being entertained by them & going out with them—The Mother wants to make the girl a true noble woman & she has qualities for such if under such influence as Northfield—I will pay for her, and am most anxious that she be accepted.... The Mother, of course is white with good ancestry, and Belle inherits brains & ability.[47]

Dodge's letter is a fascinating mixture of fact and fiction. Genevieve *was* a teacher, but not a Mount Holyoke graduate. She *had* married a Black man who was a lawyer and Harvard graduate, but she herself was not white. The letter also indicates that by June 1896 Belle's parents had separated. This was fully two years before President William McKinley appointed Greener to a foreign consular post. Thus, his departure overseas did not precipitate the family's breakup, as is sometimes claimed, although it certainly may have cemented the separation. Genevieve and Richard Greener severed all ties but never formally divorced.

Belle's earliest surviving letter (fig. 6), dated August 27, 1896, and previously unknown to scholars, in which she arranges her arrival at Northfield, is especially illuminating.[48] Unlike the application, it is signed "B. Marion Greene"—not Greener.[49] Indeed, upon close inspection, Belle appears to have abruptly lifted her pen at the end of her surname, suggesting the drama of the moment she crossed the color line, as her mother had done before her. By the 1900 census, Genevieve and all five of her children were listed as white. Around the same time, Genevieve and her two youngest daughters adopted the middle name "Van Vliet" (possibly because it sounded like Genevieve's maiden name "Fleet"), while Belle and her brother, Russell, took the middle name "da Costa," to bolster what they now claimed was Portuguese ancestry.[50]

The evangelist preacher Dwight Lyman Moody founded Northfield in 1879 to educate students of modest means systematically denied education in the United States.[51] In the 1890s most classes included at least one Native American or African American student.[52] Some were passing; others were known to the administration not to be white.[53] But the diversity of the student body reached beyond American borders. During Belle's last year at Northfield, for

FIG. 6
Belle da Costa Greene (1879–1950), Autograph letter signed to Evelyn S. Hall, August 27, 1896. Northfield Mount Hermon Archives; Greene, File 2052N.

EDUCATION

instance, of the 361 students enrolled, twenty-four were from outside the United States. They included eleven from Canada, three each from Turkey and Jamaica, two each from China and Mexico, and one from England, Japan, and Micronesia.[54] Disparate as the students' backgrounds may have been, the campus newspaper celebrated the "comradeship, sympathy, and good-feeling among the students which makes itself felt at the very first."[55]

Belle moved to the sprawling bucolic campus in September 1896 (fig. 7).[56] She lived in North Hall, where she shared a room with Agnes Williams, and followed the school's traditional course of study.[57] In addition to English—which aimed "not only to train the student in mastering English for the expression of her own thought, but to encourage the reading and appreciation of the best literature"[58]—Belle took courses in mathematics (arithmetic, algebra, and geometry), history (which required "library work"),[59] science, and physical geography.[60] Like all Northfield students, Belle also participated in vocal music classes and "Household Science," which, using *Mrs. Lincoln's Boston School Kitchen Text-Book*, included instruction in cooking, household economy, laundry work, and sewing.[61]

At Northfield Belle revealed a flair for languages. She studied (and excelled at) Latin, taking "Lessons and Grammar" in her first year; "Caesar and Latin Prose" (an intermediate course focused on the first four books of the Gallic War) in her second; and "Cicero and Latin Prose" (an advanced course focused on Cicero's seven orations) in her third. During Greene's second and third years she also studied German, which involved reading "the works of good authors," among them Johann Wolfgang von Goethe, Friedrich Schiller, and Gotthold Ephraim Lessing.[62] She probably partook in the dining hall's dedicated German

FIG. 7
A. French, Northfield Campus and East Hall, ca. 1890.
Photographic print; 6⅞ × 9¹³⁄₁₆ in. (17.5 × 25 cm). Northfield Mount Hermon Archives.

table in order to hone her conversation skills. Long after Greene left Northfield, she continued to pursue the study of languages: in 1909 she began studying Italian; in 1912 she restarted both German (twice a week) and Latin (once a week) with a tutor.[63] She would draw on these language skills for the rest of her career.

The cornerstone of Northfield's curriculum was study of the Bible, with required daily attendance at religious services.[64] This ecclesiastical foundation served Greene well when she began working with Morgan, who had a lifelong interest in Bibles.[65] A deep doctrinal knowledge was likely one of Greene and Morgan's many shared passions. Indeed, as Greene recalled many years after his death, Morgan "liked to have her read the Bible aloud to him" when they sat together in the Library.[66]

Northfield's Talcott Library, which in the late 1890s contained about 5,500 volumes, played a prominent role in campus life.[67] Overseen by three women librarians during Belle's time at Northfield, the library employed a card catalogue and the Dewey system of classification (then quite novel).[68] The librarians actively sought to expand the collection. During Belle's first semester on campus, for instance, eighty-seven titles—ranging from Sarah Knowles Bolton's *Lives of Girls Who Became Famous* to George Eliot's *Middlemarch*—were acquired.[69] As an undated Northfield pamphlet declared: "No school can hope to realize, to any marked degree, the generally recognized aims of secondary education unless it is prepared to serve the kind of mental food that is stored on the shelves of a good library."[70]

The importance of reading, as both a didactic and pleasurable practice, was instilled in the students beyond the library's confines. Campus-wide lectures on literary subjects were held with regularity. On one occasion, Professor Caleb T. Winchester of Wesleyan (formerly that university's librarian) delivered "The Lake Poets."[71] On another, Margaret Sangster delivered a lecture on "Books and their relations to life," in which she described them as "servants, tools, weapons, resources, friends, companions, and masters."[72] The Young Women's Christian Association (YWCA) welcome party in September 1897 offered a more playful demonstration of campus academic activity. In order to introduce incoming and returning students, "each of the old girls was asked to take a new girl for her partner. They then marched around the sides of the room where were ranged girls dressed to represent some well-known books. Each guest was provided with pencil and paper with which to record the names guessed."[73] Belle would exhibit similar intellectual playfulness throughout her life.

While at Northfield, Belle not only studied literature, but also experimented with producing it. During her second term, she published a three-stanza poem, "The Evening Star," in the *Hermonite*, the joint Northfield and Mount Hermon biweekly publication (fig. 8).[74] Belle rhapsodized:

> How many evenings have I watched its birth
> Before the full, round moon had upward sailed;
> How often has its loveliness been veiled
> By some intruding cloud—wreath child of earth.
> And, then, when all the sea was crested white
> And ribbed with black, in alternating bars,
> I oft have seen a hundred evening stars,
> All blurred together, in the water bright.
> But thou, thyself, nor cloud nor wave can mar,
> O Evening Star.[75]

One can hardly imagine a teenage Belle writing a paean to the night sky had it not been for her time at Northfield. There, she developed a love of nature that persisted many years after her departure.

Social as well as academic life at Northfield prepared Belle well for later successes. Mirroring the activities undertaken at other East Coast boarding schools, student life was filled with social gatherings and outdoor activities. In the fall, students enjoyed Mountain Day (when they "climbed the mountain and contested in feats of nimbleness and strength," followed by a clam bake)[76] and a Halloween bonfire.[77] In the winter, they sledded and skated, had midwinter picnics (held indoors), and attended concerts.[78] Spring was full of sunset teas, lawn parties, tennis tournaments, and candy pulls.

Belle's time at Northfield proved to be transformative. After her first semester, she visited Grace Dodge in New York. Struck by Belle's "great improvement and happiness," Dodge described how "with tears" in her eyes, Belle pleaded that her younger sister Ethel "might have the advantages of Northfield," which she attended for one year.[79] In November 1913, more than ten years later, Greene made the impressive donation of $1,000 to the YMCA and the YWCA (favored recipients of Dodge's philanthropy). Greene explained in an accompanying letter that her gift was "a slight appreciation of what Miss Grace Dodge has done for myself and countless other girls to whom she has given not only a start in life, but also life itself."[80]

Despite the foundation the school laid for Greene's subsequent career, virtually no trace of Northfield appears in her papers or extensive correspondence. She never donated to Northfield as an alumna and only one letter, written in November 1942 by the rare book and manuscript dealer Edward L. Dean, mentions her time there. Offering Greene an original hymn, "To Evening in Winter," written by Mary Whittle on the occasion of the eighty-ninth birthday of Betsy Moody, mother of Dwight Lyman, Northfield's founder, Dean wrote, "I thought of you after I had discovered it, and was I right in thinking that this lovely Memorial about your old school would be most fitting and charming to you, should you decide to present it to the Seminary for all time?"[81] There is no record that Greene purchased the manuscript. Northfield may have given her

THE HERMONITE.

Learn as if you were to live forever; Live as if you were to die to-morrow.—*Ansalus de Insulis*.

Vol. X. MOUNT HERMON, MASS., MAY 8, 1897. No. 15.

A CONCEIT.*

From the Modern Greek Folks-Poetry.
HENRY W. RANKIN.

Let me become a tree, my Christ,
 Growing upon a meadow,
And grant me plenteous fruit as well,
 And lowly, spreading branches,
And make beside my roots to flow
 A spring of cooling water.
So shall the maidens come to me,
 Coming unto the mountains,
To drink the water of the well,
 And eat the fruit above them,
And lay them down to sleep beneath
 The shadow of my branches.

*NOTE.—The new renown of the old land of Greece may give some interest to this brief specimen of its modern ballad literature, which was translated by the writer in Athens, May 31, 1874.

THE EVENING STAR.

BELLE M. GREENE, Seminary, '00.

Far to the westward lie the purple hills,
Whose rising vapors shroud the dying sun.
The sweet, short sway of twilight has begun,
And all the air with vague, soft whispers thrills.
To east, the sea has stopped its solemn beat,
And lies a moment at the full, low tide,
With every ripple of its bosom wide,
Lulled to a transient languor, subtly sweet;
And, in the darkening heavens, glows afar
 The Evening Star.

How many evenings have I watched its birth
Before the full, round moon had upward sailed;
How often has its loveliness been veiled
By some intruding cloud—wreath child of earth.
And, then, when all the sea was crested white
And ribbed with black, in alternating bars,
I oft have seen a hundred evening stars,
All blurred together, in the water bright.
But thou, thyself, nor cloud nor wave can mar,
 O Evening Star.

My soul is like the sea, with hollows deep,
And dark and fitful heights of flashing spray.
O white Ideal, shining far away,
Beam on, tho envious clouds between us sweep.
Thy light I dim; thy beauty I deface,
By my unquiet mirror. But at last
Must come a time, when struggles all are past,
And I shall see thee in thy perfect grace.
Wait we for ebb-tide, when no billows are,
 O thou sublime, sweet Evening Star.

MILTON'S "SATAN."

JAMIE SAUTAR.

WHO is there that does not feel the thrill of a mighty thought? Who is there whose mind and soul are not stirred by the master hand? To the one who does not feel the thrill of a mighty thought, to the one who is not stirred, do not read Milton's "Paradise Lost." Milton's description of Satan is pictured so vividly that one can almost see the evil one; like a work of art in painting there is nothing hazy; every point, every feature is distinct, and one can almost see the blood coursing thro his veins. Milton's God is the One altogether mighty; away up amid the purest realms stands His sanctuary, in the place of the most blessed light. On the other hand he puts the miserable and treacherous Satan

FIG. 8
Belle da Costa Greene (1879–1950), "The Evening Star,"
The Hermonite 10, no. 15 (May 8, 1897). Northfield Mount Hermon Archives.

"life itself," but here, as elsewhere, Greene seems to have done everything possible to block access to her past.[82]

After three years at Northfield, Greene left following the 1899 spring semester, one year prior to her intended graduation.[83] Where and how she spent the next year remains unknown, but the following July she participated in Amherst College's five-week Summer School of Library Economy. The college's librarian, William I. Fletcher, directed the course, then in its tenth year. According to the informational pamphlet, the curriculum involved lectures on "the whole field of library work" and covered both "Cutter's Expansive Catalogue Rules" and "Dewey's Decimal Classifications."[84] Complementary courses were offered in French and Handwriting, focusing exclusively on the "Vertical Round Hand." Greene mastered this script and later used it to write almost all of her (untyped) professional correspondence.[85] She also employed the vertical round hand to

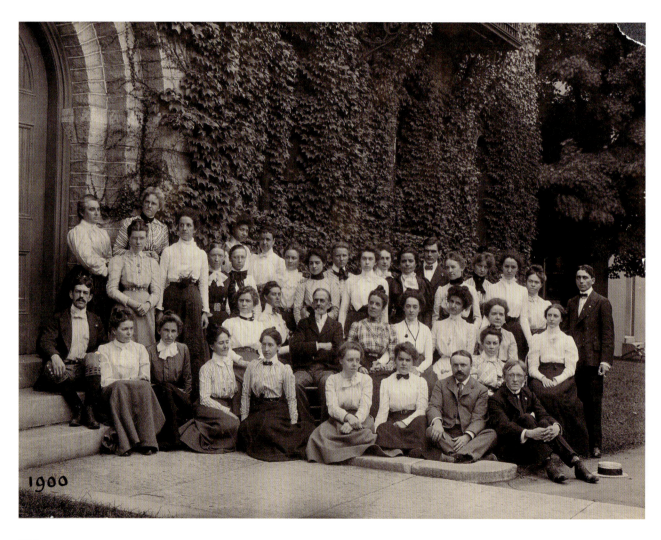

FIG. 9
Amherst College Summer School, Fletcher Course in Library Economy, Class of 1900, 1900. Gelatin silver print; 9 × 11 in. (22.9 × 27.9 cm). Amherst College Archives and Special Collections.

notate card catalogue entries and collection items, which she annotated with sometimes extensive bibliographic references, visiting scholars' verbal comments, and other notes.

The earliest surviving photograph of Greene (fig. 9) was taken that summer.[86] She stands in the back row and somewhat coyly looks out from behind the cascading ivy vines. Greene and her nearly forty classmates, predominantly women, incurred a significant cost in enrolling. The course itself was $15 and there were additional expenses of $2.50 for "necessary books and material" and between $25 and $50 for room and board. Most of the aspiring librarians were local to Massachusetts. Greene was among four participants from New York. An equal number hailed from Washington, DC, but others had traveled quite far—from San Jose, California; Fort Worth, Texas; and Tuscaloosa, Alabama.

After Amherst, Greene's training as a librarian continued at Princeton. It remains unclear exactly how Greene came to be employed there, but had it been known that she was Black—according to the American one-drop definition of race—she would never have been able to work in the library.[87] Throughout her life Greene maintained a "peculiar fondness" for Princeton, that "most adorable spot in the world" where she "spent so many happy days."[88] But her situation while there would have been precarious. Often referred to as "the southern Ivy" because of the large number of students from the states of the former Confederacy, Princeton was an enclave of white privilege. The path Greene would have followed on the five-minute walk from her lodgings on University Place to the library passed several buildings named in honor of men who had either owned enslaved people or profited from slavery. Indeed, the tower of Pyne Library was adorned with J. Massey Rhind's statues of James Madison, a 1771 graduate of Princeton, and Oliver Ellsworth, a 1761 graduate of Princeton, both owners of enslaved people. And during Greene's second year at Princeton, Woodrow Wilson, a notorious racist, was elected the university president.

Greene's four-and-a-half years at Princeton proved to be a formative experience, during which she honed her interests in collection development, library organization and classification, and bibliographic study.[89] During her time there, the Princeton Library administration sought to address the challenges faced by "older college libraries."[90] Greene would go on to do something similar. As the *New York Times* commented in 1949, she "transformed a rich man's casually built collection into one which ranks with the greatest in the world."[91]

In the years leading up to Greene's arrival at Princeton by July 1901, the University Library, under the leadership of pioneering librarian and bibliographer Ernest Cushing Richardson, had undergone a fundamental renovation.[92] In 1897 Pyne Library (now East Pyne) opened.[93] Equipped with heat, light, ventilation, an electric elevator, and a telephone switchboard, the building employed cutting-edge technology and was significantly larger than its prede-

cessor in order to accommodate the rapid growth of the library's collection.[94] Richardson, who wrote one of the first books promoting new ideas on library reclassification, oversaw the library's shift from a system based on "fixed location," in which every book was assigned a definite shelf space, to one of "relative location" based on a "four-number scheme" of his invention.[95] Although Richardson's particular method of classification was never widely adopted, as another librarian who worked at the Princeton Library in the early twentieth century later wrote, Richardson "made centralized cataloging not only possible but practical."[96] A great paleographer and bibliophile, Richardson possessed an abiding interest in manuscripts, and on at least one occasion, Greene spoke of her admiration for and training under Richardson, describing him as "her first mentor in the field."[97]

While Richardson may have provided an initial model of a scholar-librarian, more important for Greene's career development was Junius Spencer Morgan (fig. 10), Princeton's associate librarian and J. Pierpont Morgan's nephew.[98] A Princeton alumnus and an ardent bibliophile with a particular affection for Virgil, Junius became "a very loyal friend" and "great chum" of Greene.[99] And though she was still "putting up my hair from pig tails" when they met, Greene credited Junius with first teaching her about rare books and incunabula.[100] In a 1912 profile on Greene, the *Chicago Daily Tribune* reported that she "began to learn about old books in the Princeton library, where she made a special study of them under the direction of Junius Morgan."[101]

Scant evidence exists regarding Greene's precise role at the Princeton University Library. But newly discovered documents suggest that she worked as a clerk or assistant in the New Books Department, overseen by Charlotte Martins.[102] Probably to save as much of her $480 annual salary as possible, Greene not only worked for Martins but also lived with her and her father, John Martins, on University Place.[103] The first trace of Greene's work in this capacity appears on July 1, 1902, when she added 112 entries to the Library's *Condensed Accession Book*.[104] Originated by Melvil Dewey, whose classification system Greene had studied at Amherst, and comprising "the official record of each volume added to the Library," the Standard Accession-books served as the "official indicator for the whole collection."[105] With a unique accession number, each single-line entry included the publication's salient details: author's name; title; place and year of publication, as well as imprint; size; and binding type. Additional columns could be used to detail the monetary source used to fund the acquisition and other miscellaneous remarks. The Accession Books were a volume's first port of call upon arrival at the Library. As Dewey directed in the introduction, "Enter each book immediately after it is collated and agreed with order-book and bill."[106]

The range of material Greene encountered while undertaking this work is staggering. On February 28, 1905, for instance, she entered 146 books, beginning with *Recollections and Letters of General Robert E. Lee* and ending with Henry van Dyck's *Brief for Foreign Missions*.107 The books she examined on that day alone included Austin Flint Rogers, *Crystallographic Studies*; Clarence Linton Meader, *Study of the Latin Pronouns "Is" and "Hic"*; Allan Hoben, *The Virgin Birth*; Emma Metcalf Nakuina, *Hawaii, Its People, Their Legends*; and Walter Hough, *The Moki Snake Dance*. One has the sense that for perhaps the first time in Greene's life, she had a world of knowledge at her very fingertips.

In addition to entering new acquisitions in the accession books, Greene carried out clerical tasks on behalf of Martins. The words "Received payment, C. Martins per B. Greene" appear on two invoices for Allan Marquand, a Princeton graduate, founder of its Department of Art and Archaeology (becoming its first professor in 1883), and inaugural director of the campus Museum of Historic Art (today the Princeton University Art Museum).108 In addition to signing receipts

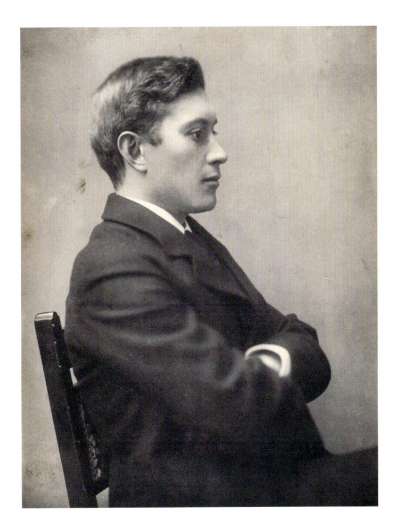

FIG. 10
Gainsborough Studios, *Junius Spencer Morgan*, ca. 1900.
Courtesy of Elisabeth Morgan.

on Martins's behalf (as Greene would later do countless times for Morgan), she probably corresponded with various vendors and conducted basic cataloguing, work that would constitute her principal duties when she first began working for Morgan.

According to William Warner Bishop, hired in 1903 to head the cataloguing department, "Aunt Lottie," as Greene affectionately referred to Charlotte Martins, was "a law unto herself," ruling the library's order department "with a rod of iron."[109] Bishop, who went on to work as the superintendent of the Library of Congress's Reading Room and librarian of the University of Michigan as well as to catalogue and systematize the Vatican's Archivio Apostolico, considered his time at Princeton "equally formative and influential," a moment that coincided with the "rapid crystallization" of library practice. He wrote that his employment at Princeton "permitted and developed knowledge of the whole [bibliographic] field and its relations to library administration."[110] Greene's time at Princeton must have left a similar mark.

Under Richardson, Morgan, Martins, and Bishop, the Princeton Library was run according to principles of "close organization and attention," "strict routine," and "economy," fundamentals that later dictated how Greene governed at the Morgan.[111] When Greene's close friend Gertrude Atherton wrote about this period of Greene's life, she described a time of "unceasing application, what the college boy calls 'grind,' without which Miss Greene is convinced it is impossible for any one to succeed in any vocation or attain a distinguished position."[112] The work load, especially on the more junior members of staff, must have been tremendous—as the library's annual report noted, the staff was "in great need of reinforcement."[113] Greene's work ethic and "dauntless determination" was surely already apparent.[114]

Coinciding with Greene's time at Princeton was an increased emphasis on "the character of the books purchased" resulting in the growth of special collections.[115] Throughout 1904, Greene accessioned a sizeable number of items for the John Shaw Pierson Civil War Collection of printed material, manuscripts, and ephemera.[116] On May 10, 1904, for instance, she created entries for Ellen Leonard's "Three days reign of terror, or The July riots in 1863, in New York," on the New York draft riots; Alexander Crummell's *The Relations and Duties of Free Colored Men in America to Africa, A Letter*; and John H. Van Evrie's *Free Negroism, or Results of Emancipation in the North and the West India Islands*, among other titles; one can only speculate on her reaction.[117]

Traces of many initiatives later spearheaded by Greene at the Morgan can be found in her time at Princeton. Greene recalled studying the British Museum's printed catalogue as part of her training, writing in a letter to the *New York Times*: "I still maintain that the circulating library system of America, with its card catalogue system, as adopted by the Library of Congress, is unrivaled in the world."[118] Indeed, the lessons learned at Princeton may have planted the seed for the Morgan's eventual iconographic directory and comprehensive dictionary catalogue, which included subject cards for important provenances,

iconographic representations, and bindings.[119] Richardson and Morgan contributed to "co-operative bibliographic projects," much as Greene would advocate for "real scholarly co-operation" among research libraries.[120] Moreover, Junius Morgan's 1904 exhibition on Greek and Roman numismatics may well have been the first scholarly exhibition whose curation she was exposed to prior to the creation of the Pierpont Morgan Library's own exhibition program in the 1920s.[121]

After three or four years at Princeton, Greene was ready for a change and increased responsibility. By this point, the scope of her knowledge, if not her actual position, had greatly expanded. Dating from June 21, 1905, Greene's final entries in the Library Accession Books, which include significant amounts of information beyond that required (or previously recorded) in the large volumes, reveal just how much she had learned and absorbed. Greene annotated the right-hand side of the double-page spread with detailed comments on the specific type of bindings used by the various binders, whom she lists by name. "Probably the most beautiful copy in existence," she even transcribed from the dealer's description pasted on the volume's front free endpaper, regarding Pickering's 1821 diamond classics edition of Virgil's *Bucolica; Georgica; Aeneis*, which retained its original cloth binding and included the "rare" corrigenda slip at the end.[122]

After her period at Princeton, Greene was introduced to Pierpont Morgan by his nephew Junius.[123] All we know of Greene's first encounter with the man she would call the "Big Chief" is a brief reminiscence published in *Time* two years before Greene's death:

> Seated massively at his desk that day in 1905, John Pierpont Morgan seemed lost in thought. He hardly even bothered to look up when his nephew Junius appeared before him with a slim, grey-eyed girl in tow. "Uncle," said Junius, "this is Miss Greene." Thereupon the Great Man grunted a "How d'you do?"—and the interview was over. Thus, scarcely out of her teens, "quaking with fear and shaking like an aspen" Belle da Costa Greene began her career.[124]

Armed with a love of learning imbued by family, an excellent education acquired at Northfield and Amherst, work experience gained at Princeton, and fearless ambition, Greene was uniquely well-equipped to begin her career working with Morgan.

NOTES

1
Bernard Berenson to Mary Berenson, August 25, 1910, Bernard and Mary Berenson Papers, Box 29, Folder 116, Biblioteca Berenson, I Tatti, the Harvard University Center for Italian Renaissance Studies; Gertrude Atherton, *The Living Present* (New York: Frederick A. Stokes, 1917), 295.

2
"Return of a Birth to the Office of Health Officer," no. 20945. District of Columbia, Births and Christenings, 1830–1955. Jean Strouse discovered this document and unearthed Greene's connection to Richard T. Greener (then unknown to be her father), who listed his family members in submissions to the *Harvard Alumni Bulletin*. See Jean Strouse, *Morgan: American Financier* (New York: Random House, 1999), 512.

3
So described by H. O. Wagoner Jr., "A Trip to the East—Scenes and Thoughts by the Way," *New National Era*, September 12, 1872.

4
Heidi Ardizzone, *An Illuminated Life: Belle da Costa Greene's Journey from Prejudice to Privilege* (New York: W. W. Norton, 2007), 32–33. They were so light-skinned that well before any member began to pass, the 1880 census-taker recorded the family as white. Mary A. Askins, the household's "Servant," was listed as "Black." The Greeners lived beside Genevieve's mother (with whom Genevieve's younger brothers Bellini and James Jr. resided) and Genevieve's brother Mozart, an engineer, and his wife and son. 1880 United States Census.

5
Katherine Reynolds Chaddock, *Uncompromising Activist: Richard Greener, First Black Graduate of Harvard College* (Baltimore: Johns Hopkins University Press, 2017), 111; Michael Robert Mounter, "Richard Theodore Greener: The Idealist, Statesman, Scholar and South Carolinian," PhD diss. (University of South Carolina, 2002), 232, 270, 359; Ardizzone, *Illuminated Life*, 31. For the Grimké family, see Kerri K. Greenidge, *The Grimkes: The Legacy of Slavery in an American Family* (New York: Liveright, 2023).

6
Both Genevieve and Richard's parents had mixed-race ancestry. Hers, all free people of color, had been born in Washington, DC. His maternal grandfather was of Spanish descent and born in Puerto Rico; his paternal grandfather was born enslaved in Virginia. Ardizzone, *Illuminated Life*, 16, 17, 24, 26.

7
"Hymen's Halter, A Wedding Which Called Out the Elite of Our Colored Society," *National Republican*, April 6, 1881.

8
"Married," *National Republican*, September 29, 1874; "The Ladies of the 15th Street Presbyterian Church, Washington, D.C., will hold a fair, beginning December 22nd . . . ," [Washington, ca. 1880]. Library of Congress, Rare Book and Special Collections Division; Printed Ephemera Collection, Portfolio 207, Folder 4a.

9
1880 United States Census; "Hymen's Halter."

10
"Entertainment for the Holidays," *Sun*, May 26, 1855.

11
She also had two siblings with nonmusical names: a brother, James Jr., and a sister, Minerva.

12
Annual Catalogue of the Officers and Students of Oberlin College for the College Year 1866–7, 31, as "Genevieve J. Fleet." Richard T. Greener also attended Oberlin; however, their paths did not cross: he enrolled in 1862 and left in 1864. See Chaddock, *Uncompromising Activist*, 16–23.

13
Genevieve I. Fleet, "Teacher's Monthly School Report," October 1867. United States, Freedmen's Bureau, Records of the Superintendent of Education and of the Division of Education, 1865–1872.

14
"The Colored Schools," *Evening Star*, April 25, 1872; "Colored School Examinations," *Evening Star*, June 8, 1872; "Condensed Locals," *Evening Star*, January 16, 1873; "The Colored Schools," *Daily National Republican*, May 17, 1873; "The Colored Schools," *New National Era and Citizen*, May 29, 1873.

15
"Bachelors' Club," *National Republican*, April 10, 1874; "The Charity Matinee," *National Republican*, April 2, 1874. The Civil Rights Act was approved after Sumner's death in 1874. The Supreme Court declared it unconstitutional in 1883.

16
William Gatewood, *Aristocrats of Color: The Black Elite, 1880–1920* (Fayetteville: University of Arkansas Press, 2000), 38.

17
The others were Page C. Dunlop and Charles H. Webb. See Gregory Bond, "'Love Him and Let Him Go': The American Colonization Society's James Brown—Pioneering African-American Apothecary in the United States and Liberia, 1802–1853, Part I—The United States," *History of Pharmacy* 60, no. 3 (July 2018): 79.

18
James H. Fleet, Page C. Dunlop, and Charles H. Webb to the Board of Managers of the American Colonization Society, October 7, 1833. MS American Colonization Society, I.A., Library of Congress; Bond, "'Love Him,'" 85.

19
See Russell W. Irvine, *The African American Quest for Institutions of Higher Education Before the Civil War: The Forgotten Histories of the Ashmun Institute, Liberia College, and Avery College* (Lewiston, NY: Edwin Mellen, 2010), 490.

20
"Obituary," *Evening Star*, December 7, 1861; "Card Musicale," *Evening Star*, June 27, 1857.

21
On Greener, see Ardizzone, *Illuminated Life*, 16–23, as well as Chaddock, *Uncompromising Activist*, and Mounter, "Richard Theodore Greener."

22
"Greener, Richard Theodore," in *Who's Who of the Colored Race*, ed. F. L. Mather (Chicago: Memento Edition, 1915), 1:121.

23
See John F. Marszalek, *Assault at West Point: The Court-Martial of Johnson Whittaker* (New York: Collier Brooks, 1994).

24
Richard T. Greener to Mishiyo Kawashima, December 12, 1916, Richard T. Greener Papers, University of South Carolina.

25
Greener described the invitation and Sumner's impressive collection in the public address he delivered upon the senator's death, later published as *Charles Sumner, The Idealist, Statesman and Scholar* (Columbia, SC: Republican Printing Company, 1874), 30–31. The manuscript, illuminated by Gioacchino di Giovanni de Gigantibus, is in Harvard University's Houghton Library, MS Lat 177.

26
Richard T. Greener to "Frank," December 25, 1906, Howard University, Correspondence, 57.

27
Richard T. Greener to Carter Woodson, October 24, 1917, quoted in Chaddock, *Uncompromising Activist*, 159. Greener ultimately sold his collection to the New-York Historical Society. It included an inscribed copy of George Washington Williams's *The Negro as a Political Problem* (Boston: Alfred Mudge & Son, 1884); an 1827 copy of *Freedom's Journal*, the first African American newspaper published in the United States; and David Walker's *Walker's Appeal in Four Articles: Together with a Preamble, to the Coloured Citizens of the World* (Boston, 1830). See Chaddock, *Uncompromising Activist*, 159.

28
Richard T. Greener to Arturo Schomburg, June 4, 1918, New York Public Library, Schomburg Center for Research in Black Culture, Manuscripts, Archives and Rare Books Division; Richard T. Greener Papers, Sc MG 107.

29
Richard T, Greener, Minute Book, no. 1, pasted-in flyleaf, 8, Grant Monument Association, Box 3, Folder 2.

30
Ibid., 5–6.

31
Richard T. Greener, typed report, February 21, 1889, 5, Grant Monument Association, Box 2, Folder 8.

32
Mounter, "Richard Theodore Greener," 359.

33
Belle Marion Greener, Application for Admission to Northfield Seminary, June 28, 1896, Northfield Mount Hermon Archives (hereafter "Northfield Archives").

34
This likely explains the erroneous belief that Belle attended Teachers College. Strouse was the first to publish this claim, though with the caveat that Greene "may not have completed the course." Strouse, *Morgan*, 514–15. It has since been repeated by Richard Mounter, Katherine Chaddock, Flaminia Gennari-Santori, and Heidi Ardizzone (who qualifies the statement by noting, "Teachers' [*sic*] College does not have records of a Belle or Marian Green, Greene, or Greener."). Mounter, "Richard Theodore Greener," 391, 402; Chaddock, *Uncompromising Activist*, 121, 133; Gennari-Santori, "'This Feminine Scholar': Belle da Costa Greene and the Shaping of J. P. Morgan's Legacy," *Visual Resources* 33, no. 1–2 (March–June 2017): 184; Ardizzone, *Illuminated Life*, 47, 495n21.

35
Belle Marion Greener Application, Northfield Archives.

36
Ibid.

37
From West 58th Street, they relocated to 100 West 64th Street, before moving to 29 West 99th Street, the last location where the nuclear family remained intact. Mounter, "Richard Theodore Greener," 362n11.

38
Thomas Junius Calloway to Booker T. Washington, May 2, 1894, quoted in Strouse, *Morgan*, 514.

39
Located on Amsterdam Avenue at 105th Street.

40
John Balcom Shaw to Evelyn S. Hall, July 8, 1896, Northfield Archives.

41
Ibid.; Shaw to Hall, January 25, 1897, Northfield Archives. In the latter, Shaw specifically notes that he does "not know a Miss Alice Ethel Greene," writing "it must be Miss Alice Ethel Greener."

42
Lucetta Daniell to Secretary of Northfield Seminary, July 2, 1896, Northfield Archives. Based out of Chicago, Richard T. Greener spent the Summer of 1896 working throughout the Midwest. Chaddock, *Uncompromising Activist*, 125–26.

43
One of the first two women appointed to the New York Board of Education, Dodge founded the Girls' Public School Athletic League in 1903.

44
Today Northfield is part of the coeducational Northfield Mount Hermon School.

45
Belle Marion Greener Application, Northfield Archives. By the time Belle's younger sister Ethel applied the following year, both she and Genevieve used the last name "Greene" on the application. Alice Ethel Greene Application for Admission to Northfield Seminary, January 16, 1897, Northfield Archives. Most of Belle's classmates at Northfield "were preparing to be either missionaries, kindergarten teachers, or nurses." *Hermonite*, November 6, 1897, 57. Of the school's 240 alumnae at the time of Belle's enrollment, sixty-five attended college. Of these, thirty-one had enrolled at Wellesley College (with six graduating). "From the Principal's Report," *Hermonite*, June 16, 1896, 294. Very few of Belle's peers pursued library work.

46
Dodge had initially met Moody in 1878, when he stayed with the Dodges in New York.

47
Grace H. Dodge to Emma Charlotte Moody, July 1, 1896, Northfield Archives. As promised, Dodge served as Belle's benefactress, paying for tuition, room, and board. Tuition (which students were typically required to pay) was $100 per year; the full annual cost of attendance was $4,000, with the $3,900 balance covered either by the school, special scholarship, or a wealthy sponsor. "Expenses," in *Calendar of Northfield Seminary, East Northfield, Franklin Co., Mass. 1898–99* (printed by E. L. Hildreth & Co., Brattleboro, VT, 1899), unpag. end matter, Northfield Archives.

48
B. Marion Greene to Evelyn S. Hall, August 27, 1896, Northfield Archives. That Belle's trunk was valued at $300 suggests Dodge had also supplied her with clothes, books, and other accoutrements. Adams Express Company receipt, September 3, 1896, Northfield Archives.

49
Intriguingly, in March 1894 Belle received a copy of Bernard Berenson's *The Venetian Painters of the Renaissance*. The book was inscribed "Belle Greene with love from 'Aunt Julia.'" In other words, by early 1894 at least one family friend believed Belle's last name to be Greene, not Greener. The volume's current whereabouts are unknown, but the inscription is reproduced in John Walter Osborne, "A Liaison to Remember: The Friendship of Belle da Costa Greene and Bernard Berenson," *Biblio* 2, no. 11 (November 1997): 38.

50
1900 United States Census. Mary Louise, Belle's older sister, does not seem to have used either "da Costa" or "Van Vliet." Indeed, in 1897, when Genevieve, Belle, and Ethel had all adopted the last name "Greene," Mary Louise continued to sign her letters "Greener." See Mary Louise Greener to Grace H. Dodge, January 22, 1897, Northfield Archives. Belle told friends that her middle name "came from her maternal grandmother, Genevieve (da Costa) Van Vliet." See, for instance, Dorothy Miner and Anne Lyon Haight, "Greene, Belle da Costa," in *Notable American Women, 1607–1950* (Cambridge, MA: Belknap Press, 1971), 2:83.

51
Northfield's stated objective was to educate girls "who have not the means to avail themselves of the opportunities of the ordinary boarding school." *Calendar of Northfield Seminary*, 12.

52
I am grateful to Peter Weis, Northfield Mount Hermon's archivist, for discussing the school's history with me.

53
Among the other attendees who were passing was Anita Hemmings, the first African American graduate of Vassar College, who went on to become a librarian at the Boston Public Library.

54
See "Summary of Students, September, 1898," in *Calendar of Northfield Seminary*, unpag. end matter.

55
Hermonite, October 9, 1897, 29.

56
Among the other young women who enrolled at Northfield in September 1896 was Juliana Rieser Force, who went on to become the inaugural director first of the Whitney Studio Club and then of the Whitney Museum of American Art. One wonders if the two young women forged (or maintained) a friendship. Avis Berman, *Rebels on Eighth Street: Juliana Force and the Whitney Museum of American Art* (New York: Atheneum, 1990), 29–33.

57
"Belle was exceptionally fortunate in having been placed with Miss Williams and I think her influence has done much for her." Genevieve I. Greene to Grace H. Dodge, July 1, 1897, Northfield Archives. Williams graduated in 1897 and attended the Chicago Institute; two years later, she moved to Cantonment, Oklahoma, to teach at the Mennonite Cheyenne Mission. "Miss Agnes Williams," *Mennonite Weekly Review*, June 14, 1951, 8.

58
Calendar of Northfield Seminary, 20.

59
"In this department the topical method is used. With a text-book as a basis of fact and sequence, library work is carried on by the student under a system of analysis and note-taking." *Calendar of Northfield Seminary*, 22.

60
Class roster and grades, 1896–99, Northfield Archives.

61
Calendar of Northfield Seminary, 29, 30, and unpag. end matter.

62
Ibid., 21.

63
Greene to Berenson, April 6, 1909, April 9, 1909, and July 1, 1912, Berenson Papers, Box 60, Folder 2; Box 61, Folder 1.

64
Calendar of Northfield Seminary, 26; Berman, *Rebels on Eighth Street*, 32.

65
See John Bidwell, "Morgan's Bibles: Splendor in Scripture," in *Morgan—The Collector: Essays in Honor of Linda Roth's 40th Anniversary at the Wadsworth Atheneum Museum of Art*, ed. Vanessa Sigalas and Jennifer Tonkovich (Stuttgart: Arnoldsche, 2023), 112–29.

66
Greene, quoted in "Belle of the Books," *Time*, April 11, 1949, 78.

67
"Gateway to the Past Horizon for the Future," Northfield Archives.

68
Margaret F. Newell, Mrs. R. Henry Ferguson, and Elizabeth Conway, *Calendar of Northfield Seminary*, 14.

69
"Library Notes," *Hermonite*, January 16, 1897, 132–33.

70
"Gateway to the Past Horizon for the Future," Northfield Archives.

71
"Sixth Lecture-Course Entertainment," *Hermonite*, March 26, 1898, 191.

72
"Seminary Items," *Hermonite*, April 30, 1898, 208.

73
"The First Reception," *Hermonite*, September 25, 1897, 15.

74
The publication's motto, "Learn as if you were to live forever; Live as if you were to die to-morrow," seems an apt encapsulation for Greene's approach to life.

75
Belle M. Greene, "The Evening Star," *Hermonite*, May 8, 1897, 233.

76
"Mountain Day," *Hermonite*, October 23, 1897, 44; "Mountain Day at Northfield," *Hermonite*, 27.

77
"Hallowe'en at Marquand," *Hermonite*, November 14, 1896, 81.

78
"A Midwinter Picnic," *Hermonite*, February 27, 1897, 181.

79
Grace H. Dodge to Evelyn S. Hall, January 8, 1897, Northfield Archives. In Dodge's letter, she describes Ethel, who had previously attended Training School at Normal College, as "inheriting her Grandmother's Spanish beauty." As Dodge had done for Belle, she paid for Ethel's tuition, room, and board. Alice Ethel Greene Application, Northfield Archives.

80
"Four Million Clock Marks $2,180,787," *Sun*, November 13, 1913.

81
Edward L. Dean to Greene, November 14, 1942, Archives of the Morgan Library & Museum, ARC 3291, Box 8, Folder 6. (Archives of the Morgan Library & Museum material hereafter cited as "ARC.") Dean does not appear to have routinely conducted business with either Greene or the Pierpont Morgan Library.

82
According to Dorothy Miner, Greene "refused to cooperate with efforts to record her life, scorning such personal history as unimportant and of no concern to anyone." Dorothy Miner, foreword to *Studies in Art and Literature for Belle da Costa Greene* (Princeton, NJ: Princeton University Press, 1954), xi.

83
She was originally part of the class of 1900, as indicated by her byline: "Belle M. Greene, Seminary, '00." See "The Evening Star," *Hermonite*, May 8, 1897, 233. At the time it was not unusual for students to leave prior to graduation.

84
"Amherst College Library Summer School of Library Economy, Eleventh Year," brochure, 1901, Amherst College Archives and Special Collections, Amherst Summer School Collection; MA 00058.

85
Greene would later tell friends that she developed her round handwriting "in response to [Sydney Cockerell's] testy criticism of her illegible scrawl." Miner and Haight, "Greene, Belle da Costa," 84.

86
Belle must have had her photograph taken on at least one previous occasion. Prior to her enrollment at Northfield, her mother wrote they "have to have a picture of Belle taken as she has none at present." Genevieve Greene to Evelyn S. Hall, June 27, 1896, Northfield Archives.

87
Grace Dodge may have played a role in securing the position: two of her brothers had attended Princeton (both class of 1879), and in 1900 her brother, Cleveland H. Dodge, and father donated Dodge Hall in memory of her other brother, Earl Dodge. Alternatively, William I. Fletcher may have recommended her to Ernest Cushing Richardson, who had attended Amherst and worked at his alma mater's library first as library assistant and then as assistant librarian, before moving to Princeton.

88
Greene to Berenson, March 19–21, 1909, and June 7, 1909, Berenson Papers, Box 60, Folder 1; Box 60, Folder 3. She wrote Berenson in the 1930s, "As you know, anything of mine which is of any interest or value to students, will be left either to this Library, or to Princeton University." Greene to Berenson, November 8, 1935, Berenson Papers, Box 63, Folder 31.

89
Lawrence C. Wroth and Curt F. Bühler described her time at Princeton as "a brief apprenticeship"; the *New York Times* wrote she had been "a student at Princeton, specializing in early printed books." Lawrence C. Wroth, "A Tribute to the Library and Its First Director," in *The First Quarter Century of the Pierpont Morgan Library: A Retrospective Exhibition in Honor of Belle da Costa Greene*, exh. cat. (New York: Pierpont Morgan Library, 1949), 9; Curt F. Bühler, "Belle da Costa Greene," *Speculum* 32, no. 3 (July 1957): 642; "Spending J. P. Morgan's Money for Rare Books," *New York Times*, April 7, 1912.

90
Report of Committee on Library and Apparatus, December 14, 1899, Trustees Minutes, 9:203, Princeton University Archives.

91
Aline B. Louchheim, "The Morgan Library and Miss Greene," *New York Times*, April 17, 1949.

92
A handwritten "round-robin" of the 1900 Amherst Summer School class that lists "Belle M. Greene" as "In Library of Princeton University, N.J." notes that the employment information contained therein was "received in July, 1901, and in most cases written the previous winter" (Amherst College Archives and Special Collections).

93
Mrs. Percy Rivington Pyne anonymously donated the necessary funds to mark the University's sesquicentennial in 1896. Upon her death in 1900, the building was named in her honor.

94
The library included offices and seminar rooms, as well as extensive shelving (which remained sufficient for the next quarter century). Robert S. Fraser, "Building from a Bookcase: A History of the Princeton University Library," *Princeton University Library Chronicle* 36, no. 3 (Spring 1975): 218.

95
Ernest Cushing Richardson, *Classification, Theoretical and Practical* (New York: C. Scribner's Sons, 1901). The wholesale "tour de force" undertaking involved reclassifying 130,222 volumes. Report of Committee on Library and Apparatus, October 19, 1900, Trustees Minutes, 9:347, 349, Princeton University Archives.

96
William Warner Bishop, "Reminiscences of Princeton; 1902–7," *Princeton University Library Chronicle* 8, no. 4 (June 1947): 156.

97
Miner and Haight, "Greene, Belle da Costa," 83. Bernard Berenson relayed a similar sentiment to his wife Mary: Greene had "put herself quite young under the best bibliographer in America, a certain Richardson of Princeton with whom she worked for nearly

3 years." Bernard Berenson to Mary Berenson, August 25, 1910, Berenson Papers, Box 29, Folder 116.

98
Pierpont's sister Sarah Spencer Morgan had married a distant cousin, George Hale Morgan. On Junius's important role in shaping his uncle's collection, see Colin B. Bailey and Daria Rose Foner, "J. Pierpont Morgan: Becoming a Bibliophile," in Bailey et al., *J. Pierpont Morgan's Library: Building the Bookman's Paradise*, exh. cat. (New York: Morgan Library & Museum; London: Scala, 2023), 17–61.

99
Greene to Berenson, June 1, 1914; Greene to Berenson, June 1, 1909, Berenson Papers, Box 60, Folder 3. She would later recall "the time when, (a kid) I carried about with me a Terrific crush on him, which I secretly gloated over as the tragedy of my young life." Greene to Berenson, April 18, 1921, Berenson Papers, Box 63, Folder 10.

100
Ibid.

101
"'The Cleverest Girl I Know,' Says J. Pierpont Morgan," *Chicago Daily Tribune*, August 11, 1912.

102
At the time, the library was divided into three departments overseeing the acquisition of new books, their classification, and their cataloguing, respectively. Bishop, "Reminiscences of Princeton," 151.

103
1905 New Jersey Census. The whole household is listed as "White." Belle Greene (erroneously aged twenty-one) is described as occupied with "Library Work" and Charlotte Martins (aged fifty-four) is described as a librarian. According to the 1900 federal and 1905 state censuses, John Martins had been born in the West Indies. The former lists both of his parents as being from the West Indies, the latter lists his father as being from Spain and his mother from Massachusetts.

104
Accession Book 32, nos. 162726–162838, Princeton University Archives. Mathilde Sauquet, a PhD student in the Department of Art and Archaeology at Princeton University, first identified Belle Greene's handwriting in the accession books.

105
Accession Book 31, unpag. frontmatter, Princeton University Archives.

106
Ibid.

107
See Accession Book 37, nos. 189076–189222, Princeton University Archives.

108
The first, dated March 1, 1905, remits payment of $5.11 for Gerald S. Davies, *Frans Hals, The Great Masters* (London: G. Bell, 1904); Salomon Reinach, *The Story of Art Throughout the Ages* (New York: Scribner's, 1904); and William Richard Lethaby, *Mediaeval Art* (London: Duckworth; New York: Scribner's, 1904). The second, dated July 1, 1905, remits payment of $3.75 for Percy Gardner, *A Grammar of Greek Art* (New York: Macmillan, 1905); and Heinrich Wölfflin, *The Art of the Italian Renaissance* (New York: Putnam, 1903). Both receipts are in the Alan Marquand Papers, C0269, Boxes 21–23, Princeton University Library. I am most grateful to Stephen Ferguson for bringing these to my attention and for reading a draft of the present essay.

109
Bishop, "Reminiscences of Princeton," 151. Martins worked at the library for over forty years. See "Miss Martins Retires," *Daily Princetonian*, November 10, 1920.

110
Bishop, "Reminiscences of Princeton," 159.

111
Report of Committee on Library and Apparatus, December 14, 1899, Trustees Minutes, 9:198–99, Princeton University Archives.

112
Atherton, *Living Present*, 296.

113
Morgan, *Report of the Librarian*, 15, 19.

114
Miner and Haight, "Greene, Belle da Costa," 83. According to Atherton, whenever asked for advice, Greene responded: "'Work, work, and more work.'" Atherton, *Living Present*, 296.

115
Report of Committee on Library and Apparatus, December 10, 1903, Trustees Minutes, 10:382, Princeton University Archives. See Stephen Ferguson, "Rare Books at Princeton, 1873–1941," *Princeton University Library Chronicle* 80, no. 1 (Autumn–Winter 2023): 9–81.

116
See entries from April, May, and late October 1904, Accession Book 36, nos. 180026–180075; 180387–180442; Book 37, nos. 185719–185979, Princeton University Archives. See John F. Joline, "Special Collections at Princeton, VI: The Pierson Civil War Collection," *Princeton University Library Chronicle* 2, no. 3 (April 1941): 105–10.

117
No. 180403 (W13.904q Oversize); no. 180420 (W94.276.2); no. 180425 (W90.361).

118
Belle Greene, letter to the editor, *New York Times*, December 7, 1913.

119
Marilyn Domas White, "Greene, Belle da Costa," in *Dictionary of American Library Biography*, ed. Bohdan S. Wynar (Littleton, CO: Libraries Unlimited, 1978), 217.

120
Bishop, "Reminiscences of Princeton," 159; Greene to Max Farrand, November 17, 1930, ARC 3291, Box 13, Folder 22.

121
Report of Committee on Library and Apparatus, June 13, 1904, Trustees Minutes, 10:437, Princeton University Archives.

122
Accession Book 38, no. 192484 (Ex 2945.1821s copy 1), Princeton University Archives.

123
Before Pierpont Morgan offered Greene the position, Junius had recommended Henry Watson Kent, an assistant secretary at the Metropolitan Museum of Art and the Grolier Club's former librarian. Greene to Berenson, March 14, 1913, Berenson Papers, Box 61, Folder 16. Greene remained grateful to Junius Morgan for many years: "I love him a great deal as he has helped me so much ever since I have known him." Greene to Berenson, June 1, 1914, Berenson Papers, Box 62, Folder 2.

124
"Belle of the Books," 76. As is not uncommon, Greene fudged her age on occasion. She was, in fact, twenty-six.

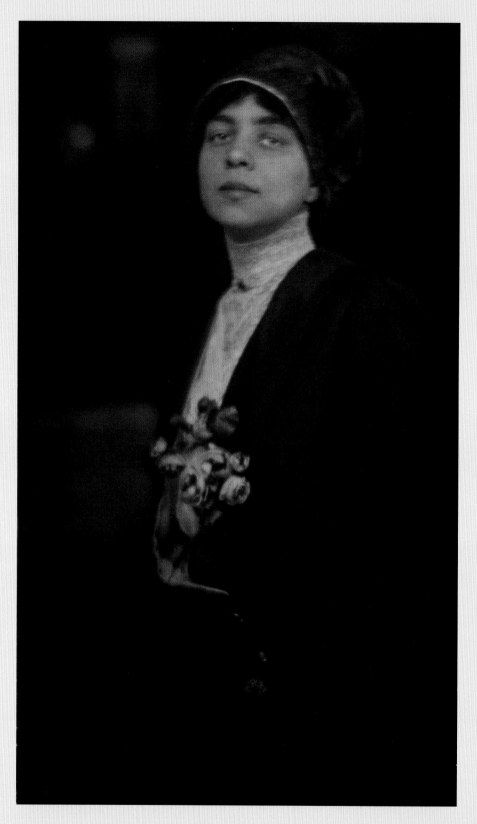

Clarence H. White (1871–1925), *Belle da Costa Greene*, 1911.
Platinum print; 9½ × 5½ in. (24.2 × 14 cm). Biblioteca
Berenson, I Tatti, the Harvard University Center for Italian
Renaissance Studies; Bernard and Mary Berenson Papers,
Personal Photographs, Box 12, Folder 37.

Julia S. Charles-Linen

THE CLEVEREST GIRL
STRATEGIC RACIAL PERFORMANCE AND THE MAKING OF BELLE DA COSTA GREENE

Miss Green [sic] bore no earthly resemblance to the traditional bookworm, so far as appearance went. An alert young lady, wearing a few orchids, is not the mental picture one would have made of a rare book expert, but that is what she is.
—The New York Times, April 30, 1911[1]

But we people of mixed blood are ground between the upper and nether millstone. Our fate lies between absorption by the white race and extinction in the black. The one doesn't want us, but may take us in time. The other would welcome us, but it would be for us a backward step. "With malice towards none, with charity for all," we must do the best we can for ourselves and those who are to follow us. Self-preservation is the first law of nature.
—Charles W. Chesnutt, "The Wife of His Youth," 1899[2]

The story of Belle da Costa Greene did not begin and end at any one library, as many seem to want to believe. While she is most remembered as the first—and perhaps most eminent—director of the Pierpont Morgan Library, Greene was, for better or worse, far more than the professional work she did as J. Pierpont Morgan's personal librarian. Inasmuch as she was known to have personally

expanded and curated the collections at the Morgan, shifting it from a private library to a formidable institution, Greene was just as diligent in shaping her own life and image. While becoming an influence in the art world, she was equally as incisive about curating her persona to the public, from her style of dress to the presentation of her race. Greene established an aesthetic of refinement and beauty beyond what was expected of the conventional librarian. The daughter of two Black parents who had mixed-race ancestry, she was known to have presented herself as white—or at the very least, as something other than Black. Greene was strategic in all areas of her life, from the men she spent time with to the ways in which she performed race. Her position in New York society was relatively unmatched by any other Black woman or librarian of the moment, and much of that hinged on her life mirroring the furtiveness of the world of art, artifacts, and rare books to which she belonged. While other scholars have centered their discourse on Greene toward her work as a Black woman librarian—a subject that is worthy of even more exploration given the continued relative dearth of Black women in the field in contemporary spaces—and on Greene's relationships with various men, perhaps especially her famous love affair with the preeminent Renaissance art historian Bernard Berenson, this investigation is different.

The main objective of this essay is not to examine how the Morgan became the impressive research institution it is, nor is it to determine how J. Pierpont Morgan established himself as one of the major economic minds in American history. Rather, for all of its allusions to the nebulous worlds of art and rare books and manuscripts, this inquiry is chiefly concerned with the contrivances of Belle Greene's racial performances, which landed her at the very center of elite circles of power. Thus, this account also explores how Greene disrupts the notion of legal race as always legible on the body, by highlighting the ways in which Greene's strategic racial performances, along with her then-burgeoning reputation in acquiring rare artifacts, made room for her ascension into the often covert world of art and polite society in New York by the mid-1920s, leading her boss and rumored lover, J. Pierpont Morgan himself, to reportedly call her "the cleverest girl" he ever met.[3] That Greene's skills in acquisitions transformed Morgan's collection from private hobby to public institution, "turning them into a metaphor for international economic relations," suggests that Greene was more than a racially ambiguous body that could vacillate between multiple worlds.[4] Her reach was so wide, in fact, that upon her death the *New York Times* called her "one of the best-known librarians in the country."[5] They further quoted the *London Times Literary Supplement*, saying, "the prescriptive dignity of her office, her single-minded devotion…her canny sense of quality in books or manuscripts…set Ms. Greene in a unique position in the library world."[6] Of everything the *New York Times* reported upon Greene's death—her time at Princeton, how she arrived at the Morgan, her skills in acquisitions,

her respected reputation in America and abroad, et cetera—one of the major aspects of her life that they did not reveal was her race. For while Belle da Costa Greene was legally a Black woman, she occupied decidedly white spaces, took white lovers, and rarely, if ever, publicly discussed her personal racial identity, save for in her letters to Berenson—which are at once private and public to some degree, as is the nature of the epistolary form.

In the following sections, I chart Greene's presentations of racial identity alongside her professional rise in order to remark on how her strategic racial performances[7] and her excusable beauty contribute to her project of self-making as a non-Black woman and a professional, while maintaining the air of mystery that she hoped would follow her to her grave. The goal here is not to condemn the enterprise of racial passing, but rather to interrogate or even indict a nation that would force such a practice. The aim is to study a woman who effectively disturbed the purportedly fixed boundaries of race—and thereby underscored the failure of the body as a reliable signifier of it—for her own gain, which is to say, her own freedom of movement through spaces traditionally only racialized as white. I argue, in part, that regardless of the racial attitudes Greene adopted or projected throughout her life, her disassociation from a Black racial identity is not her own moral failure, at least not exclusively. Instead, the onus is equally on a nation for its egregious racial failures and often arbitrary margins of identity.

THE GRASS IS ALWAYS GREENER: REIMAGINING A LIFE THROUGH STRATEGIC RACIAL PERFORMANCE

Passing is an intriguing cultural phenomenon and an even more complex social enterprise. While passing, which is often taken as shorthand for racial passing, is historically perceived as deception that is steeped in disloyalty to a race (usually to the Black race in favor of the white one), I contend that rather than viewing it solely as an indication of a subject's perfidy, it is more accurately a political initiative that can—or rather *should*—be interrogated as a response to America's oppressive race laws. When Randall Kennedy outlines a legal definition for passing in his 2001 article in the *Ohio State Law Journal*, he links the terms "passing" and "deception," saying, "Passing is a deception that enables a person to adopt certain roles or identities from which he would be barred by prevailing social standards in the absence of his misleading conduct."[8] That which Kennedy terms "misleading conduct" I might call performance, as the latter suggests a deliberate and concerted effort to subvert the unjust race laws that restrict Black freedom. The penchant for assigning moral judgment to the praxis of passing, specifically to people who move from a nonprivileged subject position to a privileged one—that is, from Black to white—is an indication of the pervasiveness of racial oppression in the United States. In *Bodies in Dissent*, Daphne Brooks offers readers context for figures who "developed risky, innovative paths of resistance

in performance."⁹ And while her book is not restricted to mixed-race figures, it does provide a useful framework for examining performance as resistance. Performance as resistance—or more aptly, resistance through performance—is a useful way to interpret racial passing schemes. For if race laws were impartial, then there would be no need to perform a different race.

When Belle da Costa Greene, whose given name was Belle Marion Greener, was born in 1879, the United States was experiencing radical political shifts. Greene was born into a well-established African American family just after the failure of Reconstruction. Post-Reconstruction brought with it new—or the changing same—political ideologies that sought to establish greater distance between Black and white in the United States. The state and local laws collectively known as Jim Crow strictly enforced the separation of the races; they would later be forever entrenched into American legal structures with the outcome of the 1896 landmark *Plessy v. Ferguson* Supreme Court decision, which declared that the separation of races was not a violation of the US Constitution. It also gave us the language, doctrine, and pretense of "separate but equal," which would not be partially overturned until another landmark Supreme Court decision, *Brown v. Board of Education* in 1954, exactly four years and one week after Greene's death in 1950. In other words, Greene never lived in an America that believed in the legal equality of the races. Consequently, though her family was financially comfortable, they also had to navigate post-Reconstruction America, which constantly reinforced for them that their racial makeup was a defining factor in whether they could ever access certain social and political spaces.

In 1883 Greene's father, Richard T. Greener (fig. 1), engaged in fierce public debates with renowned Black abolitionist Frederick Douglass, in which he opposed Douglass's approaches to working with Republicans, who Greener felt had abandoned Black people. Nevertheless, Greener was still but a Black man in a United States that constantly devalued Black people through both law and social custom. His fierce loyalty to his race allowed him access into spaces other Black

FIG. 1
The Crisis 13, no. 4 (February 1917). New York Public Library, Schomburg Center for Research in Black Culture, Jean Blackwell Hutson Research and Reference Division.

FIG. 2
State Census of New Jersey, 1905. New Jersey State Archive, Trenton, NJ; Reference Number L-06, Film Number 27.

people in the country could not occupy, but it could not save his marriage and family from the effects of bigotry. Around the turn of the century, Greener and his wife, Genevieve Ida Fleet, separated, leaving the fair-skinned Belle and her other siblings to eventually drop the R from their last name and adopt the name Greene in order to distance themselves—just as the law had mandated distance between the races—from Greener and his public reputation as a Black man.

After the dissolution of her marriage to Richard, Genevieve created a life for herself and her children that could only see success or comfort if they were read as white—or at least something other than Black, like Portuguese or Cuban, perhaps. While she had already begun passing as white before the official end of her marriage, given the fact that Richard was not often around, the end of the marriage resulted in even more freedom to do so. Toward that end, by the 1905 New Jersey census, Genevieve's birthplace was listed as Spain (fig. 2). The ambiguity of their racial identity would follow Greene throughout the remainder of her life, leading her to cancel a planned trip and lament to Berenson decades later, "I am so damned black that it is impossible for me to go anywhere, among people whose names are known without being identified."[10]

By all accounts, Greene experienced reinventions that are familiar to any person who chooses to perform a race different than their legally assigned one. From name changes and relocations to secrecy and outright omissions about their past and personal history, Greene's life could have been captured in any of the multitude of novels and short stories from authors who were writing around the time of her birth and during her childhood. In the late nineteenth century and through the turn of the century, authors like Frances Ellen Watkins Harper with *Iola Leroy* (1892); Charles W. Chesnutt with *Mandy Oxendine* (ca. 1890s, published 1997), *The Wife of His Youth and Other Stories of the Color Line* (1899), and *The House Behind the Cedars* (1900, fig. 3); and Pauline Hopkins with *Contending Forces: A Romance Illustrative of Negro Life North and South* (1900) each wrote stories that center mixed-race characters, usually women, who pass for white and, through their racial performances, are able to experience multiple sides of the color line. A common thread throughout these novels is a protagonist who lives under the threat of racial discovery after having carefully crafted a life that is, on the surface at least, racialized as white. Notably, these authors are not necessarily highlighting racial passing as an indictable offense. Rather, they are interrogating a racially fractured nation that would

FIG. 3
Charles W. Chesnutt (1858–1932), *The House Behind the Cedars* (Boston: Houghton, Mifflin and Company, 1900). The Morgan Library & Museum, New York, purchased on the Gordon N. Ray Fund, 2024; PML 199107.

make such an enterprise even necessary. Their works of fiction are not too dissimilar from Greene's lived experiences. Indeed, in 2021 Greene's life became the subject of a contemporary work of historical fiction. That the *New York Times* bestselling novel *The Personal Librarian* is dedicated, "For the two sides of Belle: Belle da Costa Greene and Belle Marion Greener," reveals the authors' understanding of the complexities inherent in racial passing.[11]

As mixed-race characters found their way into our literary imaginations throughout the nineteenth century, they stoked white fears about who had access to the privileges of whiteness. Public intellectuals, Harper and Chesnutt among them, publicly probed the race question in both their fiction and nonfiction alike, with the latter taking up the subject in a series of essays entitled "The Future American." Civil rights and suffrage activist Mary Church Terrell also broaches the topic in a 1905 speech:

> At first blush it would seem that a camel with a hump could literally pass through a cambric needle's eye easier than an individual tainted with even a drop of the fatal African tincture could palm himself off as a bona fide white man in the United States. And yet colored people are doing this very thing in droves every year. It requires neither voluminous knowledge nor great profundity to comprehend why some colored people are tempted to pursue such a questionable course.[12]

Together, these Black authors use the mixed-race figure to interrogate a nation. After all, when "separate but equal" was codified into law, it hinged on the government's handling of a mixed-race man from Louisiana who became the plaintiff in the Supreme Court decision that would shape American racial politics for nearly sixty years: Homer Plessy.

The Greene family's choice to perform a race other than their legally ascribed one is a direct reflection of a nation at odds with a new generation of Black people who were not born enslaved in the United States, many of whom looked no nearer to Black than white people did themselves. The irony is not lost on Chesnutt, who, in his 1889 essay "What Is a White Man?" noted that some states offer a "condition of public opinion" as to whom to deem white or Black, especially where it is not readily legible in their features. That some states left the determination of race up to a jury, who would then determine race based on both looks and reputation, emphasized what these intellectuals-turned-race theorists already knew: while very real in the ways in which we govern, race is a farce in the United States. The Greenes' exploitation of visual codes meant to signify race further attests to this fact.

While we cannot be sure that Belle Greene read these writers, it is not unlikely given the popularity of their works. Indeed, Greene embodied the spirit of Clare Kendry, the protagonist of Nella Larsen's 1929 novella *Passing* (fig. 4). In

it, Clare disassociates from everything and everyone Black she knows in order to maintain a white life with her husband, who is unaware of her racial ancestry. Clare even goes so far as to rekindle her friendship with Irene Redfield, a mixed-race woman from her past who is well aware of Clare's racial makeup. While Irene could also pass for white, she chooses to live as a Black woman (save for a few instances in which she casually dines in whites-only spaces).[13] When the two reencounter each other on a rooftop of a hotel in Chicago (read: a whites-only space), their continued conversation over tea and their friendship beyond the rooftop set off a series of circumstances from which neither can escape. Larsen (fig. 5), who was of mixed race—Black and Danish—and was, like Greene, a librarian in New York, offers readers a glimpse into the dangers of racial crossing when Clare dies as a direct result of her choice to pass for white. It is as if Larsen was cautioning readers while simultaneously chiding America for its racial failures. The fictional character, Clare, and the very real woman, Greene, both become objects of affection or curiosity for many male suitors. While Clare catches the eye of nearly every man in the room, Greene becomes the inspiration or subject for many an artist.

FIG. 4
Nella Larsen (1891–1964), *Passing* (New York: Alfred A. Knopf, 1929). The Morgan Library & Museum, New York, the Carter Burden Collection of American Literature; PML 185968.

FIG. 5
Carl Van Vechten (1880–1964), *Nella Larsen*, November 23, 1934. Photographic print; 9⅞ × 8 in. (25.2 × 20.2 cm). Carl Van Vechten Papers Relating to African American Arts and Letters, James Weldon Johnson Collection in the Yale Collection of American Literature, Beinecke Rare Book and Manuscript Library; JWJ MSS 1050, Box 96, Folder 1706.

FIG. 6
Paul-César Helleu (1859–1927), *Portrait of Belle da Costa Greene*, 1913. Black, white, and red chalk; 26 9/16 × 21 in. (67.5 × 53.4 cm). The Morgan Library & Museum, New York; 1950.12.

EXCUSABLE BEAUTY: ELEGANCE, AFFLUENCE, AND ANCESTRY

By 1911, Greene was at the center of collections at the Morgan, making a name for herself as the person in charge of the library's acquisitions. Whether at an auction or some high society event, "Greene routinely wore fashionable gowns, brilliant jewelry, violet corsages, and extravagant hats. She wore Renaissance-styled gowns, festooned with jewels, outfits no doubt enhanced by her penchant for waving silk handkerchiefs while she spoke. Contemporary descriptions frequently note that she dressed like a 'society girl.'"[14] Thus she became the inspiration for artists who were intrigued by her—arguably hyperfeminine—presentation of self in often male-dominated spaces.

The famous 1913 chalk portrait of Greene by French artist Paul-César Helleu, who was known for his portraits of beautiful society women, is emblematic of what scholars know about the unknowable Greene (fig. 6). It is a profile image of the librarian that depicts her in her signature hat and plume, which she became known for wearing as she navigated the exclusive world of art auctions for rare books and artifacts. Later, in 1929, photographer Mattie Edwards Hewitt captured an image of Greene in classic flapper attire (fig. 7), flappers being a subculture of the 1920s Jazz Age that saw a radical shift in feminine expression. Shelia Liming characterizes flappers this way: "The flapper is, in essence, a perceived negation of the Victorian woman.... But the less form-fitting styles of the 1920s also gave way to exposed arms, legs, and necklines. Flappers sported boyishly cropped hair, but did so alongside dramatic 'vamp' makeup."[15] Despite the irony of having once famously quipped, "Just because I am a librarian doesn't mean I have to dress like one!," Hewitt's image—and therefore Greene herself—has a visual affinity with the German-American artist Winold Reiss's drawing *The Librarian* (fig. 8), which was produced only four years earlier, in 1925, at the height of the New Negro Renaissance, also termed the Harlem Renaissance. The cultural, intellectual, and artistic movement that centered Black life was partly situated in Harlem, and anyone nearby would have known of its emergence and likely felt its impulse, especially following the 1925 publication of the Alain Locke–edited issue of *Survey Graphic* entitled *Harlem: Mecca of the New Negro*, which featured a Reiss portrait on its cover and included *The Librarian*. The special issue would become the magazine's most popular issue. It was also the basis for Locke's culture-defining anthology, *The New Negro* (1925), a collection of fiction, poetry, essays, and art by and about African American authors and artists. This was the culture of Black life that was emerging at the same time as Greene's ascension at the Morgan.

Greene's style and fashionable dress are possible keys to unraveling her relationships to art, high society, and, perhaps most notably, race and identity, for a major aspect of any performance—especially a racial one—is believability. In order for a performance to be successful, it must be convincing, always suiting

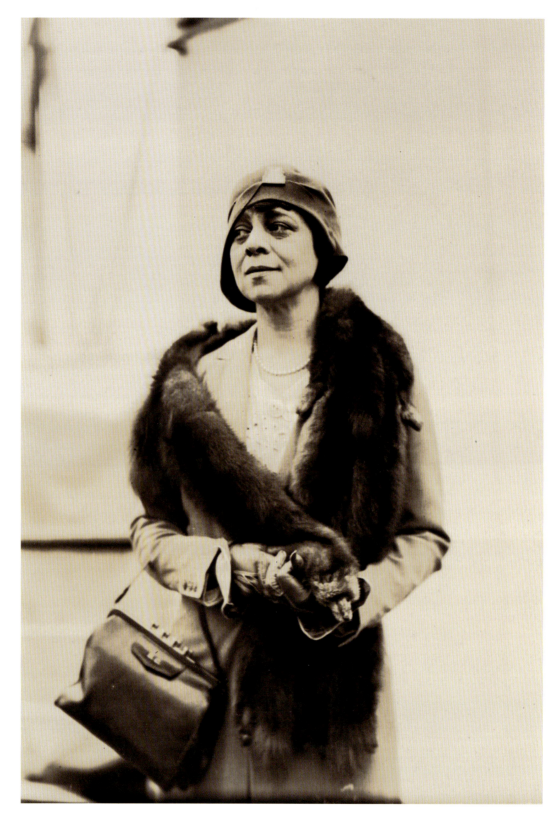

FIG. 7
Mattie Edwards Hewitt (1869–1956), Belle da Costa Greene, 1929, for Bain News Service. Photographic print; 7 × 5 in. (17.8 × 12.8 cm). Library of Congress, Prints & Photographs Division, George Grantham Bain Collection; LC-USZ62-93225.

precedent. In addition to performing whiteness, Greene had to perform class status. She was not unaccustomed to a bookish life—her father having been an accomplished scholar in his own right, albeit an openly Black-identified one. By the time Greene is working at Princeton in 1901, she and her family had been performing other races for some time. "Ironically," Flaminia Gennari-Santori notes, "Princeton was the only Ivy League school that still did not admit African American students."[16] Yet, Greene arrived, then in her early twenties and just beginning to shape her career in librarianship and rare books (fig. 9).

The world of incunabula, rare books, and art is as exciting, compulsive, capricious, and, at times, as duplicitous as the world of racial performance, leading one observer to remark:

FIG. 8
Winold Reiss (1886–1953), *The Librarian*, 1925. Pastel and tempera on Whatman board; 30 × 22 in. (76.2 × 55.9 cm). Fisk University Museum of Art, Nashville, TN.

FIG. 9
Clarence H. White (1871–1925), *Belle da Costa Greene*, 1911. Platinum print; 8⅞ × 5⅜ in. (22.5 × 13.7 cm). The Morgan Library & Museum, New York; ARC 3275.

I don't remember if I've spoken of Miss Greene, with her tanned complexion. I believe she was born in Cuba, she is even said to be a mulatto; her hair is frizzy, her cheeks are thick, her lips big. She's a figure sculpted by a savage of genius. And she's "a savage" herself: she is savage in her furies, in her preconceived notions, even in her marvelous intelligence. She's J. P. Morgan's librarian and the architect of that collection of famous, precious books. On ancient books and publications and old manuscripts, she possesses universal knowledge.[17]

The two worlds—rare books and racial performance—at least for the furtive Greene, cohered to make her "the center of a web of dealers scattered between New York, London, Paris, and Italy, who were creating the largest private collection of the time"[18] (fig. 10). Her racial performances certainly helped her achieve prominence at the Morgan and secure social status beyond it. As she quickly developed expertise in various aspects of collecting, Greene rarely ever openly addressed her racial ancestry, save for in her letters to Berenson. Jean Strouse tells us, "Whatever Belle did tell Berenson about her background, her letters to him made constant, deeply conflicted reference to blackness and her physical appearance—reflecting a painful consciousness of a world that defined beauty in features that were not her own."[19] Although she was rather tongue-in-cheek about her race in those private exchanges,[20] her intention had been for Berenson to destroy their correspondence upon her death, leaving the question of her race and her internal struggle with it to spectators as it had been throughout her life.

Just as many of the portraits of Greene are profile shots, oriented to show only one side of her, so, too, did Greene live her life this way. The enigma therefore remains. While I diverge from her biographer Heidi Ardizzone's contention that "the term 'passing' suggests a masquerade and deception" and, by extension, her preference for the phrase "'living as white' because it allows for the possibility that Belle was a woman of color who believed her predominantly white ancestry made her just as white as her Italian, Jewish, and other white ethnic neighbors and schoolmates,"[21] there is utility in establishing more capacious categories of racial identity. The notion of passing as deception makes the enterprise of passing a moral issue and thus puts the onus on the passer rather than on the nation. Instead, as I have argued in my previous research on passing, I am more "particularly attentive to the ways in which racially ambiguous bodies craft new forms of bodily representation through performance."[22] This language—"living as white"—does not seem to consider the instances in which Greene

FIG. 10
"Woman Is Custodian of Famous Morgan Library," *Trenton Evening Times*, November 16, 1913.

overtly identified herself or leaned into suggestions that she was something other than white and perhaps even something other than altogether Black, like, for instance Chinese, Persian, Arab, Egyptian, or Abyssianian, the latter of which would have undoubtedly been associated with Blackness at the time.[23] Still, Greene's decision to not identify as one specific race was an intentional one—certainly an effort to obviate potentially negative social and professional outcomes for her in a racially fractured America. Moreover, Ardizzone's claim is further upended by the biographer's own reasoning that "Belle believed her visibility was due partly to her dark skin and ambiguous ethnic appearance."[24] If Greene truly considered herself to be white rather than performing white, then her skin color could not belie her identity, no matter how dark—or olive in tone, as most people described it—it appeared.

Greene's social acceptance as perhaps not white but certainly not altogether Black all hinged on the racial illegibility of her body. Therefore her strategic racial performances must be considered alongside her performance of class status and her acceptable beauty, the latter of which does not intend to determine whether she was a remarkable beauty, but rather that she was *beautiful enough* not to arouse lasting suspicion. Much of the discourse around the making of Belle da Costa Greene is decidedly fixated on race. This essay does not intend to decide Greene's racial identity. After all, she identified as more than one race throughout her life. In fact, she was sixteen when her mother made the decision for the family to pass for white. Whether she felt a stronger sense of belonging to one race than another is not for this writer to say. What can be said, though, is that Greene lived her life in the in-between: in the gaps between public and private, visible and invisible, and Black and white. This is among the truest lived experiences of a space I have termed "that middle world": a metaphysical space in which "mixed-race subjects invent cultural spaces in the interstice between the Black and white worlds and thereby, through various performance strategies, make meaning of their corporeal—turn social—in-betweenness. Put differently, performing race and gender becomes an adroit method of circumventing the legal and social boundaries of identity, especially race."[25] And through that Greene carved out a magnificent, if enigmatic, life. One in which, as far as research shows, she mostly relished. That she utilized her position for causes much bigger than herself, such as advocating for higher wages for working women, also suggests that she never intended to be the only woman—Black or otherwise—in such a notable position.[26] That research often focuses on her race—which some erroneously read as deceptive—alongside her professional and social rise as a woman librarian, curator, and socialite begs the question of research's complicity in white supremacy. Our penchant for categorization, definitive boxes into which our various identities are neatly fitted, is a byproduct of that white supremacy. For, as James Baldwin once poignantly put it, "We take our shape, it is true, within and against that cage of reality bequeathed us at our birth; and yet it is precisely through our dependence on this reality that we are most endlessly betrayed."[27]

NOTES

1
"J. P. Morgan's Librarian Says High Book Prices Are Harmful," *New York Times*, Magazine section, April 30, 1911.

2
Charles W. Chesnutt, *The Wife of His Youth and Other Stories of the Color Line* (Boston: Houghton, Mifflin, 1901), 7.

3
Heidi Ardizzone, *An Illuminated Life: Belle da Costa Greene's Journey from Prejudice to Privilege* (New York: W. W. Norton, 2007), 318. For the unsubstantiated rumors that Belle Greene and J. Pierpont Morgan were lovers, see ibid., 4, 488n4.

4
Flaminia Gennari-Santori, "'This Feminine Scholar': Belle da Costa Greene and the Shaping of J. P. Morgan's Legacy," *Visual Resources* 33, nos. 1–2 (2017): 183.

5
"Belle D. Greene Morgan Librarian: Noted Figure in Field, Holder of Post 1905–48, Is Dead—Paid Thousands for Rarities," *New York Times*, May 12, 1950.

6
Ibid.

7
Julia S. Charles, *That Middle World: Race, Performance, and the Politics of Passing* (Chapel Hill: University of North Carolina Press, 2020), 4.

8
Randall Kennedy, "Racial Passing," *Ohio State Law Journal* 62, no. 3 (2001): 1.

9
Daphne A. Brooks, *Bodies in Dissent: Spectacular Performances of Race and Freedom, 1850–1910* (Durham, NC: Duke University Press, 2007), 4.

10
Greene to Bernard Berenson, Bernard and Mary Berenson Papers, Box 61, Folder 19, Biblioteca Berenson, I Tatti, the Harvard University Center for Italian Renaissance Studies.

11
Marie Benedict and Victoria Christopher Murray, dedication in *The Personal Librarian* (New York: Berkley, 2021).

12
Mary Church Terrell, "How, When, Why, and Where Black Becomes White" (1905), Mary Church Terrell Papers: Speeches and Writings, 1866–1953, Library of Congress, https://www.loc.gov/item/mss425490380/.

13
See Charles, *That Middle World*, chapter 5, for a more in-depth analysis of Clare's and Irene's specific iterations of racial crossing.

14
Deborah Parker, "Belle da Costa Greene," *A Hymn to Intellectual Beauty: Creative Minds and Fashion* (blog), 2013, https://creativemindsandfashion.com/2013/08/20/belle-da-costa-greene/.

15
Sheila Liming, "Suffer the Little Vixens: Sex and Realist Terror in 'Jazz Age' America," *Journal of Modern Literature* 38, no. 3 (Spring 2015): 110.

16
Gennari-Santori, "'This Feminine Scholar,'" 185.

17
René Gimpel, *Diary of an Art Dealer*, trans. John Rosenberg (New York: Farrar, Straus & Giroux, 1966), 162.

18
Gennari-Santori, "'This Feminine Scholar,'" 185.

19
Jean Strouse, *Morgan: American Financier* (New York: Random House, 2014), 518.

20
Greene does not talk very plainly about her racial identity in her letters to Berenson; she uses playful and cryptic language in many cases. Therefore it becomes clear that she is engaged with how people view her racially and how she sees herself.

21
Ardizzone, *Illuminated Life*, 57–58.

22
Charles, *That Middle World*, 34.

23
Greene to Berenson, May 6 and October 19, 1910, and January 19, 1911, Berenson Papers, Box 60, Folders 7, 10, and 14, respectively.

24
Ardizzone, *Illuminated Life*, 318.

25
Charles, *That Middle World*, 7.

26
For more on Greene's advocacy for higher wages, see p. 231 in Ciallela and Palmer's essay, "Belle Greene as Director: Transitions."

27
James Baldwin, *Notes of a Native Son* (Boston: Beacon Press, 2012), 20.

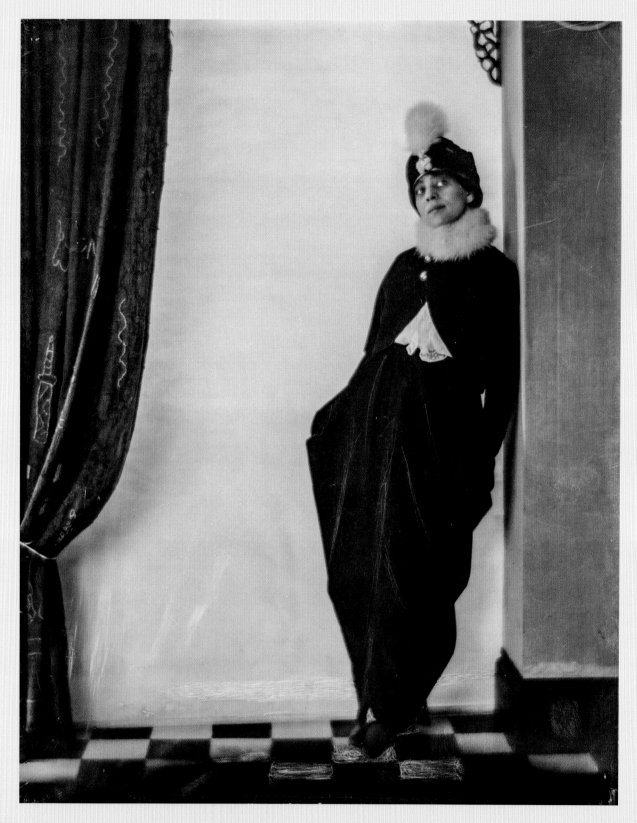

Clarence H. White (1871–1925), *Belle da Costa Greene*, 1911. Digital positive from a gelatin dry plate negative; 10 × 8 in. (25.4 × 20.3 cm). Princeton University Art Museum, The Clarence H. White Collection, assembled and organized by Professor Clarence H. White Jr., and given in memory of Lewis F. White, Dr. Maynard P. White Sr., and Clarence H. White Jr., the sons of Clarence H. White Sr. and Jane Felix White; CHW NEG-1085.

Deborah Willis

BECOMING OR BELONGING
BELLE'S CAMERA PORTRAITS

It's funny about "passing." We disapprove of it and at the same time condone it. It excites our contempt and yet we rather admire it. We shy away from it with an odd kind of revulsion, but we protect it. Instinct of the race to survive and expand.
—Nella Larsen, *Passing*[1]

This epigraph, from Nella Larsen's novella *Passing* (1929), deals explicitly, painfully, and profoundly with a Black woman who, because of her physical features, is able to pass for white. Larsen's words are powerful and apropos as a framework in which to examine the photographic portraits of Belle da Costa Greene, born Belle Marion Greener, a Black American woman who lived most of her life claiming or assumed to be of European descent, specifically Portuguese. Greene's image is inextricably bound by gender, race, and class; the daughter of a prominent Black family in Washington, DC, she became financier J. Pierpont Morgan's longtime private librarian and the first director of the Morgan Library. Consequently, the Morgan collection includes ten portraits of Greene across photographs, drawings, and paintings; two newspaper clippings depicting additional images of her; and one sculpture.[2]

Greene posed for many of the leading American and European photographers working at the turn of the twentieth century, including Ernest Walter Histed, Theodore C. Marceau, and Clarence H. White. Portraits produced in

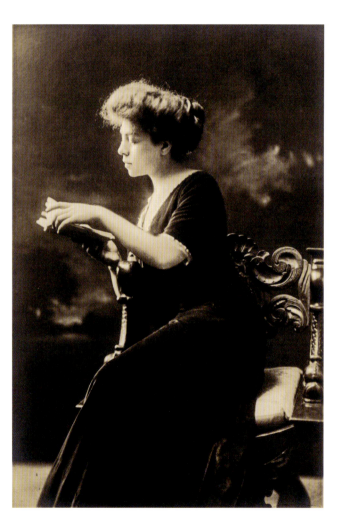

FIGS. 1–4
Theodore C. Marceau (1859–1922), Series of portraits of Belle da Costa Greene, May 1911. Gelatin silver prints; 14 15/16 × 10 7/8 in. (38 × 27.7 cm) each. Biblioteca Berenson, I Tatti, the Harvard University Center for Italian Renaissance Studies; Bernard and Mary Berenson Papers, Personal Photographs: Box 1 Friends (Large Format).

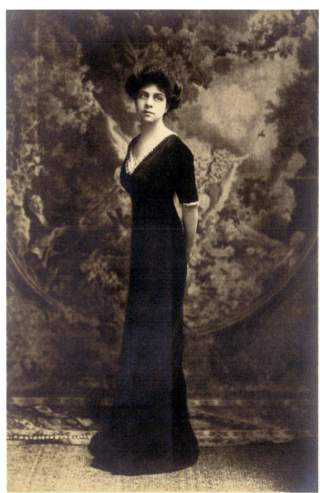

their studio were instrumental in advancing the art of photography through Pictorialism and the Photo-Secessionists movements, which promoted idealized images of women in picture books and magazines. Again and again, Greene made her way into these studios to pose for photographs that she used to bolster her professional profile or, at other times, sent to her long-distance lover, art historian Bernard Berenson. Imagine the fearless, elegantly dressed, and feisty Belle walking into the studios of some of the most noted photographers of the day. Yet who is the "we" that Larsen references, and what are the historical, economic, and political implications undergirding that pronoun when applied to Greene? Specifically, who are we, what are we, and why are we when contemplating the image of this extraordinary, complicated, and intelligent woman? Greene's own self-consciously playful words may provide a clue: "Just because I am a librarian doesn't mean I have to dress like one."[3] Posing in a Paul Poiret–designed pantsuit with fur collar (p. 84),[4] or in long coats, pants, hats, dresses, and gloves, Greene performed femininity and class that aligned with her dreams and ideals of the modern woman. Constructing her own image as someone who makes the conscious choice to not look her part offers a framework in which to position Greene's photographic portraits and personal history. Along with fashion, photography played a crucial role in shaping and fixing Greene's identity and sense

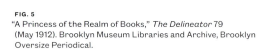

FIG. 5
"A Princess of the Realm of Books," *The Delineator* 79 (May 1912). Brooklyn Museum Libraries and Archive, Brooklyn Oversize Periodical.

FIG. 6
Adolph de Meyer (1868–1946), *Belle da Costa Greene*, 1912. Platinum print; 9 5/16 × 7 1/2 in. (23.6 × 19 cm). Biblioteca Berenson, I Tatti, the Harvard University Center for Italian Renaissance Studies; Bernard and Mary Berenson Papers, Personal Photographs, Box 12, Folder 37.

of self, stabilizing her social transformation from Belle Marion Greener to Belle da Costa Greene. She used her photographs as evidence of her new life (figs. 1–4).

For Greene, being photographed by the preeminent photographers of the time was also a public act. As she became known in the New York society set, her photographs were published in the New York press and in the society pages in cities from Atlanta to San Francisco. Her fashion style attracted society page writers who were also curious about her powerful position. Greene's portraits were also used to illustrate accounts of her many successful acquisitions for the Morgan Library, her role in the Morgan dynasty spotlit through long, descriptive articles that were accompanied by her likeness. As biographer Heidi Ardizzone notes, "One of the [Theodore] Marceau portraits fills over a quarter of the page...one of the [Adolph] de Meyer portraits was reprinted in the *New York Times*"[5] (figs. 5–7). On August 11, 1912, the *Chicago Daily Tribune* published a full-page article on Greene (fig. 8):

> She knows more about rare books than any other American. She has spent $42,000 for a single volume and outwitted a rich duke at an auction. Her opinion on Caxton editions is sought by the greatest scholars. She is chic, vivacious, and interesting, in fact, a "dandy, wholesome American

FIG. 7
"Spending J. P. Morgan's Money for Rare Books,"
New York Times, April 7, 1912.

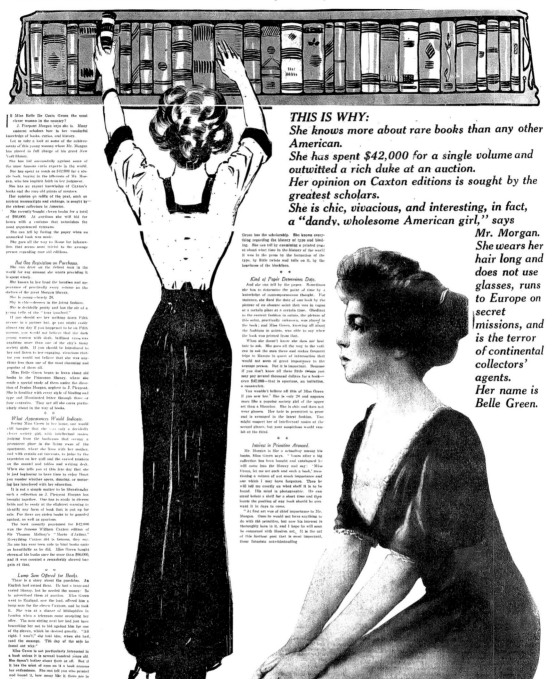

FIG. 8
"'The Cleverest Girl I Know,' Says J. Pierpont Morgan,"
Chicago Daily Tribune, August 11, 1912.

> girl." ... She wears her hair long and does not use glasses, runs to Europe on secret missions, and is the terror of continental collectors' agents. Her name is Belle Green [*sic*].

How did these portraits of Greene, which were ambiguous on race, age, and the tensions she experienced as a proto-feminist, function in their early context as compared to how they function for us now in the archive? Were the photographers complicit in erasing Greene's past and reinventing her present life? How do we look at Greene's portraits when we know her secret? Can we ever know more than what she wants us to see, even from our twenty-first-century vantage point? How could Greene risk losing the admiration of Morgan, who described her as "the cleverest girl I know"? Was she "modeling" the constructed "self" or sheer force of her will? Was she positioning her future outside of what she believed were the constraints of racism? How do her portraits compare to those identified with the feminist-oriented, progressive New Woman movement and the New Negro Woman? The many narratives around Greene make it impossible to write about her images without recalling the complexities of her life, which have been examined in a biography, reframed in fiction, and reimagined in exhibitions and articles over time.

BELLE AND THE CAMERA

> The photographer and his subject may collude to present confections of any sort, but unless the basic artifice of the commercial portrait is revealed, the resulting picture becomes an impervious presentation, a mask held up to the larger world. Those portraits that dare to reveal the person behind the persona were generally not produced for public consumption but for private contemplation.[6]

Despite the small amount of evidence in either Greene's writings or published works about her portraits, from her strategic choices it is clear she sought to control how she was portrayed, and that the camera's lens held meaning for Greene that we can only imagine today.[7] Her photographs did much more than record her presence in Morgan's life; they claimed her notability, her sexuality, and blurred the lines of her racial passing. Greene's portraits typified her ideals, and she knew how to use portraiture to establish an identity outside of the respectability lens of the New Negro Woman (figs. 9, 10). Already rejecting the mainstream of a woman's place and the sociocultural readings of women of the time, Greene demonstrated that there were no limits on her life—certainly none that her deliberate posing couldn't dispel. It is evident she well understood the collaborative nature of photography and performance. Indicative of her deliberate intentions, she thought long and hard about the images she would eventually share with Berenson: "She arranged for sitting after sitting, trying to find the right photographer, the right pose and look that he would appreciate."[8]

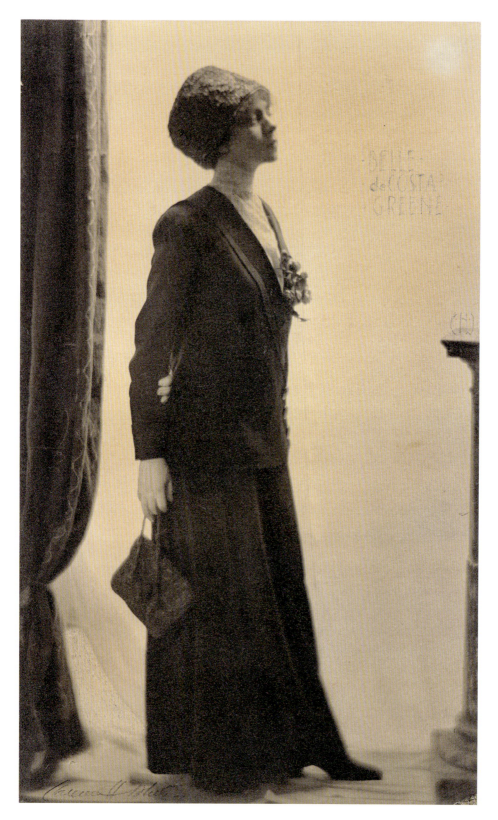

FIG. 9
Clarence H. White (1871–1925), *Belle da Costa Greene*, 1911.
Platinum print; 8⅞ × 5⅜ in. (22.5 × 13.7 cm). The Morgan
Library & Museum, New York; ARC 2821.

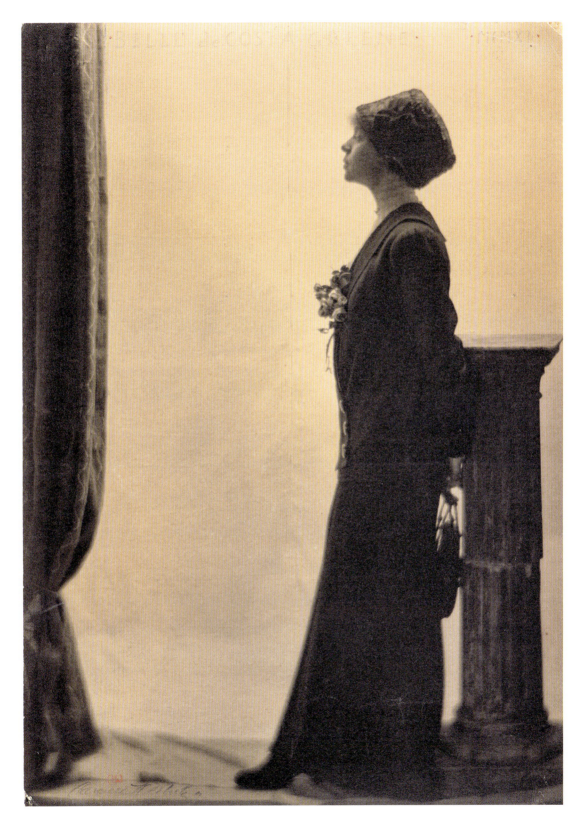

FIG. 10
Clarence H. White (1871–1925), *Belle da Costa Greene*, 1911.
Platinum print; 9⅞ × 7¾ in. (25.1 × 19.7 cm). The Morgan
Library & Museum, New York; ARC 2822.

Entering Ernest Walter Histed's Fifth Avenue photography studio wearing a large and elaborately designed hat, Greene announced her image as one of empowerment. Confronted with Greene's unexpected style, Histed grumbled about her elaborate clothing, which did not fit the stereotype of a librarian (fig. 11).[9] Ardizzone writes, "Belle very much used her femininity and her allure in both her personal and professional life. She attracted a series of admirers and loved a good flirtation, preferably with someone creative, knowledgeable, or otherwise 'interesting!'"[10] Clarence White's portraits of her are undoubtedly alluring and suggestive. White's photographs of Greene are dreamlike and reflect her desire to be of the moment, an independent New Woman connecting to the self—feminine, clever, and determined. Yet there is no one way to read Greene's portraits through the lens of early twentieth-century constructions of femininity. White's portraits of Greene represent an inner identity that is occluded in real life yet projects abstract qualities such as her drive. Her seated poses convey a sense of modesty (fig. 12). The image is in White's signature soft-focused Pictorialist style, with her white gloves mirroring the brightness of her skin. The muted backdrop sets her face apart in a seemingly three-dimensional setting that highlights her determined and thoughtful gaze. Is she projecting beauty or loss, or is her gaze sending an intentional message—one we will never know?

Writing about Greene's portraits necessitates processing the meaning of feminine representation and the concepts of spectatorship at the same time. Greene's portraits show a woman who was working with an unbeknownst collaborator—the studio photographer—who had likely cemented their ideas of femininity and the conventions of portraiture in posing white women. The portrayals of women in early twentieth-century studio photography were a mixture of strength, sultriness, seductiveness, and demureness. Many capture performances constructed by the sitter and/or directed by the photographer. John Pultz observes that "women use clothing, make-up, hairstyle, and color as tools to alter their appearance in an infinite variety of ways. They can hide behind such a masquerade, using it to deflect the male gaze and to find a space in which they can act freely."[11] In Greene's case, exploiting the highly stylized and exaggerated poses of the day, she deflected the racialized gaze that haunted her throughout her lifetime. Her heritage and secret could be masked through posing in these constructed styles and spaces.

Photography helped Greene imagine and create the opportunity of a future outside of oppression. Pultz posits that photography was invented at a period of social conflict throughout Europe and America, when a series of proletarian uprisings convinced the bourgeoisie and aristocracy that the capitalist system upon which they depended required social stability.[12] Greene was aware of this history and the effects of institutional racism and its (mis)representations. Vernacular images—depicting enslaved men and women, servant children, field workers, for example—were the most frequently mass-produced images of Black people. As a result, when we think of nineteenth-century Black America, we often think of such stereotypical images as the minstrel

FIG. 11
Ernest Walter Histed (1862–1947), *Belle da Costa Greene*,
1910. Gelatin silver print; 23 × 18 in. (58.4 × 45.7 cm).
The Morgan Library & Museum, New York; ARC 2702.

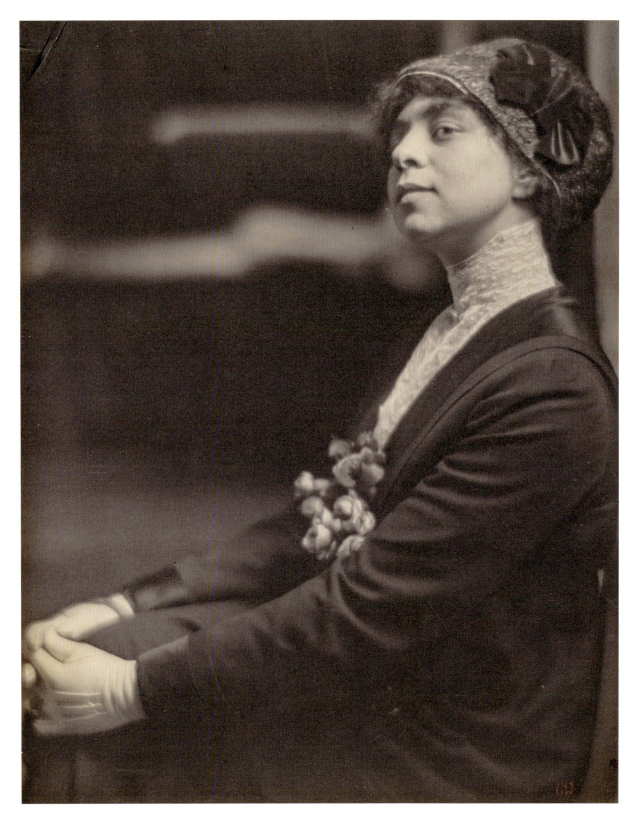

FIG. 12
Clarence H. White (1871–1925), *Belle da Costa Greene*, 1911. Platinum print; 9⅜ × 7⅝ (23.9 × 19.2 cm). Biblioteca Berenson, I Tatti, the Harvard University Center for Italian Renaissance Studies; Bernard and Mary Berenson Papers, Personal Photographs, Box 12, Folder 37.

performer in blackface, the "mammy," the "primitive," or the Black woman as an exotic Other. The exaggerated features and demeaning situations depicted by white photographers in the mid-1800s undoubtedly left an enduring negative impact that continued through Greene's lifetime. She would have been well aware of this long history that denied an existence outside of servitude. I agree with Pultz's assertion: "Photographs are explicitly political, dealing with problematic sexuality and notions of self-identity. Most of these photographers act out assumed or fictive roles; they refuse to seek any 'true' or 'real' self."[13]

NEW WOMAN, NEW NEGRO

Photography provided agency and created a sense of self-esteem for the New Woman in a new century. Photographs made during this period transformed the visual representation of Black America and the New Woman. In images of women from this period, photography was an intervention for those who had a desire to participate in a democratic society. In my view, a visual categorization of all women emerged from the photographic image in film and popular media.

What we glean from Greene's portraits is that photography studios were accessible to all classes of American society. This fact creates a curious tension as to how racial identity could be performed and considered in Greene's photographic images of Black Americans during the era of the New Negro. The term New Negro focused on a new spirit of self-awareness, artistic consciousness, and racial pride in the Black community after 1900. Greene's photographs include poses exemplifying beauty, pride, and determination—all evidence of what these images meant to her. Writing about identity in the twenty-first century, art historian Cherise Smith emphatically states, "I harbor the notion that everyone should have equal access to everything, that slipping between identities is a birthright."[14] And yet there is something awry in Greene's portraits as she obscures her African ancestry through the turn of her head—she is frequently photographed in profile—stylized clothing, and studio backdrops. It is impossible to imagine the life of a young woman such as Greene in the early twentieth century yearning to "be-come." She masked not only her race but also her age, suggesting she was years younger than her actual age.[15]

Cultural historian Alan Trachtenberg argues that the rise of photography to a position of social text is significant in reading images today. "Consisting of images rather than words," he writes, "photography places its own constraints on interpretation, requiring that photographers invent new forms of presentation of collaboration between images and text, between artist and audience."[16] Imagine Belle Greene's challenges in constructing a narrative for each sitting: how she might have considered creating a hairstyle like the American New Woman, the Gibson Girl, or a hat designed in Paris; and how she masked the veil of vulnerability when she was also described as the "Lady Directress," "lady dictator," and "czarina of the library."[17]

PASSING ON

"Passing may now be seen as an unnecessary, outdated strategy," according to contemporary scholar Sterling Lecater Bland. "But in a broader historical context, it has been seen as an act of survival, necessity, and even rebellion. Nevertheless, the decision of racially ambiguous men and women to pass—and particularly to pass as white—exposes the paradox and contradiction of race in America and the ways it has changed over time."[18] While Greene's portraits link the history of portraiture to identity and fashion in the early part of the twentieth century, they offer different narratives over a period of time. As cultural historian Stuart Hall points out,

> It may be true that the self is always, in a sense, a fiction, just as the kinds of 'closure' which are required to create communities of identification—nation, ethnic group, families, sexualities, etc.—are arbitrary closures.... I believe it is an immensely important gain when one recognizes that all identity is constructed across difference and begins to live with the politics of difference.[19]

Belle Greene was the New Woman at the beginning of a New Century. "Belle da Costa Greene" is a construct, from the name change to the process of denying her race in order to achieve the life of her dreams to the posing of her camera portraits. Her portraits become a keynote to her unfinished story. On the one hand, she appears fully present, powerful, and feminine. On the other, the study of Greene offers a perplexing dilemma in portraiture that reflects in photography the novelist Richard Wright's characterization, "We are not what we seem."[20] Greene's self-conscious images portrayed the possibilities of a dream realized through the denial of race and the loss of identity. Her aspirations helped her to construct an identity shaped by silence and visualized by her surviving portraits. These images were important to Greene. She destroyed her personal letters before her death but some of the photographs were preserved by Berenson and she kept others, now held at the Morgan. As a result, through photography we are able to see the emergence of an amazing woman who, subject to public disapproval of her African ancestry, lived and worked in troubling times in the United States.

NOTES

1. Nella Larsen, *Passing* (New York: Alfred A. Knopf, 1929), 97.

2. Other notable photographic portraits of Greene are held by the Princeton University Art Museum and I Tatti, the Harvard University Center for Italian Renaissance Studies.

3. Greene, quoted in Heidi Ardizzone, *An Illuminated Life: Belle da Costa Greene's Journey from Prejudice to Privilege* (New York: W. W. Norton, 2007), 94.

4. Anne McCauley, "The Photo-Secession and the Paradox of Pictorialist Commercial Photography, 1904–1912," in *Clarence H. White and His World: The Art and Craft of Photography, 1895–1925*, exh. cat. (Princeton, NJ: Princeton University Press, 2017), 116.

5. Ardizzone, *Illuminated Life*, 265.

6. Maria Morris Hambourg, in Hambourg et al., *The Waking Dream: Photography's First Century; Selections from the Gilman Paper Company Collection*, exh. cat. (New York: The Metropolitan Museum of Art, 1993), 225.

7. There are several comments in Greene's letters to Berenson about the photographic portraits she sent him over the years. In 1909 she describes a set of presumably now-lost images as "photographs of my bacchanalian self" (Greene to Berenson, June 21, 1909, Bernard and Mary Berenson Papers, Box 60, Folder 3, Biblioteca Berenson, I Tatti, the Harvard University Center for Italian Renaissance Studies). A year later she remarks on an image that may be the 1910 photograph by Histed: "I am sending you a 'real' photograph such as you demand today—It may look rather sad for the simple reason that I was thinking of you all the time it was being taken" (Greene to Berenson, June 9, 1910, Berenson Papers, Box 60, Folder 7). In 1912 Greene is elated that Berenson likes a set of photographs she sent him, probably referring to the Clarence White photographs taken in 1911, which includes one of her smoking: "I am so glad, you beloved you, that you liked the photographs—As you say, they are mine own self, poor, indifferent and bad—I hope the smoking one particularly appealed to you" (Greene to Berenson, January 9, 1912, Berenson Papers, Box 60, Folder 22). In 1911–12 she probably comments on photographs of her taken by Marceau and De Meyer, in both cases telling Berenson he should destroy them if they are not to his liking (Greene to Berenson, May 22–25, 1911, and February 6, 1912, Berenson Papers, Box 60, Folder 18, and Box 60, Folder 22, respectively).

8. Ardizzone, *Illuminated Life*, 264.

9. Ibid., 94.

10. Ibid., 95.

11. John Pultz, *The Body and the Lens: Photography, 1839 to the Present* (New York: Abrams, 1995), 78.

12. Ibid., 10.

13. Ibid., 11.

14. Cherise Smith, *Enacting Others: Politics of Identity in Eleanor Antin, Nikki S. Lee, Adrian Piper, and Anna Deveare Smith* (Durham, NC: Duke University Press, 2011), xi.

15. In their biographical entry on Greene in *Notable American Women*, Dorothy Miner and Anne Lyon Haight listed Belle Greene's year of birth as 1883. See Dorothy Miner and Anne Lyon Haight, "Greene, Belle da Costa," in *Notable American Women, 1607–1950* (Cambridge, MA: Belknap Press, 1971), 2:83. Alternatively, a personal questionnaire in Greene's hand, dated April 1940, lists her year of birth as 1886 (Archives of the Morgan Library & Museum, ARC 3291, Box 96, Folder 6). Heidi Ardizzone documents several other instances of Greene falsifying her age, including for customs agents and the US Census. See Ardizzone, *Illuminated Life*, 71, 384, 423.

16. Alan Trachtenberg, *Reading American Photographs: Images as History; Mathew Brady to Walker Evans* (New York: Noonday, 1989), xvi.

17. Ardizzone, *Illuminated Life*, 426, 400.

18. Sterling Lecater Bland Jr., "The Secret Life Within: Race, Imagination, and America in Nella Larsen's *Passing*," *South Atlantic Review* 84, no. 2–3 (2019): 55 ff.

19. Stuart Hall, "Minimal Lives," in *Black British Cultural Studies: A Reader*, ed. Houston A. Baker Jr., Manthia Diawara, and Ruth H. Lindeborg (Chicago: University of Chicago Press, 1996), 117.

20. Richard Wright and Edwin Rosskam, *12 Million Black Voices* (New York: Basic Books, 2008), 10.

Alfred Launder, Bookbinding originally housing the earliest surviving fragment of Edgar Allan Poe's "The Raven," early twentieth century. The Morgan Library & Museum, New York, purchased by J. Pierpont Morgan, 1909; MA 621A.

Philip S. Palmer
and Deborah Parker

BELLE GREENE AND LITERATURE

In January 1915 Belle Greene listed her six favorite books in a letter to her friend, the connoisseur Bernard Berenson (fig. 1):

> I have spent all my free minutes before going to sleep, rereading my beloved "Mille Nuits"—isn't it too adorable? I have also been reading Rabelais (in English) and the Apochrypha [sic]—Lordy how I have howled with laughter until I ached from it later—I think if I were to choose my six favorite books (and were limited to that number) I'd take Alice in Wonderland, the Bible, the Mille Nuits, Rabelais, the Apocrypha, the Miracle Plays, Casanova—oh! dear I'm only just beginning and there's 7 already except that the Apocrypha will go in with the Bible so my six indispensables are there anyhow—now what would you choose?[1]

Limiting herself to naming only six works makes the librarian giddy. Her romance with books was extensive.[2] While Greene's professional correspondence abounds with references to manuscripts and rare incunabula, her personal correspondence reveals affinities of a different order. In Greene's letters to Berenson, himself an avid reader, we find citations from poems, titles of works she is reading, plays she has seen, and assessments of a wide range of authors. She read canonical authors—Dante, Baudelaire, Rabelais—as well as many contemporary authors including Joseph Conrad, William James, Fyodor Dostoevsky, Anatole France, H. G. Wells, Gertrude Stein, Ronald Firbank, Gertrude Atherton, John Davidson, and Fiona Macleod. While poetry remained

a favorite genre, during the First World War Greene read books on German politics and history, and with the rise of Freud's theories, a number of psychological studies. In all there are more than 125 distinct literary references in her nearly six hundred letters to Berenson.

Greene's literary allusions encapsulate her sentiments, register aesthetic affinities, and, in her most intriguing references, reveal her identifications with literary characters. In such instances, Greene projects herself into the works, demonstrating in the process her imaginative capacities. After meeting Greene in January 1909—an encounter that was electric for both—Berenson sent her a sixteen-volume French translation of *The Thousand and One Nights*.³ This gift was freighted with meaning as one of his favorite works, which Berenson had read in English translation as a boy and in Arabic while an undergraduate at Harvard.⁴

FIG. 1
Bernard Berenson holding a photograph of an artwork, ca. 1909. Photographic print; 8 3/16 × 6 3/16 in. (20.8 × 15.8 cm). Biblioteca Berenson, I Tatti, the Harvard University Center for Italian Renaissance Studies; Bernard and Mary Berenson Papers, Personal Photographs, Box 2, Folder 1.

FIG. 2
Belle da Costa Greene (1879–1950), Autograph letter to Bernard Berenson, April 9, 1909. Biblioteca Berenson, I Tatti, the Harvard University Center for Italian Renaissance Studies; Bernard and Mary Berenson Papers, Box 60, Folder 2.

Sending Greene a work famed for its erotic elements was a message in itself. How many nights would pass before they saw one another again?

Greene's letter of April 9, 1909 (fig. 2), reveals the extent to which she could project herself into a work and the nature of her literary imaginings.

> I have this moment received the Mille et une Nuits—all sixteen volumes—and I am so excited by the mere joy of possessing them. I was all alone in My library when they arrived and I sat right down on the floor with all I could hold in my lap & the rest around me on the floor—I am impatient to read them especially one which I just glanced at "La tendre histoire du Prince Jasmin et de la Princesse Amande"—I opened to these lines "et le Prince Jasmin exerças extérieurement la profession de berger, et intérieurement il s'occupait d'amour" ["and outwardly Prince Jasmin appeared to be a shepherd, and internally he was taken up with love"]. It fitted my case so perfectly that I could hardly bring myself back to the everyday workaday world. Et exercer extérieurement (au moins!) la profession de bibliothécaire ["And exercise outwardly (at least!) the profession of librarian"]—but I immediately went to the phone and broke a theatre engagement... and instead I shall dine quietly at home—put on my most comfortable peignoir and go off into "les nuits enchantés" [sic; "the enchanted nights"]. I shall take you with me and we won't come back at all—never.[5]

The immediacy of this rapturous response pops off the page. Reveling in his gift, Greene fashions herself as a kind of Scheherazade. One story in particular speaks to her. Just as Prince Jasmin embodies a double life, outwardly appearing a shepherd and inwardly harboring love, so does Greene. Outwardly a librarian, she is aflame with love within. Weaving her own fantasy, she sweeps Berenson and herself into an enchanted world. This is a performance replete with costume—Greene attired in a peignoir.

Greene's references to another work, Dante's *Vita Nuova*, exemplify further her capacity for entering into works imaginatively—her romance with books. Berenson had told Greene that Dante's love for Beatrice typified his love for her. After his departure, she takes up "our Dante" to ponder the next stage of their relationship. Greene visited Berenson at his hotel in New York before he returned to Italy. Although on the verge of yielding, she did not wish to take so momentous a step on the eve of his departure. She quotes Dante to communicate this message in another letter from April 1909.

> Dear, I wish I could put into words my feeling for you—you must be patient with me, if I do not—at once—give you all— but it is so sudden a thing—this invasion which you have made of my life and heart—and (don't misunderstand) it does not often always seem real and yet. I feel—as our beloved Dante says "I have reached that point in life—beyond which, if passed, there is no possibility of return—but—shall I pass it?"[6]

Dante writes these lines to convey his devotion to Beatrice. Greene adroitly repurposes them to indicate that she is on the brink of passing beyond a point of no return—of becoming Berenson's lover. In essence, she employs literary quotations to aestheticize her ardor. Elsewhere in the letter she cites another passage from the *Vita Nuova* to urge Berenson to write her often—"remember what our dear Dante says of love 'through speech of Thee alone doth he survive.'"[7] Berenson, she hopes, will conjure himself through his words, making his absence present—and he did, writing her nearly every day in the first years of their ardent romance.[8]

The centrality of the *Vita Nuova* in fostering Greene and Berenson's romance is evident from her response to another gift. In a June 1909 letter she acknowledges her receipt of the "greatest joy of all the Vita Nuova—a most enchanting edition with the Italian text and the English of Rossetti—How dear of you to send it to me—how I love you for all your thought for me."[9] This "enchanting edition" would have appealed to Greene's love of medieval culture. Rossetti, one of the leading Pre-Raphaelites, spent more than thirty years working and refining his translation of the *Vita Nuova* and the poetry of Dante's contemporaries. First published in 1861, *The Early Italian Poets: From Ciullo d'Alcamo to Dante Alighieri (1100-1200-1300) in the Original Metres, Together with Dante's Vita Nuova* exemplifies the Pre-Raphaelites' fascination with medieval culture. At the end of Belle's letter

of April 6, 1909, she ponders the effect of a long separation: "Is this truly a Vita Nuova for both of us—or only for me?"[10]

A year and a half later the two did embark on a new life. Belle reunited with Bernard and the two traveled to London, Paris, Munich, and several Italian towns. Before they reconnected, however, Greene strengthened their bond to the *Vita Nuova* by sending him the first Italian edition as a Christmas gift: "I mailed you my copy of the Vita Nuova for a little Christmas gift I wanted <u>so</u> much for you to have something that <u>I</u> had owned & that we both loved & that was all I could think of. You will find an <u>incorrect</u> note on the fly leaf that I made in a hasty moment. The book I sent you is <u>the editio princeps</u> & the note refers <u>not</u> to Dante's Vita Nuova but to Boccaccio's Life of Dante. I hope you will like it as it was one of my treasures" (fig. 3).[11]

The cultural references in Greene's notes are often revealing. Greene's letter refers to the "editio princeps." Wouldn't Berenson have kept such a "trea-

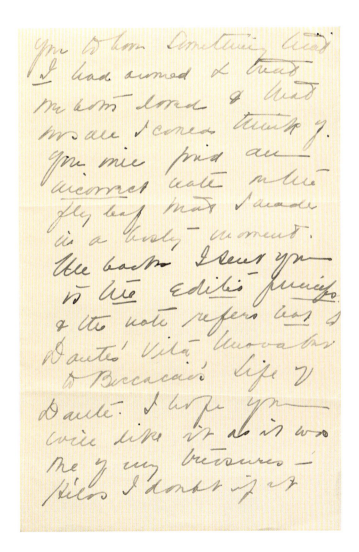

FIG. 3
Belle da Costa Greene (1879–1950), Autograph letter to Bernard Berenson, December 21, 1909. Biblioteca Berenson, I Tatti, the Harvard University Center for Italian Renaissance Studies; Bernard and Mary Berenson Papers, Box 60, Folder 5.

sure"? Some sleuthing, aided by librarians at the Morgan Library and I Tatti, revealed a likely candidate among the Dante holdings at Houghton, Harvard's rare book library. Information on the catalogue entry for one stood out—"from the library of Bernard Berenson"—as did the partial transcription of a note on the flyleaf: "To Philip Hofer as a memento from B.B's personal library, from Nicky [Mariano]."[12]

A scan of the entire flyleaf shows Greene's signature and her initialed comments (fig. 4):

> Belle da Costa Greene
> 12 October 1909
> First printed in the "Divina Comedia" of Vindelin de Spira 1477—First separate issue at Rome by "Francesco Priscianese fiorentino" in 1544. This is second edition (1576).
> B.G.

FIG. 4
Flyleaf showing Belle da Costa Greene's signature and inscription. Dante Alighieri (1265–1331), *Vita nuova di Dante Alighieri* (Firenze: Stamperia di B. Sermartelli, 1576). Houghton Library, Harvard University; Typ 525.76.316.

This book, Bartolomeo Sermatelli's 1576 edition of the *Vita Nuova*, was indeed the copy Greene had sent Berenson.[13] The librarian here supersedes the lover. Greene frequently wrote notices on books she acquired for the Morgan Library, and in this case she reports that the Sermatelli edition is not the first printing of Boccaccio's *Life of Dante*.

The more we know about Greene's references to books and works of art, the more we learn about her personal affinities and the social world that informs them. Prominent contemporaries also showed an interest in the *Vita Nuova*: Edith Wharton mentions the book to romanticize her relationship with Morton Fullerton in her diary, and Isabella Stewart Gardner's relationship with Francis Marion Crawford prompted her to commission an ornate Tiffany binding for an edition of Dante she owned.[14] Charles Eliot Norton, professor of art at Harvard, nourished each of these women's interest in Dante. Greene's and Berenson's admiration for Dante, then, is part of a wider nineteenth- and early twentieth-century fascination with the author's youthful work.

If books spoke to Belle Greene, this particular book could be said to speak more completely through two different archival artifacts—one bibliographical, what's written on the flyleaf, and one personal, Greene's December 1909 letter to Berenson. The fuller picture, its role in Berenson and Greene's love story, emerges only when seen against the broader context of Greene's other allusions to Dante in her correspondence. Each allusion to the *Vita Nuova* enhances our understanding of the way in which this work functioned as a go-between in the early stages of their relationship—not unlike the way in which Francesca describes the role played by the Lancelot romance in Canto 5 of *Inferno*.

The cultural references in Greene's letters are part of what amounts to a performance of her likes and dislikes. Of course, such staginess leads to the stage itself. While Greene's multiple references to the *Vita Nuova* and *The Thousand and One Nights* offer ready grist for interpretive mills, brief allusions can also yield insights. In a May 1921 letter Greene refers to a Broadway performance of Eugene O'Neill's *The Emperor Jones* she has recently seen, noting that the central role was played by "a real (New York) darky—and amazingly well done—really magnificent acting."[15] Greene's slur stands out, a comment all the more disruptive given that she herself was Black. The actor whose performance she praises is Charles Sidney Gilpin, the first Black actor to appear on Broadway, whose acting was widely praised in contemporary reviews of the play (fig. 5).[16] Greene's observation attests to the contradictory and ambiguous nature of her comments on race.

FIG. 5
Francis Bruguière (1879–1945), *Charles Sidney Gilpin in "The Emperor Jones,"* 1920. *Theatre Magazine* 33 (January–June 1921).

A book Greene read and owned also complicates her perspective on race. One of the books from her library, given to the Hroswitha Club by the Morgan in 1954 and then donated back to the Morgan in 1984, is Ronald Firbank's *Prancing Nigger* (1924; ARC 653). Firbank was an experimental British novelist who owed as much to Oscar Wilde's literary influence as to the comedic novels and plays of the eighteenth century.[17] First published in Britain as *Sorrow in Sunlight*, Firbank's 1924 novel came to the United States through the influence of Carl Van Vechten, who wrote the introduction to the American edition and suggested the change in title.[18] The novel is set in the West Indies and follows the life of the socially aspirant Mouth family, who speak in a phonetically spelled dialect that certainly appears racist and offensive by today's standards. The novel was popular in America and even received praise from writers like W. E. B. Du Bois, who encouraged readers to "forget its title . . . and look upon Mr. Firbanks [*sic*] as an artist and not a nordic propagandist."[19] For Van Vechten, "Firbank's treatment of the Negro is his own."[20]

Belle Greene read Firbank's novel the year it was published. Writing to Berenson in April 1924, she recommends he read three of her "pet books": "Speaking of mundane matters, have you read my three pet books. The Flower beneath the foot—Prancing Nigger and Jurgen (unexpurgated!)?? You must— at once—."[21] Her copy of the novel, preserved in the Morgan Archives, bears the pencil inscription "It's Mine" scrawled in large letters that take up much of the flyleaf, with her signature written in cursive below. From these two slight pieces of evidence—in addition to the fact that the pages are cut all the way through the volume—one can safely assume that Belle Greene read (and enjoyed) the book. Such an interest in modern literature aligns with her patterns of reading, which included both historical and contemporary works, and the novel may have appealed to her because of the connection to Van Vechten, whom she seems to have known through her social circles.[22]

The inscription "It's Mine" remains curious, as she did not inscribe any of her other books in this manner. How are we to read it? Is it simply a statement of enthusiastic ownership of a book she particularly loved? Or does it tacitly register her affinity with the themes and characters of the novel? These characters move from the country to the city for education and advancement into "society," and Greene perhaps could relate to this upwardly mobile trajectory. Going further, can one read the inscription as an oblique emotional response to racial passing, perhaps capturing Greene's feelings of guilt or shame? Is she "owning" her Blackness with this inscription, or, conversely, affirming her whiteness? Regardless of how one reads the inscription, Greene's partiality to a novel with this title, being a Black woman herself, is difficult for modern readers to understand. But as with the slur she used to describe Charles Sidney Gilpin, Greene at times clearly appropriated the racist tropes of white America while simultaneously appreciating creative work by or related to Black people. That she lived

this seeming contradiction is one of the many aspects of her life and character that make her endlessly complex, flawed, and, above all, human.

Greene's literary references are not made in a vacuum. One might begin by contextualizing her literary allusions. Yet little effort has been made to explore the social world which informs them. Further investigations would enrich our understanding of Greene's multifaceted interests. Like many nineteenth- and twentieth-century epistolary writers, Belle Greene had a lively style full of allusions to art and literature. The more we look into these references the better we will see and understand not just the nature of her predilections but the richness of her singular life.

Belle Greene's avid reading of literature undoubtedly inspired her acquisition of literary manuscripts for the Morgan Library. J. Pierpont Morgan himself began collecting in this area around 1890, when he purchased the manuscript of Charles Dickens and Wilkie Collins's collaborative play *The Frozen Deep* (1856; MA 81.10).[23] Over the next two decades he would add to the collection an impressive group of British and American writers' manuscripts, including Henry David Thoreau's *Journal*, Charles Dickens's *A Christmas Carol*, John Milton's *Paradise Lost*, Anne Brontë's *Poems*, Lord Byron's *Don Juan*, and Oscar Wilde's *The Picture of Dorian Gray*.

Accounts of Belle da Costa Greene's interest in incunabula and medieval illuminated manuscripts have typically overshadowed the story of her work to develop the Morgan's collection of literary manuscripts. But she was acquiring in this area from an early date and continued to build these holdings until a year before her retirement. Her first major acquisition can be dated to the spring of 1909, when she negotiated the purchase of the earliest known manuscript fragment of one of the great poems in American literature, Edgar Allan Poe's "The Raven" (MA 621; fig. 6). As she mentions casually to Bernard Berenson, "This morning I spent some of my bosses' [sic] hard-earned money in buying part of the original manuscript of Poe's Raven."[24] She describes this acquisition more thoroughly in a now-lost letter to Pierpont:

> I also bought the only existing ms. of the Raven by Poe. The ms. consists of a letter to Poe's friend Shea—enclosing the eleventh stanza of the famous poem and corrections for the 10th stanza. I think it one of the most important items in Amer. lit. and as it is almost certain that the main draft of the poem was destroyed in the printing office of the Whig Review.... I felt that this belonged with your other Poe mss. It was offered by Hellman for $2500—I bought it at $1500. I have bought other books to fill gaps—one aim is to make the Library preeminent, especially for incunabula, manuscripts, bindings, and the classics. Our only rivals are the British Museum and the Bibliothèque Nationale. I hope to be able to say some day that there is neither rival nor equal.[25]

This passage reveals so much: Greene's deep knowledge of the collection less than four years into the job, her shrewd negotiating skills, and, most importantly, her vision for the library's future. She not only recognized an opportunity to add a "high-spot" item to Morgan's collection of exemplary manuscripts, but also had the wherewithal to obtain it at an advantageous price. In this passage she also articulates an early acquisitions policy: Greene is "filling gaps" and checking items off her list of desiderata while also keeping an eye on the future, hoping one day to develop Morgan's library into a collection of international regard.[26]

The binding in which the Poe manuscript was once bound even bears Greene's penciled research notes, indicating her ongoing work on the manuscript after its acquisition (p. 100). In fact, she later learns of a complete autograph manuscript of "The Raven," now in Philadelphia, and corrects her earlier statement that the fragment was the only extant manuscript of the poem.[27] These handwritten notes, as her successor Frederick Adams described them, comprise "a continuous, living record of the growth of knowledge," and in this case document how Greene updated older assumptions with new research.[28]

British women writers were of great interest to both the Morgans and Belle Greene. Jack built on his father's acquisition of manuscripts created by the Brontë sisters through his purchase of several important Jane Austen collections, including forty-one letters to her sister, Cassandra, formerly in the Alfred Morrison collection.[29] Greene seems to have had an interest in the British poet Elizabeth Barrett Browning, who is best known for her cycle of forty-four poems titled *Sonnets from the Portuguese* (1850). In one of her letters to Berenson, Greene quotes a portion of Sonnet XXIX from memory.[30]

FIG. 6
The earliest surviving fragment of "The Raven." Edgar Allan Poe (1809–1849), Autograph letter to John Augustus Shea, February 3, 1845. The Morgan Library & Museum, New York, purchased by J. Pierpont Morgan, 1909; MA 621.

There are details of Barrett Browning's life and work that are fascinating and provocative to consider in light of Belle Greene's interest in her. "From the Portuguese" in the sonnet sequence's title, while certainly referencing the fiction of the poems' translation, also playfully calls to mind the nickname Elizabeth's husband and fellow poet Robert called her—"my little Portuguese." The nickname purportedly arose from Elizabeth Barrett Browning's dark skin, eyes, and hair.[31] As has been well established, Greene used a fiction of Portuguese heritage, along with the middle name "da Costa," to explain her own dark complexion and mask her Black ancestry.[32] Though there is no direct evidence to suggest Greene was attracted to *Sonnets from the Portuguese* for this reason, the parallel is tantalizing and underscores the connection between Southern European identities and racial passing for white.[33] A further provocation of Greene's interest in Elizabeth Barrett Browning lies in the source of the Browning and Barrett families' wealth, namely plantations in the West Indies that exploited the labor of enslaved individuals.[34] It is unknown if Greene would have been aware of this detail.

Several Elizabeth Barrett and Robert Browning manuscripts came on the market in 1913, not long after Pierpont Morgan's death, at a Sotheby's auction of the property of their only son, who had died intestate.[35] Around the time of the sale, when Jack Morgan was cautious about new purchases, Greene wrote to Bernard Berenson and explained why most of the manuscript material did not pique her interest:

> now you know that as far as author's mss. are concerned I am cold-blooded and indifferent[.] I never could see the point or value of buying an original manuscript which was what we call a fair copy—and differed in no way from the printed version—if they were to be had cheap—I would not mind so much—but you know what prices they bring! I am eager to get the first draft of a book or poem in [manuscript]—and note the differences— the growth of the idea—or the betterment of the expression—that, it seems to me is worthwhile, but to pay thousands of dollars for a [manuscript] that is after all, but a written copy of the printed book never appealed to me.[36]

Out of all of Greene's correspondence and writings, this passage contains the most revealing description of her rationale for acquiring literary manuscripts. Greene's perspective may seem obvious, but at a time when the handwriting of literary manuscripts themselves (and their aesthetic appearance) was sometimes privileged more than their historical and textual value, this view was ahead of its time. Pierpont Morgan collected many nineteenth-century literary manuscripts, for instance, that might be described as "but a written copy of the printed book." Greene's focus on the way manuscripts can reveal the creative process—"the growth of the idea—or the betterment of the expression"—seems to have been a guiding principle in her efforts at collection development.

In the letter to Berenson, Greene proceeds to describe how Jack Morgan had a chance to buy one of the several *Sonnets from the Portuguese* manuscripts that had sold at the 1913 auction. The bookseller (and successful bidder) Bernard Alfred Quaritch offered one of these manuscripts to Jack, but in the end he balked at the price and declined the offer. The manuscript was purchased by another private collector and is now preserved at Baylor University.[37] This manuscript, which only contains very slight revisions and was substantively identical to the printed edition (it was used as printer's copy), probably did not appeal that strongly to Greene.

Later, in 1917, she had the chance to purchase a much more interesting draft of *Sonnets from the Portuguese* (MA 933)—the earliest extant manuscript copy—also sold at the 1913 sale.[38] The manuscript, a fair copy with significant revisions in Barrett Browning's hand, was originally bound in a sumptuous gold-tooled binding by Dawson & Lewis, with the front cover promising "the loveliest sonnets in the English language" (fig. 7). The manuscript itself was mounted on larger album leaves, as was customary with finely bound manuscripts in the early twentieth century, though they were removed at an unspecified time for separate storage. (Such album leaves can be acidic and pose conservation problems for the mounted original manuscripts.)

FIG. 7
Dawson & Lewis, Bookbinding originally housing the *Sonnets from the Portuguese* manuscript. The Morgan Library & Museum, New York, purchased by J. P. Morgan Jr., 1917; MA 933.3-28A.

The album leaves, however, comprise an important body of evidence for how Greene researched this particular object. When the original manuscript is placed on top of these album leaves, Greene's penciled commentary in the margins can be physically matched up to lines of poetry in Browning's original (fig. 8). Greene's notes record variant readings of certain words in the sonnets; in other words, these notes are textual annotations, the product of her labors to collate the manuscript against the first printed edition of *Sonnets from the Portuguese*. Contrary to the standard narrative that Greene's expertise lay primarily in illuminated manuscripts and fifteenth-century printed books, here she is conducting a detailed textual and bibliographical study of nineteenth-century British literature. The changes wrought upon this text as it progressed from manuscript to printed book, so meticulously

documented by Greene in her annotations, align with her stated interest in the nature of draft manuscripts, which, as she described to Berenson, evocatively capture "the differences, the growth of an idea, or the betterment of the expression."

Eight years later Greene would acquire a manuscript that is perhaps the greatest embodiment of this curatorial ethos. In the first report she submitted to the Board of Trustees of the newly formed Pierpont Morgan Library, Greene singles out the draft manuscript of the French novelist Honoré de Balzac's *Eugénie Grandet* (1834; MA 1036), acquired in 1925. As she notes, "From the point of view of rarity alone, it is the most important autograph manuscript acquired by the Library during the 20 years of my connection with it. No other Balzac manuscript has ever come to America, nor is any known outside of the Balzac Museum at Chantilly, France."[39] *Eugénie Grandet* is one of the earliest novels in Balzac's larger literary project, known as *La Comédie Humaine*, and is recognized as one of his greatest works (fig. 9).[40]

This remarkable object combines 114 pages of manuscript with forty-one pages of heavily revised printed proofs. Many pages are voluminously corrected and annotated, with the crowded margins extended in some cases by small pieces of paper affixed to the main leaf. The manuscript held great personal importance for the novelist, who presented it as a gift to his beloved, Ewelina Hańska, a Polish countess whom he would marry in 1850. After her death in 1882 the manuscript was sold at auction and passed through the hands of a private collector and several dealers before it was sold to the New York bookseller Gabriel Wells in December 1925.[41] That same month, exactly ninety-two years to the day after Balzac gave the manuscript to Hańska, an employee of Gabriel Wells, William H. Royce, delivered the manuscript to Belle Greene at the Pierpont Morgan Library, where it was purchased for $9,600.[42]

A year before Belle Greene's death the Pierpont Morgan Library put on an exhibition in her honor, featuring the most celebrated acquisitions of the last twenty-five years. *Eugénie Grandet* was singled out among the literary manuscripts, as well as Charles Dickens's *Our Mutual Friend* (MA 1202–1203), purchased by Greene in 1944.

FIG. 8
The manuscript of Browning's Sonnet XX laid atop the sheets of its original binding, with Belle da Costa Greene's notes in the margins. Elizabeth Barrett Browning (1806–1861), *Sonnets from the Portuguese*, autograph manuscript of Sonnet XX, ca. 1845–50. The Morgan Library & Museum, New York, purchased by J. P. Morgan Jr., 1917; MA 933.20.

As the only manuscript of a full-length Dickens novel held outside of Britain, *Our Mutual Friend* was an important late acquisition for Greene, joining the only complete manuscript of any of Jane Austen's novels—*Lady Susan* (MA 1226)—also acquired by her, in 1947. From the very beginning of her career Belle da Costa Greene took a keen interest in building the literary collections formed by Pierpont and Jack Morgan, and she continued that work until just a few years before her death in 1950.

FIG. 9
Honoré de Balzac (1799–1850), *Eugénie Grandet*, autograph manuscript, 1833. The Morgan Library & Museum, New York, purchased by J. P. Morgan Jr., 1925; MA 1036.

NOTES

1
Greene to Bernard Berenson, January 29, 1915, Bernard and Mary Berenson Papers, Box 62, Folder 11, Biblioteca Berenson, I Tatti, the Harvard University Center for Italian Renaissance Studies. All transcriptions of Greene's letters are by Philip Palmer and Deborah Parker.

2
Christopher de Hamel comments on manuscripts a twelve-year-old Greene might have seen. See *The Posthumous Papers of the Manuscripts Club* (London: Allen Lane, 2022), 467.

3
This is likely the edition translated by Joseph-Charles Mardrus: *Le Livre des Mille Nuits et Une Nuit* (Paris: Charpentier, 1904), published in sixteen volumes. Greene's copy has not been located.

4
On the significance of *The Thousand and One Nights* for Berenson, see Ernest Samuels, *Bernard Berenson: The Making of a Connoisseur* (Cambridge, MA: Belknap Press, 1979), 31.

5
Greene to Berenson, April 9, 1909, Berenson Papers, Box 60, Folder 2.

6
Greene to Berenson, April 6, 1909, Berenson Papers, Box 60, Folder 2. Greene's Dante citations are from Frances de Mey's 1902 translation of the *Vita Nuova* (London: G. Bell & Sons, 1902), 31. On this translation and the book's artful format, see Federica Coluzzi, "The *Vita nova* in the Victorian *Fin de Siècle*: Translations, Editions and Commentary, 1893–1906," in *The Afterlife of Dante's "Vita Nova" in the Anglophone World: Interdisciplinary Perspectives on Translation and Reception History*, ed. Coluzzi and Jacob Blakesley (Abingdon, UK: Routledge, 2022), 126–35.

7
Dante, *Vita Nuova*, 39.

8
Ernest Samuels, *Bernard Berenson: The Making of a Legend* (Cambridge, MA: Belknap Press, 1987), 541.

9
Greene to Berenson, June 21, 1909, Berenson Papers, Box 60, Folder 3.

10
Greene to Berenson, April 6, 1909, Berenson Papers, Box 60, Folder 2.

11
Greene to Berenson, December 21, 1909, Berenson Papers, Box 60, Folder 5.

12
The provenance of this book deserves fuller explanation: Greene gave Berenson a first edition of the *Vita Nuova* in December 1909; the book remained at I Tatti until October 1960, when, following Berenson's death, Nicky Mariano (I Tatti's first librarian) sent it to Philip Hofer, the first assistant director of the Morgan Library, who then bequeathed it to Harvard's Houghton Library after he became curator of printing and graphic arts at Houghton.

13
Among the books found in Greene's apartment after her death was the 1576 edition of the *Vita Nuova* (PML 45872), indicating that the work was dear to her and that she replaced the copy she gave to Berenson.

14
On Wharton's and Gardner's interest in the *Vita Nuova*, see Kathleen Verduin, "Edith Wharton, Adultery, and the Reception of Francesca da Rimini," in *Dante Studies*, no. 122 (2004): 95–136; and Verduin, "Fair Beatrice: The Vita Nuova in Nineteenth-Century America," in Coluzzi and Blakesley, *Afterlife of "Vita Nova*,*"* 60–75. On Gardner's Tiffany-decorated edition, see https://www.gardnermuseum.org/experience/collection/13374.

15
Greene to Berenson, May 10, 1921, Berenson Papers, Box 63, Folder 11.

16
Gilpin's life is the subject of the film *The Black Emperor of Broadway* (2020).

17
See Alan Hollinghurst, "I Often Laugh When I'm Alone: The Novels of Ronald Firbank," *Yale Review* 89, no. 2 (April 2001): 1–18.

18
Kate Hext, "Rethinking the Origins of Camp: The Queer Correspondence of Carl Van Vechten and Ronald Firbank," *Modernism/Modernity* 27, no. 1 (January 2020): 165. The title in some ways reflects the different perspectives on race in the US and UK. Firbank himself approved the new title but then attempted to change it back after publication. Van Vechten's 1926 novel *Nigger Heaven* met with considerable controversy over its title. See Hollinghurst, "I Often Laugh."

19
W. E. B. Du Bois, review of *Prancing Nigger*, 1924, W. E. B. Du Bois Papers (MS 312), Special Collections and University Archives, University of Massachusetts Amherst Libraries, https://credo.library.umass.edu/view/full/mums312-b228-i018.

20
Ronald Firbank, *Prancing Nigger* (New York: Brentano's, 1924), vi.

21
Greene to Berenson, April 9, 1924, Berenson Papers, Box 63, Folder 16.

22
Greene saw the Van Vechtens at a party held at I Tatti in 1910 (when Berenson was traveling elsewhere) and again at a restaurant in New York in 1914. Greene and Carl Van Vechten did not correspond, however, nor did he photograph her. Greene to Berenson, September 17, 1910, and March 4, 1914, Berenson Papers, Box 60, Folder 8; Box 61, Folder 15, respectively.

23
Pierpont's first important acquisition of a literary manuscript, however, was Sir Walter Scott's *Guy Mannering*, given to him by his father, Junius, in 1882 (MA 436–438). For more on Morgan's early collecting, see Colin B. Bailey and Daria Rose Foner, "J. Pierpont Morgan: Becoming a Bibliophile," in Bailey et al., *J. Pierpont Morgan's Library: Building the Bookman's Paradise*, exh. cat. (New York: Morgan Library & Museum; London: Scala, 2023), 17–61.

24
Greene to Berenson, April 23, 1909, Berenson Papers, Box 60, Folder 2.

25
Greene to J. Pierpont Morgan, April 23, 1909. Part of the letter is quoted in Jean Strouse, *Morgan: American Financier* (New York: Random House, 1999), 510. Strouse consulted this letter at the Morgan in the 1990s and quotes more extensively from it in her unprocessed research papers related to her biography, on deposit at the Morgan. The above quote is taken from her notes, and I am grateful to Jean for permission to quote from her papers. The letter disappeared from the Morgan's collection at some point in the 1990s. See also Heidi Ardizzone, *An Illuminated Life: Belle da Costa Greene's Journey from Prejudice to Privilege* (New York: W. W. Norton, 2007), 79–80 (where the letter's location is erroneously cited as I Tatti).

26
It is unknown what thoughts Greene may have had about Edgar Allan Poe's racism or his family's ownership and sale of enslaved individuals.

27
Free Library of Philadelphia, The Richard Gimbel Collection.

28
Frederick Adams, quoted in Lawrence C. Wroth, *The First Quarter Century of the Pierpont Morgan Library: A Retrospective Exhibition in Honor of Belle da Costa Greene*, exh. cat. (New York: Pierpont Morgan Library, 1949), 17.

29
For more on the provenance of these Jane Austen letters (MA 977.1–41), see Philip S. Palmer and Daria Rose Foner's forthcoming essay on "Autograph Manuscripts" in *Millionaire Shopping: The Collections of Alfred Morrison (1821–1897)*, ed. Caroline Dakers (London: University College London Press, 2024).

30
"Dearest 'my thoughts do turn about thee as the vine about the oak' by which you will perceive that I do not remember the Portugese [*sic*] Sonnets as well as I ought." Greene to Berenson, June 29, 1909, Berenson Papers, Box 60, Folder 3. Greene only partially misquotes the lines, which read, "my thoughts do twine and bud / About thee, as wild vines, about a tree" (ll. 1–2). Sandra Donaldson, ed.,

The Works of Elizabeth Barrett Browning (London: Pickering & Chatto, 2010), 2:467.

31
Fiona Sampson, *Two-Way Mirror: The Life of Elizabeth Barrett Browning* (New York: W. W. Norton, 2021), 32.

32
Ardizzone, *Illuminated Life*, 14, 84, 207; Strouse, *Morgan*, 509, 512.

33
In her study of legal challenges to racial identity, Ariela Gross recounts numerous examples of mixed-race individuals passing as Portuguese or assumed to be Portuguese. Ariela Gross, *What Blood Won't Tell: A History of Race on Trial in America* (Cambridge, MA: Harvard University Press, 2008), 63–70.

34
Rowena Fowler, "Browning and Slavery," *Victorian Poetry* 37, no. 1 (Spring 1999): 59; Sampson, *Two-Way Mirror*, 16–17, 29–31, 82–85.

35
The Browning Collections. Catalogue of Oil Paintings, Drawings & Prints; Autograph Letters and Manuscripts; Books . . . the Property of R. W. Barrett Browning, Esq. (London, 1913).

36
Greene to Berenson, May 9, 1913, Berenson Papers, Box 61, Folder 8.

37
D0876, Armstrong Browning Library, Baylor University.

38
According to Belle Greene's handwritten notes, the manuscript was purchased by the dealer Frank T. Sabin at the 1913 sale and was later acquired by Dodd, Mead & Co., from whom Jack Morgan purchased it in 1917.

39
"Report of the Director of The Pierpont Morgan Library for the Year ending December 31st, 1925," 3, Archives of the Morgan Library & Museum (hereafter "ARC").

40
The complete text of *Eugénie Grandet* was published in 1834 as part of Balzac's twelve-volume *Études de moeurs au XIXe siècle*, though the first chapter was published a year earlier in the periodical *L'Europe littéraire* (September 19, 1833).

41
Seymour de Ricci to Greene, January 28, 1926 (letter tipped into the back of MA 1036).

42
William H. Royce, "Additional Data Concerning the Provenance of the Manuscript of Balzac's Eugénie Grandet," autograph manuscript (New York, 1926), 8, Morgan Library & Museum Reference Collection, 912 B2e; receipt dated December 24, 1925, ARC 3291, Box 29, Folder 18.

Plates

**HIGHLIGHTS
OF BELLE
GREENE'S
ACQUISITIONS
FOR
THE MORGAN
LIBRARY**

INTRODUCTION

When Belle da Costa Greene retired from the Pierpont Morgan Library at the end of 1948, she had added 138 illuminated manuscripts, 596 incunabula, and more than seventeen thousand reference works to the library's collection, presented forty-six exhibitions, issued thirty-five publications, started a lecture series, and provided scholars with access to some of the world's most significant cultural artifacts.[1] These numbers don't include her work before being named director in 1924 or her collecting in areas such as autograph manuscripts or the Morgan's renowned collection of Rembrandt etchings.

In her work expanding the Morgan's collection, Greene's knowledge, eye, and shrewd negotiating skills are on full display. From the start of her career at the Library, she carefully added to the collection, not only meeting J. Pierpont Morgan's aspirations but anticipating the future of the institution

In this ledger book, acquisitions of medieval illuminated manuscripts were recorded in Belle Greene's handwriting.

Early accession book of medieval and Renaissance manuscripts, ca. 1900–1974. The Morgan Library & Museum, New York.

as well. Balancing the needs of the collection with the research interests of scholars, Greene's acquisitions tell the story of a librarian at the top of her field. In the catalogue for the 1949 *First Quarter Century* exhibition, which was staged in Greene's honor upon her retirement, librarian and historian Lawrence C. Wroth writes, "The books and manuscripts she bought for the library were acquired slowly, selectively, and with regard to the relationship of each one to the collection as a whole and to its separate parts. Any item she purchased for the Library must be a fitting addition and it must meet the threefold test imposed by her taste, knowledge, and austerity of purpose."[2]

The following selection of acquisitions only begins to represent her work in creating the Library collection we know today. Spanning the breadth of the early collection, these works are part of Greene's story and the legacy she left behind.
— Erica Ciallela

[1] Lawrence C. Wroth, "A Tribute to the Library and Its First Director," in *The First Quarter Century of the Pierpont Morgan Library: A Retrospective Exhibition in Honor of Belle da Costa Greene*, exh. cat. (New York: Pierpont Morgan Library, 1949), 9–29.

[2] Ibid., 15.

Belle Greene daringly traveled to England during the First World War and purchased this manuscript, one of the finest sets of biblical miniatures in existence, without the express permission of Jack Morgan. As she wrote in a letter to her boss after returning to New York, "If I had been able to stay here several weeks longer I know I could have bought every important manuscript in private hands in England."

Old Testament Miniatures, Paris, France, ca. 1244–54.
The Morgan Library & Museum, New York, purchased by
J. P. Morgan Jr., 1916; MS M.638, fols. 4v, 23v.

121 GREENE'S ACQUISITIONS

Belle Greene acquired the two manuscripts shown on this spread from the collection of Henry Yates Thompson, who famously kept his collection at exactly one hundred manuscripts; he sold off less choice volumes to maintain this number.

Mont-Saint-Michel Sacramentary, Mont-Saint-Michel, France, ca. 1060.
The Morgan Library & Museum, New York, purchased by J. P. Morgan Jr., 1919;
MS M.641, fols. 155v–156r.

This manuscript was made at the Italian abbey of Monte Cassino, destroyed during the Second World War. Belle Greene visited the abbey in the 1920s and befriended the Benedictine monk and medievalist scholar Dom Mauro Inguanes, afterward corresponding with him for many years and together bemoaning the fate of the abbey's destruction.

Usuard (d. 876 or 877), *Martyrology and Miscellaneous Texts*,
Italy, between 1075 and 1099. The Morgan Library & Museum, New York;
MS M.642, fols. 81v–82r.

When the British Museum could not raise sufficient funds for its acquisition, Belle Greene was able to secure this important English manuscript from the library of George Holford. It tells the story of the East Anglian King known as Edmund the Martyr (ca. 840–869) and is one of the earliest illustrated histories of an English saint.

Miscellany on the Life of St. Edmund, Bury St. Edmunds, England, ca. 1130.
The Morgan Library & Museum, New York, purchased by J. P. Morgan Jr., 1927;
MS M.736, fols. 17v–18r.

The two sumptuously illuminated manuscripts on this page spread were also acquired by Belle Greene from the library of George Holford in 1927.

Hours of François I, Tours, France, ca. 1515.
The Morgan Library & Museum, New York, purchased by J. P. Morgan Jr., 1927; MS M.732, fols. 31v–32r.

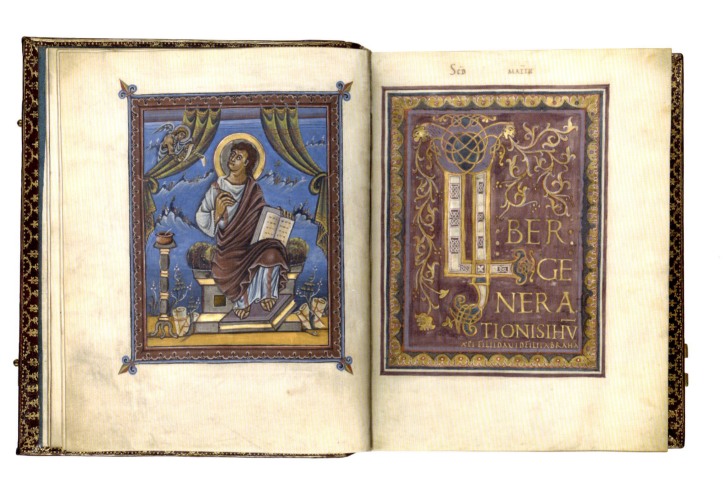

Gospel Book, Reims, France, ca. 870s.
The Morgan Library & Museum, New York, purchased, 1927;
MS M.728, fols. 14v–15r.

Belle Greene and the Morgans were interested in European history, collecting many documents from the reigns of various monarchs. Greene acquired this letter signed by Anne Boleyn, Henry VIII's second wife, in the middle of the Great Depression, when the Library had slowed down its purchases.

Anne Boleyn, Queen, consort of Henry VIII, King of England (1507–1536), Letter to the dean and canons of Exeter Cathedral, March 26, [1536]. The Morgan Library & Museum, New York, purchased, 1936; MA 1131.

By the time she entered high school Belle Greene had already studied elementary French and Latin. She would continue her French education, later interspersing her letters with French phrases and corresponding with French scholars. Her acquisition of a collection related to Robespierre reflects her own Francophilia and interest in French history, a passion she shared with J. Pierpont Morgan.

Jacques Louis David (1748–1825), *Maximilien Robespierre on the Day of His Execution*, eighteenth century. Graphite; 7¼ × 7⅞ in. (18.4 × 20 cm). The Morgan Library & Museum, New York, purchased, 1928; MA 1059.6.

Greene cherished the lyrics of British Romantic poets John Keats and Percy Bysshe Shelley, who were two of her favorite writers. She continued to build the Morgan's Keats collection and corresponded with researchers about his manuscripts, including the collector and poet Amy Lowell, who formed the great Keats holdings now at Harvard.

John Keats (1795–1821), "On First Looking into Chapman's Homer," autograph manuscript, n.d. [October 1816 or later]. The Morgan Library & Museum, New York, purchased by J. P. Morgan Jr., 1915; MA 214.3.

Late in her career Belle Greene built on the Dickens collection formed by J. Pierpont Morgan—headlined by the manuscript of *A Christmas Carol* (1843)—by acquiring the only manuscript of a full-length Dickens novel held in North America: the working draft of his late masterpiece *Our Mutual Friend*.

Charles Dickens (1812–1870), *Our Mutual Friend*, autograph manuscript, September 2, 1865. The Morgan Library & Museum, New York, purchased, 1944; MA 1202–1203.

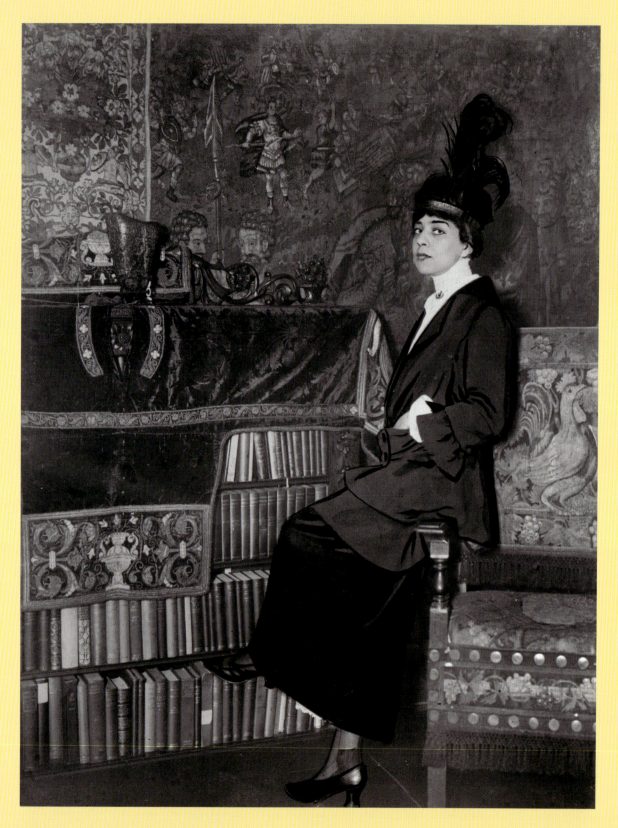

Paul Thompson (1878–1940), *Belle da Costa Greene, a Morgan librarian who is numbered among the women of the country, earning $25,000 a year*, ca. 1915. Photographic print of Greene in her home on East 40th Street, overpainted for newspaper reproduction.

Anne-Marie Eze

THE BALLAD OF BELLE DA COSTA GREENE:
LIBRARIAN AS MEDIEVALIST

Olive complexion
Green-eyed reflection
Proud, black lady, but maybe not in detection
Not cause neglection
We're talking early 1900's
Her mom chose to pass and kid took direction
Belle da Costa Greene
It's the queen librarian
Born Marion Greener,
but she went contrarian
See her father was Harvard educated and black
In fact, the first to get that stat
So better know that
But no Kodak needed for all of Richard's feats
Her mom was special too, Ms. Genevieve Fleet
Straight from DC where she married Mr. Richard
Love started flowing and Belle entered the picture
Before image fully formed, went their separate ways
Changed their last name and a new life was paved
And that path, was passing for white
Which lasted for life

> *If asking if right, don't judge, it was cause life was much easier if you aint gotta do it when black*
> *And Belle understood*
> *So she did just that*
> *Claimed a Portuguese background was for her stellar mind*
> *It also should be noted... Belle was kinda fine*
> *Gorgeous, but her brain's knowledge was more important*
> *Thus catching the attention of Mr. Junius Morgan*
> *There's more when you realized his uncle, JP, who lured her*
> *Out of Princeton's library to a job at his quarters*
> *It's JP Morgan*
> *So we're talking big time*
> *She illuminated,*
> *So we're talking big shine*
> *I don't mean to lecture*
> *But she was legendary, Pierpont Morgan Library's, First Director*
> *Expert in*
> *Illuminating manuscripts and bargaining prowess*
> *Million dollar negotiations*
> *She had the power*
> *Was given Jorge Ingles's painting up one early hour*
> *But she knew it was a fraud*
> *And for that we give applause*
> *She caught the Spanish Forger tricking folks for days*
> *But she was sharp though, and caught up on his ways*
> *Plus in 1939*
> *Situation got merrier*
> *Elected Fellow Medieval Academy of America*
> *The second woman and the first person of color*
> *Ms. Belle da Costa Greene / Unlike any other . . .*
> —Big Piph, "The Ballad of Belle da Costa Greene"[1]

INTRODUCTION

In 2018 Epiphany "Big Piph" Morrow rapped "The Ballad of Belle da Costa Greene" at "Celebrating Belle da Costa Greene: An Examination of Medievalists of Color within the Field," a conference held at Saint Louis University in Missouri. The ingenious lyrics of the emcee's hip-hop panegyric perfectly articulated the conference's central tenet, that Greene's "legacy highlights the professional difficulties faced by Medievalists of Color, the personal sacrifices they make in order to belong to the field, and their extraordinary contributions to Medieval Studies."[2] Greene's evolution as an important figure for a growing racially and ethnically diverse membership in the field of medieval studies is a development that would have been unfathomable to her and the six eminent medievalists—all white men—who nominated her for fellow of the Medieval Academy of America eighty years earlier, in 1938. This essay charts Belle da Costa Greene's formation as a medievalist, her contributions to medieval studies in the United States, and her evolving legacy from

respected librarian-scholar to revered patron saint of medievalists of color. In doing so it positions Greene center stage in a discipline where, due to her librarian status, she has been overlooked as a supporting actor in a cast of academic leads.[3]

TWO COMINGS OF AGE: MEDIEVAL STUDIES IN AMERICA AND GREENE'S CAREER

The 1870s are bookended by two seemingly unrelated events that are now recognized as milestones in the history of medieval studies in America. In 1870 Harvard professor Henry Adams became the first American academic to make the Middle Ages his domain by devoting his teaching to medieval history only. His patrician background and time spent in Europe obtained him a position for which he himself admitted to holding no qualifications.[4] In 1879 a baby girl named Belle Marion Greener was born into a well-educated Black family in Washington, DC. Her father was the first Black man to graduate from Harvard College, in the same year of Adams's appointment. These events converged in the new century when the same Black girl, now a young woman going by the name of Belle da Costa Greene and passing as white, was appointed librarian to powerful banker J. Pierpont Morgan. Greene would go on to defy her place ordained at birth among the lowest rungs of American society to transform the Pierpont Morgan Library into America's first important center for primary source research for medieval studies.

The 1920s witnessed two more milestones in the history of medieval studies in the United States, the incorporations of the Pierpont Morgan Library and the Medieval Academy of America in 1924 and 1925, respectively. This time, both were related to each other through a now mature Belle da Costa Greene. In 1924 J. P. "Jack" Morgan Jr. gave the Pierpont Morgan Library with its collections and an endowment to a Board of Trustees for the purpose of establishing a fitting memorial to his father, J. Pierpont Morgan, who had died in 1913. In March 1924 the Morgan Library was transformed from private collection to public educational institution with Greene as its first director. In December 1925, a group of men and one woman with a shared interest in medieval Latin and a desire to create a "rallying point for the cultivation and study of these Middle Ages" founded the Medieval Academy of America, finally giving medievalists in the United States a strong shared identity. The academy's aim was to promote and support research of all aspects of medieval culture.

The proximity of the two incorporations is no coincidence. Much had changed in the half century since the birth of medieval history as a distinct field of study in America and Greene's entrance into the world in the 1870s. The United States went from having few medievalist scholars of standing such as existed in Europe (except for in the realms of medieval literature and Romance languages) to around sixty medievalist academics at Harvard, Chicago, Columbia, Johns Hopkins, Wisconsin, Cornell, Yale, and elsewhere who devoted their graduate

teaching and research to the Middle Ages.⁵ They rubbed shoulders with wealthy private scholars whose interests were antiquarian and fueled by the romantic appeal of the period and search for aristocratic European lineage, which had already found expression decades earlier in American medievalism of the mid-1880s.⁶ Many of these early American medievalists were self-taught or had some formal graduate studies acquired from a period of European travel or university study, usually in Germany before the First World War, and in France and England afterward. The war profoundly changed the landscape of medieval studies in the United States. The conflict brought young Americans from a broader swath of society than ever before to Europe and in close contact with the continent's medieval past and, for many of them, their own ancestry. After the war, along with the great expansion in higher education among white Americans, there was a dramatic increase in demand within American colleges for courses on European languages, literature, history, and art. This demand fueled an increase in academic, library, and museum staff and augmented the medieval holdings of institutions, such as at the Metropolitan Museum of Art and George Grey Barnard's Cloisters in New York, to support research and teaching, and for the enjoyment of the public. The impressive and growing medieval European collections now available in the United States were a boon for American medievalists.

As we shall see, Greene's formation and contributions as a medievalist share many of the characteristics that defined the development of the field during her lifetime, such as fashioning her own education, spending time in Europe, and, of course, partnering with her wealthy collector employers to import original medieval artifacts into the Unites States in support of scholarship and public edification. Greene, like the field of American medieval scholarship itself, not only came of age in a relatively short period of time but also grew to command the respect of her European counterparts.

LIKE FATHER, LIKE DAUGHTER: THE PATERNAL INFLUENCE

In 1916, Greene claimed in a newspaper interview:

> I knew definitely by the time I was twelve years old that I wanted to work with rare books. I loved them even then, the sight of them, the wonderful feel of them, the romance and the thrill of them. Before I was sixteen I had begun my studies, omitting the regular college courses that many girls take before they have found out what they want to do.⁷

Though it seems improbable that as a child Belle handled the kind of rare books she would later go on to acquire and steward, she was likely intimately familiar with her father Richard Theodore Greener's personal collection of rare books and documents related to African American history. In fact, Greene's professional origin story echoes the experience and words of her father at Harvard thirty years earlier. In a tribute to his late professor Charles Sumner, Greener

recalled seeing rare books, including medieval manuscripts and incunables, in the private libraries of Sumner and Rev. Robert C. Waterston and noted:

> With what tenderness [Sumner] would bring forth his art and literary treasures, a missal, some book in law French or patois, a black lettered volume, Claudianus with the poet Gray's autograph, Cicero de Officiis in MSS. of the XVth century.[8]

Sumner bequeathed to Harvard his fifteenth-century Italian humanist manuscript of Cicero's *De Officiis*, which opens with a richly illuminated full-page border of gold and white ivy vine-stem with birds and a coat of arms on a blue ground (fig. 1). The book was one of several medieval manuscripts the Harvard professor and antislavery senator for Massachusetts acquired during the tour of

FIG. 1
A manuscript from the library of Charles Sumner shown to Richard T. Greener at Harvard in the 1870s. Marcus Tullius Cicero (106 BC–43 BC), *De Officiis*, Italy, around 1450. Houghton Library, Harvard University; MS Lat 177, fol. 1r.

Europe he made as part of his convalescence after being savagely beaten with a cane on the floor of the Senate by an opponent of abolition in 1856.

Greener's private collecting, knowledge of classical European languages, and professional experience working in the University of South Carolina's library explain the bibliophilic proclivities of the young Belle.[9]

BELLE'S FORMAL EDUCATION IN MASSACHUSETTS AND MEDIEVALIST APPRENTICESHIP AT PRINCETON

Belle received a formal education in Massachusetts that laid the building blocks for her formation as a medievalist on top of the foundation created by her book-loving family. From 1896 to 1899, she attended the rural all-girls boarding school the Northfield Seminary for Young Ladies. In 1900 Belle attended Amherst College's five-week Summer School of Library Economy. The course included the latest techniques in cataloguing and indexing, and "library hand," described as a "vertical round" style of handwriting more legible than cursive.[10] Northfield equipped Belle with a thorough knowledge of the Bible, including the history of the Church and of the biblical canon. Amherst formally introduced her to the burgeoning field of library science and taught her to pay attention to forms of handwriting. Together they increased Belle's proficiency in French and Latin, which she had begun studying before 1896, and paved the way for the development of her expertise in paleography, textual criticism, historical bibliography, and classical and vernacular European languages.

After brief stints at Teachers College from 1894 to 1896 and possibly in the New York Public Library system around 1900, Greene had a formative work experience at Princeton University Library. From 1901 until 1905 she "apprenticed herself" to two librarians whom she later credited as her early career mentors. Professor Ernest Cushing Richardson, the university librarian, was a pioneer in library science and advocate for scholarly training for librarians.[11] Richardson was also a medievalist who taught paleography and bibliography, and researched and published on the early Christian Fathers, St. Clement, and Jacobus de Voragine. Greene's other influence was the associate librarian Junius Spencer Morgan, who was also an art and book collector, and philanthropist. Morgan was a classicist and built one of the world's largest collections of printed editions of Virgil.[12] He introduced Greene to Italian manuscripts and William Caxton, the father of English printing. While at Princeton Library, she also had access to numerous manuscript facsimiles, incunables, and early editions of printed books. Greene learned firsthand from Richardson and Morgan about European manuscript and early printing culture, and vicariously of the benefits of consulting institutional and private library collections and purchasing from the book trade in Europe. Cushing and Morgan brought the Middle Ages to life for Greene through these collections and gave her eye-opening insights into the possibilities of a library career in the field of medieval studies.

MR. MORGAN'S LIBRARY: LEARNING ON THE JOB

Junius Spencer Morgan features in Greene's public account of her professional origin story. He recommended his uncle J. Pierpont Morgan hire her to be librarian of his private collection at his newly built library in Manhattan in late 1905. Pierpont had started collecting manuscripts not much earlier, in 1899, and had also purchased entire libraries such as the collections of Theodore Irwin and Richard Bennett. An anglophile, Pierpont favored medieval and Renaissance codices made in England or for English patrons, with illustrious provenances, especially royal ones, and was particularly interested in decoration (over illustration), which was a typical nineteenth-century preference.[13] Greene's first year on the job was a "busy hive" of activity, organizing and installing at the new library building on 36th Street collections housed in Mr. Morgan's home study, and calling back those on loan, displayed or stored at other institutions, or still with dealers.[14] During her second year as Mr. Morgan's librarian, Greene's role expanded to screening books and artworks offered for sale to Morgan and handling correspondence with scholars supported by her employer. She also learned about the inner workings of the rare books market by corresponding with F. W. Wheeler, an agent at the London booksellers J. Pearson & Company, which had been Morgan's primary source of books for over a decade before Greene's arrival.[15] Greene furthered her understanding of the books in her care by taking private lessons in French, Latin, Italian, and German as well as classes in binding and other book arts. After the hands-on work of uniting, cataloguing, and shelving the collection amassed by Morgan as well as informal lessons from Wheeler and other tutors, Greene had seen, handled, and learned enough on the job to surpass Junius as Pierpont's primary adviser and to make purchases for the Library on her own.

A TRANSATLANTIC NETWORK

Greene's formation as a medievalist took place outside as well as inside the walls of the Morgan Library. Her position brought her into contact with a transatlantic network of scholars, collectors, and dealers. Learning much from them, she often wrote their opinions on books at the Morgan directly inside the front cover (fig. 2). In the United States, she visited private and institutional collections of medieval art and books, including those of Isabella Stewart Gardner ("one of the finest 'ensemble,' I have ever seen"),[16] Henry Walters ("It seemed to me that all the trash of the world had been swept up and dumped into that poor building"),[17] Archer M. Huntington, General Rush C. Hawkins, the Princeton Art Museum, and Harvard's Fogg Art Museum. She also befriended American medievalists, such as Charles Rufus Morey, founder of the Index of Christian Art (now the Index of Medieval Art); Thomas Whittemore, who founded

the Byzantine Institute of America; and William M. Ivins Jr., curator of the Department of Prints at the Metropolitan Museum of Art.

In 1908 Greene left the United States for the first time for a business trip to England.[18] She would go on to make another four trips to Europe as Morgan's librarian and at least nine more after she became director of the Library in 1924. On her stays in Europe, she based herself in the capitals and toured the major university cities and the countryside, attending auctions and exhibitions, visiting curators, librarians, dealers, and private collectors, and studying medieval architecture, art, and libraries in their original settings. These trips helped

FIG. 2
Inside front cover of Gospels of Judith of Flanders, England, probably Canterbury, ca. 1065, with Belle da Costa Greene's notes. 11½ × 7½ in. (29.3 × 19.1 cm). The Morgan Library & Museum, New York, purchased by J. P. Morgan Jr., 1926; MS M.709.

Greene to form and sustain relationships with the foremost medievalists in the United Kingdom, France, Germany, and Italy.

In London she befriended curators and librarians from the British Museum, National Gallery, Victoria & Albert Museum, and Society of Antiquaries, including Charles Hercules Read, Alfred W. Pollard, Sidney Colvin, and Arthur Hind, and conducted business with the firms Quaritch, Maggs Brothers, Duveen Brothers, Durlacher Brothers, and the dealers George C. Williamson, Lionel Harris, and others. Sydney Cockerell, the new director of the Fitzwilliam Museum in Cambridge, noted his first impression of Greene in his diary on December 7, 1908, as "A very nice intelligent woman with a great enthusiasm for manuscripts," after accompanying her around the colleges to see the libraries and meet his predecessor, Montague Rhodes James, who had catalogued Morgan's manuscripts formerly in the libraries of William Morris, Richard Bennett, and the 4th Earl of Ashburnham.[19] Cockerell also introduced Greene to medievalist collectors Charles St. John Hornby, founder of the Ashendene Press, and Henry Yates Thompson, who maintained a collection of the hundred best manuscripts he could acquire by weeding out lesser ones as better books came his way. Greene ventured to Gloucestershire to stay with George and Susannah Holford, whose Westonbirt House held a large collection of illuminated miniatures formed by his father, Robert Stayner Holford. She found the couple "too charming & adorable for words & the most delightful hosts."[20] Greene visited Lord Amherst of Hackney at Didlington Hall in West Norfolk, and famously persuaded him to sell her his collection of sixteen incunable editions of the works of Caxton ahead of the sale of his library at Sotheby's in London.

In 1910 Greene made her first trip to Italy accompanied by Bernard Berenson, the American historian of Italian Renaissance art who became her tutor and intimate partner. They toured the medieval and Renaissance Italian sights between Venice and Rome, lingering in smaller Northern and Tuscan towns to avoid being detected traveling alone together. They studied early Christian mosaics in Ravenna, examined frescoes and altarpieces in Orvieto, and looked at manuscripts in the Vatican Library with its prefect and conservator Franz Ehrle. Berenson also introduced Greene to France, where she just missed meeting Léopold Delisle, the retired head of the Manuscripts Department at the Bibliothèque Nationale, with whom she had corresponded about his review of the Bennett-Morris-Ashburnham collection catalogue. Delisle died weeks before Greene's arrival in Paris in August 1910. On this and subsequent visits to France, Greene visited the Gothic cathedrals of Notre Dame and Chartres, the medieval art collections at the Cluny and Louvre museums,[21] and likely met or planned to meet with French collectors and dealers of medieval and Renaissance books and art including Edmond Foulc,[22] Victor Martin Le Roy,[23] Gustave Dreyfus,[24] Jacques Seligmann,[25] Arthur Sambon,[26] Édouard Rahir,[27] and Ludovic Badin.[28]

FIG. 3
Julius Diez (1870–1957), *Ausstellung München 1910. Meisterwerke muhammedanischer Kunst—Musik-Feste* (*Exhibition Munich 1910 / Masterpieces of Mohammedan Art—Music Festivals*), 1910. Color lithograph; 42½ × 28⅛ in. (108 cm × 71.5 cm). Munich City Museum, Collection of Advertising Art; P-70/56.2.

Greene's first trip to Germany was also with Berenson, in summer 1910. Himself a collector of Persian and Indian illumination, Berenson took her to the landmark exhibition of *Masterpieces of Islamic Art* in Munich (fig. 3) that opened her eyes to the calligraphy, binding, illumination, and illustration of manuscript cultures from around the Muslim world and was the catalyst for building a collection of Islamic book art for the Morgan and herself.[29] Greene later purchased for the Morgan an album of Persian and Indian miniatures loaned to the exhibition by her friend Charles Hercules Read of the British Museum (MSS M.386 and 458; figs. 4, 5). Berenson annotated her copy of the exhibition catalogue in pencil with attributions "after Gentile Bellini."[30] Greene disliked Germany and did not return there until 1936. On that first trip together, Berenson found Greene an expert in her own field and a quick learner in his.

FIG. 4
A Seated Courtier with His Pet Falcon, Afghanistan, ca. 1600. The Morgan Library & Museum, New York, purchased by J. Pierpont Morgan, 1911; MS M.386, fol. 1r.

FIG. 5
Ibrāhīm Adham of Balkh Served by Angels, Faizabad, Oudh, India, ca. 1750–75. The Morgan Library & Museum, New York, purchased by J. Pierpont Morgan, 1911; MS M.458, fol. 32r.

FIG. 6
Qur'an owned by Belle da Costa Greene. Turkish Qur'an by Pashāzāde, Turkey, probably Istanbul, 1832–33. The Morgan Library & Museum, New York, gift of the Estate of Belle da Costa Greene, 1950; MS M.835, fols. 2v–3r.

A MEDIEVAL ABODE

Greene's taste in interior design at home was influenced by her work with medieval books and art, and the installations of the collections she had seen in the United States and Europe, such as at Isabella Stewart Gardner's Fenway Court in Boston and Berenson's Villa I Tatti outside of Florence. In 1911 she described her home on 138 East 40th Street in a letter to Berenson:

> I wish you could see how wonderful my Spinello Aretino looks in my our library room—I put a 16th Cent. rich old green velvet bit on the wall between two windows & hung my "chef d'oeuvre" on that & then have a light underneath. It looks two [sic] wonderful— glows & radiates & dazzles me—unfortunately one cannot see the reverse that way but I did not want it low where the common herd could handle it—Our room looks very fine now—Three sides of the room are covered with divine tapestries (as to color) & at least genuine of the 16 Century They are heavenly dull blues & greens with bits of lighter color—Then I have a large tapestry about 1650 with the Medici arms in the centre surmounted by a ducal (?) crown— which I have put on the floor and use as a rug—It really tones in beautifully & makes the room look a bit unusual.[31]

FIG. 7
Medieval Book of Hours owned by Belle da Costa Greene. Book of Hours, Rouen, France, ca. 1460–70. The Morgan Library & Museum, New York, Melvin R. Seiden Collection, 2007; MS M.1160, fols. 37v–38r.

In a photograph of Greene likely in her apartment at 104 East 40th Street, taken three to four years later, she perches on a seventeenth-century Italian armchair upholstered with tapestry weave depicting a rooster and grapevines (p. 132). Behind her are walls hung with sixteenth- and seventeenth-century Flemish tapestries with floral decoration and martial scenes, respectively, and a medieval-looking boiled leather case on top of a bookcase draped with a Spanish or Italian liturgical vestment, possibly a dalmatic or a tunicle, made of cut and uncut velvet with apparel appliques.[32] Greene also owned a personal collection of art from the Middle Ages and Renaissance, including leaves, manuscripts, and panel paintings, as well as later and contemporary art. Gifts of her estate to the Morgan Library included codices and over forty leaves from Islamic and Christian medieval manuscripts, including an exquisite Ottoman Qur'an (MS M.835; fig. 6) and Book of Hours (MS M.1160; fig. 7).[33] After visiting Greene's home on 123 East 38th Street on October 31, 1920, her friend Sydney Cockerell recorded in his diary that it was "full of beautiful things."[34]

FALSE MEDIEVAL: UNCOVERING THE SPANISH FORGER

Greene's contributions to the field which are of greatest interest to modern medievalists include the study of medievalism through fakes and forgeries, promoting a global view of the Middle Ages, supporting marginalized medievalists, and popularizing medieval culture through public history.

Greene's scholarship suffused her day-to-day work and influenced the scholarly output of the academics in her circle, but she published nothing on the Middle Ages outside of catalogues and reports of Morgan Library collections. Greene's most significant scholarly contribution was her exposure, around 1930, of a series of fourteen forgeries of medieval and Renaissance illuminated manuscripts, single leaves, cuttings, and a panel painting as works all by the same skillful and prolific painter active in Paris from the 1890s through the 1920s. Greene, who was the first to assemble an oeuvre for this artist, nicknamed the artist the Spanish Forger after a panel painting of the *Betrothal of St. Ursula* wrongly attributed to Jorge Inglés, a painter active in Spain around the middle of the fifteenth century (fig. 8).[35] Greene's "careful and fully documented study" of the artist's corpus was never published,[36] but it inspired later Morgan Library curators of medieval and Renaissance manuscripts John Plummer, William M. Voelkle, and Roger S. Wieck to build on her research, culminating in 1978 in the groundbreaking and highly acclaimed *The Spanish Forger*, the first ever exhibition to be dedicated to a forger by a major art institution.[37] Since then appreciation for the value of studying fakes and forgeries as art in their own right, the scientific technical analyses applied to their detection, and the public's fascination with artful hoaxes have flourished, not only for manuscript painting but other art forms, too.[38]

FIG. 8
Spanish Forger, *Betrothal of St. Ursula*, late nineteenth / early twentieth century. Oil on panel; 30½ × 24½ in. (77.5 × 62.3 cm). The Morgan Library & Museum, New York, gift of Martin Cooper; 1988.125.

ANTICIPATING THE GLOBAL MIDDLE AGES

Greene initiated the Morgan's collecting of examples of manuscript traditions from around the world, including Coptic, Ethiopian, Armenian, Ottoman, Indian, and Persian codices, and tried to acquire a Korean manuscript.[39] In broadening the scope of the Library's holdings beyond Pierpont's European collections, she anticipated the now emerging field of scholarly inquiry called the Global Middle Ages, which studies the period traditionally known as medieval for Europeans (around 500–1500) through the lens of Africa, Asia, the Americas, and Austronesia.[40] Greene wasn't unique in doing so at that time; her peers who collected books and art from around the world included Berenson, Henry Walters, Chester Beatty, Charles Hercules Read, and Charles Lang Freer. Greene, who wanted to learn Chinese,[41] was aware of the limitations of her knowledge for materials produced outside of Western Europe, so she enlisted the aid of renowned experts to assess manuscripts for sale, deliver lectures, give graduate courses, and contribute to exhibitions, and supported their scholarship and publications. It is thanks to Greene that the Morgan has one of the most important collections of Coptic manuscripts and bindings in the world. In 1911 she acquired for $200,000 fifty ninth- and tenth-century Coptic codices produced at the Egyptian Monastery of St. Michael, which were mostly still in their original bindings (MS M.604; fig. 9). These books, which had been

FIG. 9
Homily on Gilead, Egypt, ca. 822/23–913/14. The Morgan Library & Museum, New York, purchased by J. Pierpont Morgan, 1911; MS M.604, fols. 1v–2r.

discovered the previous year in a well in the town of Hamuli in the Faiyum Oasis located southwest of Cairo, constituted the only remaining physical evidence of the monastery's existence. Greene collaborated for decades on the restoration, photography, and cataloguing of the manuscripts and bindings with Franz Ehrle and his Restoration Laboratory of the Vatican Library and fathers Henri Hyvernat and Theodore Petersen, both professors at the Catholic University of America who were experts in Egyptian and Semitic languages and literature.[42] For the Armenian manuscripts—such as MS M.740 (fig. 10), a Gospel Book made for Marshal Ōshin in 1274 and owned by Ohan of St. Sargis in the fifteenth century, which Greene purchased from Mrs. John D. Rockefeller Jr. in December 1928[43]—from the 1930s she called on Sirarpie Der Nersessian, an Armenian scholar of Armenian and Byzantine art history at Wellesley. Greene invited her to deliver a lecture at the Morgan in 1935 and from September 1936 to February 1937 to deliver a survey course for graduate students of Columbia University and New York University consisting of fifteen illustrated lectures on Armenian monuments and illumination from the tenth to the end of the fourteenth century, the first devoted to the subject of Armenian art to be offered in the United

FIG. 10
Gospel Book, Sis, Cilicia, 1274. The Morgan Library & Museum, New York, purchased in 1928; MS M.740, fols. 4v–5r.

States and the first to be given anywhere in English. It was accompanied by an exhibition of Armenian manuscripts from the Morgan's collection and loans from the Walters Art Gallery.[44] Der Nersessian also delivered a five-lecture graduate course on Armenia and Byzantium from March to May 1942.[45] Not only were Der Nersessian's courses at the Morgan a series of firsts, but she herself was, too. After starting her career teaching at Wellesley in the 1930s, in 1945 Der Nersessian became the first Professor of Byzantine Art and Archaeology for Dumbarton Oaks and Harvard University and the only woman of her era to gain full professorship at Harvard.

For Islamic manuscripts, Greene consulted various scholars, including Berenson, Read, the German art historian Rudolf Meyer-Riefstahl, the Assyrian professor Reverend Abraham Yohannan, who taught Asian languages at Columbia University from 1894 to 1925, Iranian exiled politician-scholar Sayyed Hasan Taqizādeh,[46] and Richard Ettinghausen, a historian of Islamic art and a Jewish refugee, who held teaching positions in New York City institutes in the 1930s before becoming a curator at the Freer Gallery. From February to May 1938, Ettinghausen delivered at the Morgan a course on Painting in Islam with Eustache de Lorey, professor at the École du Louvre, Paris, dealing with the history of Muslim painting from the early eighth to nineteenth century, including the various schools of miniature painting in Iran, Turkey, and India. Ettinghausen also assessed the date and quality of Islamic manuscripts in Greene's personal collection, which focused on calligraphy and ninth–tenth century Qur'an leaves on vellum such as an illuminated leaf of the Khamsah of Nizami (MS M.836), before they were accessioned by the Library as a gift of her estate.[47]

Greene's last acquisition for the Morgan was a fifteenth-century Gospel Book made in 1400–1401 for Princess-turned-nun Zir Ganela, granddaughter of King Amda Seyon, who reigned in Ethiopia from 1313 until 1344. She purchased it with "sparkling joy" in December 1948. The manuscript, which consists of canon tables and a cycle of illustrations on the life of Christ, includes rare iconography such as a Crucifixion without the figure of Christ (fig. 11).[48] For this acquisition, Greene sought the opinion of Patrick Skehan, who was the chair of the Department of Semitic and Egyptian Languages and Literatures at the Catholic University of America, and taught Hebrew, Aramaic, and Syriac there. Skehan described the manuscript for the Library's five-year report published in 1949, and also wrote an essay on it for Greene's Festschrift.[49] For East Asian scrolls and art, Greene consulted Alan Reed Priest, curator of the Far Eastern Art Department of the Metropolitan Museum of Art from around 1928 to 1965. He later recalled that Greene coveted for the Morgan for twenty years the Vimalakirti Sutra, an early twelfth-century Chinese illuminated Buddhist scroll named for its frontispiece portrait of the supremely wise layman Vimalakirti, which Priest acquired for the Met in 1937.[50]

In 1949 the Morgan Library celebrated its first quarter century as a public institution under Greene's directorship with an exhibition of 256 collection

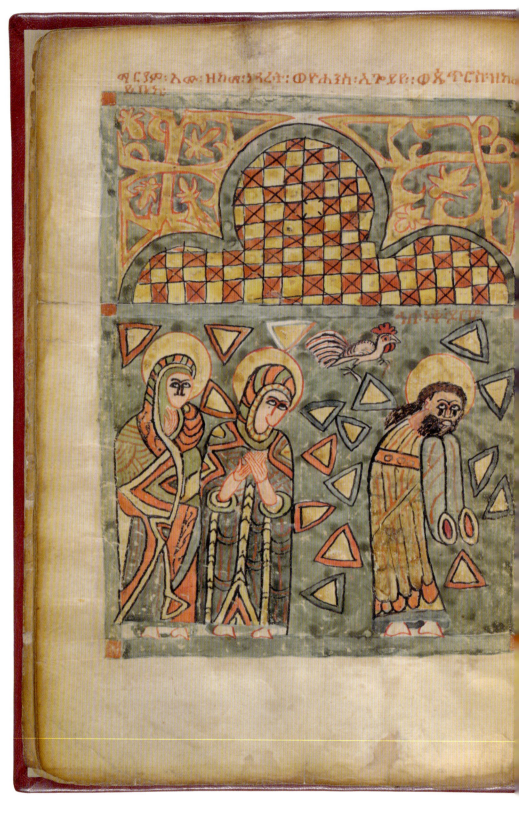

FIG. 11
Zir Ganela Gospels, commissioned by Princess Zir Ganela,
Ethiopia, 1400–1401. 14 5/16 × 9 7/8 in. (36.2 × 25.1 cm). The
Morgan Library & Museum, New York, purchased on
the Lewis Cass Ledyard Fund, 1948; MS M.828, fols. 13v–14r.

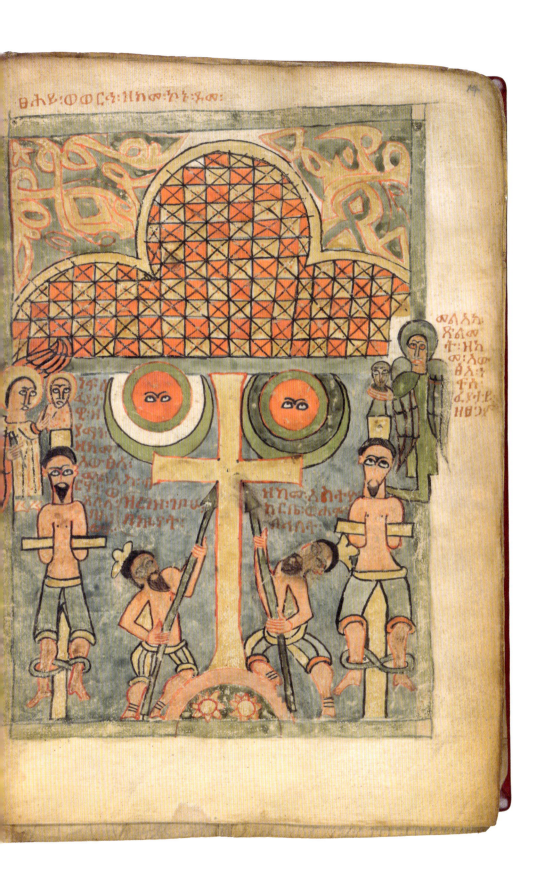

items that she thought the most significant among the works she acquired during this period. The Global Middle Ages was represented by eleven out of the seventy-four illuminated manuscripts on display, including Syriac, Armenian, Byzantine, Ethiopian, Persian, Turkish, and Indian codices.

"THE BEST MEN (WOMEN!)": BUILDING THE MEDIEVALIST SISTERHOOD

Greene was active in a supportive network of female medievalists, including academics, collectors, employees at the Morgan Library, and librarians and curators elsewhere.[51] Shedding light on this network serves as a corrective to past narratives of Greene's sexual attractiveness to men furthering her career. As Kate Ozment has written, it also repositions her and her female peers "as part of a community rather than gendered exceptions to the cis-male-focused norm" in medieval studies and the rare books world.[52] Women professors in Greene's circle who taught medieval art and literature mainly at women's colleges included Wellesley's Myrtilla Avery and Sirarpie Der Nersessian, as well as Laura Hibbard Loomis and Marion Lawrence, who were also affiliated with Mount Holyoke and Barnard, respectively.[53] Greene was one of the eight founding members of the Hroswitha Club—a bibliophilic organization named after after Hrosvitha of Gandersheim, a tenth-century German canoness, playwright, and poet—established in New York City in 1944 by some of the most distinguished women authors, book collectors, curators, and librarians on the East Coast as an alternative to the male-only Grolier Club, which barred women members until 1976.[54] The Grolier did allow members' wives to attend some events as guests, but this access was denied to unmarried women such as Greene. As the leading medievalist among the founders of the women's club, Greene was pivotal in the yearlong decision over the club's namesake, by leading a debate about Hrosvitha of Gandersheim's authenticity.[55] The Club contributed greatly to scholarship on its namesake and acceptance of her as the first female writer, poet, and historian from the German-speaking world. They commissioned a biography of Hrosvitha and produced a bibliographical checklist of her works supplemented with a contextual biography.[56]

The medievalist women whom Greene employed and mentored at the Morgan included her first assistant, Ada "Thursty" Thurston, who worked at the Morgan from around 1905 until 1934, became an expert in incunables, and published the "Checklist of 15th Century Printing in the Pierpont Morgan Library" (1939).[57] Meta P. Harrsen, Greene's assistant in the Department of Illuminated Manuscripts by 1930, curated exhibitions on medieval topics and was promoted to keeper of manuscripts in 1948 following Greene's retirement.[58] Helen M. Franc, a Morgan employee from 1936 to 1942, was initially Harrsen's assistant and then later head of the Department of Drawings and Prints.[59] Mary Ann

Farley worked at the Morgan from 1942 to 1945 and later worked at Princeton on the Index of Christian Art and with Professor Millard Meiss.60 Among the rare class of medievalist women curators outside of the Morgan Greene knew were Margaret Stillwell, curator of the Annmary Brown Memorial Library at Brown University, and Elinor Mullett Husselman, a papyrologist and Copticist who worked as a cataloguer and then curator of Manuscripts and Papyri at the University of Michigan Library from 1918 until 1965. Like Hrosthwithans Greene and Stillwell, Husselman was actively involved in an important intellectual and social network for the sometimes-marginalized women faculty of her time called the University of Michigan Women's Research Club.61 Greene's closest curatorial colleague-friend was Dorothy Miner, keeper of manuscripts and later of the Islamic art collection at the Walters Art Gallery, Baltimore (fig. 12). Miner worked briefly at the Morgan, from 1933 to 1934, and left the Library to join the inaugural curatorial team at the newly incorporated Walters. Greene, who was on the Walters's advisory board, objected to the trustees' plans to hire students instead of experts to catalogue the collection. She insisted, "We should do this with the best men (women!) in the various fields,"62 and recommended Miner as keeper of manuscripts with an annual salary of "at least $2,500." Miner's starting salary was $3,000, the highest among the curators, including her male colleagues.63 Greene lamented the Morgan's loss of Miner to Mrs. Sarah Walters, widow of the late Henry Walters:

> You have a tremendous conquest of my little miss Dorothy Miner, who does nothing but speak, sing, and dream, evidently, "of Mrs. Walters." She is such a brilliant young person, that I will admit to you (but only to you) that it was a real sacrifice to me to give her up to the Walters Gallery, but I feel it was worthwhile, as I find that she has been able to assist practically everyone of the noted scholars in his or her field, whereas she went there presumably as custodian of the manuscripts and books.64

Miner and Greene, who by 1938 called each other affectionately by the nicknames "Dere Keed" (Dear Kid) and "BG," maintained a lifelong professional association and friendship. After Greene's death, her protégés Miner and Harrsen replaced her as medievalists in the Hroswitha Club, joining in 1954 and 1958, respectively.65 On the twentieth anniversary of joining the Club, Miner published, if not the first, one of the first books on women artists of the Middle Ages, aptly named *Anastaise and Her Sisters*.66

FIG. 12
Photograph of Dorothy Miner, from *Gatherings in Honor of Dorothy E. Miner*, edited by Ursula E. McCracken, Lilian M. C. Randall, and Richard H. Randall Jr. (Baltimore: Walters Art Gallery, [1974]). The Morgan Library & Museum, New York; 167.8 M66.

"CAVIARE FOR THE PEEPUL": BRINGING THE MIDDLE AGES TO THE MASSES

Greene was a staunch believer in the importance of public engagement with medieval culture through the Morgan's exhibitions, programs, publications, and partnerships. After the Library became a public institution in 1924, it was inundated with requests for admission from the general public. Greene met this demand by curating with her assistants exhibitions of Morgan collections at other venues in Manhattan, such as the New York Public Library and Metropolitan Museum of Art, and lending generously to other institution's shows in the United States and Europe, including the Fogg Art Museum and Victoria & Albert Museum. Many of the Morgan's exhibitions in the 1920s were of unprecedented size in the United States; were accompanied by catalogues, lectures, and reserved viewing times for high school students; and were often extended due to popular demand.[67] In November 1928 an Annex to the original Library building opened, adding a dedicated exhibition gallery and separate reading and reference rooms for scholars and students, respectively, the latter space doubling up as a lecture hall, as well as staff offices and workspaces.[68] This enabled the Library to cater to both scholars and the public alike. Between 1924 and 1949 the Morgan held forty-six exhibitions, published thirty-five books, and supported over a thousand publications referencing Pierpont Morgan Library collections published by others, including monographs, reports, catalogues of materials, catalogues of exhibitions, reprints, and facsimiles. It also held numerous lectures by high profile European and American scholars and informal talks given by teachers to visiting classes of students (fig. 13), and hosted

FIG. 13
Hellmut Lehmann-Haupt with his class from Columbia University, 1950s. The Morgan Library & Museum, New York; ARC 3291, Box 46, Folder 1.

meetings of national learned societies. Jewish refugee scholar Erwin Panofsky must have had Greene in mind years later when he recalled encountering in America "librarians and curators [who] seemed to consider themselves primarily as organs of transmission rather than 'keepers' or 'conservateurs.'"[69]

A high point for the Morgan Library was the exhibition of illuminated manuscripts held at the New York Public Library in 1933, which was the "first comprehensive major exhibition of illuminated works."[70] It was also among the Unites States' earliest blockbuster exhibitions on medieval culture alongside the extremely popular traveling exhibition of Guelph Treasure that toured New York, Cleveland, Detroit, Philadelphia, Chicago, and San Francisco in 1930–31, and *Arts of the Middle Ages: 1000–1400* at the Museum of Fine Arts, Boston in 1940.[71] Co-curated by Greene and Meta Harrsen, the Morgan exhibition at the NYPL showcased 134 illuminated manuscripts and twenty illuminated leaves dating from the ninth to the sixteenth century, beautifully installed in the main exhibition room (fig. 14). Having opened on November 28, 1933, it was attended by 36,913 people in its first month and thereafter by a daily average of 1,118 visitors (fig. 15). It was extended by popular demand to April 1934, evening openings were added, and Friday afternoons were reserved for visits from high school students. Two complementary catalogues were published in 1934, one by the NYPL with an overview of the history of illumination for the general public by Charles F.

FIG. 14
Manuscripts M.708, 709, 710, and 711 on display in the main exhibition room of the New York Public Library, 1933–34. The Morgan Library & Museum, New York; ARC 3291, Box 91, Folder 4.

FIG. 15
Unknown woman with choirbook and stand displayed at the New York Public Library *Illuminated Manuscripts* exhibition, 1933–34. The Morgan Library & Museum, New York; ARC 3291, Box 91, Folder 4.

McCombs, and the other by the Morgan with a more scholarly introduction by Charles Rufus Morey of Princeton on the development of medieval painting. Greene later recalled modestly that "when this Exhibition was planned, it was expected to have a somewhat limited appeal; consequently the large and serious attendance was gratifying as well as astonishing."[72] In January 1934, however, while the exhibition was still on, she boasted to a trustee of the newly incorporated Walters Art Gallery about its popularity to demonstrate the trickle-down effect of hiring expert curators to produce both high quality scholarly work and programs with public appeal:

> We have a grand chance here [at the Walters] to do scholarly work which the Public—or "Peepul" are the first to recognize (witness the largest exhibition attendance which the N.Y.P.L. has ever had during our exhibition of Illum[inated] M[anuscripts]—which we thought would be in the nature of "caviare" [sic] to the Public.[73]

Greene also partnered with popular magazines to reach a wider public. To coincide with the Morgan's exhibition *The Written Word*, in April 1945, *Life* magazine ran an eight-page article titled "The Morgan Library: It Houses Treasures."[74] Perfectly pitched for a general audience, it focused on the Easter Story as "exquisitely told in the manuscripts of the Middle Ages," complete with headers in uncial font, eleven color images of a jeweled binding and miniatures of the Stations of the Cross explained with pithy captions, and details from miniatures presented as black line drawings. In the same year, she approved J. Walter Thompson Company's request to reproduce in Kodachrome color photography and on microfilm an illuminated manuscript from the collection in a full-page advertisement in *Life* for its client Eastman Kodak.[75] Greene recommended the Berry Apocalypse (MS M.133; fig. 16), an early fifteenth-century French manuscript made for Jean, Duc de Berry, on the condition of copies of the color photographs, two strips of microfilm, a credit line, and recommendations for photographers. In the Morgan's archives exists a rough layout of the ad, "On the Head of a Pin" (fig. 17), showcasing the capability of Kodak's Recordak System of microfilm that promised to:

> make the greatest contents of the greatest library in the world—or the choicest volumes of all libraries—available in the library of any small town or college.... Instead of the dissemination of learning being limited by the necessity of transporting scholars to the great sources, through Kodak's photographic methods the sources of scholarship can be brought to all who are interested... in their schools or even their homes.

The final advertisement never appeared in *Life* in 1946 nor elsewhere. This may have disappointed Greene, who valued the "camera as another agency for the service of scholarship," namely for the reproduction of manuscripts for scholars and students in distant places.[76] A decade earlier, in 1935, Greene had established a photographic department for the Library. By 1949 its photostatic apparatus had made thousands of copies of printed and manuscript pages,

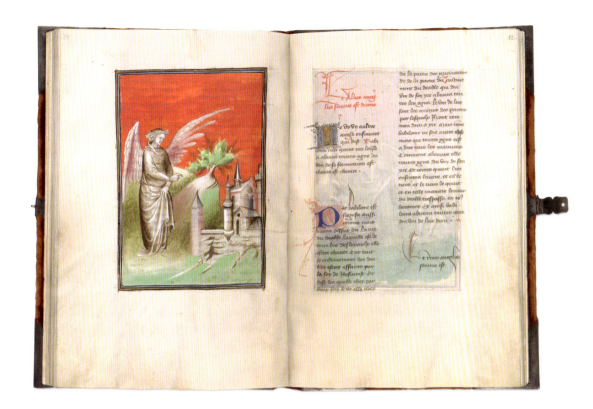

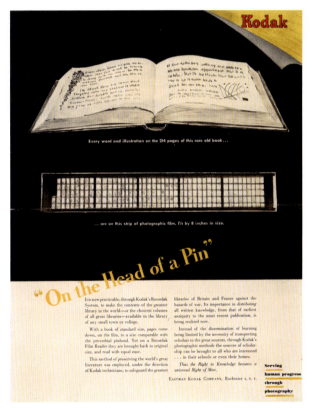

FIG. 16
Berry Apocalypse, Paris, France, ca. 1415. The Morgan Library & Museum, New York, purchased by J. Pierpont Morgan, 1910; MS M.133, fols. 51v–52r.

FIG. 17
J. Walter Thompson Company, "On the Head of a Pin" advertisement mock-up, 1945. The Morgan Library & Museum, New York; ARC 3291, Box 68, Folder 3.

drawings, engravings, and illuminations for study or for publication, and about ten thousand colored and black-and-white lantern slides, and acquired a specially built Beseler duplex-slide projector for lectures and classes. The department was also an early adopter of infrared ray in deciphering faded or overwritten manuscripts, earning it praise for being "in progressiveness of method and in excellence of result…an example to other institutions."[77]

"VOLUME, RANGE, AND VALUE": RECOGNITION FROM THE MEDIEVAL ACADEMY OF AMERICA

In 1938 John Nicholas Brown II, a founder of the Medieval Academy of America and its treasurer, nominated Belle da Costa Greene for fellow for the second time, stating, "Those nominating Miss Greene wish to emphasize their belief that she has contributed no less than any of the Fellows of the Academy to the advancement of American scholarship in the Middle Ages."[78] Brown went on to summarize Greene's activities in eight key areas demonstrating "the volume, range, and value of her contribution." He highlighted her development of the Morgan's collection of nine hundred manuscripts; its publication of forty-three collection catalogues, making primary resources available to scholars; her professional service on advisory and visiting committees at the Walters Art Gallery, New York University's Institute of Fine Arts, Princeton's Department of Art and Archaeology, and Harvard's Fogg Art Museum; her outstanding exhibitions, her hosting of classes for the IFA, Columbia, Harvard, and other colleges; and her support of scholars in the publication of their research. Brown's nomination was cosigned by five distinguished American and European medievalists, who all sent individual notes of support to George William Cottrell Jr., the academy's secretary to the fellows.[79]

Greene was up against four other candidates, all Ivy League professors, for three vacancies. They were Harvard's Samuel Hazzard Cross, professor and chairman of the committee of Slavic Languages and Literature, and George Sarton, pioneering professor of the history of science. The other two were Princeton's Ernest Theodore DeWald, professor of art and archaeology, and Kenneth McKenzie, professor of Italian. Mindful of Greene's status as a librarian against academics, Walter W. S. Cook drafted the nomination letter and vita for Greene, sent Cottrell a sample of supporting materials borrowed from the Morgan, and made his case that "Miss Greene has no academic degrees, but she has done more than anyone else to foster and add to the publication of material in the field of the Middle Ages."[80] Cottrell replied to Cook, "I am somewhat appalled at the avalanche of material relating to Miss Greene."[81] In the first round of voting, sixteen of the thirty voting fellows chose Greene, and she, Cross, and McKenzie were nominated and inducted as fellows in 1939. Greene did not attend the induction ceremony conducted in Latin during the academy's

14th Annual Meeting.[82] Greene was only the second woman fellow of the academy, after Nellie Neilson of Mount Holyoke, who was a charter fellow in 1926 and would later serve as first woman president of the fellows in 1945–47. Neilson's and Greene's memberships presented some conundrums for the academy. For the 1940 Annual Meeting held at Harvard University, the academy negotiated to get special permission for their "two ladies" to attend the newly instituted fellows dinner at the men-only Harvard Faculty Club. Greene did not attend due to her mother's poor health, though she did attend the dinner the following year in Princeton. In 1948 Greene hosted the 23rd Annual Meeting of the academy at the Morgan Library, which was deemed "one of the best attended in the history of the Academy."[83]

ESTEEM OF HER PEERS (1949–1971)

"If her monument you would see, look about you."[84]

These words perfectly describe Greene's legacy as institution-builder recognized by her peers and also resonate with the last known photograph of her (fig. 18). A mature woman at the end of her quarter-century directorship, she sits not in her own office but in the Library's West Room behind the imposing desk of her two former employers, Pierpont and Jack Morgan. Greene is surrounded by medieval treasures, including metalwork, stained glass, and portraiture. Behind her on the book cabinet is a fourteenth-century Spanish polyptych with *Scenes from the Life of Christ, the Life of the Virgin, and Saints* (AZ071, purchased 1907). On a table partly obscured by a lamp is the famed Stavelot Triptych, a twelfth-century Byzantine-Mosan reliquary of the True Cross (AZ001, purchased 1910), and in her hands is the twelfth-century German Anhalt Gospels (MS M.827; fig. 19) from the library of the abbey of Moenchen-Nieuburg in Magdeburg diocese, which Greene acquired in February 1948.[85] On the wall hangs a rare late sixteenth–early seventeenth-century Venetian portrait of an African man with light skin tone and a thin moustache, believed to be a Moorish ambassador at the court of the Republic of Venice. Jack Morgan acquired it as a work of Domenico Tintoretto (now considered workshop) in 1929 (AZ072). Did the painting remind Greene of her father, who had been a US diplomat in Siberia?[86] Did its presence in the West Room influence her choice of setting for her photograph?[87]

From 1949 through 1971 Greene's peers paid tribute to her and recorded her accomplishments for posterity. In 1949, the year before Greene's death, the Pierpont Morgan Library held a retrospective exhibition in her honor to celebrate twenty-five years of the Library's service as a public educational institution under her directorship, marking "two anniversaries which may be thought of and spoken of as one."[88] The exhibition showcased Greene's bibliographical knowledge and outstanding scholarship through 256 treasures from the collection

acquired by her between 1924 and 1948, including seventy-four, or roughly half, of the illuminated manuscripts that entered the Library during that period. The accompanying catalogue was introduced by a glowing and detailed tribute by Lawrence C. Wroth, librarian of the John Carter Brown Library in Providence, Rhode Island. Wroth noted that the Morgan's greatest strength, its medieval and Renaissance manuscripts and early printed books, presented Greene with the greatest challenge for transforming the Library from a private institution to a public one because they served "fields of restricted interest even among men of learning," and that she had risen to the occasion by making them accessible to students and the public and by creating a scholarly community for their appreciation and use.[89]

Following Greene's death on May 10, 1950, the *New York Times* published an obituary. This was a rare honor for a woman (and secret person of color), as

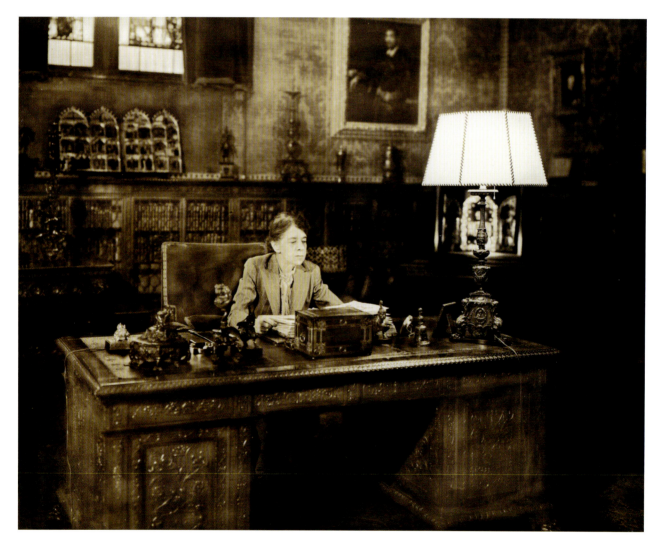

FIG. 18
Belle da Costa Greene in the West Room of J. Pierpont Morgan's Library, ca. 1948–50. Gelatin silver print; 7⅝ × 9⅝ in. (19.4 × 24.5 cm). Biblioteca Berenson, I Tatti, the Harvard University Center for Italian Renaissance Studies; Bernard and Mary Berenson Papers, Personal Photographs, Box 12, Folder 38.

the newspaper largely chronicled the lives of white men.[90] Greene's Hroswitha Club sisters mourned her, speaking often of her in their gatherings that year and writing an affectionate memorial that celebrated her generosity and intellect.[91] Greene's protégé and close friend Dorothy Miner edited a book of scholarly essays in honor of her "beloved mentor."[92] While the 1949 exhibition and catalogue showcased the treasures Greene acquired for the Morgan, the Festschrift *Studies in Art and Literature for Belle da Costa Greene*, published by Princeton University Press in 1954, magnified the "extraordinary scholarly microcosm" she formed around the Morgan's collections and the scholarship they inspired.[93] Originally conceived as a "liber amicorum" started while Greene was still alive, it turned into an almost nine-hundred-page "volume for which the epithet monumental would be a patent understatement."[94] The posthumous Festschrift featured tributes and new contributions by "a veritable 'Who's Who'" of fifty-one

FIG. 19
Gospel Book (Anhalt-Morgan Gospels), possibly St. Bertin, France, or at St. Vaast in Arras, Belgium, late tenth century. The Morgan Library & Museum, New York, purchased on the Lewis Cass Ledyard Fund, 1948; MS M.827, fol. 98v.

Americans and Europeans,[95] including a duke, three knights, an earl, and a cardinal, and scholars in fields of interest to its honoree: iconography, painting, architecture, sculpture, the decorative arts, the graphic arts, illumination and paleography of medieval manuscripts, bookbinding, textual, literary, and bibliographical studies. Medievalists predominated among the contributors, demonstrating their esteem for Greene and recognition of her place in their field. They included both Greene's age peers and the next generation of medievalists born after 1900. Among the former were the abovementioned Lowe, Panofsky, Der Nersessian, Loomis, and the British Museum's Eric George Millar. The latter were represented by Barnard's Marion Lawrence, the Boston Museum of Fine Arts's Hanns Swarzenski, Columbia's Millard Meiss and Meyer Schapiro, the Morgan's keeper of printed books Curt F. Bühler, and others. Seven years after Greene's death, *Speculum*, the journal of the Medieval Academy of America, published Bühler's memoir of Greene among its tribute to deceased fellows. Personal and full of anecdotes "in place of the usual" account of academic positions held and publications, it drew on remarks of appreciation Bühler made on behalf of the Morgan's staff at a celebration in Greene's honor at the Library on April 4, 1949, and ended by proposing a tongue-twisting alliterative Latin epitaph for her: "VIS VIRIDIS VIRIS VIVIS VIRESCAT. May the Greene power embellish humanity!"[96] In 1971, over two decades after her death, Hroswitha Club sisters Dorothy Miner and Anne Lyon Haight coauthored an entry on Greene for the biographical dictionary *Notable American Women, 1607–1950*, the first major reference work dedicated to important female contributors to American life.[97] Since 1954, when Miner had lamented in her introduction to the Festschrift that "it seems unlikely that this biography [of Greene] will ever be written," she and her coauthor had assembled enough details on Greene's family background, mentors, and career to depict her life to the fullest, if not wholly accurate, extent.[98] Over the course of two to three more decades, the truth of Greene's African American identity and parentage, which Haight had suspected, would come to light in a *New Yorker* article by Jean Strouse and be explored in full in a biography by Heidi Ardizzone, *An Illuminated Life*, published in 1999 and 2007, respectively.[99]

PATRON SAINT OF MEDIEVALISTS OF COLOR (2018–NOW)

Since *An Illuminated Life* was published there has been an exponential growth of awareness and admiration among BIPOC medievalists of Belle da Costa Greene as an early person of color in their field. Greene's recent evolution from bygone respected librarian-director to revered patron saint of medievalists of color derives not just from Ardizzone's biography but also the zeitgeist of racial reckoning in twenty-first-century America and Europe, the examination of her life

through the lens of critical race theory,[100] the activism of Medievalists of Color, and diversity, equity, and inclusion initiatives in the cultural sector.

The year 2018 was key in the timeline of the evolution of Greene's legacy as a medievalist. The Medieval Academy of America established the Belle da Costa Greene Award, a grant to be given annually to support the research of a medievalist of color among its members. The award was the culmination of a couple of years of calls for the diversification of the academy by members of the Medievalists of Color, a global and racially diverse group of scholars working across the disciplines in medieval studies. In 2017 a series of events played out on the national stage and within the field that spotlit the connections between white supremacy and medieval studies. These ranged from the uptick in blatant racism in the United States emboldened by the election of Donald Trump and the violent Unite the Right Rally in Charlottesville, Virginia, that co-opted medieval imagery, to a tasteless racist joke made by the moderator of the keynote speech at the "Otherness"-themed meeting of the International Medieval Congress at the University of Leeds, England, and subsequent polarized public debate about critiques of the field by medievalists of color and their allies.[101] Following these incidents, the Medieval Academy of America worked closely with Nahir I. Otaño Gracia, the liaison between the academy and Medievalists of Color, to create and approve the latter's proposals for measures to enhance diversity in the organization, namely the collection of opt-in demographic data on its membership, the creation of the research and travel award judged by an Inclusivity and Diversity Prize Committee, and an Inclusivity and Diversity Committee.[102] The academy also hosted a plenary session on "Building Inclusivity and Diversity: Challenges, Solutions, and Responses" organized and chaired by Otaño Gracia at its 93rd annual meeting in 2018.[103] The research and travel award, named for Belle da Costa Greene at the suggestion of one of the Medievalists of Color, which as a group embraced the librarian with compassion for her passing for white within the racial context of her time, was largely met with enthusiasm by the wider community of the Medieval Academy of America but also had detractors among some members who expressed their outrage at the new initiative they perceived as racist against whites. In spite of the pushback, the academy continued to work with the Medievalists of Color to establish a Belle da Costa Greene Fund and Award.

Also in 2018, Tarrell R. Campbell organized and held the first ever conference dedicated to Greene, "Celebrating Belle da Costa Greene: An Examination of Medievalists of Color within the Field," at the Center for Global Citizenship at Saint Louis University in Missouri. The conference sought to "address the relative lack of inclusivity experienced by scholars of color and to highlight the roles of Belle da Costa Greene in shaping aspects of Medieval Studies and manuscript production and archival [processing]."[104] Medievalist academics Seeta

Chaganti and Dorothy Kim delivered plenary lectures on "Forged Dawn: Belle da Costa Greene, Edith Wharton, and American Medieval Studies" and "Belle da Costa Greene, Book History, Race, and Medieval Studies," respectively. In Kim's lecture (later published as an article), she used critical race and Black feminist theories to reexamine the Greene family's passing, Belle's familial responsibilities, her career, and her personal book collection against her roles as the librarian, director, and person responsible for shaping the Pierpont Morgan Library.[105] Kim contextualized the gift of Greene's personal art collection from her estate within her family's financial precarity and premature deaths, and the difficulty African Americans face in securing intergenerational wealth, underscoring that the collection was "specifically geared toward long-term financial stability" of her family and ended up going to the Morgan because she did not update her will when her beneficiaries predeceased her. Kim outlined reparative actions the Morgan Library & Museum could take to undo the whitewashing of the past century and make Greene visible again as a Black woman librarian, medievalist, bibliographer, and director.[106] She also noted that Greene was not only the first Black female fellow at the Medieval Academy of America but probably also the first Black woman to be a member of the College Art Association and the American Library Association.[107]

In 2019, acting on the recommendations of the Medievalists of Color the previous year, the Medieval Academy of America heralded Greene as its first Black and second female fellow, created the Belle da Costa Greene Fund and inaugurated the Belle da Costa Greene Award to be granted annually to a medievalist of color for research and travel. The award is adjudicated by the academy's Inclusivity and Diversity Prize Committee, which the Council of the Medieval Academy of America also established at the suggestion of the Medievalists of Color. Drawing on a statement made by Tarrell R. Campbell, the academy posits Greene's legacy as "highlight[ing] the professional difficulties faced by medievalists of color, the personal sacrifices they make in order to belong to the field, and their extraordinary contributions to Medieval Studies."

In 2020 the Morgan Library & Museum inaugurated the Belle da Costa Greene Curatorial Fellowships, providing "a two-year curatorial fellowship to be awarded to two promising scholars from communities historically underrepresented in the curatorial and special collections fields." The first three fellows worked exclusively or in part on projects related to Belle Greene. Metadata librarian Nicholas Caldwell helped transcribe and interpret Greene's letters to Bernard Berenson; the Department of Literary and Historical Manuscripts hired archivist Erica Ciallela to process Greene's professional papers in the Library's archives; and medieval art historian Juliana Amorim Goskes joined the department of Medieval and Renaissance Manuscripts to research items gifted from the estate of Belle da Costa Greene, a group of approximately sixty sin-

gle leaves and manuscripts (primarily in Persian or Arabic) once belonging to Greene's private collection.

In 2023 medievalist Sierra Lomuto proposed a countervailing argument about the "the field's recuperation of Belle da Costa Greene" through initiatives such as the abovementioned conference, awards, fellowships and, by extension, the Morgan Library & Museum's centennial exhibition honoring Greene and the present essay. Lomuto cautioned that the recuperation "inadvertently exposes the Orientalism that still lurks within the Global Middle Ages," and called attention to the paradox between Greene as a modern-day symbol of diversity, equity, and inclusion in medieval studies, and her role in aiding the development of the field's white Euro-American project.[108]

CONCLUSION: A MEDIEVALIST LIBRARIAN UNLIKE ANY OTHER

Following the discovery of Greene's African American identity a century after she entered the field, medievalists of color have embraced this previously "hidden figure," with all her complexities, as their own,[109] seeing Belle as a symbol of belonging and inspiration in a predominantly white and at times hostile discipline. Through her life's accomplishments in defiance of the misogynoir of American society of her time, and the evolution of a legacy of representation seventy years after her death, Greene has rightly earned her place center stage as, in the words of Big Piph (fig. 20), a "medievalist unlike any other" in the history of medieval studies in America.[110]

FIG. 20
Epiphany "Big Piph" Morrow in the East Room of the Morgan Library, 2019.

NOTES

Acknowledgments: Philip Palmer, Erica Ciallela, Deborah Parker, Jathan Martin, María Molestina, Victoria Stratis, Laura Nuvoloni, Juliana Amorim Goskes, Nahir Otaño Gracia, Tarrell R. Campbell, Epiphany "Big Piph" Morrow, Lisa Fagin Davis, Sonja Drimmer, William P. Stoneman, Jeffrey Hamburger, Deirdre Jackson, Roger Wieck, Josh O'Driscoll, Lisa Unger Baskin, Garrett Scott, Josh Larkin Rowley, and Anna Wilson.

1
Big Piph, "The Ballad of Belle da Costa Greene" (lyrics), *Quimbandas* 1, no. 1 (December 2020): 81–82, https://www.scribd.com/document/502468305/11-Article-Text-64-1-10-20201231. Listen to Big Piph perform "The Ballad of Belle Da Costa Greene" on SoundCloud: https://soundcloud.com/user-287983019/the-ballad-of-belle-da-costa-greene.

2
Tarrell R. Campbell, "Notes from the Editor," *Quimbandas* 1, no. 1 (December 2020): 11, https://www.scribd.com/document/502468305/11-Article-Text-64-1-10-20201231.

3
For example, Greene neither has a biographical entry nor is mentioned in the entries of any of the seventy women profiled in Jane Chance, ed., *Women Medievalists and the Academy* (Madison: University of Wisconsin Press, 2005).

4
William J. Courtenay, "The Virgin and the Dynamo: The Growth of Medieval Studies in North America: 1870–1930," in *Medieval Studies in North America: Past, Present, and Future*, ed. Francis G. Gentry and Christopher Kleinhenz (Kalamazoo, MI: Medieval Institute, 1982), 6–7.

5
Bulletin of *Progress of Medieval Studies in the United States of America*, no. 1 (1924), mentions sixty medievalists. Courtenay, "Virgin and the Dynamo," 16.

6
Jan Ziolkowski, *The Juggler of Notre Dame and the Medievalizing of Modernity*, vol. 3, *The American Middle Ages* (Cambridge, UK: Open Book Publishers, 2018); available for free online.

7
New York Evening Sun, October 19, 1916, quoted in Jean Strouse, *Morgan: American Financier* (New York: Random House, 1999), 509.

8
Christopher de Hamel, *The Posthumous Papers of the Manuscripts Club* (London: Allen Lane, 2022), 467, citing Richard Theodore Greener and University of South Carolina, sponsoring body, *Charles Sumner, the Idealist, Statesman and Scholar: An Address Delivered on Public Day, June 29, 1874, at the Request of the Faculty of the University of South Carolina* (Columbia, SC: Republican Printing Company, 1874), 30.

9
Christopher de Hamel's suggestion that a twelve-year-old Greene attended with her father the 1892 Grolier Club loan exhibition *Illuminated and Painted Manuscripts, Together with a Few Early Printed Books with Illuminations* is intriguing but seems a stretch according to what we know about Greener's lack of involvement in family life at this time, following the deterioration of his marriage with Genevieve.

10
"Amherst College Library Summer School of Library Economy, Eleventh Year," brochure, 1901, Amherst College Archives and Special Collections, Amherst Summer School Collection; MA 00058.

11
Lewis C. Branscomb, *Ernest Cushing Richardson: Research Librarian, Scholar, Theologian, 1860–1939* (Metuchen, NJ: Scarecrow Press, 1993).

12
Craig Kallendorf, *A Catalogue of the Junius Spencer Morgan Collection of Virgil in the Princeton University Library* (New Castle, DE: Oak Knoll Press, 2009).

13
Roger S. Wieck, "Morgan and Manuscripts: The Bennett Catalogue as a Window onto Pierpont Morgan's Taste in Illumination," in *Morgan—The Collector: Essays in Honor of Linda Roth's 40th Anniversary at the Wadsworth Atheneum Museum of Art*, ed. Vanessa Sigalas and Jennifer Tonkovich (Stuttgart: Arnoldsche, 2023), 109–10.

14
Heidi Ardizzone, *An Illuminated Life: Belle da Costa Greene's Journey from Prejudice to Privilege* (New York: W. W. Norton, 2007), 85–86.

15
Ibid., 86–88.

16
Greene to Bernard Berenson, December 13, 1909, Bernard and Mary Berenson Papers, Box 60, Folder 5, Biblioteca Berenson, I Tatti, the Harvard University Center for Italian Renaissance Studies, quoted in Ardizzone, *Illuminated Life*, 143.

17
Greene to Sydney Cockerell, March 10, 1914, London, British Library, Add. Ms 52717, ff. 6–9, quoted in De Hamel, *Posthumous Papers*, 581.

18
She arrived too late in the year to attend the now legendary 1908 exhibition on manuscripts at the Burlington Fine Arts Club, to which J. Pierpont Morgan had lent many manuscripts.

19
Sydney Cockerell, December 7, 1908, diary entry, British Library, Add. Ms 52645, f. 65v.

20
Greene to Berenson, letter written on Westonbirt House stationery, November 1911 [undated], Berenson Papers, Box 62, Folder 20.

21
Greene to Berenson, October 12, 1910, Berenson Papers, Box 60, Folder 9.

22
Greene to Berenson, November 19, 1909, Berenson Papers, Box 60, Folder 5.

23
Greene to Berenson, July [undated] 1909, Berenson Papers, Box 60, Folder 4.

24
Ibid.; Greene to Berenson, October 12, 1910, Berenson Papers, Box 60, Folder 9.

25
Seligmann is mentioned over sixty times in Greene's letters to Berenson between 1909 and 1920. Berenson Papers, passim.

26
Greene to Berenson, December 31, 1912, March 4, 1913, and March 13, 1914, Berenson Papers, Box 61, Folder 5; Box 61, Folder 7; and Box 61, Folder 16, respectively.

27
Greene to Berenson, May 22, 23, and 25, 1911, Berenson Papers, Box 60, Folder 18.

28
Morgan Collections Correspondence, Archives of the Morgan Library & Museum, ARC 1310, Badin. (Archives of the Morgan Library & Museum material hereafter cited as "ARC.") Letters between Badin and Greene dating from April 2, 1907, to June 10, 1920. Greene likely met Badin in person during her first trip to France in 1910.

29
Karen Deslattes Winslow, "Moguls Collecting Mughals: A Study of Early Twentieth-Century European and North American Collectors of Islamic Book Art," DPhil thesis (University of London School of Advanced Studies, 2023), 135–38.

30
ARC 3299.

31
Greene to Berenson, February 17, 1911, Berenson Papers, Box 60, Folder 15.

32
I am grateful to Tess Fredette, Senior Textiles Conservator, Isabella Stewart Gardner Museum, for helping me to identify the textiles in the photograph.

33
Araceli Bremauntz-Enriquez, "Belle da Costa Greene: Collecting Chinoiserie," The Morgan Library & Museum blog, September 22, 2022, https://www.themorgan.org/blog/belle-da-costa-greene-collecting-chinoiserie.

34
Sydney Cockerell, October 31, 1920, diary entry, British Library, Add. Ms 52657, f. 52v.

35
William M. Voelkle and Roger S. Wieck, introduction to *The Spanish Forger*, ed. Voelkle, exh. cat. (New York: Pierpont Morgan Library, 1978), 9, for

35

Greene's naming of the artist. See also Voelkle, "The Spanish Forger: Master of Manuscript Chicanery," in *The Revival of Medieval Illumination: Nineteenth-Century Belgium Manuscripts and Illuminations from a European Perspective / Renaissance de L'enluminure Médiévale: Manuscrits et Enluminures Belges Du XIXe Siègle et Leur Contexte Européen*, ed. Thomas Coomans and Jan de Maeyer (Leuven, Belgium: Leuven University Press, 2007), 206–27.

36

Lawrence C. Wroth, "A Tribute to the Library and Its First Director," in *The First Quarter Century of the Pierpont Morgan Library: A Retrospective Exhibition in Honor of Belle da Costa Greene*, exh. cat. (New York: Pierpont Morgan Library, 1949), 18.

37

Voelkle and Wieck, introduction to *The Spanish Forger*, 9–11, 13–15.

38

Later landmark exhibitions and publications in this field include *Vandals and Enthusiasts: Views of Illumination in the Nineteenth Century* (Victoria & Albert Museum, 1995) and *Manuscript Illumination in the Modern Age: Recovery and Reconstruction* (Mary and Leigh Block Museum, Northwestern University, 2001).

39

Thanks to Roger Wieck for telling me about the Korean manuscript.

40

Bryan C. Keene, "Introduction: Manuscripts and their Outlook on the World," in *Toward a Global Middle Ages: Encountering the World through Illuminated Manuscripts*, ed. Keene (Los Angeles: J. Paul Getty Museum, 2019), 5–34.

41

According to Karl Kup, review of *Studies in Art and Literature for Belle da Costa Greene* (ed. Dorothy Miner), *Papers of the Bibliographical Society of America* 49, no. 4 (1955): 368.

42

Francisco H. Trujillo, "A History of the Monograph," in Theodore C. Petersen, *Coptic Bookbindings in the Pierpont Morgan Library*, ed. Trujillo (Ann Arbor, MI: Legacy Press, 2021), i–vii.

43

Helen C. Evans, "Cilician Manuscript Illumination: The Twelfth, Thirteenth, and Fourteenth Centuries," in *Treasures in Heaven: Armenian Illuminated Manuscripts*, ed. Thomas F. Mathews and Roger S. Wieck (New York: Pierpont Morgan Library; Princeton, NJ: Princeton University Press, 1994), 66–83, no. 64. See also the catalogue record in CORSAIR for more on the manuscript's provenance.

44

List of addresses, in *The Pierpont Morgan Library: Review of the Activities and Acquisitions of the Library from 1930 through 1935: A Summary of the Annual Reports of the Director to the Board of Trustees* (printed by Plantin Press, New York, 1937), 34 (hereafter, this and other Morgan Library reports are cited as "*PML Review*" followed by the date range); *PML Review, 1936–1940* (printed by Plantin Press, New York, 1941), 2.

45

PML Review, 1941–1948 (printed by Plantin Press, New York, 1949), 28.

46

Winslow, "Moguls Collecting Mughals," 152, 157–58, 164.

47

Ibid., 165, and notes in curatorial file for MS M.836.

48

Patrick W. Skehan, "An Illuminated Gospel Book in Ethiopic," in *Studies in Art and Literature for Belle da Costa Greene*, ed. Dorothy Miner (Princeton, NJ: Princeton University Press, 1954), 350–57. There has been some confusion over whether the last medieval manuscript acquired by Greene was a late fourteenth- or early fifteenth-century Italian manuscript of the Martyrology and rule of St. Benedict (MS M.829) or the Zir Ganela Gospels (MS M.828). She acquired both in 1948, in November and December, respectively, but accessioned the African book first.

49

PML Review, 1941–1948, 43, plate 3.

50

Alan Priest, "An Illuminated Buddhist Scroll in the Metropolitan Museum of Art," in Miner, *Art and Literature*, 128.

51

Though not medievalists, two noteworthy women curators in Greene's professional sphere were Edith Porada, honorary curator of Ancient Mesopotamian Seals and Tablets at the Morgan, and classicist Gisela Richter, the first woman to hold the rank of full curator at the Metropolitan Museum of Art.

52

Kate Ozment, *The Hroswitha Club and the Impact of Women Book Collectors* (Cambridge: Cambridge University Press, 2023), 3.

53

David Herlihy, "The American Medievalist: A Social and Professional Profile," *Speculum* 58, no. 4 (1983): 881–90; Judith M. Bennett, "Medievalism and Feminism," *Speculum* 68, no. 2 (1993): 309–31. See detailed profiles of two of these women: Dickran Kouymjian, "Sirarpie Der Nersessian (1896–1989): Pioneer of Armenian Art History," and Kathryn L. Lynch, "Laura Hibbard Loomis (1883–1960): 'Mrs Arthur,'" in Chance, *Women Medievalists*, 483–94 and 239–54, respectively.

54

Ozment, *Hroswitha Club*, 56. Mildred Abraham, "The Spirit of '76: The First Women of the Grolier Club," *Gazette of the Grolier Club: New Series*, no. 52 (2001): 31–48; "Hroswitha Club Records," *Grolier Club Exhibitions*, accessed June 4, 2023, https://grolierclub.omeka.net/items/show/975.

55

Ozment, *Hroswitha Club*, 5–6.

56

Robert Herndon Fife, *Hroswitha of Gandersheim* (New York: Columbia University Press, 1947); Anne Lyon Haight, ed., *Hroswitha of Gandersheim: Her Life, Times and Works* (New York: Hroswitha Club, 1965).

57

PML Review, 1930–1935, 13.

58

Harrsen started working at the Library in 1921 as a part-time secretary and became full-time in 1922.

59

For Franc and Farley, see *PML Review, 1941–1948*, 34. Jennifer Tonkovich, "Origins of the Drawings Department at the Morgan," The Morgan Library & Museum blog, April 13, 2021, https://www.themorgan.org/blog/origins-drawings-department-morgan.

60

Ibid.

61

Terry G. Wilfong, obituary for Elinor Mullett Husselman, *Bulletin of the American Society of Papyrologists* 33, no. 1–4 (1996): 5–10.

62

Greene to Francis Taylor, January 7, 1934, copy, ARC 3291, Box 29, Folder 11. Taylor was the director of Worcester Art Museum and a member of the advisory board of Walters Art Gallery.

63

Cablegram from Francis Taylor to Greene with names of hires and salaries, June 21, 1934, in which he boasted, "Don't tell me I ain't got no charm," of his success in persuading the trustees to pay Miner's high salary (ARC 3291, Box 29, Folder 11).

64

Greene to Mrs. Sarah Walters, December 12, 1934, ARC 3291, Box 29, Folder 11.

65

Ozment, *Hroswitha Club*, 72, 78.

66

Dorothy Eugenia Miner, *Anastaise and Her Sisters: Women Artists of the Middle Ages* (Baltimore: Walters Art Gallery, 1974).

67

PML Review, 1924–1929, 4.

68

Ibid., 111–17.

69

Erwin Panofsky, "Three Decades of Art History in the United States: Impressions of a Transplanted European," *College Art Journal* 14, no. 1 (1954): 16.

70

Sandra Hindman and Nina Rowe, "Reconstructions: Recuperation of Manuscript Illumination in Nineteenth- and Twentieth-Century America," in Hindman et al., *Manuscript Illumination in the Modern Age: Recovery and Reconstruction*, exh. cat. (Evanston, IL: Mary and Leigh Block Museum of Art, 2001), 248.

71
Heather McCune Bruhn, "The Guelph Treasure: The Traveling Exhibition and Purchases by Major American Museums," and Kathryn McKlintock, "Arts of the Middle Ages and the Swarzenskis," in Elizabeth Bradford Smith et al., *Medieval Art in America: Patterns of Collecting, 1800–1940*, exh. cat. (University Park, PA: Palmer Museum of Art, 1996), 199–202 and 203–8, respectively.

72
PML Review, 1930–1935, 10–11.

73
Greene to Taylor, January 7, 1934, copy, ARC 3291, Box 29, Folder 11.

74
"The Morgan Library: It Houses Treasures," *Life* magazine 18, no. 14 (April 2, 1945): 56–59.

75
ARC 3291, Box 68, Folder 3.

76
Wroth, "Tribute to the Library," 14.

77
Ibid.

78
Greene did not win enough votes in the ballots for fellows nominated in 1937. Dossiers on Belle da Costa Greene, Fellows-Nominations 1937 and 1938, Medieval Academy of America Archive.

79
Charles Upson Clark, professor of languages at City College, New York; Oxford University's paleographer E. A. Lowe; Walter W. S. Cook, founding director of the Institute of Fine Arts, New York; Charles Rufus Morey, founder of the Index of Christian Art at Princeton; and E. K. Rand, Pope Professor of Latin at Harvard, and cofounder and first president of the Medieval Academy of America.

80
Professor Walter W. S. Cook to Mr. G. W. Cottrell, Secretary to the Fellows, January 13, 1938, Fellows- Nominations 1938, Medieval Academy Archive.

81
Cottrell to Cook, January 15, 1938, ibid.

82
"Proceedings of the Fourteenth Annual Meeting of the Corporation: 29 April 1939," *Speculum* 14, no. 3 (1939): 398.

83
"1948 Annual Meeting," *Mediaeval Academy News*, no. 1 (September 1948): n.p.

84
Wroth, "Tribute to the Library," 29.

85
Hans Peter Kraus, *A Rare Book Saga: The Autobiography of H. P. Kraus* (New York: Putnam, 1978), 139–41. Thanks to Joshua O'Driscoll for sharing his identification of the book with me.

86
Ardizzone, *Illuminated Life*, 422, 446.

87
Ibid., 422, 446.

88
Wroth, "Tribute to the Library," 9.

89
Ibid., 10.

90
The *Times*'s Overlooked project is retroactively correcting this historical bias through a series of obituaries about remarkable people whose deaths, beginning in 1851, went unreported; https://www.nytimes.com/interactive/2018/obituaries/overlooked.html.

91
Ozment, *Hroswitha Club*, 40.

92
"Editors' Foreword," in *Gatherings in Honor of Dorothy E. Miner*, ed. Ursula E. McCracken, Lilian M. C. Randall, and Richard H. Randall Jr. (Baltimore: Walters Art Gallery, 1974), xii.

93
Kenneth John Conant, review of *Studies in Art and Literature for Belle da Costa Greene* (ed. Dorothy Miner), *Speculum* 30, no. 2 (1955): 291.

94
Cornelius Vermeule, review of *Armor and Arms* (Thomas T. Hoopes), *American Journal of Archaeology* 59, no. 2 (1955): 191.

95
Kup, review of *Studies in Art and Literature*, 366

96
Ernest Hatch Wilkins et al., "Memoirs of Fellows and Corresponding Fellows of the Mediaeval Academy of America," *Speculum* 32, no. 3 (1957): 641–49.

97
Dorothy Miner and Anne Lyon Haight, "Greene, Belle da Costa," in *Notable American Women, 1607–1950* (Cambridge, MA: Belknap Press, 1971), 2:83–85.

98
Dorothy Miner, foreword to *Art and Literature*, x–xi.

99
Jean Strouse, "The Unknown J. P. Morgan," *New Yorker*, March 22, 1999, 76–78.

100
Dorothy Kim, "Belle da Costa Greene, Book History, Race, and Medieval Studies," *Quimbandas* 1, no. 1 (December 2020): 51, https://www.scribd.com/document/502468305/11-Article-Text-64-1-10-20201231. Kim refers here to Stephanie Danette Smith, "Passing Shadows: Illuminating the Veiled Legacy of Belle da Costa Greene," PhD diss. (Dominican University Graduate School of Library and Information Sciences, 2015). See also Sierra Lomuto, "Belle da Costa Greene and the Undoing of 'Medieval' Studies," *boundary 2* 50, no. 3 (August 2023): 12–19.

101
For the IMC incident and its aftermath, see J. Clara Chan, "Medievalists, Recoiling from White Supremacy, Try to Diversify the Field," *Chronicle of Higher Education*, July 16, 2017, https://www.chronicle.com/article/medievalists-recoiling-from-white-supremacy-try-to-diversify-the-field, and the Medievalists of Color's collective statement *On Race and Medieval Studies*, August 1, 2017, https://medievalistsofcolor.com/statements/on-race-and-medieval-studies/.

102
See the academy's online statements on its Inclusivity and Diversity Prize Committee and its Inclusivity and Diversity Committee, accessed March 25, 2024, https://www.medievalacademy.org/page/IncluDiversityPrize, and https://www.medievalacademy.org/page/InclusivityDiversity.

103
In addition to Nahir Otaño Gracia, the speakers were Geraldine Heng, Cord J. Whitaker, Afrodesia E. McCannon, Wan-Chuan Kao, Kavita Mudan Finn, Dorothy Kim, and Sharon Kinoshita. Program of The 93rd Annual Meeting of the Medieval Academy of America, Emory University, Atlanta, Georgia, March 1–3, 2018, 29.

104
Campbell, "Notes from the Editor," 11.

105
Dorothy Kim, "Belle da Costa Greene," 43.

106
Ibid., 55–59.

107
Also in 2018, American collector and philanthropist Lisa Unger Baskin funded the establishment of Belle da Costa Greene Scholarships in the United States and United Kingdom, at the Colorado Antiquarian Book Seminar (CABS-Minnesota) and York Antiquarian Book Seminar. Both scholarships support booksellers or librarians from historically underrepresented communities with the goal of actively working to achieve a more diverse and inclusive community.

108
Lomuto, "Belle da Costa Greene," 4, 12, 15.

109
Ibid., 15.

110
Big Piph, "Ballad of Belle da Costa Greene," 81–82.

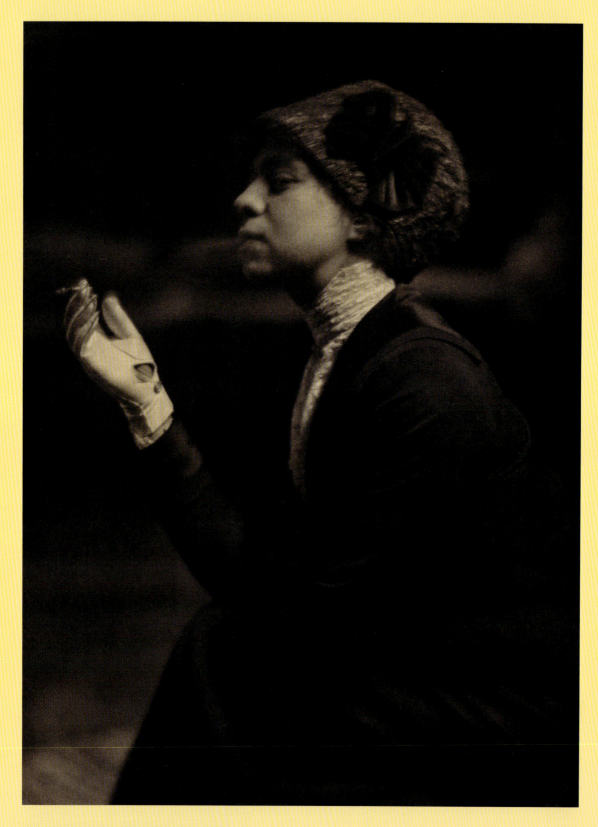

Clarence H. White (1871–1925), *Belle da Costa Greene*, 1911. Platinum print; 9½ × 7 in. (24.2 × 17.8 cm). Biblioteca Berenson, I Tatti, the Harvard University Center for Italian Renaissance Studies; Bernard and Mary Berenson Papers, Personal Photographs, Box 12, Folder 37.

Gail Levin

BELLE DA COSTA GREENE, THE STIEGLITZ CIRCLE, AND MODERN ART

Belle da Costa Greene, though working for the socially prominent J. Pierpont Morgan, often socialized in bohemian and avant-garde artistic circles in New York. She frequented the Little Galleries of the Photo-Secession, run by the art dealer and photographer Alfred Stieglitz, which came to be known as "291" for its address on Fifth Avenue. Her only signed article, a short piece in praise of 291 appearing in a 1914 issue of Stieglitz's periodical *Camera Work*, emphatically marks her place within modernist circles and registers her conflicted interest in modern art. This essay positions Belle Greene within the New York art world of the 1910s and '20s while engaging with the various perspectives on race and African art held within those circles, particularly how they reflect back on our understanding of Belle Greene.[1]

Greene's first contact with Stieglitz was in October 1909, when she was trying to track down the history of a photograph of J. Pierpont Morgan taken by Stieglitz's close associate Edward Steichen (p. 28). Stieglitz wrote in response to her inquiry that Steichen had "photographed Mr. Morgan about six years ago" and that an original photogravure was published in the *Camera Work* issue devoted to Steichen.[2] At this time Stieglitz invited Greene to "look me up some day at the Photo-Secession."[3] Months later, on December 18, after learning that there was more than one version of Steichen's portrait of Morgan, Greene invited Stieglitz to come to the Library and "possibly show me the different photographs." She added, "I think Mr. Steichen and yourself are very much to be congratulated on the impetus you have given to photography in America."[4] When, after much

delay, Steichen finally arranged to produce extra prints of his portrait of Morgan to meet his subject's demand, he corresponded directly with Greene. On January 18, 1912, she told him that she was delighted to learn that he "would be able to make me some prints similar to the one which Mr. Stieglitz showed me the other day, and which I admired immensely."[5]

Stieglitz's connection to Belle Greene is underscored by his publication of photographs of her taken by Clarence H. White, another photographer of the Stieglitz coterie, who produced portraits of Greene in 1911. By then, White's photographs had appeared in six issues of *Camera Work* and Stieglitz had devoted the entire July 1908 issue to him. From February 5 to 19, 1906, White's work was also featured, alongside the photography of Gertrude Käsebier, in the third exhibition held at 291. By the time White photographed her, Greene was a close follower of the Stieglitz circle.

We know from a letter Greene wrote to the influential art connoisseur Bernard Berenson, her friend and sometime lover, that she found Stieglitz's show of Matisse drawings (and photographs of his paintings) held in 1910 "most extraordinary."[6] Matisse's new modern style seemed so baffling that she invested two hours at the tiny gallery trying to make sense of it. Greene confessed that she achieved only a "slight glimmer of understanding" of Matisse, while the sketches she saw by Auguste Rodin (which were on hand for a subsequent show) she found easier to fathom, though not as gripping. On that occasion, she arranged to buy a photographic print of Rodin's sculpture of Balzac taken by Steichen (fig. 1). Once she had been told to expect its delivery, she wrote telling Stieglitz that it would have "the place of honor in my humble apartment," and that she was planning to visit the gallery in a few days to see the Rodin show.[7]

Greene had met Berenson in early 1909 at Mr. Morgan's Library and corresponded with him for four decades. In contrast to Greene's attraction to Stieglitz and the avant-garde in New York, Berenson was much less enthusiastic about Stieglitz, who he said "affected me although he was surrounded ten deep with cranks and professional geniuses, and *altre cose inconvenienti* [other inconvenient things]."[8] Berenson, who immigrated with his Jewish family from Lithuania but rejected his background, converted to Episcopalian while at Harvard. It has been suggested that Belle Greene and Bernard Berenson were drawn to one another in part because they were both hiding their true ethnic identities.

Greene knew that Berenson, who admired Matisse's work, had met the artist in the fall of 1908 while visiting Paris. She may have read Berenson's letter to *The Nation* of October 29, defending Matisse after a critic's derision. Berenson praised Matisse as being "singularly like" the "best great masters of the visual arts...in every essential respect....He is a magnificent draughtsman and a great designer."[9] Matisse was an enthusiasm that Berenson shared with the Stein family in Paris, who were important American expatriate art collectors. It was Sally Stein, the wife of Michael Stein, Gertrude's brother, who had introduced Berenson to Matisse. Berenson wrote to his wife, Mary, praising the

artist's "detailed feeling for design" and enthusing, "One felt in contact with a brain of astonishing vigour, entirely—alas, as I am not—absorbed by art."[10]

Berenson recalled of the letter he wrote to *The Nation* that the response made him "aware of the authority I could wield as a critic of modern art. The entire Stein family—Michael, Sally, Leo, Gertrude, who at the time arrogated to themselves the office of High Protectors of newness in painting—began to prod me to leave all I had and to dedicate myself to expounding the merits of the new school."[11] Berenson concluded that his refusal to turn to writing about modern art caused the Steins to put him down. He said that his chief reason for not writing about contemporary art was that he "dreaded the personal element in my job."[12]

On a later visit to Matisse's studio, Berenson purchased *Trees near Melun* (1901), which he loaned to London's Grafton Galleries *Postimpressionist Exhibition* in 1910. Greene herself ended up purchasing a Matisse drawing of a female nude, which was exhibited for the first time at Stieglitz's 291 gallery in March 1912, during the show *Exhibition of Sculpture—The First in America—and Recent Drawings by Henri Matisse* (fig. 2). Years later, she reportedly told a colleague that it depicted herself, seen from behind.[13] She was surely joking, since the claim that

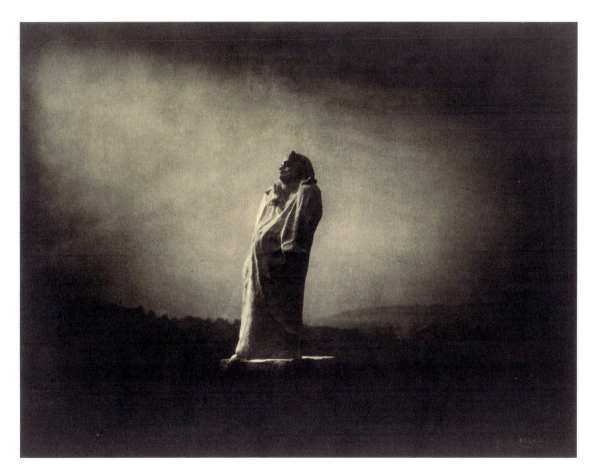

FIG. 1
Edward J. Steichen (1879–1973), *Balzac, Towards the Light, Midnight*, 1908. Direct carbon print; 14 3/8 × 19 in. (36.5 × 48.2 cm). The Metropolitan Museum of Art, New York, Alfred Stieglitz Collection, 1933; 33.43.38.

she posed for this figure does not convince: its setting and style relate closely to another Matisse work made in Tangier, where Greene never ventured.[14]

Both Greene and Berenson disliked Gertrude Stein, who wrote about Matisse in a "word portrait" in *Camera Work* in 1912. Perhaps Stein's literary modernism, with its baffling repetition and word play, was just too opaque for Greene, who knew and liked Leo Stein, Gertrude's brother, whose writing style was more traditional. Greene went so far as to write and send to Stieglitz her spoof of Stein's word portrait, which she signed "B. G. Picasso." The first page reads, "All are quite certain that for this part of her being one being living, all are quite certain knowing and this ought to be certain being being that this which she was doing, she was wrong in doing."[15]

Yet Greene is said to have owned two copies of Gertrude Stein's 1909 book *Three Lives*, both received as gifts, including one, in 1914, from her friend John

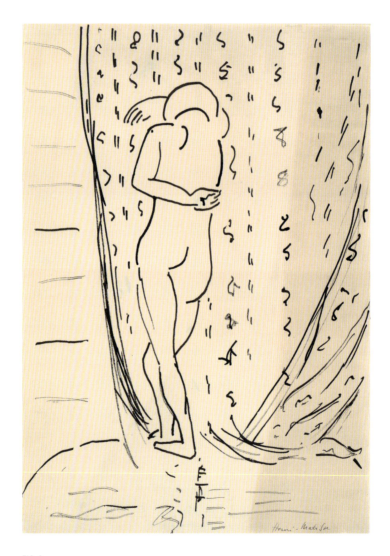

FIG. 2
Henri Matisse (1869–1954), *Nude*, 1912. Pen and ink on paper; 12⅜ × 8¾ in. (31.4 × 22.2 cm). The Morgan Library & Museum, New York, gift of the Estate of Belle da Costa Greene, 1950; 1950.14.

Lane, Stein's publisher.[16] Two of the stories in *Three Lives* are about immigrant women, and the third one, "Melanctha," is about a woman who is the daughter of a Black father and a mixed-race mother living in segregated "Bridgepoint." This investigation into mixed-race ancestry would have seemed far too risky for Greene to champion, even to discuss with others. Furthermore, Stein's prose sounds almost as if she could have been describing Greene herself: "Melanctha Herbert always loved too hard and much too often. She was always full with mystery and subtle movements and denials and vague distrusts and complicated disillusions."[17] This was far too close for comfort to Greene's reality.

Like Greene, her close friend Agnes Ernst Meyer also admired Leo Stein and dismissed his sister Gertrude.[18] That Belle met Gertrude at a party for writers on one of her visits to New York is documented by Stein's inclusion of her as a wry observer in the first chapter of her 1937 book *Everybody's Autobiography*, a kind of memoir: "We were by this time standing near a couch where Belle Greene was seated. I had never met Belle Greene before although everybody I knew knew her."[19] This scene centers on the movie star Mary Pickford, "America's Sweetheart" of the silent film era, and her willingness to pose with Stein for a newspaper photographer who is expected at the party. Belle voices skepticism that Pickford will consent to be photographed with Stein, a prediction that proves accurate, as Stein writes, "no no she said I think I had better not and she melted away. I knew you would not do it, said Belle Greene behind me."[20]

While not fans of Gertrude Stein, both Greene and Meyer were nonetheless drawn to the spirit of artistic rebellion at Stieglitz's 291. Meyer was able to have close associations with Stieglitz and others in his circle, in part through the help of her affluent husband, a principal backer of the gallery. Meyer's engagement at 291 might also reflect that diverse crowd's acceptance of her, since her daughter recorded that, after her marriage to a Jew, Agnes "was deeply hurt . . . by suddenly being touched by social discrimination in New York."[21]

Greene was friendly not only with Meyer but with several of the 291 artists, including John Marin, a newly abstract painter featured in a show at the gallery in 1912; Edward Steichen, whose photographs she respected; and the Mexican-born caricaturist Marius de Zayas, who was a close friend of Agnes Meyer. In 1910 the gallery presented a solo exhibition of de Zayas's work titled *Up and Down Fifth Avenue*, which featured caricatures of New Yorkers made as six-to-twelve-inch cardboard cutouts. Reviewing the show, the American art critic Sadakichi Hartmann described de Zayas's figures as emphasizing the physiognomist's idea that "each man has some external characteristic, an appearance, gesture, attitude, which reveals the essence of his personality."[22] Hartmann added that the new caricaturist's interest was "not in the actor but in the role the particular Thespian plays," emphasizing the theatrical aesthetic communicated by many of de Zayas's subjects for whom identity now appeared to be in flux, rather than fixed.[23] This "offered dynamic possibilities of mixing, passing, and transforming," themes that Greene knew something about.[24] Hartmann's interpretation that de Zayas focused on identity as mutable and performative as the primary

significance of his caricatures suggests that they spoke to Greene, who felt compelled to choreograph her own identity. De Zayas would go on to portray her in a caricature around 1913 (fig. 3). His somber charcoal and graphite drawing caught Greene's slender figure and her striking glamour as a fashion plate, emphasizing her stylish hat.

It was also de Zayas who arranged the Picasso show at 291 in 1911. An article at the time described Picasso as "young, fresh, olive-skinned, black eyes and black hair, a Spanish type with an exuberant superfluous ounce of blood in him."[25] Greene might have related to the idea of Picasso's "olive-skinned" complexion suggesting some heritage beyond European that was present on the

FIG. 3
Marius de Zayas (1880–1961), *Belle da Costa Greene*, 1913.
Charcoal and graphite on paper; 23⅝ × 17½ in. (60 × 44.5 cm). The Metropolitan Museum of Art, New York, Alfred Stieglitz Collection, 1949; 49.70.188.

Iberian Peninsula, since this was the logic behind her and her brother's adoption of their invented "Portuguese" middle name: da Costa.[26]

After running into de Zayas, Stieglitz, Marin, and the Canadian poet Bliss Carman, Greene wrote to Berenson in December 1913, not long after he had departed from a visit to New York, telling him how through a chance encounter, she had been drawn into an impromptu lunch with a "wild group of men." She then reported spending the rest of the afternoon with them looking at art by Picabia, Picasso, and Marin.[27]

Greene's attention to the art of Picasso in the company of Stieglitz and de Zayas had to have brought up the modernist search for what had come to be called "primitivism." In his now-iconic painting from 1907 *Les Demoiselles d'Avignon*, Picasso had drawn upon images of African tribal masks for two of the featured women. Although this perspective makes the error of presuming that the West is the dominant culture that will absorb the other, at the same time it suggests that non-Western culture offers some superior alternatives to the West.[28]

Though many critics today have dismissed this early modernist focus on the "primitive" as racist, to do so categorically is to misunderstand the term's complexity.[29] There was sometimes a complicated motivation, especially among the avant-garde. Some pursuing African art sought a utopian end in a notional "state of nature" in which they imagined that their ancestors had existed.[30] It is important to differentiate those who were early supporters of African Americans' civil rights from some of their contemporaries who were racist white supremacists. Yet even with the best of intentions, white supporters of Black people sometimes related to Black culture in ways that do not sound enlightened today.

As for Greene, she had to remain silent on the subject of African culture because of her need to conceal her Black ancestry, yet to know what she thought about her friends' pioneering promotion of African art in the West would be fascinating. She was aware that in the first half of the twentieth century, both in Europe and in America, there was a growing interest in African culture in general, especially among the intellectually curious.

Her friend Agnes Meyer, who collected African art, complained that Belle had no respect for the form: "Yesterday, I bought a hard-wood goblet, African art, at Vignier's that will make you think differently and more respectfully of Negro things forever after."[31] In fact, the probate of Greene's will contradicts Meyer's contention, documenting that Greene displayed two African wooden sculptures (each just over a foot high, but otherwise unidentified) in the entrance hall to her apartment.[32] Greene accepted the sculptures in London, in 1916, as a gift from an old friend, Charles Hercules Read, Keeper of the Department of British and Mediaeval Antiquities and Ethnography at the British Museum. Her description of them captures one of the few times she is known to have expressed admiration for African art: "He brought me two enchanting Congo wood figures the other day which I really love—They are so simply & so brazenly sculpted & with such a patina on the wood."[33]

Here Greene asserts her admiration for these African sculptures, which was independent of Berenson's opinion. He would not have approved of her new acquisition, since he disdained what he deemed exotic art—by which he meant "'primitive' tribal arts."[34] He liked to recall attending a pre–World War I exhibition of "Negro Art" in Paris at the Grand Palais: "As we were leaving I remarked that it was the beginning of a renaissance of savagery, of primitive infantilism, as the Italian Renaissance had been of Antiquity. I had no idea, however, how soon it would happen, how far it would go, and how it would carry almost all practicing artists and positively all writers with it."[35]

In the pre–World War I years, in both the Stieglitz circle in New York and across Western Europe, African sculpture had become desirable and was often collected or depicted by visually sophisticated artists—from Picasso and Matisse in Paris to Ernst Ludwig Kirchner, Max Pechstein, and Karl Schmidt-Rottluff in Berlin. Dadaists and Surrealists in Paris, during the 1910s and 1920s, collected African art and other so-called primitive art while reading Freud's *Totem and Taboo* (1913).[36] Freud suggested that certain indigenous cultures were close in psychological structure to "primitive man.... Such is our view of those whom we describe as savages...and their mental life must have a particular interest for us."[37]

Freud's psychoanalytic ideas became popular in the United States, especially after he gave a series of lectures in 1909 at Clark University in Worcester, Massachusetts. With reservations about a traditional marriage and family for herself, Greene was drawn to new ideas about adult social and sexual behavior. In 1914 she read Freud's *Interpretation of Dreams* (1899), which discussed the validity of dream phenomena as related to the "primitive" mind.[38] Greene, socializing in New York in 1914, met Freud's disciple, Dr. Paul Federn. After dining with Federn on several occasions, she considered purchasing for the Morgan collection some of Freud's papers, particularly those related to the 1909 lectures.[39] Freud offered Stieglitz and critics in his circle, like Waldo Frank or Paul Rosenfeld, concepts that related to their desire for both artistic and sexual liberation.[40]

Always in search of the new, Stieglitz organized a show of African sculpture at his 291 gallery, from November 3 to December 8, 1914, *Statuary in Wood by African Savages—the Root of Modern Art*, which he boasted was the first exhibition anywhere to present African sculpture as fine art rather than as ethnographic artifact. With the help of de Zayas, Stieglitz showed works from West and Central Africa, which he admired for what he perceived to be their spiritual and expressive qualities.[41]

Stieglitz's enlightened curiosity about new forms and other cultures stood in sharp contrast to nationalist critics like Forbes Watson, who, writing in the *New York Evening Post*, was characteristically dismissive of the exhibition. The transparency of his racism is nonetheless shocking: "'African Savage Art' is the sign at the street door of...an exhibition of statuary in wood by African savages. The word art is in large letters, for this, according to the announcement, is the

first time in the history of exhibitions that 'negro statuary' has been shown 'as art.'"[42] He complained: "The rank savor of savagery attacks the visitor the instant he enters the diminutive room. This rude carving belongs to the black recesses of the jungle. Some examples are hardly human, and are so powerfully expressive of gross brutality that the flesh quails. The origin of these works is somewhat obscure. The gallery describes them as 'the root of modern art,' and this might be admitted in the same sense that the family of apes may be called the root of modern man."[43] Watson concluded: "there can be no doubt that they convey a sense of a race of beings infinitely alien to us.... The good, familiar daylight, the friendly white faces on the street, come as a relief after this blackness."[44]

While such antagonism to African sculpture was widespread, other New York critics were won over. J. Edgar Chamberlin, in the *New York Evening Mail*, wrote that the show proved that the people who made the sculptures "are real artists, expressing a definite idea with great skill."[45] To the extent that critics began to respect makers of African sculpture as fine artists, Stieglitz achieved his victory. Charles H. Caffin, critic for the *New York American*, was also relatively accepting: "The objects, however, which are here shown do not go down to the deepest elemental expression of the savage. They represent him at a comparatively advanced stage, by which time he had evolved a very marked feeling for beauty. These specimens, when once you have got over the first impression of grotesqueness, are easily found to be distinguished by qualities of form, including the distribution of planes, texture and skillful craftsmanship that are pregnant with suggestion to one's aesthetic sense."[46] The critic Henry McBride wrote in the *New York Sun*: "The most ancient of these carven masks are the most dynamic. The eyes, lips, nostrils, project from concave surfaces in these heads as surfaces are projected in modern cubistic art. The parallel was not long in being remarked; but just who among the cubists was the first to adopt the cult for it is not known."[47]

Greene may have read these reviews, either when they came out in 1914 or were later reprinted in an October 1916 issue of *Camera Work*. Of course, she knew de Zayas, the organizer of the show, personally, so how must she have felt over lunch, or at 291, to hear him speak of "a slave race—victims of nature"?[48] It must have been even more difficult for her to read the racist rants of critics like Forbes Watson or Guy Pène du Bois, but then she was accustomed to observing racism in American society and keeping her own opinions private. While passing as white, she could not afford to do otherwise. At least in the coterie around Stieglitz at 291, she found some people with more progressive attitudes toward race in American society.

In 1914, as the war approached in Europe, Stieglitz invited some thirty people to write what "291" meant to them. Others volunteered, and in the end sixty-eight people responded to his prompt. Included in this first select group, invited by Stieglitz as one of his supporters, was Greene, who is identified in the issue as "Belle Greene, J. P. Morgan's librarian."[49] On July 10, 1914, she had received Stieglitz's letter of invitation to write for the special issue of *Camera*

Work her "*feelings* in from fifty to one-thousand words."⁵⁰ He added, handwritten in pen and ink, "With greetings, Don't refuse!" to the typed letter of request (fig. 4).⁵¹ By July 13, 1914, Greene wrote to accept the assignment and Stieglitz wrote back a personal note the next day: "You in bad grace at '291'! That's really rich. Don't you hear my laugh at such a ridiculous thought?...I think you had better come down & lunch with me. Set a day so that I can rid you of those phantasies. When will you come?"⁵² He signed: "Cordially Your old Stieglitz."

By November 1914 Greene wrote to Stieglitz apologizing that she had been preoccupied with the declaration of war in Europe and had not had time to write. She assures Stieglitz how grateful she is for all the hours that she has spent at 291 and promises that she will write her piece on the gallery.⁵³ Clearly, she was not offended by Stieglitz's recent and public embrace of African art. Greene submitted her response in January 1915 (fig. 5).

Greene's was a remarkable and generous statement of praise by someone who prized the many Rembrandt etchings and other earlier treasures that Morgan had purchased. She also seems to play on the sound of "morgue" and Morgan, her late boss who had been a leading trustee at the Metropolitan Museum of Art, which she labels "but a morgue."

In the October 1916 issue of *Camera Work* that reprinted many reviews of exhibitions held at 291 over the previous two years, Stieglitz published an essay by Marius de Zayas called "Modern Art in Connection with Negro Art," in which he credited Picasso as the discoverer of African art: "He introduced into European art, through his own work, the plastic principles of negro art—the point of departure for our abstract representation. Negro art has had thus a direct influence on our comprehension of form, teaching us to see and feel its purely expressive side and opening our eyes to a new world of plastic sensations."⁵⁴ De Zayas saw African art as correcting education's influence to make us "always connect what we see with what we know—our visualization with our knowledge, and [make] us, in regard to form, use our intellect more than our senses." He argued that, as opposed to "the naturalistic point of view, arriving at mechanical representation, Negro art has made us discover...the possibility of finding new forms to express our inner life."

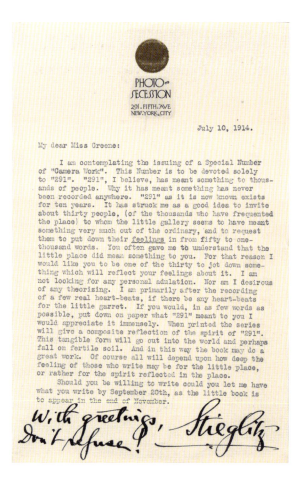

FIG. 4
Alfred Stieglitz (1864–1946), Typed letter to Belle da Costa Greene, July 10, 1914. The Morgan Library & Museum, New York; ARC 1310.

It is impossible to know if Greene shared in de Zayas's enthusiasm for African art and its expressive potential, or how she responded to the African art she saw at 291 more broadly. But it was positive enough that she did accept the 1916 gift of two African wooden sculptures and displayed them in the foyer of her apartment. Because she was concealing her Black ancestry, it must have seemed risky for her to have gotten too closely involved with collecting and discussing African culture. But there are many suggestive links between Greene and the artists of Stieglitz's coterie who did take such an interest in what moderns misguidedly labeled "primitive," despite how much value they recognized in it.

One fascinating link between Greene, the Stieglitz circle, and the "primitive" was her friendship with the American dancer Isadora Duncan, whose vanguard

291

What does "291" mean to me?—The thrills received from Matisse, from Picasso, from Brancusi? The Rabelaisian delights of Walkowitz, the glorious topsy-turvydom of Marin or the glowing sincerity of Steichen? In vain do I try to convince myself that all this is "291"—quite in vain—"291" is *Stieglitz*.

I can see you rage as you read this, dear Stieglitz. I can see that wonderful hirsute adornment of yours rise as if under the machiavellian hand of De Zayas—but you are quite helpless, you cannot apply the blue pencil—the Censor has never yet been admitted to "291."

Yes, Stieglitz, in spite of your "art stuff" you are *It*. In spite of your endless drool you are the magnet of Life.

I wish that I were able to repay you for the countless times you have so lavishly poured courage into my soul, enthusiasm into my living, and clarity into my thinking;—for the countless times I have come to you a hopeless incoherent mass, my courage like so much wet tissue paper, my mind fringed by the seeming uselessness of things, and left you an optimistic, determined and directed Endeavor.

I owe you much, Stieglitz, perhaps more than do your Satellites, for they, at least have seen the Light—they *know* that Rembrandt, Leonardo, Raphael, Velasquez and the other old fogies are weak, flabby and hopelessly defunct; *they know* that the Metropolitan Museum is but a morgue and as such should be relegated to its proper place under ground—but I, oh Stieglitz, am still groping in darkness—my eyes are still unopened—and when you are not looking, I creep back to that same Morgue, and find there, as I have at "291", the glory you radiate.

Stieglitz—I salute you.

BELLE GREENE

FIG. 5
Belle da Costa Greene (1879–1950), "291," *Camera Work*, no. 48 (July 1914): 64. The Morgan Library & Museum, New York, gift of Mrs. Herbert J. Seligmann, 1986; PML 78904.

style of art and life set her apart from propriety. Admiring images of Duncan dancing, photographed by Steichen and drawn by the painter Abraham Walkowitz, were exhibited at 291—two artists with whose work Greene did engage. Walkowitz gave Greene two drawings, one of which could be a very abstract depiction of Duncan's movement, and she corresponded with Steichen (fig. 6).[55] She shared their fascination with Duncan and even recounted to Berenson a tea that she hosted at her home in the dancer's honor in March 1911.[56]

Greene was also aware of the link between modern art and anarchism, which had been used to describe Stieglitz's aesthetics in 1914 by the activist Hippolyte Havel. Havel called the photographer and promoter of the new in art a "bombthrower" who "stands without doubt in the foremost rank. He is a most

FIG. 6
Abraham Walkowitz (1880–1965), *Human Abstract*, ca. 1913. Graphite; 17 1/16 × 11 in. (43.3 × 27.9 cm). The Morgan Library & Museum, New York, gift of the Estate of Belle da Costa Greene, 1950; 1950.22.

dangerous agitator...more than any other man he has helped undermine old institutions....An iconoclast in the realm of art, he has succeeded in shocking cruelly the moral guardians of classicism."⁵⁷ Since this discussion was published in *Camera Work* in January 1915 by Stieglitz himself, we know that he was pleased with this characterization. And it is likely that Greene (fig. 7) read this account, since it appeared alongside her own testimonial on the meaning of 291.

Anarchism briefly attracted Greene, too. She responded to ideas expressed by the California anarchist William "Big Bill" Haywood, who spoke out against the US entry into war, advocating a general strike to protest. She attended with enthusiasm his anticapitalist speech at Carnegie Hall on April 19, 1914.⁵⁸ As to what drew her to Haywood and the Industrial Workers of the World (IWW), the syndicalist labor union, which he cofounded,⁵⁹ we can consider the opinion of Mary White Ovington, who wrote in her 1913 article, "The Status of the Negro in the United States": "There are two organizations in this country that have shown they do care about full rights for the Negro. The first is the [NAACP]....The second organization that attacks Negro segregation is the Industrial Workers of the World....The I.W.W. has stood with the Negro."⁶⁰ An IWW leaflet from 1919 that would have resonated for Greene stated: "When the Negro goes to ask for work he meets systematic discrimination. Thousands of jobs are closed to him solely on account of his color. He is considered only fit for the most menial kind of occupation. In many cases he is forced to accept a lower wage than is paid to white men for the same work. *Everywhere the odds are against him in the struggle for existence.*"⁶¹

By the time Greene went to hear Haywood, J. Pierpont Morgan had been dead just over a year, since March 31, 1913. He had left Greene a generous bequest of $50,000, today's equivalent of roughly $1,500,000. Although Greene's own economic interests and future rested with the American elite, it is possible that her sudden support of this anticapitalist stance resulted from her disgust with systemic racism, particularly that of President Woodrow Wilson, whose racist statements while at Princeton, when he was the university's president and she worked in its library, she would have recalled.

Greene's brief flirtation with anarchism, however, ended forever on September 16, 1920. She was horrified when some anonymous group or person exploded a wagon with dynamite outside of J. Pierpont Morgan and

FIG. 7
William Rothenstein (1872–1945), *Belle da Costa Greene*, 1912. Red and black chalk; 12¼ × 9⁷⁄₁₆ in. (31.1 × 24 cm). The Morgan Library & Museum, New York, gift of Frederick B. Adams Jr., 1956; 1956.5.

Company, on the corner of Broadway and Wall Street. Greene was close to her boss at the time, Morgan's son, John Pierpont Jr., known as Jack, who was on holiday in Scotland on that day. However, Jack's eldest son, Junius, was among the hundreds wounded. Forty people died. Though the perpetrators were never identified, it was widely assumed to have been anarchists attacking a symbol of capitalism, especially after a stack of anarchist flyers were found in a mailbox in the vicinity (fig. 8).[62]

From the end of the nineteenth century in the United States, anarchists were often unfairly linked to Jews, probably because a few anarchists of Jewish origin such as Emma Goldman became notorious. Goldman and Berenson were near contemporaries born into Jewish families in Lithuania, both of whom immigrated to the United States, although their paths could not have been more divergent. Yet Jack Morgan's view of Berenson would have been linked to his strong dislike of Jews and this would have been apparent to Greene, who must have sensed that her boss disliked Berenson at least as much as his father, J. Pierpont Morgan, did. Jack's antisemitism was such that in evaluating his father's collection and deciding what to do with it, he stated privately that he preferred working with Fairfax Murray because of his "not being a Hebrew."[63] Jack's dislike of Jews might derive from the fact that it was a Jew, the lawyer Samuel Untermyer, who in 1912–13 led the US Congress's Pujo hearings, which investigated the role of Jack's father in a so-called money trust that held too much control over national finances—or so speculated Jack's biographer.[64]

None of the congressmen who introduced and authorized the probe, however, including Charles Lindbergh Sr. and Arsène Pujo of Louisiana, were Jewish. Still, if this explanation is accurate, it would appear as if Jack had followed a long

FIG. 8
Wall St., September 1920, from Bain News Service. Glass negative; 5 × 7 in. (12.7 × 17.8 cm) or smaller. Library of Congress Prints and Photographs Division; LC-B2- 5289-11 [P&P].

tradition in turning Jews into scapegoats, much as Henry Ford would do during the 1920s, in his antisemitic newspaper *The Dearborn Independent*, which blamed Jewish Americans for many of the nation's ills.[65]

If Jack had wanted to blame anarchists in the United States, there were some of Jewish origin, such as Goldman or Alexander Berkman, as well as Yiddish-speaking followers of leading anarchists from Pierre-Joseph Proudhon to Mikhail Bakunin or Peter Kropotkin, none of whom were Jewish. Though she found Jack supportive of her, Greene must have sensed that he would have rejected her had he known of her Black ancestry. Greene would have been aware of growing white supremacy in the United States, especially after the reorganization of the Ku Klux Klan, inspired in 1915 by the extremely popular film *The Birth of a Nation*. The new KKK spread prejudice against both Blacks and Jews, which coincided with increased attention paid to the racially biased pseudoscience of eugenics, which sought to prevent "racial mixing" in the United States, through state laws prohibiting interracial marriage.[66] But where, then, does her friend Stieglitz and his fascination with the "primitive" stand in all this racist culture in early twentieth-century America? A clue to understanding Stieglitz's personal attitudes toward race is his close association with the author and poet Herbert J. Seligmann, who, after graduating from Harvard University, worked as a journalist for such publications as *The Nation* and wrote such books as *The Negro Faces America* (1920), which denounced racist stereotypes across the United States; *Race Against Man* (1939), and *Alfred Stieglitz Talking* (1966).[67] Seligmann was active in the civil rights movement and served as publicity director for the NAACP from 1919 to 1932. In 1920 Seligmann's article "The Menace of Race Hatred" was published in *Harper's Magazine*.[68]

Stieglitz's closeness to Seligmann, who worked with him at the Intimate Gallery during the second half of the 1920s, is evident in Stieglitz's inscription to Seligmann in the inside cover of the *Camera Work* issue number forty-seven, dated July 1914, which included the feature "What is 291?" to which Belle Greene contributed her published response:

> Five years ago I asked a question: What is 291?—Before the War.—
> The replies were in form shortly after the War's beginning. There is "Peace" to-day—Victory too—they say—
>
> The doors of 291 closed two years ago—yet I sometimes wonder are they not still wide open—What is 291?—I still ask the question.—I know less than I knew five years ago—but because of some things I know a little more—
>
> For me there is no Victory—nor Defeat—just Life.—To one Struggling with it—from another—
>
> To H.S. from A.S.[69]

It was not a coincidence that Seligmann's essay for *America and Alfred Stieglitz*, the 1934 book assembled as a tribute to Stieglitz on his seventieth birthday, cites Belle da Costa Greene. Seligmann wrote about this same special issue of *Camera Work* from July 1914, which he noted, "constitutes as comprehensive and penetrating a cross-section of spiritual America as can be found." When he writes the following, citing Dodge as a radical white woman, then a Black Caribbean person, then someone who is passing, and then a Jewish banker, it may suggest that he knows about Greene's Black ancestry, but does not divulge it:

> The individual contributors to the symposium are shown in their varying grasp of the central idea, international, multi-racial in its scope. The book, opening with Mabel Dodge, ranged from the Negro elevator boy at 291, Hodge Kirnon, whose contribution is one of the clearest and most perceptive the volume contains, to J. P. Morgan's librarian, Belle Greene; from a banker, Eugene Meyer, Jr., later a governor of the Federal Reserve system, to a man in jail on Blackwell's Island, for political "crime."... All testified to the reality and vitality of the living spirit of freedom, tolerance, vital experiment which had found a home at 291.[70]

Hodge Kirnon, credited as "the West Indian Elevator Boy at 291 Fifth Avenue since 1912," wrote in his own statement, "Without losing sight of his wonderful Socratic ability, I think that Mr. Stieglitz will be obliged to plead his inconsistency this once.... What does '291' mean to me? It has taught me that our work is worthy in proportion as it is the honest expression of ourselves."

Knowing that Seligmann read the 1912 novel *The Autobiography of an Ex-Colored Man*, a fictional account of a young biracial man passing as white, first published anonymously and then claimed by its author, James Weldon Johnson, who was a friend of Seligmann's, it becomes even more difficult to believe that he did not know that Greene was passing, although if he did know, he would have empathized with her dilemma in life.

At a time of ingrained racism in American society, Greene found a welcoming coterie in Alfred Stieglitz and his circle. The gift to Greene of a 1945 book, *Isadora Duncan in Her Dances*, inscribed by the artist Abraham Walkowitz, suggests that her connection with this enlightened group continued beyond Stieglitz's activity at his last gallery, An American Place.[71] At Stieglitz's death in 1949, his widow, the artist Georgia O'Keeffe, presented Fisk University, one of the noted historically Black colleges and universities in Nashville, Tennessee, with ninety-nine works of art from the Alfred Stieglitz Collection, which was otherwise dispersed only to major urban museums, including the Metropolitan Museum of Art, the National Gallery of Art, the Art Institute of Chicago, and the Philadelphia Museum of Art. She was presumably acting on what she believed was her late husband's wishes. It is perhaps not surprising, then, that Greene perceived in Stieglitz someone with whom she could have a friendship of mutual respect and acceptance.

NOTES

I wish to thank Philip Palmer, the Morgan's Robert H. Taylor Curator and Department Head, Literary and Historical Manuscripts, and Erica Ciallela, Exhibition Project Curator, for their help with this essay.

1
To accurately portray attitudes during this era, the author quotes the authentic racialized language used at that time—despite our aversion to it today.

2
Alfred Stieglitz to Greene, October 30, 1909, Archives of the Morgan Library & Museum, ARC 1310. (Archives of the Morgan Library & Museum material hereafter cited as "ARC.")

3
Ibid.

4
Greene to Stieglitz, December 18, 1909, ARC 1310.

5
Greene to Edward Steichen, January 18, 1912, ARC 1310. See also Penelope Niven, *Steichen: A Biography* (New York: Clarkson Potter, 1997), 168.

6
The show ran from February 23 to March 8, 1910.

7
Greene to Stieglitz, April 4, 1910, ARC 1310. A little over a month earlier, Belle Greene was given a print of one of Steichen's Balzac photographs by Steichen himself. See Greene to Bernard Berenson, March 1, 1910, Bernard and Mary Berenson Papers, Box 60, Folder 6, Biblioteca Berenson, I Tatti, the Harvard University Center for Italian Renaissance Studies.

8
Bernard Berenson to William Ivins, March 4, 1928, William Ivins Papers, Archives of American Art, Smithsonian Institution.

9
Bernard Berenson, letter to the editor, *The Nation*, November 8, 1908, 422, repr. in *Brushes with History: Writing on Art from "The Nation," 1865–2001*, ed. Peter G. Meyer (New York: Thunder's Mouth Press; Nation Books, 2001), 95–96. See also Ernest Samuels, *Bernard Berenson: The Making of a Connoisseur* (Cambridge, MA: Belknap Press, 1979), 315.

10
Berenson, quoted in ibid., 66.

11
Bernard Berenson, *Sketch for a Self-Portrait* (New York: Pantheon, 1949), 44.

12
Ibid., 45.

13
Heidi Ardizzone, *An Illuminated Life: Belle da Costa Greene's Journey from Prejudice to Privilege* (New York: W. W. Norton, 2007), 274. The story originates with Greene's former library coworker Felice Stampfle, who recalled that Belle identified herself as the model in the sketch.

14
See also Sarah Greenough, *Modern Art and America: Alfred Stieglitz and His New York Galleries*, exh. cat. (Washington, DC: National Gallery of Art, 2001), 95, 496n63, which cites correspondence at Yale.

15
Greene to Stieglitz, ca. 1912, YCAL MSS 85, Box 99, Folder 2013, Beinecke Rare Book and Manuscript Library, Yale University.

16
Gertrude Stein, *Three Lives* (New York: Grafton Press, 1909), cited in Ardizzone, *Illuminated Life*, 302.

17
Gertrude Stein, "Melanctha," in *Three Lives* (1909; New York: Penguin, 1990), 62.

18
Katharine Graham, *Personal History* (New York: Alfred A. Knopf, 1997), 15.

19
Gertrude Stein, *Everybody's Autobiography* (New York: Random House, 1937), 7–8.

20
Ibid., 8.

21
Graham, *Personal History*, 17.

22
Sadakichi Hartmann, review of *Up and Down Fifth Avenue*, *Camera Work*, no. 31 (July 1910): 31, quoted in Lauren Kroiz, "Breeding Modern Art: Criticism, Caricature, and Condoms in New York's Avant-Garde Melting Pot," *Oxford Art Journal* 33, no. 3 (October 2010): 346.

23
Hartmann, review of *Up and Down Fifth Avenue*, quoted in ibid., 346. See also Lauren Kroiz, *Creative Composites: Modernism, Race, and the Stieglitz Circle* (Berkeley: University of California Press, 2012), 58.

24
Hartmann, review of *Up and Down Fifth Avenue*, 31, as paraphrased by Kroiz, "Breeding Modern Art," 337.

25
Ibid., 349.

26
The name "da Costa" is said to be Portuguese, Galician, Italian, and Jewish (Sephardic). See Patrick Hanks, Simon Lenarčič, and Peter McClure, eds., *Dictionary of American Family Names*, 2nd ed. (Oxford: Oxford University Press, 2022).

27
Greene to Berenson, December 14, 1913, Berenson Papers, Box 61, Folder 11, cited in Ardizzone, *Illuminated Life*, 308.

28
Colin Rhodes, *Primitivism and Modern Art* (London: Thames & Hudson, 1994), 13.

29
Marianna Torgovnick, *Gone Primitive: Savage Intellects, Modern Lives* (Chicago: University of Chicago Press, 1990), 12–13.

30
A. O. Lovejoy and George Boas, *Primitivism and Related Ideas in Antiquity* (Baltimore: Johns Hopkins Press, 1935).

31
Agnes Meyer to Greene, n.d. [1914], Berenson Papers, Box 84, Folder 17; Douglas Hyland, "Meyer," 43, cited in Ardizzone, *Illuminated Life*, 271, 517n60.

32
A copy of her will and its probate is at the Morgan Library. No photographs of these sculptures have yet turned up, and their present whereabouts are unknown.

33
Greene to Berenson, November 13, 1916, Berenson Papers, Box 62, Folder 20, quoted in Ardizzone, *Illuminated Life*, 359.

34
Berenson, quoted in Mary Ann Calo, *Bernard Berenson and the Twentieth Century* (Philadelphia: Temple University Press, 1994), 149.

35
Bernard Berenson, *Sunset and Twilight: From the Diaries of 1947–1958*, ed. Nicky Mariano (New York: Harcourt, Brace & World, 1963), 222; published posthumously. For his distaste of African sculpture, see also Berenson's letter from Paris in 1918 to his wife, Mary, quoted in Calo, *Berenson and the Twentieth Century*, 150.

36
See Evan Maurer, "Dada and Surrealism," in *"Primitivism" in 20th Century Art: Affinity of the Tribal and the Modern*, ed. William Rubin, exh. cat. (New York: The Museum of Modern Art, 1984), 2:535–93. Torgovnick, *Gone Primitive*, misidentified sub-Saharan African sculptures among Freud's collection of diverse objects shown in an image of the psychoanalyst at his desk in Vienna, gazing out into the distance through a row of statues. This photograph of Freud appears on the title page of his book *Totem und Tabu* of 1913.

37
Sigmund Freud, *Totem und Tabu*, translated as *Totem and Taboo* by James Strachey (New York: W. W. Norton, 1950), 1.

38
Ardizzone, *Illuminated Life*, 337; Sigmund Freud, *Interpretation of Dreams* (New York: Macmillan, 1913).

39
Ardizzone, *Illuminated Life*, 336.

40
Search-Light [Waldo Frank], *Time Exposures* (New York: Boni & Liveright, 1926), 96.

41
From December 9, 1914, through January 11, 1915, Stieglitz showed at 291 an African reliquary figure from the Kota people of Gabon together with works by Picasso and Braque and a found wasp's nest. Of all the twenty-nine

exhibitions held there, seven included examples of African art. Stieglitz clearly hoped to stimulate conversation about relationships between Western and African art and between art and nature.

42
Forbes Watson, review of *Statuary in Wood by African Savages*, *New York Evening Post*, 1914, repr. in *Camera Work*, no. 48 (October 1916): 15.

43
Ibid.

44
Ibid. Another review appeared in the mainstream journal *Arts and Decoration* by the artist and critic Guy Pène du Bois, which was reprinted in *Camera Work* and misattributed to "Réné Guy DuBois." "Personally at the exhibition of 'Statuary in Wood by African Savages,'" wrote du Bois, "we found the root of Brancusi's handicraft more directly than that of Picasso. My interest in the work of the blacks may have been increased by the previous view of Brancusi while the interest of the work of Brancusi, who happens to be a European, was entirely destroyed. It is very likely that without that grin Mr. Stieglitz would not have shown, in the works of the blacks, the ancient models of Brancusi's modern work." Du Bois seems to have imbibed literature from the eugenics movement that argued that selective breeding could improve the evolution of the human species and believed in the genetic superiority of Nordic, Germanic, and Anglo-Saxon peoples, which led some Americans to oppose immigration and support antimiscegenation laws. His review concludes with a shocking rant, stating, "we like our dogs to be thoroughbreds, to inherit physical traits from similar physics, *to have pure blood*." Guy Pène du Bois, review of *Statuary in Wood by African Savages*, *Arts and Decoration*, 1914, repr. in *Camera Work*, no. 48 (October 1916): 16; italics added.

45
J. Edgar Chamberlain, review of *Statuary in Wood by African Savages*, quoted in Richard Whelan, *Alfred Stieglitz: A Biography* (Boston: Little, Brown, 1995), 336.

46
Charles H. Caffin, review of *Statuary in Wood by African Savages*, repr. in *Camera Work*, no. 48 (October 1916): 13–14.

47
Henry McBride, review of *Statuary in Wood by African Savages, New York Sun*, repr. in *Camera Work*, no. 48 (October 1916): 15–16.

48
Marius de Zayas, untitled contribution, *291*, no. 12 (February 1916): 2, http://libserv14.princeton.edu/bluemtn/?a=d&d=bmtnaao191602-01.2.5&e.

49
Herbert J. Seligmann, "291: A Vision through Photography," in *America and Alfred Stieglitz: A Collective Portrait*, ed. Waldo Frank et al. (New York: Doubleday, Doran, 1934), 61.

50
Stieglitz to Greene, July 10, 1914, ARC 1310.

51
Ibid.

52
Greene to Stieglitz, July 13, 1914, Alfred Stieglitz / Georgia O'Keeffe Archive, Yale Collection of American Literature, Beinecke Rare Book and Manuscript Library, Yale University; Stieglitz to Greene, July 14, 1914, ARC 1310.

53
Greene to Stieglitz, November 13, 1914, Stieglitz / O'Keeffe Archive.

54
Marius de Zayas, "Modern Art in Connection with Negro Art," repr. in *Camera Work*, no. 48 (October 1916): 7.

55
Greene thanked Walkowitz for the two drawings in a letter dated February 23, 1914; Abraham Walkowitz Papers, Box 1, Folder 20, Archives of American Art.

56
Greene to Berenson, March 21, 1911, Berenson Papers, Box 60, Folder 16, cited in Ardizzone, *Illuminated Life*, 242.

57
Hippolyte Havel, untitled contribution, *Camera Work*, no. 47 (dated July 1914, published January 1915): 67.

58
Ardizzone, *Illuminated Life*, 327; Greene to Berenson, April 20, 1914, Berenson Papers, Box 61, Folder 19.

59
Syndicalist unions sought to transfer the ownership and means of production and distribution to workers' unions, not just improve conditions and wages for workers.

60
Mary White Ovington, "The Status of the Negro in the United States," *New Review*, September 1913, 747–48, quoted in Philip S. Foner, "The IWW and the Black Worker," *Journal of Negro History* 55, no. 1 (January 1970): 45. Alongside W. E. B. Du Bois and others, Ovington was a founder of the National Association for the Advancement of Colored People (NAACP), formed in 1909 as an interracial endeavor to advance justice for African Americans.

61
"Justice for the Negro: How Can He Get It," four-page leaflet produced in 1919 by the Industrial Workers of the World, quoted in Foner, "IWW and the Black Worker," 48.

62
Maria Kiriakova, "Wall Street Bombing of 1920," *Encyclopedia Britannica*, accessed August 30, 2023, https://www.britannica.com/event/Wall-Street-bombing-of-1920. Ardizzone, *Illuminated Life*, 373–74. Greene to Henri Hyvernat, October 20, 1920, Henri Hyvernat Papers, Semitics-ICOR Library, Catholic University of America.

63
As quoted in Ardizzone, *Illuminated Life*, 309. Jack wrote: "He is rather deformed, but with a fine straightforward countenance, and, not being a Hebrew, I have hope that we can get along all right together."

64
See John Douglas Forbes, *J. P. Morgan, Jr., 1867–1943* (Charlottesville: University Press of Virginia, 1981), 74, 115–17, cited in Ardizzone, *Illuminated Life*, 522n76.

65
See Neil Baldwin, *Henry Ford and the Jews: The Mass Production of Hate* (New York: Public Affairs, 2001).

66
See Tom Rice, *White Robes, Silver Screens: Movies and the Making of the Ku Klux Klan* (Indianapolis: Indiana University Press, 2015).

67
Herbert J. Seligmann, *The Negro Faces America* (New York: Harper & Brothers, 1920).

68
Herbert J. Seligmann, "The Menace of Race Hatred," *Harper's Magazine*, March 1, 1920.

69
This inscribed copy from Stieglitz to Seligmann, with the inscription dated "One day after 'Peace'—to-day—Sunday—June 29, 1919," is in the collection of the Morgan Library (PML 78904). The title page indicates the issue was published in January 1915, even though the issue is dated July 1914.

70
Herbert J. Seligmann, in Frank et al., *America and Alfred Stieglitz*, 61.

71
The object file for 1950.21 in the Morgan's Department of Modern and Contemporary Drawings contains a copy of Abraham Walkowitz's *Isadora Duncan in Her Dances* (Girard, KS: Haldeman-Julius Publications, 1945), inscribed "to Miss Belle da Costa Greene from Abraham Walkowitz."

Plates

BELLE GREENE'S PERSONAL COLLECTION

Entries by
**Juliana Amorim Goskes
Araceli Bremauntz-Enriquez
Daria Rose Foner
Jiemi Gao
Philip S. Palmer**

Laura Coombs Hills (1859–1952), *Belle da Costa Greene*, 1910. Watercolor on ivory; 5¾ × 4¼ in. (14.6 × 10.8 cm). The Morgan Library & Museum, New York, gift of the Estate of Belle da Costa Greene, 1950; AZ164.

INTRODUCTION

While the vast bulk of Belle Greene's acquisitions were made on behalf of the Pierpont Morgan Library, she also collected for herself. Thanks to her high salary she was able to purchase works ranging from Chinese sculpture and old master paintings to modern drawings and antique jewelry. She received gifts of artwork from some of her many social connections, particularly Bernard Berenson. And as an avid reader, she owned a large collection of modern and antiquarian books. Despite their potential for reflecting the range and eclecticism of Greene's personal taste, her private collections have been little explored.

The key sources documenting Greene's collection of art and books are the appraisal of her estate (conducted in July 1950) and her will (written in July 1936). Three of Belle's beneficiaries predeceased her (her mother, sister, and nephew), and since the will was never revised in the 1940s following these deaths, much of the estate passed to the Pierpont Morgan Library as the residuary legatee.[1] Paragraph six of the will empowers the estate's executors (Belle's brother Russell da Costa Greene and her lawyer Nathan Goldberger) to sell Greene's books and works of art, place the proceeds in a trust fund, and from that fund pay annuities to her mother, her sister Theodora (for the benefit of her daughter, Belle Greene Harvey), and her nephew Bobbie. Additional arrangements were made in negotiation between the Pierpont Morgan Library and Theodora to pay her a $3,600 annuity, based on an oral agreement she made with Belle in 1929.[2] There seems to have been a further agreement between the executors and the Library that it would tender these annuity payments to Theodora and Belle Greene Harvey (the trust fund was held by the Morgan bank) and manage the process of selling the contents of the estate.[3] This arrangement is evident because the Library accessioned the bulk of Belle Greene's artworks as a gift of her estate, including old master and modern drawings, a piece of Chinese sculpture, and her Persian and Islamic manuscript leaves.[4] Other works of art, presumably out of scope, were sold by the Library, including a group of eight paintings auctioned at Sotheby's on May 14, 1958.[5] The minutes of a 1951 Library staff meeting details the fate of Belle Greene's library, of which part was added to the collection, part sold (first to staff mem-

In describing this miniature painting, which was one of Greene's favorites, she wrote, "the veil which I have around me is a most wonderful glowing saffron with high lights of sunset colors in it & the background is a dull gold—It is not the Belle that you know but you will know her some day & you, I think will like her—It is the Belle of one of my former incarnations 'Egyptienne.'"

bers and then bookdealers), and part given to the Hroswitha Club, a book-collecting club for women in New York City.[6] Remaining funds from Greene's estate managed by the Library became a special acquisitions fund, the "Belle da Costa Greene Fund," which was used primarily to purchase medieval illuminated manuscripts and bindings.[7]

The following catalogue entries and plates present works of art from Belle Greene's collection that are emblematic of the range of media and time periods that interested her. Though hardly a collector on the scale of J. Pierpont Morgan or Isabella Stewart Gardner, she nonetheless used her modest wealth to express a personal style and distinctive taste through this unique collection.

—Philip S. Palmer

1
Probate record, "Belle daCosta [sic] Greene," New York County Clerk's Office, Manhattan, New York County Surrogate's Court, File No. P. 1771–1950. See in particular paragraphs 6.3 and 9 for the Pierpont Morgan Library inheriting the estate in the case of her nephew Bobbie's death; Heidi Ardizzone, *An Illuminated Life: Belle da Costa Greene's Journey from Prejudice to Privilege* (New York: W. W. Norton, 2007), 542; Frederick Adams to William Voelkle, January 25, 1996, departmental files, Literary and Historical Manuscripts and Morgan Archives.

2
Probate record, "Belle daCosta [sic] Greene"; Minutes of the Pierpont Morgan Library Board of Trustees, September 29, 1950, Archives of the Morgan Library & Museum (hereafter "ARC").

3
Neither the probate documents nor the Library's Trustees minutes shed light on the details of such an arrangement.

4
Many of these were formally accessioned on December 20, 1950 (Accession Books, Departments of Drawings and Prints). See also "Report of the Director," January 9, 1951, ARC.

5
Catalogue of Fine Old Master Drawings and Paintings, Including a Group of Gold Ground Pictures the Property of the Pierpont Morgan Library, New York (from the Collection of the Late Miss Belle da Costa Greene) (London: Sotheby, 1958). For more on this collection, see Daria Rose Foner, "Belle da Costa Greene: Morgan's Librarian as Private Collector," in *Morgan—The Collector: Essays in Honor of Linda Roth's 40th Anniversary at the Wadsworth Atheneum Museum of Art*, ed. Vanessa Sigalas and Jennifer Tonkovich (Stuttgart: Arnoldsche, 2023), 140–47.

6
Minutes of the Pierpont Morgan Library Staff Meeting, October 11, 1951, ARC. Today Belle Greene's books can be found at the Morgan Library in the Morgan Archives, Department of Printed Books, and Reference Collection; the Grolier Club, as part of the Anne Lyon Haight Papers; and other institutional and private collections.

7
Minutes of the Pierpont Morgan Library Board of Trustees, November 1, 1950, ARC; Adams to Voelkle, January 25, 1996, departmental files, Literary and Historical Manuscripts and Morgan Archives.

Initial H with the Adoration of the Magi, cutting from a 15th-century Italian choir book, Milan, Italy, second quarter of fifteenth century. The Morgan Library & Museum, New York, gift of Belle da Costa Greene, 1941; MS M.558C.

Albrecht Dürer (1471–1528), *Melencolia I*, 1514. Engraving; 9 7/16 × 7 5/16 in. (24 × 18.6 cm). The Morgan Library & Museum, New York, gift of the Estate of Belle da Costa Greene, 1950; 1950.33.

MELANCHOLY

One of the most striking and famous prints owned by Belle Greene is Albrecht Dürer's enigmatic *Melencolia I*. Greene may have first encountered the work of Dürer when she was employed at Princeton, from 1901 to 1905. The Princeton librarian and benefactor Junius Spencer Morgan owned a vast collection of Dürer prints, including *Melencolia I*, which he sold to the Metropolitan Museum of Art in 1919.[1] In an early letter to Bernard Berenson, Greene describes a recent visit to Princeton in which she spent "two delicious hours . . . looking at some splendid Rembrandt and Dürer etchings."[2]

Since Greene left no written account of the engraving, it is unclear when or from whom she acquired it. It is unknown what exactly drew her to Dürer's art or this specific print. Yet various readings of the image—as an emblem of the symptoms of Greek humoral theory, a self-portrait of the tormented creative genius, the paralysis of the imagination—align with many of the emotions that Greene experienced in her personal and professional life. Outwardly exuberant, Greene often experienced depression. Sometimes these feelings stemmed from her romantic engagement with Berenson, who himself was subject to even longer-lasting fits of depression. The distance between them was a source of sadness for Belle: "Tonight I feel desolée—some-how even you feel so far away—I have a sense of the miles between us that I have not known before—I can't even send my spirit 'singing through the spheres' to find you—I feel hemmed in—isolated and altogether blue."[3] Her job could also contribute to this feeling of melancholy:

> I have not written you for a long long time simply and solely because I have been so blue and discouraged—my life seems to be no longer my own and I no longer a "free-born" person—I spend all of my waking hours in the library, rarely leaving before 7:30 and often not until 8—after which I am too exhausted even to eat and so have been going supperless to bed lately.[4]

Dürer's winged Melancholy sits among unused instruments related to woodworking, geometry, metallurgy, and mathematics—a view of the creative imagination mired in unproductive stasis. While Belle Greene's executive function was never in doubt—as the reams of surviving business correspondence and long hours in the office stand testament—she may have noticed an affinity with the central figure of *Melencolia I* in her feelings of powerlessness. No longer feeling "free-born" and unable to "send her spirit" to Berenson, she at times seems as flightless as Dürer's grounded angel.

—Philip S. Palmer

1
The Metropolitan Museum of Art, New York; 19.73.85.

2
Greene to Bernard Berenson, March 19 and 21, 1909, Bernard and Mary Berenson Papers, Box 60, Folder 1, Biblioteca Berenson, I Tatti, the Harvard University Center for Italian Renaissance Studies.

3
Greene to Berenson, April 29, 1909, Berenson Papers, Box 60, Folder 2.

4
Greene to Berenson, October 22, 1912, Berenson Papers, Box 61, Folder 3.

Two single leaves from a Qur'an, Sultanate, India, possibly fourteenth century. The Morgan Library & Museum, New York, gift of the Estate of Belle da Costa Greene, 1951; MS M.846.4a, b.

A Native Woman (bhīl) Playing a Vina, nineteenth century.
The Morgan Library & Museum, New York, gift of the Estate of Belle da Costa Greene, 1950; MS M.849.2r.

MARRIAGE PORTRAIT

This sumptuous portrait by the celebrated Italian Baroque painter Lavinia Fontana depicts an as-yet unidentified woman dressed in material splendor.[1] Illustrated three-quarter length and slightly turned away from the picture plane, she averts her eyes from the viewer and pets a lapdog. Her fine clothing and extravagant accessories display her material wealth and elite status.

The woman's spectacular red velvet overdress, adorned with gilt-thread embroidery and fringed velvet strips, has a skirt that opens at center below her waist. Her undergown, of white and pink brocaded silk (or damask brocaded in silver and gold gilt), is similarly luxurious. The sitter is further adorned with several pieces of jewelry. She wears rings of gold and possibly agate on both little fingers and a gold earring hangs from her ear. Two necklaces sit on either side of her gown's standing collar. Around her neck, suspended from a highly embellished *collare*, hangs a gold pendant cross seemingly embedded with emeralds. A gold and pearl strand is fastened on her chest with another elaborate pendant set with an emerald, ruby, and three hanging pearls. Similarly ornate clusters of pearls and gems ornament her hair, fashioned in a braid that is wound with pink ribbons. One can imagine the demure sitter's costume and accessories appealing to Greene, who herself wore "sweeping Renaissance gowns with matching jewelry" and whose taste in Fortuny gowns, fur coats, and Cartier jewelry was an integral part of her persona.[2]

Further distinguishing the sitter's elite social position is the opulent *zibellino*, or marten fur, the jeweled head of which hangs from a gold chain that attaches to a richly encrusted girdle around her waist. The inclusion of the marten, at the time associated with fertility, childbirth, and chastity, has in part led recent scholars to propose that the painting was commissioned as a marriage portrait, in which the elaborate clothes and jewelry provided pictorial representations of the bride's trousseau—an ironic association for a woman like Greene, who, though she entertained a number of suitors, never married. At one point she even declared that marriage "is the one pitfall that is lurking for me somewhere & of course I shall avoid it as long as I have eyes to see & ears to heed warnings—above all else it will be the ruination of my career."[3]

This portrait was among eight Italian paintings from Greene's collection that became the property of the Pierpont Morgan Library and were subsequently sold at Sotheby's, London, in 1958.[4] While it remains unknown how Greene acquired this work, Bernard Berenson likely played a part, as he had for the other Italian paintings in her small but significant collection.[5] The most valuable item in Greene's estate, the painting, identified as a portrait of the Duchess of Mantua by Parmigianino, was appraised for $25,000.[6] Both the identification of the sitter as Leonora de' Medici, Duchess of Mantua, and the work's attribution have since been revised, with the correct attribution to Fontana first appearing in the 1958 Sotheby's sale catalogue.[7] The painting subsequently featured in Ann Sutherland Harris and Linda Nochlin's groundbreaking exhibition *Women Artists: 1550–1950*.[8]

—Daria Rose Foner

1
See Vera Fortunati, ed., *Lavinia Fontana of Bologna, 1552–1614*, exh. cat. (Milan: Electa, 1994), 64, cat. no. 8.

2
Dorothy Miner and Anne Lyon Haight, "Greene, Belle da Costa," in *Notable American Women, 1607–1950* (Cambridge, MA: Belknap Press, 1971), 2:84.

3
Greene to Bernard Berenson, August 3, 1909, Berenson Papers, Box 60, Folder 4.

4
See Greene's will, sixth stipulation; The Morgan's 1951 Director's Report to the Trustees; Internal Staff Report, July 1–December 1, 1957. The paintings were designated "The Property of the Pierpont Morgan Library, New York, From the Collection of the Late Miss Belle da Costa Greene." London, Sotheby's, May 14, 1958, lots 60–67. The present painting, lot 67, sold for £250 to "Cooke."

5
On Greene's collection of Italian art, see Foner, "Belle da Costa Greene: Morgan's Librarian as Private Collector," in Sigalas and Tonkovich, *Morgan—The Collector*, 140–47. According to an internal memo, the painting cost 30,000 francs (or about $4,000) in 1907. "Proposed Sale of Paintings from Estate of Belle da Costa Greene," November 14, 1957.

6
"Report of the Appraiser, filed 22 August 1951," in probate record for Belle da Costa Greene, New York County Clerk's Office.

7
Prior to the sale, the work was considered "possibly by Sofonisba Anguissola," as indicated in the internal memo "Proposed Sale of Paintings." See Anne Sutherland Harris and Linda Nochlin, *Women Artists: 1550–1950*, exh. cat. (Los Angeles: Los Angeles County Museum of Art; New York: Alfred A. Knopf, 1976), 113n24.

8
Ibid., 113, cat. no. 6.

Lavinia Fontana (1552–1614), *Marriage Portrait of a Bolognese Noblewoman*, ca. 1580. Oil on canvas; 45¼ × 35¼ in. (114.9 × 89.5 cm). National Museum of Women in the Arts, Gift of Wallace and Wilhelmina Holladay; 1986.77.

PERSIAN CALLIGRAPHY

This calligraphic leaf is but one example from Belle Greene's collection of Arabic and Persian manuscripts. Among the many important acquisitions that Greene made professionally on behalf of J. Pierpont Morgan was the purchase, in 1911, of Charles Hercules Read's album of Indo-Persian miniatures, when Morgan himself was not "particularly interested in Persian art."[1] But she also amassed a small personal collection. Her excitement for Islamic Persian materials transpires in a letter to Bernard Berenson, dated February 18, 1913, when she wrote about having purchased "six wonderful Persian miniatures," which may correspond to two sets of three Indian miniatures with Persian calligraphy backings originally part of her estate (now MSS M.848.1-3 and M.849.1-3).[2] No epistolary evidence exists for the purchase of the majority of her collection, which comprised primarily textual specimens, including several leaves of Persian calligraphy like the present leaf. It is probable, however, that they were also purchased in the early 1910s as the Western market for Persian book arts bloomed.

This flourishing was closely associated with the 1910 exhibition *Ausstellung von Meisterwerken muhammedanischer Kunst* in Munich, the first in the continent to be dedicated solely to "Muhammedan art" in various media. Greene visited this show with Berenson and it was there that she first saw leaves from the Read Album. The halls were populated primarily by private collections from across Europe, and Persian styles were over-represented. The reason behind this imbalance lay in the intense political crisis for the ruling Persian Qajar dynasty, which led to the dispersal of royal collections between 1905 and 1911 and their acquisition primarily by European dealers and collectors.

Audiences unfamiliar with the Persian language consumed these handwritten artifacts as an aesthetic experience in a way that was not completely foreign to their intended appreciation. Indeed, in Arabic and Persian traditions, calligraphic specimens were valued for both the texts and the way in which they were written and adorned. Here, the close connection between form and content is highlighted by the various uses of nastaliq, the gently downward-slanting script employed throughout this specimen. This type of script was developed in the Indo-Persian region beginning in the fourteenth century and is intimately associated with Persian poetry. The central panel, with its textured background, is the early work of Persian calligrapher Asad-Allāh Shīrāzī, who would come to represent the revival of this art in the second half of the nineteenth century. The rectangular panels above and below this area (containing verses from Sufi Abudallah Ansari of Herat's *Munajat Namah*, or "Dialogues with God") predate the composition of this specimen and may have been culled from a full manuscript or a decorative piece. Reuse is not unusual for Persian calligraphy pieces. Here the collage also concerns the blue, mustard, and pink borders, as well as the smaller cartouches in the corners: each represents a different paper added to the composition.

—Juliana Amorim Goskes

1
Greene to Charles Hercules Read, June 1, 1911, ARC 1310, R-Read.

2
Greene to Bernard Berenson, February 18, 1913, Berenson Papers, Box 61, Folder 6.

[Calligraphy], commissioned for Muhammad Shāh Qājār and
written by Asad-Allāh Shīrāzī, 1841. The Morgan Library & Museum, New York,
gift of the Estate of Belle da Costa Greene, 1951; MS M.846.5.

Jean Pillement (1728–1808), *Chinoiserie: Fisherman with Two Nets*, eighteenth century. Colored chalks; 14 1/16 × 9 1/2 in. (35.7 × 24.1 cm). The Morgan Library & Museum, New York, gift of the Estate of Belle da Costa Greene, 1950; 1950.16.

CHINOISERIE

This eighteenth-century drawing of a fisherman in a verdant landscape is one of three that belonged to Belle Greene. Each vignette combines arabesque and rococo ornamental elements with imagined Chinese themes for audiences in France and across Europe. In 1771, this drawing and eleven similar scenes by Jean Pillement were engraved by Jean Jacques Avril and printed in reverse as part of an album for collectors, *Suite de douze Pêcheurs et Chasseurs*. These motifs were further transformed into a series of wool and silk tapestries woven at Aubusson. Decorative designs featuring Asian influences, known as chinoiseries, were one of Pillement's specialties since 1754. This drawing was likely done after Pillement completed the chinoiserie-themed room at the Ujazdów Palace in Warsaw for the King of Poland in 1765–67. Throughout his career, Pillement was commissioned to decorate royal spaces, and he eventually served as court painter to Marie-Antoinette in Versailles. At the same time, he popularized chinoiseries and made these objects affordable to a middle-class audience by creating new ways to print his designs on fabric and by collaborating with printers in Paris to produce illustrated suites.

European chinoiserie was a material expression of global interactions of the seventeenth and eighteenth centuries. It was popularized and shaped by events like the Siamese embassy to Versailles in 1686, a diplomatic effort that introduced technologies, artworks, fashion, and new customs to the French imagination. Likewise, published and illustrated travel accounts, including most notably the work of Dutch traveler Johan Nieuhof, circulated views of Asia across Europe. While Pillement never traveled outside of Europe, he drew from printed material and decorative objects made in Asia in this era of global trade.

William M. Ivins Jr., the Morgan's honorary curator of prints in the 1940s (who had served as the inaugural curator of prints at the Metropolitan Museum of Art since 1916), was a friend and close correspondent of Greene's. His description of Pillement's work, published in 1926, is equally applicable to Greene's trio of drawings: "Barques of flowers and leaves pursue their courses in flat defiance of all rules of physics and experience. Chinamen fish from pagodas perched on ladders rising from the most fragile of petals."[1] In 1941, Greene lent this drawing to the exhibition *The China Trade and Its Influence* at the Metropolitan Museum of Art, where it represented the French response to trade with China alongside textiles and decorative arts.

In the twentieth century, Chinese art and chinoiserie were avidly collected in New York, and motifs from these works became fashionable and informed emerging modernist aesthetics. For example, Buddhist sculpture and chinoiserie provided a model for Gertrude Vanderbilt Whitney's image of modern womanhood in her 1914 limestone self-portrait *Chinoise*. For Greene, these drawings were certainly valued for Pillement's historical significance, and they might also have been important for her self-fashioning. Greene's acquisition of Pillement's chinoiserie designs, along with Chinese sculpture (see p. 207) and ceramics, reveal that she was at the forefront of taste when it came to the vogue for collecting Chinese art and European artists' historic response to it.

—Araceli Bremauntz-Enriquez

[1] William M. Ivins Jr., "Jean Pillement," in *Prints and Books: Informal Papers* (Cambridge, MA: Harvard University Press, 1926), 312.

BODHISATTVA HEAD

This sculpture of a bodhisattva head is thought to have come from one of the two main groups of Buddhist cave temples known as Xiangtangshan, or the "Mountain of Echoing Halls," located three hundred miles southwest of Beijing in Hebei Province. Eleven of the caves can be dated to the short-lived Northern Qi dynasty (550–577), where the large-scale construction of such Buddhist worship and cultural centers was sponsored by the royal family and government officials. Excavated from limestone and filled with stone sculptures and Buddhist inscriptions, the caves contained, according to German art historian Ludwig Bachhofer, "the most majestic sculptures China ever created."[1]

Carved from limestone, with traces of paint on the surface, the bodhisattva head originally belonged to a full-length statue of Mahāsthāmaprāpta (Dashizhi), as indicated by the vase in the center of the crown. Mahāsthāmaprāpta is one of the Eight Great Bodhisattvas of Mahayana Buddhism representing the power of wisdom, and the figure is thought to originally have been part of Southern Cave no. 1. The head was likely removed after 1909, near the end of the Qing dynasty in China, which was overthrown in 1911. Several heads from the caves were sold then for ten Chinese yuan apiece to art dealers like Ching-Tsai Loo (C. T. Loo). The earliest record of the Xiangtangshan pieces entering the Western market was in the April 1914 issue of *Burlington Magazine*, and eight full-size statues were rumored to have sold for thousands of dollars apiece. The American archaeologist and collector George Byron Gordon bought three heads for $60,000 total.

As Gordon's purchase indicates, Chinese art was in vogue. In fact, for decades J. Pierpont Morgan had been an avid collector of Chinese art, living with a wide range of objects in his home, from ancient Shang sculpture to eighteenth-century ceramics made for the export market. Following Morgan's death in 1913, Belle Greene first made mention of an interest in Chinese antiquities in a letter of March 1914 to Bernard Berenson: "I went to see a small Chinese pottery show at the Montross Gallery...a large stone Buddha head which I rather liked.... The asking price is $1500."[2] Further encouragement may have come from Greene's friend Charles Lang Freer, a prominent collector of Chinese art who later established one of the earliest houses of Asian art. Greene cultivated social relationships with many of the leading dealers of Asian art in New York, including the Japanese antiquarian Yamanaka Sadajirō, Sonying, and C. T. Loo. Greene remarked in another letter to Berenson, "I like Loo very much and also his little French wife—whenever I have a spare hour I run up there & talk with him."[3] Given Loo's personal interest in developing sculpture as a "new line of art," it seems likely that Greene bought this bodhisattva head from his New York gallery around 1915–16; however, no record of the purchase has been found.

The fine quality of the Xiangtangshan sculptures continues to be admired at many academic institutions, galleries, and museums around the world. In 2010 the Smart Museum of Art at the University of Chicago hosted an exhibition, *Echoes of the Past*, based on the findings of the Xiangtangshan Cave Project, featuring thirty sculptures and digital reconstructions of the cave interiors that aimed to convey the significance and grandeur of Hebei's sixth century Buddhist cave temples. That the caves were a place of meditation and religious worship raises the question of how Greene interacted face-to-face with this god of wisdom and the other Buddhist sculptures that adorned her private apartment.

—Jiemi Gao

1
Ludwig Bachhofer, *A Short History of Chinese Art* (New York: Pantheon, 1946), quoted in Katherine R. Tsiang and Richard A. Born, *Echoes of the Past: The Buddhist Cave Temples of Xiangtangshan*, exh. cat. (Chicago: Smart Museum of Art, University of Chicago, 2010).

2
Greene to Bernard Berenson, March 14, 1914, Berenson Papers, Box 61, Folder 16.

3
Greene to Berenson, February 17, 1916, Berenson Papers, Box 62, Folder 16.

Head of a Bodhisattva (Mahāsthāmaprāpta), Northern China, Northern Qi dynasty, 550–77. Limestone with partial polychrome; 13 3/8 × 8 3/8 × 8 5/8 in. (34 × 21.2 × 21.9 cm). The Morgan Library & Museum, New York, gift of the Estate of Belle da Costa Greene, 1949; AZ075.

Anonymous, Italian School, *Male Figure Approaching a Ruler, in a Courtyard*, sixteenth century. Pen and brown ink, brown wash, over stylus indentations; 13¼ × 10¼ in. (33.7 × 26.1 cm). The Morgan Library & Museum, New York, gift of the Estate of Belle da Costa Greene, 1950; 1950.28.

Bernard Berenson gave Belle Greene this work in 1912, and while waiting for it to arrive she wrote to Bernard, "You can imagine how wildly excited I am at the thought of having it."

Bernardo Daddi (ca. 1280–1348), *Madonna and Child Enthroned with Saints John Gualbertus, John the Baptist, Francis and Nicholas*, ca. 1334. Tempera and tooled gold leaf on panel; painted surface: 14¼ × 8¼ in. (36.2 × 21 cm); panel: 18 × 9⅝ in. (45.7 × 24.4 cm). The Norton Simon Foundation; F.1970.06.2.P.

German Pendant with a Personification of Fortitude, ca 1600.
Gold, enamel, diamonds, rubies, and pearls; 5 in. (12.7 cm). Walters Art Museum,
gift of the Trustees of the Pierpont Morgan Library in memory of
Miss Belle Da Costa Greene, 1951; 44.622.

FORTITUDE

The only property from Belle Greene's estate specifically bequeathed to the Pierpont Morgan Library was her "antique pendants, jewels, [and] boxes…to dispose of as they see fit and to use the proceeds as they see fit, for the benefit of the Pierpont Morgan Library."[1] Greene's modern jewelry, including a "diamond and platinum watch and chain with initials 'B.G.'" and a "gold mesh bag with gold chain, with name 'Belle' on bag, in diamonds," were left to her niece, sister, nephew, and sister-in-law. While these pieces have not been traced, several examples of her antique jewelry are held in museum collections, including a pair of Byzantine earrings at Dumbarton Oaks and a striking Medusa cameo at the Metropolitan Museum of Art.[2] She also owned this seventeenth-century German pendant—made with enameled gold, diamonds, rubies, and pearls, but also later embellished with a chain and other elements in the nineteenth century.[3] The piece features a woman riding a stag, most likely a personification of fortitude.

The pendant was a gift to the Walters Art Museum in Baltimore from the Morgan in 1951, but the archives document how Greene had selected the piece for the Walters—an institution with whom she had enjoyed a relationship for years—before her death. Greene was asked in 1934 to serve on an advisory committee for the newly created Walters Art Museum, and that same year recommended the Morgan's cataloguer Dorothy Miner for a librarian position at the Walters.[4] Greene and Miner kept in close contact after her move to the Walters, and a year before Greene's death the two discussed the possibility of a gift of her jewelry to the Baltimore museum:

> B.G., as you know, on her last visit here in the spring of 1949, went all over our Renaissance jewels to see if she possessed any that would be fitting additions to the wonderful ones that Mr. Walters had gathered. This one surely is—and it comes not only as a cherished souvenir of the long friendship of B.G. for the Gallery, but as a visible token of the special bond that has linked the Walters Gallery with the Morgan Library ever since we started out as a public institution in 1934.[5]

In its afterlife the piece clearly became symbolic of this institutional bond. But as jewelry that was once in Belle Greene's possession—though we have no documentation of its acquisition or how often she wore it—it is tempting to read the pendant emblematically, as an outward expression of Greene's own fortitude in the face of racism, sexism, global conflict, and personal tragedy.

—Philip S. Palmer

1
Probate record, "Belle daCosta [sic] Greene," New York County Clerk's Office, Manhattan, New York County Surrogate's Court, File No. P. 1771–1950, Paragraph 11.

2
Dumbarton Oaks, Washington, DC; BZ.1952.7.1-2. The Metropolitan Museum of Art, New York; 2003.431.

3
Pendant with a Personification of Fortitude, the Walters Art Museum Online Collection: https://art.thewalters.org/detail/29648/pendant-with-a-personification-of-fortitude/.

4
ARC 3291, Box 29, Folders 11–12, and Box 71, Folders 1–2. For more on Miner, see this volume's essays "Belle Greene as Director: Transitions" by Erica Ciallela and Philip S. Palmer and "The Ballad of Belle da Costa Greene: Librarian as Medievalist" by Anne-Marie Eze.

5
Dorothy Miner to Fred Adams, June 26, 1951, ARC 3291, Box 70, Folder 16.

Benedetto Pistrucci (1784–1855), *Head of Medusa*, 1840–50 (cameo), ca. 1860 (mount). Red jasper mounted in gold with white enamel; 2 11/16 × 2 11/16 in. (6.8 × 6.8 cm). The Metropolitan Museum of Art, New York, purchase, Assunta Sommella Peluso, Ada Peluso, and Romano I. Peluso Gift, in memory of Ignazio Peluso, 2003; 2003.431.

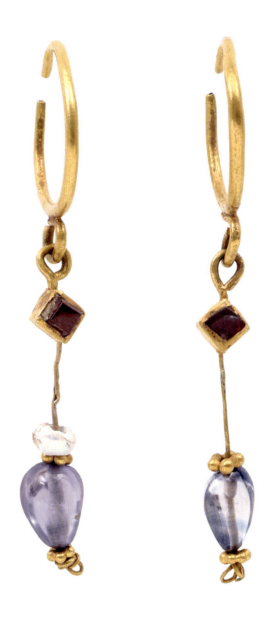

Pair of Earrings with Pearls, Sapphires, and Gold Globules, early fifth century. Gold and gems; 2¾ in. (7 cm). Dumbarton Oaks Research Library and Collection, purchased from the Pierpont Morgan Library, 1952; BZ.1952.7.1-2.

Everett Shinn (1876–1953), *Reclining Female Nude Seen from the Back*, 1904. Red chalk; 6½ × 15 13/16 in. (16.5 × 40.1 cm). The Morgan Library & Museum, New York, gift of the Estate of Belle da Costa Greene, 1950; 1950.20.

Arthur B. Davies (1862–1928), *Reclining Female Nude with Hand under Her Chin*, nineteenth century. Pastel with graphite; 6½ × 12½ in. (16.5 × 31.8 cm). The Morgan Library & Museum, New York, gift of the Estate of Belle da Costa Greene, 1950; 1950.32.

Clara Tice (1888–1973), *Anteater*, twentieth century. Opaque watercolor over graphite; 11 × 16 in. (28 × 40.5 cm). The Morgan Library & Museum, New York, gift of the Estate of Belle da Costa Greene, 1950; 1950.35.

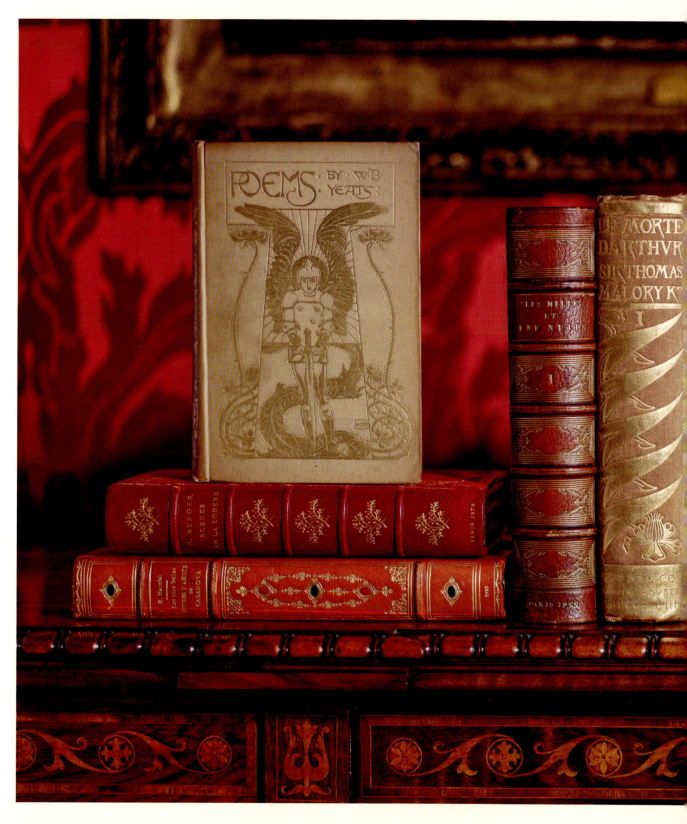

The books shown here were either owned by Belle da Costa Greene, favorite literary works of hers, or titles that appear in her estate inventory but have not been traced today in specific copies she owned.

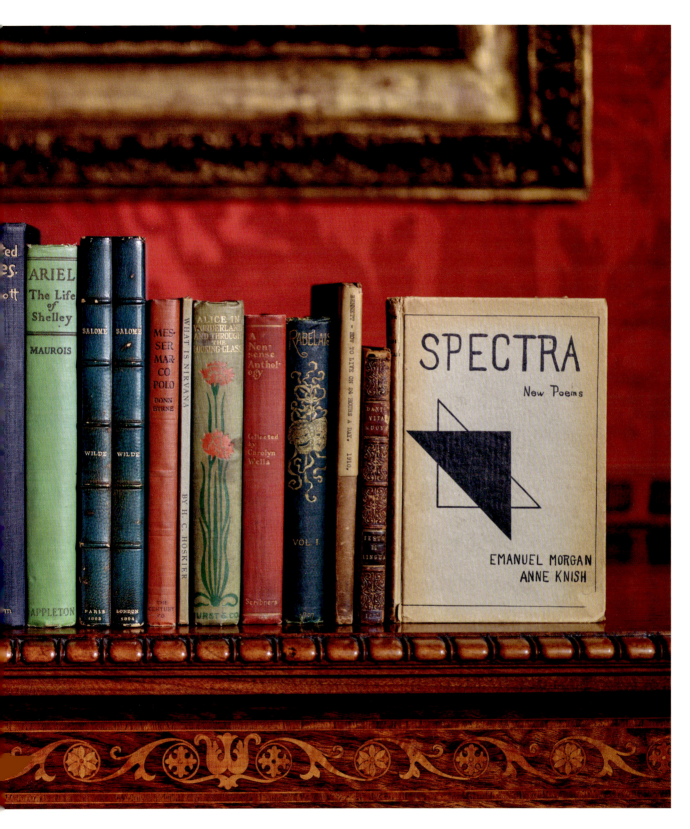

A Belle da Costa Greene Bookshelf, various titles and years of publication.
The Morgan Library & Museum, New York.

Adolph de Meyer (1868–1946), *Belle da Costa Greene*, 1912.
Platinum print; 17 9/16 × 14 1/4 in. (44.6 × 36.2 cm). The Morgan
Library & Museum, New York; ARC 1664.

Erica Ciallela
and Philip S. Palmer

BELLE GREENE AS DIRECTOR:
TRANSITIONS

With the death of J. Pierpont Morgan in March 1913, Belle Greene's world was turned upside down. Questions abounded: What would happen to the collection? Would Morgan's son, Jack (fig. 1), share his father's enthusiasm for building its holdings? And most importantly for Greene, would she still have a job? Greene had wanted nothing more than to be a librarian. She had put in the time and training and was excelling in her position. Her work since 1905 with Pierpont Morgan's library, which at the time was still a private collection, was gaining attention; scholars from around the world were requesting access to what was becoming a preeminent collection of art and literature. Between 1913 and 1918 Jack Morgan leaned on Greene as his father's estate was settled and the fate of the collection was decided. It was during this period of uncertainty and change that the professional relationship between Belle Greene and Jack Morgan was forged.

Belle Greene received "fully three hundred" letters of sympathy after Pierpont's death, an outpouring that prompted her to remark on how "he could draw out the best in everyone."[1] Although she was concerned about her uncertain future, she received early support from Pierpont's nephew, Junius Spencer Morgan, who encouraged her "to just sit tight for a year or so," as well as more than one job offer: "They are all mighty good to me—and it's fine to feel that it is now on my own account—and not because I'm tagged (or was tagged rather) to a big man."[2] But she was not yet ready to move on from the Library (fig. 2), and indicated her ambitions less than two months after Pierpont's passing: "If

I can make a big institution out of it . . . to see what I can do to make it a dernier [French: "last"] resort for scholars in certain fields, to make our material available to them and to make them welcome here."[3] Before she could realize these ambitions, however, the fate of Morgan's collection hung in the balance and there was much work to do.

By this time Jack was keenly aware of the respect his father had for his librarian, and he frequently deferred to her opinion when deciding which objects would stay and which would be sold in these early transitional years. This respect was put to the test when Greene wrote to Jack in October of 1913 about the possibility of selling off parts of the collection to create funds for future acquisitions. "I wonder if you will think me impertinent, if I suggest that a number of art objects here, could be sold (and yet in no way spoil the appearance of the Library) to the extent of $750,000.00, which amount at a fair rate of interest would yield $30,000.00, annually, and make the Library in a way, self-supporting."[4] Jack's subsequent dispersal of his father's art collection, much as Greene suggested, foreshadowed their working relationship over the next thirty years.

Rumors about the collection's future quickly circulated after Pierpont Morgan's death, with dealers telling Greene they were "saving their money, for the great Morgan sale."[5] Portions of the collection needed to be sold to fund Morgan's bequests and pay off New York inheritance tax. After Greene completed an initial inventory, the sales started in 1915 with Pierpont's collection of Chinese porcelains, which was purchased by the Duveen Brothers for $3,000,000.[6] Greene drove a hard bargain, remarking to Berenson, "I won't let it go for a cent under three and if they don't buy I'll sell it to another man and put them (the Duveens) out of the Chinese Porcelains market for good and all."[7] The following month Morgan sold the famous set of panels comprising Jean Honoré Fragonard's *Progress of Love* series for $1,250,000, again to the Duveens, who sold the works to Henry Clay Frick.[8] A few days before this sale, Greene once more expressed her unwillingness to bargain with dealers: "all I can think of now is selling the collection advantageously—It's easy enough to sell it—but I want—and insist upon 50 to 100% profit on the cost price, sometimes more—and I'll get it or leave the stuff where it is for a couple of years more."[9]

In the wake of these sales, Greene received letters expressing hope that the Library would

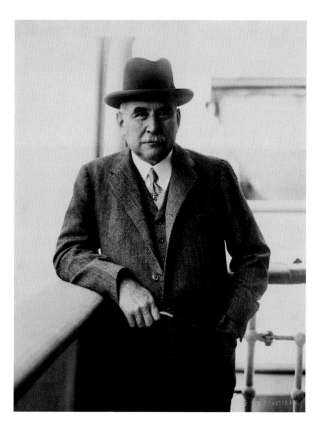

FIG. 1
Portrait of J. P. Morgan Jr. aboard *S. S. Mauretania* upon his arrival from the Paris Reparations meeting, 1929. Photographic print; 10 × 8⅛ in. (25.4 × 20.6 cm). The Morgan Library & Museum, New York, gift of Henry S. Morgan, 1955; ARC 2690.2.

stay together. "Whatever the fate of the collections of Mr. Morgan," wrote the French dealer and collector Arthur Sambon in July 1915, "try to persuade him to keep always intact the Library. It is a glory that must not go out of the family. Never again could it be put together. Its dispersion would be a calamity."[10] Sambon's words express not only the public's interest in the collection but the idea that Greene may have had some say over what would become of it. Two additional major gifts of artwork from Pierpont's collection, both made in 1917, are worth noting: one to the Metropolitan Museum of Art, forming the core of the museum's medieval holdings, and the other, of decorative arts, to the Wadsworth Atheneum.[11] Several areas of the original collection, including medieval objects, coins, and Asian artifacts, were also sold to dealers or institutions. Importantly, however, Jack Morgan decided to keep the Library's collections—the books, manuscripts, and works on paper—intact.[12]

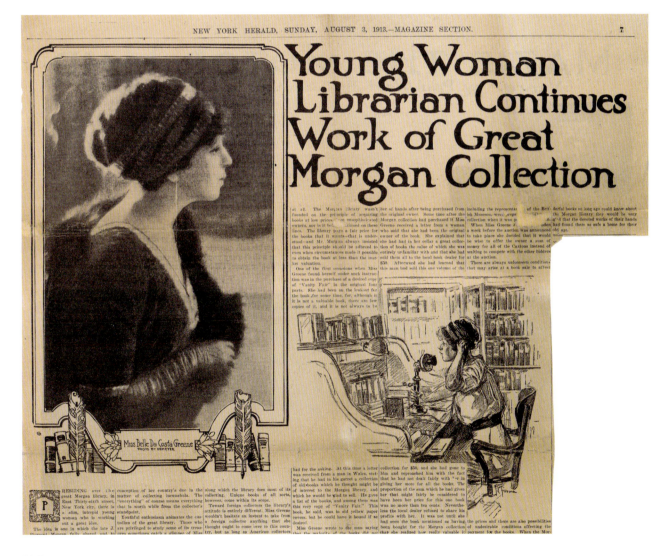

FIG. 2
"Young Woman Librarian Continues Work of Great Morgan Collection," *New York Herald*, August 3, 1913. With reproduction of a photograph by Adolph de Meyer (1868–1946). The Morgan Library & Museum, New York; ARC 3295.

Jack's decisions proved favorable to Greene, who was committed to the foundations established by Pierpont: "Is it not splendid that he is following so beautifully in the footsteps of his illustrious Father and making that great name even stronger and greater?"[13] Throughout her career, Greene credited the Morgans for the growth and achievements of the Library, even though they relied heavily on her opinions, labor, and knowledge, placing the day-to-day management of the institution squarely on her shoulders. Between 1913 and 1924 Greene and Jack Morgan formed a rapport built on mutual trust in which she could freely share her thoughts and ideas on the direction of the Library. In contrast with her trusting friendship with "my Mr. Morgan" (as Greene described Pierpont), her relationship with "this Mr. Morgan" was initially marked by formality and had to be cultivated and developed over time. In these transitional years, Greene and her new boss had to learn to understand one another, even if it meant working through tensions and disagreements.

"J.P.M., jr, and I get along better every day," Greene wrote Berenson in August 1913, only a few months after Pierpont's death: "he is most, most flattering and tremendously kind, even to having his motor stationed at the door at night ready to take me home whenever I leave. . . . I think he will be amenable—Who knows?"[14] A few months later Greene's opinion of her boss had clarified, and she now had "rather mixed" impressions of Jack:

> I steel myself against him, but all the time there are little devils tugging at me and pointing out to me charming traits in him . . . he was overwhelmingly flattering and gracious and I could not really understand it because hitherto it had been a sort of armed neutrality between us. . . . As regards his own affairs, he is as stubborn and stupid a person as I ever met—and trying to save him from himself seems well nigh a hopeless job.[15]

During these months after Pierpont's death, Greene was learning more about Jack's knowledge of the collection, his enthusiasms, and his priorities. She seems guarded against his flatteries yet also susceptible to his charms; she notes his inexperience but signals her desire to collaborate despite his faults. Yet these two strong-willed individuals were not afraid to speak their minds. In one instance, Greene recounts to Berenson a time when Jack abruptly decided to close the Library, ostensibly to create a private space for "business conferences." But Greene tells a different story.

> J.P. (I hate him!) says that he wants it closed (to all but his personally invited friends). . . . It is, in reality, the culmination of a distinct misunderstanding which we had this morning. . . . He came in, quite unexpectedly this afternoon when I had some people in his room—was cross because he could not immediately have it to himself—and flung off to his house, to return just as I was preparing to leave—He was ready for a blow-out, and I fear I was only too anxious for one—and I sent home a few truths which, unfortunately, put him into his worst mood—an icy rage. It all finished up in his informing me in his most deadly polite manner that the Library was his and not mine, and that he did not recognise my assumption of

> authority over him concerning it—Bump! Undoubtedly, I shall arrive there at 9:30 tomorrow morning—but at this writing I am certain (!) that I shall pack up & be off to Florida by noon & let him have his Library to himself until he is jolly well sick of it.[16]

Greene's biting wit is on full display in this passage, as she contends with Jack's unprovoked outburst and arbitrary assertion of his power. Occurring only a few years before the Pierpont Morgan Library was incorporated, the incident speaks to the complicated nature of authority at the Library during these transitional years. Here Jack does not acknowledge Greene's long-standing de facto leadership of the Library, and yet, since it was at this point still a private collection and under his purview, it was technically within his rights to restrict access as he saw fit.

Despite any occasional animosity that might have arisen between them, Greene had known for several years that Jack had the best intentions for the Library: "I feel that my mission here is pretty nearly finished as I have definitely succeeded in tying Jack M. up to the Library—He is perfectly mad about it."[17] They both came to view the institution as a kind of second home, and when out of town often expressed a feeling of homesickness.[18] In a letter sent from England Jack wrote, "I think of you often,—by you, I mean the librarians, as well as the Library,—and wish very much the Library was built on the corner of my place out here."[19]

The complexity of their relationship can also be understood through their acquisitions for the collection. About a month after Pierpont's funeral, Greene expressed her frustrations with Jack's approach to building the Library: "as for acquisitions, I fear alas—there will be none. The younger generation cannot bear to 'fork out' the price and with that disposition there can be no advance as you know."[20] Their acquisitions between 1913 and 1924 reveal how Greene started to learn Jack's preferred buying style; she began more formally, cabling or writing him for permission to purchase new acquisitions, but eventually became more comfortable and confident making decisions without his input.

One of the most significant early acquisitions under Jack came in 1916, when Belle Greene purchased the Old Testament Miniatures (MS M.638; pp. 120–21) from Thomas Fitzroy Fenwick.[21] Even though Pierpont Morgan had turned down an offer to purchase the manuscript for £10,000 in 1910, Greene knew the scholarly and aesthetic value of the miniatures, now regarded as some of the most significant illuminations of the Middle Ages. In the middle of the First World War, she traveled to Cheltenham and bought the manuscript for the same price offered to Pierpont six years earlier. In a letter to Jack Morgan after the acquisition was made, Greene informed him that she had made the purchase, even though she did not have his express permission:

> On my visit to Cheltenham this week I purchased from the present owner, Mr. Fitzroy Fenwick, his famous 13 century French manuscript of the *Bible Historiée*, the finest example of French art of the period in private hands.

> . . . If I had been able to stay here several weeks longer I know I could have bought every important manuscript in private hands in England.[22]

In a subsequent letter to Sydney Cockerell about the acquisition, Greene indicates that Jack Morgan "is very keen to see the manuscript but quite thoroughly approves of my purchasing it, which is a good omen (for me) for the future."[23] Jack was so taken with the Old Testament Miniatures that he chose them to be reproduced as a Roxburghe Club facsimile in 1927.[24]

Just as Greene had to navigate the process of acquisitions during this interstitial period, Jack too had to acclimate himself to his new role overseeing the Library and working with his staff to develop the collection. The famous rare book dealer A. S. W. Rosenbach once related an anecdote about "an unpleasant experience" at the Morgan in 1924, during which Jack gave in to one of his "imperious moods" and strongly criticized Belle Greene for negotiating an acquisition without his permission. Rosenbach's associate and biographer, Edwin Wolf II, related this story and wrote that the "attack . . . embarrassed the Doctor greatly, for to him Belle was far more than a rich man's employee."[25] Though the full meaning behind this outburst may not be entirely clear, this was the only time Rosenbach reported having had a bad experience at the Morgan.

There was no one model for how acquisitions were made in these years. In 1922, for instance, the Library acquired a group of nineteen William Makepeace Thackeray printed books—desiderata that, in Greene's words, "finish the Thackeray question in the Library, for all time."[26] Jack had viewed the collection before leaving New York and left instructions for Belle Greene to "arrange the matter" with Rosenbach. Despite being deputized to make these arrangements, Greene wrote Jack for his approval, given the expensive purchase price of $10,985.[27] A year later she wrote Jack to seek his authorization to acquire several printed atlases by Ptolemy, sent on approval, but also to inform him that she had bought a rare Rembrandt etching.[28] This letter shows how Belle Greene selectively sought Jack's permission in some cases while she confidently announced her purchases in others.

In 1926 Jack Morgan traveled to England to secure several medieval manuscripts from the collection at Holkham Hall. Though Jack handled the in-person negotiations, he had learned of the potential acquisition and the value of the objects through Belle Greene's research. As he quipped before leaving England, "My librarian told me she wouldn't dare spend so much of my money, but just the same I wouldn't be able to face her if I went home without the manuscripts."[29] As Anne-Marie Eze and Juliana Amorim Goskes discuss elsewhere in this volume, Greene also showed great interest in Islamic and Persian art and made multiple requests of the Morgans to pursue acquisitions in that area of focus. In one of her letters to Jack she writes, "About his Cufic Koran—I want to see it

most awfully, but I really ought to remind you (I hate to do so) that you have not been at all keen about these things."[30] Perhaps surprisingly, Jack responded in the affirmative: "by the time you get this letter the book will be on the way to you. It is very fine and will be a little luxury which I will offer myself—or rather to my librarians."[31] The playfulness in this exchange echoes the bantering relationship Belle enjoyed with Pierpont, and while Jack may not have wished to collect non-Western manuscripts, he valued Greene's knowledge and vision for the collection.[32]

In some cases, Jack made acquisitions despite Greene's disapproval. In 1929, Frank Wheeler of Pearson & Co. offered a small collection of manuscripts related to King Louis XVI and Marie Antoinette. Greene told Wheeler that Morgan would need to offer an opinion before she could make a decision,[33] but Wheeler was persistent and met with Jack in Paris to show him the collection in person.[34] Greene subsequently received a letter from Wheeler indicating that Jack wanted to purchase the manuscripts and that they would be sent to the Library.[35] Ostensibly the most interesting of the collection's five items is an unsigned autograph Marie Antoinette letter. But Greene doubted its authenticity, based on her knowledge of other Marie Antoinette materials in the collection, and annotated the album leaf upon which the letter is mounted: "Sold by F. Wheeler of J. Pearson & Co. London / It is my opinion that this letter may be a forgery / Belle da Costa Greene / 1929."[36] In addition to this note, which signaled her disagreement with Jack's judgement, Greene would later register her suspicions in a letter to Wheeler.[37]

Greene would draw upon this confidence as she and Jack entered new roles in 1924, when the Library became a nonprofit public educational institution—the Pierpont Morgan Library—as a memorial to the elder Morgan. It was intended to honor his "belief in the educational value of the collection which he had gathered" (fig. 3).[38] Jack Morgan decided that the only person qualified to lead it was the very person who had been doing so since 1905—Belle da Costa Greene. His confidence in Greene's suitability for the role is evinced by her new title and pay raise: "Miss Belle da Costa Greene, to be Director and Keeper of the Manuscripts, at a salary at the rate of Twelve thousand five hundred dollars per annum" (fig. 4).[39] The immediate question on the table was how to turn a private collection into a public institution.

The first step was transferring ownership and governance to a Board of Trustees, which in its earliest iteration comprised Jack Morgan; his wife, Jane Norton Morgan; his sons, Junius Spencer Morgan Jr. and Henry Sturgis Morgan; Jack's legal counsel Lewis Cass Ledyard; and lawyer James Gore King.[40] When the Board was first formed, Jack served as president and his son Henry served as vice president, secretary, and treasurer.[41] It was their responsibility, according to the new institution's by-laws, to "hold, manage, preserve, and protect the

FIG. 3
"The Story of the Great Morgan Treasures," *New York Herald*, February 17, 1924. The Morgan Library & Museum, New York; ARC 3291, Box 91, Folder 12.

FIG. 4
Minutes of the Pierpont Morgan Library Board of Trustees, 1924. The Morgan Library & Museum, New York; ARC 3294, Box 1425, v. 1.

property of the institution, and . . . have full and exclusive power to manage and conduct its affairs and business."[42] One of their powers included hiring a director and other staff, though at times in the first year of incorporation there was confusion over whose responsibility it was to authorize payments for Library operations.[43] The Board also had some say in acquisitions, as documented in 1925 when they declined Greene's proposal to acquire a Walt Whitman manuscript. In this case, it seems that Jack also disapproved of the acquisition, and it was perhaps his opinion that swayed the Board.[44]

Access to the library was at the forefront of Greene's mind as the institution took shape. "We are frightfully busy reorganizing the Library to make it a permanent institution," she wrote Berenson that February: "I did (do) not want it given to the public who would only kill it—either with neglect—too much 'trampling over' or too much 'officialdum' & so we are arranging to make it an 'educational institution' somewhat along the lines of Harvard, Chantilly etc."[45] Of course scholars had been able to access the collection for many years, as Pierpont Morgan regularly hosted guests and researchers, though the Library was always closed if he was out of town, and in its earliest days access was highly limited.[46] An anecdote from 1908 offers colorful detail about how prospective researchers accessed the Library:

> One had to ring an outside bell to have the door opened by a guard, and then only about four inches. A business card would be passed in and the door would be closed again and locked. After a short interval, the guard would reappear and state if Miss Greene would see the caller. After a few visits, I was admitted at once.[47]

In the February 1924 letter to Berenson, Greene seems reluctant to move away completely from the restricted access that characterized these early days, when the institution was known as "Mr. Morgan's Library." Yet her interest in making the place an "educational institution" governed by sensible rules and regulations—a special collections library *avant la lettre*—is borne out in the institution's founding documents. It was, according to the Deed of Trust, a "public library, for reference only . . . for the use and benefit . . . of all persons whomsoever, subject only to suitable rules and regulations."[48] The Board clearly took its role seriously in establishing a policy to provide access to the collection but also to protect and preserve it. An early goal was "to encourage quality of scholarship rather than 'numbers' of students and to place at the disposal of serious advanced scholars every possible facility for the conduct of their research studies under the most favourable conditions."[49] This meant that researchers were required to submit letters of recommendation and schedule special appointments with staff to consult "reserved" books and manuscripts, such as Shakespeare's First Folio. The earliest set of rules also did not allow undergraduates to consult rare materials, though by 1933 that rule had been relaxed.[50]

The Pierpont Morgan Library was required to provide access to the collection as a public institution, but since not everyone was eligible to become a

reader, an exhibition program was started to reach a wider audience. However, given the limitations of the McKim, Mead & White building, the Library's earliest exhibitions took place at the New York Public Library's large exhibition hall. In 1924 NYPL hosted two large Morgan exhibitions: the first, *The Pierpont Morgan Library: American Manuscripts*, opened shortly after the Pierpont Morgan Library was incorporated and focused on American history and literature. As the *New York Times* reported, "public access to the treasures of the Pierpont Morgan Memorial Library has followed with little loss of time upon the transfer of this incomparable collection by Mr. J. P. Morgan to a board of trustees for the public use."[51] The article goes on to describe the singular educational value of the show:

> Though the exhibition will be open to the general public, it is designed primarily for the school children of New York. A mere glance through the table of contents is sufficient ground for believing that there is an easier and more effective way of nurturing a justifiable sense of patriotic pride in the origins of this country than by Mr. Hirshfield's crusades against the menace of the history textbooks.[52]

It is noteworthy that the reporter comments on the wider educational value of exhibitions of rare material, which are not, after all, the exclusive domain of scholars:

> It is difficult to say which will be the greater usefulness traceable to Mr. Morgan's gift, the work done by specialists in the original Morgan library, or the pleasure and instruction derived by much larger audiences from popular exhibitions of the Morgan Library's resources, of which we trust the present is only the first.[53]

The educational emphasis of the first exhibition continued with the second, *Original Manuscripts and Drawings of English Authors from the Pierpont Morgan Library*, which attracted over 180,000 visitors to see more than three hundred collection items—at the time the largest exhibition of manuscripts in American history. Greene worked with the New York City Department of Education to set aside Friday afternoons as special visiting hours for junior and high school students to see the exhibition.[54]

It became evident from these popular exhibitions that a new space was needed on the Morgan's campus. Upon the death of Jack's mother, he gave his father's brownstone house to the Library so that an additional building could be constructed to house a Reading Room, exhibition space, and administrative offices. A covered walkway, known as the Cloister, was designed to connect this public-facing space to the original McKim, Mead & White Library. As planning began in 1926, Greene worked with the architects on how best to serve researchers as well as the casual visitors who were coming in the hundreds to view Morgan material on view at NYPL. While all construction plans were approved by the Board, Greene participated in meetings and suggested moveable exhibition cases as well as a large work table and second-floor gallery for the Reading Room.[55] Construction began in 1927 and in October 1928 the building opened

to the public. A document dated July 1928 contains a number of questions Belle Greene posed to Jack about the opening of the new building.[56] He indicated that he would like Greene to mount an exhibition of treasures from the permanent collection upon opening, that visitors could only see the Exhibition Room and not the Reading Room (unless they were accredited readers), and that, "as a general policy," visitors were not allowed to tour the 1906 Library (referred to as "the main building").[57] Within a year of opening, reporters from the *New York Daily News* were curious to test how publicly accessible the formerly private institution had become. The media was skeptical and expressed much confusion over the fact that, unlike the NYPL, researchers were required to schedule appointments in advance.[58]

In 1930, after what Greene called "2 Hells of Years ever since our new building has been opened," the Pierpont Morgan Library published the first of its five-year reports, documenting the institution's successful navigation from private to public between 1924 and 1929.[59] The publication, written by Greene, was based on individual reports she submitted to the Board each year and contains many of the policies and legal documents that established the Pierpont Morgan Library, including excerpts from the Reading Room rules, the Deed of Trust, and the Act of Incorporation. It also listed the principal collections of the Library and offered a description of the new Reading Room; to the art historian Meyer Schapiro, "for comparative study of literature on manuscript painting, there is no European library which is as convenient."[60] Most importantly, the report announces inaugural programs for exhibitions, public lectures, and teaching, including a list of all classes and groups that visited the Morgan over the five-year period. Principal acquisitions of rare material were also listed in the reports, which the Library published every five years during Greene's tenure.

Greene sent out hundreds of copies of the report all over the world to scholars, libraries, even to world leaders Pope Pius XI and King George V. The congratulatory letters she, Jack Morgan, and the Board received in return, as well as printed reviews of the volume, attest not only to the book's positive reception but also the esteem with which the world held the newly formed Pierpont Morgan Library and its indefatigable director.[61] The press singled out the contributions of "Belle da Costa Greene, the able and scholarly director": "Among library reports it is unique. It tells a story . . . of growth in content and above all, in the intelligent use of these priceless literary treasures . . . of its expansion along lines to better serve its purpose as an educational institution, and all told with such grace and wealth of erudition."[62] The art historian Royal Cortissoz, signing his letter "thy faithful old amico," considered the book a "glorious feather in your bonnet," while the Librarian of Congress Herbert Putnam remarked that "the impression which it must make upon any American librarian is a combination of admiration and of humility."[63] The librarian of the Grolier Club, Ruth Granniss, offered her admiration for Greene's publication: "With such treasures to tell of and with such an amount of work accomplished, the

task of choosing and arranging must have been tremendous, and I congratulate you most sincerely on the success with which you have done it."[64]

As the responses to her work at the Library demonstrate, Greene was now on par with the men she knew from the elite world of rare books and manuscripts. In the late nineteenth and early twentieth centuries, when formalized training for librarianship gained traction, the primarily male-dominated field began to evolve as part of the "feminization of librarianship."[65] Professions such as teaching and librarianship were viewed as acceptable work opportunities for women because they were considered nurturing and caregiving roles, allowing women to maintain the Victorian ideal of maternal femininity. This sexist and patriarchal model would create long-standing challenges for women in the field, including the belief that women librarians should be congratulated for their penchant for self-sacrifice.[66] This type of thinking led to the chronic underpayment of women librarians. What's more, women of color were often denied a role in the field because it was believed that they did not fit the Victorian model of femininity.[67] Excluded from "traditional views of morality," women of color were "not permitted to live by the same standards as white women."[68] Thus the Victorian model offered a rationale for women to enter the workplace as teachers and librarians but also created barriers for women of color from entering by upholding racist stereotypes of what constituted womanhood. At the turn of the century, as the Victorian model came under attack, women of color found ways to define what womanhood meant to them—outside of the racist and sexist ideals put forward by society. Greene's personality, fashion sense, and confidence in her work could be seen as her way of redefining womanhood and what it meant to her.

By 1910, 78 percent of library positions in the United States were held by white women, most of whom worked in public libraries and not in positions of leadership. With a growing number of library programs modeled after Melvil Dewey's educational curriculum, librarianship took on a more administrative role.[69] This change stood in stark contrast to special collections libraries, which remained dominated by male scholars and were typically overseen by curators, known as "bookmen," rather than trained librarians.[70] When Greene started at the Morgan she entered this world of powerful bookmen as a trained librarian, and she recognized how the two roles—scholar and librarian—could combine to offer the perfect stewardship model for these valuable and rare collections. A librarian's chief mission is to provide access. But how does one provide access to a twelfth-century illuminated manuscript or a rare printed book while also ensuring its physical integrity? This concern for preservation often led to the criticism of professional librarians working in rare book collections. The "bookmen" comprised a group of often white, privileged men, most of whom believed that by restricting access they were protecting the books and manuscripts they were charged with stewarding.[71] This approach also solidified an elitist mentality around special collections. Randolph Adams, director of the Clements Library at the University of Michigan, Ann Arbor, writes in an essay from 1937 that professionally trained librarians were "enemies of books."[72]

When Greene became director of the Pierpont Morgan Library, she provided an example of how the field could and should change. As one of the few women in a leadership position at a special collections library, Greene accomplished many things. She cultivated a strategic collection policy, developed a robust exhibition and lecture program for both scholarly and general audiences, and also created rules and regulations for the Reading Room that promoted research while also keeping the preservation of materials at the forefront. Evidence of Greene's support for further scholarship using the Library's collections can be found within her own detailed notes on collection objects and the extensive research she conducted for exhibition publications.[73]

Greene embraced this transition in librarianship, placing herself at the heart of what was viewed as a "gentlemen's club for English or History professors."[74] During her career, Greene made headlines not only as the woman librarian of one of the world's most renowned special collections libraries, but also because of the high salary she commanded (fig. 5). By 1911 she was making $10,000 a year (the equivalent of around $330,000 in 2024 dollars) and was the breadwinner for her family. Greene must have been aware that she had a unique opportunity to change how librarians were viewed. While we may not have an explicit statement to this effect, the reputation she enjoyed and the respect she commanded within the field speak volumes. Women were expected to accept salaries between one-half and two-thirds less than their male counterparts.[75] While Greene advocated for higher wages, she did so in complicated ways. She in many ways upheld traditional roles, believing that if a woman was not passionate for the work or in need of it financially, that she did not have a place in the workforce. In a 1914 newspaper article, Greene was quoted as saying,

> Many girls seek employment just as a means of passing away the time until they are married. Such girls work indifferently because they have no real interest in their work, and they are willing to accept a smaller income. As a result, they keep someone more capable and more worthy from obtaining a position and are responsible for lowering salaries paid to women.[76]

FIG. 5
Belle da Costa Greene (1879–1950), Signed check, February 1, 1922. The Morgan Library & Museum, New York; ARC 3291, Box 101, Folder 1.

As is typical with Greene, her words invoke contradictions and complexities. While the quote may appear on the surface to discourage women from entering the workforce, Greene is in fact advocating for the professional woman who wants to break free of societal pressures and traditions. She promoted their professional development while also uplifting those who decided that they wanted to follow a "traditional" path.

One of Greene's greatest accomplishments as director was her commitment to mentorship. Librarians and secretaries who worked under Greene such as Ada Thurston, Violet Burnie Napier, Mary Ann Farley Tully, Meta Harrsen, and Dorothy Miner have left archival traces of their working relationships with Greene and subsequent pursuit of professional careers under her guidance. The work environment at the Morgan was strict, and Greene had exceptionally high standards for her staff. But she was also fair and treated many of them like family. In a 1943 letter to Winifred Kennedy of the Walters Art Gallery, Baltimore, Greene bemoaned that "the Library without me, I think, has simply gone to pot, although others (the STAFF!) tell me that the only thing they missed, in my absence, was noise, 'callings down,' and curses!? Mebbe they are right?"[77] This anecdote shows that despite the seriousness of their work, Greene developed a managerial style that was playful and direct. Staff felt the freedom to be honest with "Miss Greene," as they called her.

Ada Thurston, whom Greene affectionately called "Thursty," was Greene's first hire at the Library in December 1906. They worked together until Thurston's retirement in the late 1930s. It was Greene and Thurston who would embark on the enormous project of asserting intellectual control over Morgan's collection by cataloguing and arranging its contents. Violet Burnie Napier, who started at the Library in the mid-1920s, recalled later in life that Greene was both a great boss and friend. After she left the Morgan, she would often return to visit Greene, accompanied by her child, to keep up with what was going on with the Library.[78] In Greene's correspondence with other former staff members, she discusses their post-Morgan lives, responding with excitement and pride about how well they are all doing. This was true for both professional matters—such as Helen Franc discussing her new job[79]—as well as personal matters—as when Mary Ann Farley Tully wrote to update Greene on her life after getting married.[80]

Dorothy Miner only worked at the Morgan for a year but remained close to her boss until Greene's death in 1950. She and Meta Harrsen were by her side during her final days. Greene hired Miner in 1933 to help catalogue the Morgan's collection of illuminated manuscripts. Often referring to Miner as her "pet," Greene recommended to the newly created Walters Art Gallery that Miner catalogue their manuscripts on a contract basis for an upcoming exhibition. During these days at the Walters, Miner maintained both a professional relationship and friendship with Greene, often seeking her advice as she cemented her roots in Baltimore. She would relate stories of career accomplishments that she knew would impress her mentor, while Greene would advise her on purchases and

encourage her to seek advice from various scholars. Greene had been on the advisory board for the Walters Art Gallery when it became a public institution in 1934 and advocated for Miner to be hired there in a permanent position. Miner stayed at the Walters for the next thirty years, creating a legacy of her own. In 1948 Greene even tells Miner, "Why in h— did I ever 'give' you to the W.A.G."[81] Over the course of their long-standing correspondence, Greene's and Miner's roles as mentor and mentee gradually recede, replaced by a deep mutual admiration (fig. 6). Throughout the 1940s Miner would often begin letters with a "Dear B.G" and sign them with "Yr Keed." Greene would come to view Miner as an equal, often exchanging letters marked "confidential" or "personal" containing information about colleagues or book dealers they knew in common. In 1943, with Greene's health declining, we see Miner's genuine devotion and concern when she inquires, "How have you been and are you doing what you are supposed to to take care of yourself??? I think about you always."[82]

Along with Dorothy Miner, one of Greene's closest confidants and mentees was Meta Harrsen, who specialized in illuminated manuscripts. Hired as a secretary and promoted in the early 1920s to an assistant librarian position, Harrsen would spend her entire career at the Morgan. She would take on more and more responsibilities, eventually becoming Greene's right-hand librarian. Harrsen's critical role at the institution is evident in her work on the 1934 *Illuminated Manuscripts* exhibition held at New York Public Library. Featuring the greatest medieval manuscripts in the Morgan's collection, the exhibition was collaboratively organized by Greene and Harrsen. The two worked together in choosing material, creating label text, and co-writing the catalogue, which is one of the few published examples of Greene's writing. When the boss was out of town for business or vacation, it was Harrsen who would be left in charge, often corresponding back and forth with Greene on Library matters. Greene oversaw Harrsen's development in the field, approving time away from the Library for scholarly work and sending her to conferences to network and meet with others working in similar institutions.[83]

The two evolved from colleagues to friends, forming a close bond that eventually resembled family. Harrsen, like Greene, was a workaholic. Greene spent most of her time within the gilded walls of the Library, and Harrsen similarly chose to make the Library her life. When Greene's nephew was formally accepted to Harvard, it was Harrsen,

FIG. 6
Dorothy Miner (1904–1973), Autograph letter to Belle da Costa Greene, 1948. The Morgan Library & Museum, New York; ARC 3291, Box 50, Folder 7.

not Greene, who wrote to fellow Library staff to share the good news.⁸⁴ Their close relationship is especially evident in letters from later in Greene's life. In 1946, while vacationing in the Caribbean, Harrsen sends "Greetings from Bermuda, where[,] as in the opera Trairata, il mar, il sol' are performing their usual cure. This little hotel would suit you to a T, comfortable chairs on the terrace giving one grandstand seat for races and all harbor activities, and the food is excellent."⁸⁵ While in Bermuda, Harrsen received a gift from Greene—a jasmine fragrance she had purchased from Bendel's department store, one of many gifts she gave to Harrsen over the years. Two years later, Greene made it a condition of her retirement that Harrsen be promoted to keeper of manuscripts at the Library. Well into the 1950s, after Greene's death, Harrsen would write in letters to Bernard Berenson of her thoughts and reflections on Greene.⁸⁶

Greene (fig. 7) not only took the time to mentor the librarians and secretaries at the Morgan, but also sought to provide opportunities for women scholars as well.⁸⁷ One of her most accomplished mentees was the art historian Edith Porada, an expert in ancient Western Asian cylinder seals. Porada grew up in a Jewish family in Austria, becoming the first woman in her field to earn a doctorate from the University of Vienna (1935).⁸⁸ In the wake of Austria's annexation by Germany in 1938, she escaped with her sister due in large part to the efforts of their governess, Kischi, who joined the Nazi party as a cover to buy time for the Porada family. Edith was allowed to leave the country only on the condition that she return, and so she was unable to take with her more than a few possessions, including part of her dissertation. Her dissertation was a crucial register of her learning and scholarship, but unable to bring the full thesis with her she brought the portion containing her drawings of cylinder seal impressions. As explained by Sidney Babcock, "She knew the text, she needed the images."⁸⁹ After fleeing Austria, Porada made it to Paris, and left France for the United States on the very day that *Kristallnacht* erupted throughout Germany (figs. 8–10).

In New York Porada struggled to find work in academic and cultural institutions as a junior scholar without connections in the city. But knowing the great collection of ancient cylinder seals held at the Pierpont Morgan Library, she contacted Belle Greene in early 1939 to ask if she would allow her to continue the work of cataloguing the collection begun by Reverend William Hays Ward in the 1880s. An early Porada letter to Greene articulates the scholarly importance of the collection and the necessity of an accurate catalogue describing it.⁹⁰ With the letter she enclosed a drawing of one of the Morgan seals, and not only describes the cultural sources of its visual motifs (Egyptian and Cypriot) but notes its affinity with unpublished or recently discovered seals in other collections.

FIG. 7
Belle da Costa Greene at the sale of Edward Newton's library, Parke-Bernet Galleries, 1941.

FIG. 8 (TOP LEFT)
Passport issued to Edith Porada, Vienna, September 14, 1938. The Morgan Library & Museum, New York, Edith Porada Papers; Box 8-1.

FIGS. 9 & 10 (TOP RIGHT AND BOTTOM)
Edith Porada (1912–1994), *Die Rollsiegel der Akkadzeit: Dissertation zur Erlangung der Doktorwurde an er Philosophischen Fakultat der Universitat Wien* [part two, plates], original drawings, ca. 1934. The Morgan Library & Museum, New York; ARC 3304.

Clearly intrigued, Greene wrote a letter to Ferris J. Stephens, the curator of Yale University's Babylonian Collection, and Stephens's enthusiastic endorsement of her convinced Greene to give the young scholar a chance.[91] A back-and-forth correspondence with Porada ensued, and eventually Greene agreed to hire her on a provisional basis for nine months. "I scarcely know how to write a formal letter," admits Porada in reply, "feeling as thankful as I do towards you, for having helped to bring about this change in my whole life" (fig. 11).[92]

As the Second World War raged in Europe and Porada was engrossed in her work at the Morgan, she wrote a moving thank-you letter to Greene:

> Please forgive this letter, should you find it too personal. It is to thank you again for having permitted me to work during these last two months at the Library, at a task, which took my thoughts off everything else ... I don't know how I could stand the strain of having everybody I care for most, including my parents "over there" without my work—without the daily contact with the friendly people at the Library. Less closely tied to Europe with mind and heart they constantly remind one of the fact, that there is another world, even if one's own is falling to pieces.[93]

By giving Porada the opportunity to work on the Morgan's collection of cylinder seals, Greene helped launch her academic career in the United States—she would go on to teach at Queens College and later at Columbia University, and eventually become Honorary Curator of Ancient Seals and Tablets at the Pierpont Morgan Library. Long after Greene's death, in Porada's acceptance speech for an honorary doctorate from Smith College in 1991, she "gratefully thought of"

> Miss Greene, who entrusted to a young unknown foreigner the work on the then greatest and finest collection of cylinder seals.... I was quite conscious then of the fact that such a generous faith in an untried young scholar was possible only in the United States, and this I still believe.[94]

The Second World War cast a long shadow on the work of libraries and scholarship beyond Porada's remarkable story. In a letter from 1942, Library assistant Helen Franc wrote to Greene, "Now with the war, it has become necessary to put away for a time many of those special treasures, and some of us have felt impelled to interrupt the normal tenor of our lives in order to devote our full energies to the military or civil service of our country" (fig. 12).[95] Greene had been through a war

FIG. 11
Edith Porada, 1940s–50s. The Morgan Library & Museum, New York; ARC 3305.

before. She saw how the First World War had affected scholars, dealers, and friends in Europe. After thirty years at the helm of the Morgan, her connections in Europe were more than professional. These were her friends, colleagues, and mentors. What makes Franc's letter even more poignant is that it is a resignation letter, as she was leaving the Library to serve in the Air Transport Command of the US Army. She began the letter by thanking Greene for the leave of absence and saying how she had fallen in love with the Library when she visited as a high school student. She described the "thrill of a lifetime" as she held an illuminated manuscript, the ninth-century Reims Gospels, for the first time.[96] Greene, yet again, had mentored another woman who was excelling in the rare book world. Franc, who had begun working at the Morgan in 1934, had graduated with a degree in medieval art from New York University. She catalogued illuminated manuscripts, showed visitors around, and curated an exhibition titled *The Animal Kingdom* (1940).[97] But none of that mattered as Europe was thrown into chaos.

FIG. 12
Helen Franc (1908–2006), Typed letter to Belle da Costa Greene, July 30, 1942. The Morgan Library & Museum, New York; ARC 3291, Box 36, Folder 9.

As Greene corresponded with dealers, scholars, and colleagues in Europe during this tumultuous period, she asked for updates on their well-being, families, and collections. In a letter from 1939 she writes, "We are all following as closely as we are permitted . . . although we are told to be neutral we certainly are not in thought and personal feelings, and we send you all our best wishes and hope."[98] In a 1945 letter to the Italian antiquarian Tammaro De Marinis, she decries the wartime destruction of libraries: "It is too dreadful to hear that the main lot of these books was destroyed in the bombardment of the Hoepli house. It is heartbreaking to learn of all the destruction that 'mad race' has caused, and you must know the sympathy, to say despair, of the whole 'civilized' world concerning it."[99]

Greene also kept in contact with American colleagues who had left to join the war effort. Ernest T. DeWald, an art historian and later museum director from Princeton University, wrote to Greene while stationed in Italy. There he worked with the Monuments Men, as director of the MFAA Subcommission of the Allied Control Commission in Italy. DeWald feared losing the priceless works of art they were charged with recovering, and told Greene that he longed for nothing more in those bleak moments to be back in New York sharing a drink with her:

FIG. 13
Pamphlets and notes related to the Pierpont Morgan Library's preparations for collection safety and evacuation during the Second World War. The Morgan Library & Museum, New York; ARC 3291, Box 80, Folder 15.

"and when you have that next martini or high ball give a special thought to me because I'd love to be on hand to have one with you."[100]

In the early days of the Second World War, with the London Blitz still fresh in the world's memory, there was considerable anxiety that the Germans might bomb American cities on the East Coast. Belle Greene took this threat seriously and arranged to have the most valuable collections shipped to various offsite facilities. As a member of the National Committee of the United States for the Restoration of the University of Louvain after the First World War, Greene knew firsthand the devastation met upon cultural repositories by military aggression.[101] Prompted in part by a letter of practical warning from colleagues at the British Museum, Greene worked closely with Jack Morgan and colleagues at other institutions—particularly the Metropolitan Museum of Art and the New York Public Library—to ensure the safety of the Library's most valuable collections (fig. 13).[102] In May 1942 they sent drawings to Pennsylvania, Rembrandt etchings to Oberlin College, illuminated and autograph manuscripts to a bank holding company vault in the Empire State Building, early printed books to Saratoga Springs, NY, and treasure bindings to a bank vault on Fifth Avenue.[103] All told, more than six thousand objects were inventoried and sent away for the duration of the war.[104]

During wartime the Pierpont Morgan Library continued a robust lecture and exhibition program, though it could only display selections of material that remained in the building. Greene was keen to shape exhibitions to fit the current mood of the United States in a time of conflict, and thus chose themes that variously celebrated American patriotism (*The Development of America*, 1943, and *Autograph Manuscripts of American Authors*, 1944); made "people laugh for a little while and forget" (*English Caricatures*, 1943); and offered vicarious escape and delight through fashion history (*Fashions of the French Court in the 17th and 18th Century*, 1943–44).[105] In late 1944 until summer 1945, with conflict waning, the Library presented the first exhibition featuring objects that had been previously evacuated, a show celebrating the history of *The Written Word* (fig. 14). The exhibition comprised not only specimens of ancient writing recorded on clay tablets and papyrus, but also some of the collection's most celebrated illuminated manuscripts, many of which Greene herself had acquired for the Library during the past few decades.

Greene's leadership during the Second World War cannot be overstated. While not only managing the front-facing operations of the Library with limited staff, she was involved in keeping up the morale

FIG. 14
The Written Word: Inscriptions, Texts and Illuminated Manuscripts from 2600 B.C. to the Invention of Printing in the XVth Century, December 14, 1944 to April 14, 1945, 1944. The Morgan Library & Museum, New York; ARC 3291, Box 89, Folder 10.

of Morgan employees. She would send care packages and letters of well-wishes to staff who had joined the war effort. She wrote to Bernard M. Peebles, a security guard turned sergeant, enquiring about his fellow colleagues who left to serve in the war, such as Curt Bühler and George K. Boyce. Greene continues, "I am so glad to learn from your letter that my various scholastic friends are in good health and that you are doing so well in your military service.... We long for the day which will see you back here."[106] She encouraged those still working to buy war bonds and actively supported efforts to protect and rebuild European libraries. Greene and the Morgan's site superintendent, Mark D. Brewer, were constantly concerned about staff well-being and the safeguarding of the collection. Brewer even suggested sleeping on-site to protect the Library in case of an attack. Though Greene told him it would be unnecessary, it is clear that the Morgan's staff was just as willing as Greene to do what was necessary to protect the Library.

As with Edith Porada, Greene saw the importance of assisting those who could escape the violence overseas. Greene kept in contact with the Jewish art historian Adolph Goldschmidt, who had taught in Berlin as well as at Harvard and Princeton but returned to Germany before the war to look after his extended family. He was forced to flee Nazi Germany and died in Switzerland in 1944 at the age of eighty-one, unable to see the end of the war or see his homeland again. In a condolence letter to his son, Greene remarked how so many of her colleagues had tried to convince him to stay in the United States but that Goldschmidt "felt that he had to go back to look after his loved ones."[107] Despite the grave circumstances of the war, in a letter to the art historian Erwin Panofsky she is able to find moments of lightness and laughter. "Pan," as she referred to Panofsky, was facing difficulty securing a visa to come stateside. But one of Greene's ideas, in collaboration with other institutions such as the Fogg Art Museum, was to create a lecture series that could give the war office a pretext for granting scholars visas to enter the United States. She tells "Pan" that she could write to the Office of War Information and claim "that you are really a spy in scholastic clothing and only became naturalized to successfully carry on your nefarious deeds."[108] She had great empathy for those struggling, and wanted to find ways to bring a smile to their faces, even if just with a quick line in a letter. Panofsky would successfully reenter the United States and travel on a lecture circuit of the Northeast in early 1944.

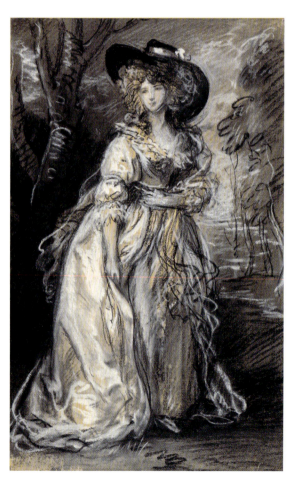

FIG. 15
Thomas Gainsborough (1727–1788), *Lady Walking in a Garden*, ca. 1785. Black and white chalks with smudging, worked wet and dry, watercolor; 19½ × 12¼ in. (49.5 × 31.2 cm). The Morgan Library & Museum, New York, acquired from the Estate of J. P. Morgan Jr., 1943; III, 63b.

With the war raging in Europe and Asia, Greene's professional world would fall to pieces in March 1943 with the loss of yet another "Mr. Morgan," Jack, under whom she worked for a much longer period (thirty years) than she did for his father (eight years). By the end of Jack's life Greene had developed a deep-seated respect for her employer, writing a moving letter to her longtime assistant librarian Ada Thurston following his death:

> I never expected to go through it twice, just as I never expected to go through two wars, this worse than the other! . . . The Library, as you can imagine, seems empty . . . this morning I was so upset (mentally) that I started to ask Kessler, as I did every morning, "Has Mr. Morgan gotten in yet?" I just stopped in time. . . . I do not know why, but I miss him more and grieve for him more than I did for "our" Mr. Morgan.[109]

In their efforts to develop the collection, Belle and Jack had, between 1913 and 1943, continued the great work begun by Pierpont in making iconic acquisitions, including the "Crusader Bible" (MS M.638; see pp. 120–21); illuminated manuscripts from the collections of Henry Yates Thompson, Holkham Hall, and George Holford; the world's largest group of Jane Austen letters (MA 977 and 1034); and Thomas Gainsborough's beautiful drawing *Lady Walking in a Garden* (III, 63b; fig. 15). One of the literary manuscripts purchased in this era was William Makepeace Thackeray's original manuscript for *The Rose and the Ring*, which happened to be a favorite of Belle's and Jack's (fig. 16).[110] When a facsimile edition was published in 1947 it bore a fitting dedication to its former owner: "To John Pierpont Morgan, 1867–1943, who acquired and particularly loved the

FIG. 16
William Makepeace Thackeray (1811–1863), *The Rose and the Ring*, autograph manuscript, 1853. The Morgan Library & Museum, New York, purchased by J. P. Morgan Jr., 1915; MA 926.

original manuscript of the Rose and the Ring."[111] In a tribute to Jack, printed in the Library's 1941–48 review publication, Greene fondly recalls how "it was his custom to pay a morning visit of an hour or so to the Library," where he would show "a keen interest" in its administrative processes and research culture. "It may be truly said that when Mr. Morgan died," wrote Greene, "scholarship in literature, history and the fine arts lost one of its most sympathetic patrons, and that the Library he founded was deprived of an active benefactor, a friend, and a vital force in its affairs."[112]

Jack's passing meant that the presidency of the Board of Trustees was vacant, and though his sons Junius (vice president) and Henry (secretary) were natural fits for the board's leadership, they were both serving in the US Navy and could not assume their roles. In 1943 Jack's daughter, Jane Morgan Nichols, became the new secretary and acting president, a position she held until the end of the war in 1945.[113] A file in Belle Greene's professional papers held at the Morgan provides more details on this era when, for the first and only time in the institution's history, both the board president and director were women.

Jane Nichols was elected to the Board on July 6, 1936, and had corresponded with Greene since at least 1933.[114] The letters they exchanged mark their professional relationship as efficient and collegial during a time of transition and crisis. In her first letter to the new head of the Board, Greene remarks, "how glad we are that you have been made Acting President of the Board of Trustees," and proceeds to give Nichols a schedule of upcoming events, including the standing meeting of the Executive Committee for the Council on Books in Wartime.[115] Their correspondence shows the president and director conferring about various movements of the collection and personnel changes during and after the conflict; deliberating on exhibition and loan requests; collaborating on the management of the Morgan's garden in the wake of landscape architect Beatrix Farrand's resignation; and discussing potential acquisitions of rare books and manuscripts. Regarding one of these, the "Last Poems" of Elizabeth Barrett

FIG. 17
Elizabeth Barrett Browning (1806–1861), *Last Poems*, autograph manuscript, undated. The Morgan Library & Museum, New York, purchased in 1945; MA 1211.

Browning (MA 1211), Nichols writes that the acquisition "would be just what the Library needs," and approves Greene's carefully calibrated bid (fig. 17).[116] In a letter from August 1943 Nichols takes a firm hand on procedures for approving exhibition concepts, indicating that such a policy is necessary during the transitional period after her father's death.[117] Like Jack Morgan, she donated material to the Library and took a particular interest in many of its collections, including a seventeenth-century almanac annotated by her great-great-great grandfather Rev. James Pierpont (1659–1714) and a gimmel ring found in her father's desk after his death that once belonged to the British Romantic poet George Gordon, Lord Byron. When Greene found the ring, she wrote "Janie" a humorous handwritten letter opening with the exclamation, "It takes a Morgan!"[118] Nichols also weighed in on Morgan publications, approving Greene's request to pay Edith Porada to write *Mesopotamian Art in Cylinder Seals of the Pierpont Morgan Library* (1947)—a book Belle envisions as "a rather popular, while scientifically accurate, booklet." After reading it Nichols sends a note to Greene in praise of the publication and extends her congratulations to Porada.[119]

One of the most memorable stories about Nichols and Greene relates to the Morgan's collection of ancient cylinder seals, which were stored in the North Office during Greene's time as director. In the fall of 1969, prompted perhaps by a request from the Library's then-director, Charles Ryskamp, to send him anecdotes about Belle, Jane Nichols typed up a one-page list of "Things I remember about Miss Greene." The first of these memories, which reveals so much about Greene's commitment to inspiring awe through the collections, is worth quoting in full:

> When my children were small we lived in 37th Street, sometimes I took them in to the Library to see Miss Greene, at that time the Assyrian cylinder seals were kept in her office on the ground floor. After we wandered about looking at different rooms, Miss Greene got out the seals, a candle and great sticks of sealing wax. The children were allowed to spread the melted sealing wax on paper and run the different seals over it, producing fascinating impressions; which they were allowed to take home. It did not injure the seals in any way, and delighted Jane and George, who have never forgotten this delight.[120]

Today, the cylinder seals still feature prominently in the Morgan's education program, and the 2022–23 exhibition *She Who Wrote: Enheduanna and Women of Mesopotamia, ca. 3400–2000 B.C.* even featured a family workshop in which participants rolled clay impressions from reproductions of Morgan cylinder seals.[121] Belle da Costa Greene would have approved.

NOTES

1
Greene to Bernard Berenson, April 21, 1913, Bernard and Mary Berenson Papers, Box 61, Folder 7, Biblioteca Berenson, I Tatti, the Harvard University Center for Italian Renaissance Studies.

2
Greene to Berenson, May 19, 1913, and October 14, 1913, Berenson Papers, Box 61, Folder 8, and Box 61, Folder 10, respectively.

3
Greene to Berenson, May 19, 1913, Berenson Papers, Box 61, Folder 8.

4
Greene to Jack Morgan, October 7, 1913, ARC 3291, Box 25, Folder 6. (Archives of the Morgan Library & Museum material hereafter cited as "ARC.")

5
Greene to Berenson, December 22, 1913, Berenson Papers, Box 61, Folder 12.

6
Colin B. Bailey, *Fragonard's Progress of Love at the Frick Collection* (New York: The Frick Collection, 2011), 150; Heidi Ardizzone, *An Illuminated Life: Belle da Costa Greene's Journey from Prejudice to Privilege* (New York: W. W. Norton, 2007), 342; Ron Chernow, *The House of Morgan: An American Banking Dynasty and the Rise of Modern Finance* (New York: Grove Press, 1990), 173; John Douglas Forbes, *J. P. Morgan, Jr.* (Charlottesville: University of Virginia Press, 1981), 80.

7
Greene to Berenson, January 10, 1915, Berenson Papers, Box 62, Folder 11.

8
Bailey, *Fragonard's Progress of Love*, 150–51; Ardizzone, *Illuminated Life*, 342; Chernow, *House of Morgan*, 173; Forbes, *J. P. Morgan, Jr.*, 80–81.

9
Greene to Berenson, February 15, 1915, Berenson Papers, Box 62, Folder 12.

10
Arthur Sambon to Greene, July 22, 1915, ARC 3291, Box 24, Folder 17.

11
"J. P. Morgan Gives $7,500,000 in Art," *New York Times*, December 18, 1917; Forbes, *J. P. Morgan, Jr.*, 81.

For more on the Wadsworth's Morgan collections, see Vanessa Sigalas and Jennifer Tonkovich, eds., *Morgan—The Collector: Essays in Honor of Linda Roth's 40th Anniversary at the Wadsworth Atheneum Museum of Art* (Stuttgart: Arnoldsche, 2023).

12
In 1915 Greene wrote to Berenson, "I dined with Mrs. Jack Morgan as she was alone and we came back to the Library and she is going into ecstasies over the Persian Bestiary [MS M.500]. Both Mr. & Mrs. Jack are mad about the Library and so won't sell that, thanks be to god." Greene to Berenson, January 15, 1915, Berenson Papers, Box 62, Folder 11.

13
Greene to Jacques Seligmann, July 2, 1915, ARC 3291, Box 25, Folder 8.

14
Greene to Berenson, August 25, 1913, Berenson Papers, Box 61, Folder 9. In a letter to Jack's assistant John Axten from June of that year, Greene states a desire to conduct Library business more formally with her new boss in charge, preferring that a request related to the Library come from him instead of her. Greene to Axten, June 25, 1913, ARC 1216, 169:226.

15
Greene to Berenson, December 22, 1913, Berenson Papers, Box 61, Folder 12.

16
Greene to Berenson, January 12, 1921, Berenson Papers, Box 63, Folder 8.

17
Greene to Berenson, February 15, 1915, Berenson Papers, Box 62, Folder 12.

18
Greene to Jack Morgan (cable), March 9, 1920, and Jack Morgan to Greene (cable), March 10, 1920, ARC 1216, 169:226.

19
Jack Morgan to Greene, June 19, 1922, ARC 1216, 170:227.

20
Greene to Berenson, May 19, 1913, Berenson Papers, Box 61, Folder 8.

21
For the fullest account of the provenance of MS M.638, see William M. Voelkle, "The Crusader Bible: Introduction and Provenance, A Curatorial Perspective," in *Biblia de los Cruzados* (Valencia: Scriptorium, 2013), 297–315.

22
The letter is dated November 24, 1916. Voelkle, "Crusader Bible," 306–7. Voelkle cites a Greene letter to Quaritch indicating that Jack would allow acquisitions to resume after the end of the First World War (ibid., 303).

23
The letter is dated December 12, 1916. Ibid., 308.

24
Ibid. The Roxburghe Club is the world's oldest bibliophilic society, founded in 1812.

25
Edwin Wolf II, with John F. Fleming, *Rosenbach: A Biography* (Cleveland: World Publishing Company, 1960), 197–98. Rosenbach immediately left, taking the manuscripts on offer with him, but later returned and sold them to Greene.

26
Greene to Jack Morgan, May 29, 1922, ARC 1216, 170:227.

27
Ibid.

28
Greene to Jack Morgan, August 15, 1923, ARC 1216, 170:227.

29
Lawrence C. Wroth, "A Tribute to the Library and Its First Director," in *The First Quarter Century of the Pierpont Morgan Library: A Retrospective Exhibition in Honor of Belle da Costa Greene*, exh. cat. (New York: Pierpont Morgan Library, 1949), 19; see also Greene to Berenson, January 20, 1927, Berenson Papers, Box 63, Folder 24.

30
Greene to Jack Morgan, July 28, 1922, ARC 1216, 170:227.

31
Jack Morgan to Greene, August 16, 1922, ARC 1216, 170:227.

32
Karen Deslattes Winslow, "The Reluctant Collector and His Librarian: John Pierpont Morgan and Belle da Costa Greene," in "Moguls Collecting Mughals: A Study of Early Twentieth-Century European and North American Collectors of Islamic Book Art," DPhil thesis (University of London School of Advanced Studies, 2023), 126–75.

33
Frank Wheeler to Greene, January 28, 1929, and Greene to Wheeler (copy of cable), March 8, 1929, ARC 3291, Box 20, Folder 17.

34
John Axten to Wheeler, March 13, 1929, ARC 1216, 173:230.2.

35
Wheeler to Greene, March 30, 1929, ARC 1216, 173:230.2.

36
Pencil annotation accompanying MA 1082.1.

37
Greene to Wheeler, June 18, 1929, ARC 3291, Box 20, Folder 17. In a letter to Berenson from 1920, Greene wrote that Jack "doesn't know a good picture from a forgery!—Nor one period (not to mention an artist or school) from another—He has a fine knowledge of tapestries & velvets, rugs & all textiles, but is pretty hopeless in general on art objects." Greene to Berenson, June 29, 1920, Berenson Papers, Box 63, Folder 5.

38
Minutes of the Pierpont Morgan Library Board of Trustees, February 15, 1924, ARC 3294, Box 1425, 1:22. In 1921 Belle Greene told Berenson that Jack Morgan was considering incorporating the Library (Greene to Berenson, June 13, 1921, Berenson Papers, Box 63, Folder 12), and she was using "Pierpont Morgan Library" stationery from 1920, indicating that plans to create the Pierpont Morgan Library had been circulating a few years before 1924.

39
Ibid.

40
The Pierpont Morgan Library, *The Pierpont Morgan Library: A Review of the Growth, Development and Activities of the Library During the Period between Its Establishment as an Educational Institution in February 1924 and the Close of the

Year 1929 (printed by Plandome Press, New York, 1930), 127. (Hereafter abbreviated as "*PML Review, 1924–29*.")

40 Minutes of the Pierpont Morgan Library Board of Trustees, February 15, 1924, ARC 3294, Box 1425, I:21. The five-year PML Review volumes typically list the Board's roster and record how its makeup changed over the years.

42 Minutes of the Pierpont Morgan Library Board of Trustees, February 15, 1924, ARC 3294, Box 1425, I:16. The Morgan Archives show how Jack transferred property first to the Board of Trustees and then to the incorporated Pierpont Morgan Library. See Jack Morgan to the Board of Trustees, May 16, 1924, ARC 1216, 173:230.1. For a full list of the Trustees' powers, see *PML Review, 1924–29*, 134–38.

43 Henry S. Morgan, for instance, wanted Greene's approval of a payment "in order to conform to the regulations." Axten to Greene, March 7, 1924, ARC 1216, 173:230.1.

44 Greene to Jack Morgan, November 2, 1925 and Jack Morgan to Greene, November 6, 1925, ARC 1216, 173:230.1. In another letter that illuminates the Board's management of Greene's authority and privileges, she writes "Mr. Directors" to request permission to attend a weekly lecture at Princeton University, given by the Byzantinist Gabriel Millet. Greene to "Mr. Directors," October 4, 1926, ARC 1216, 174:231.1.

45 Greene to Berenson, February 12, 1924, Berenson Papers, Box 63, Folder 16.

46 Greene to Edward R. Smith, February 2, 1911, ARC 1310. In an earlier letter to the Chief Librarian of Columbia University, Greene indicates that Morgan would not allow officers of the university or its advanced students to use the Library. Greene to James Canfield, November 3, 1906, ARC 1310.

47 Paul Gottschalk, *Memoirs of an Antiquarian Bookseller* (Gainesville: University of Florida, 1967), 17.

48 *PML Review, 1924–29*, 133.

49 Ibid., 8.

50 Ibid., 147–48. Pierpont Morgan Library, *The Board of Trustees of The Pierpont Morgan Library has established the following rules for the use and regulation of the Library* (New York, ca. 1933), ARC 3291, Box 81, Folder 3.

51 "Morgan Manuscripts on Exhibition," *New York Times*, March 31, 1924, ARC 3291, Box 92, Folder 10.

52 Ibid. The last sentence references David Hirshfield, NYC Commissioner of Accounts, and his 1920s investigation into alleged pro-British propaganda found in U.S. History textbooks.

53 Ibid.

54 *PML Review, 1924–29*, 5–6. Students also received special catalogues of the exhibition. See William J. O'Shea, typed circular sent to "The Principals of High Schools and Junior High Schools," December 16, 1924, ARC 3291, Box 92, Folder 10.

55 Typed meeting notes, April 27, 1926, ARC 3291, Box 80, Folder 4.

56 Though today the building is known as the Annex, and that name was also used in the 1920s, it was also sometimes known as "the Students' Wing" and the Reading Room known as "the Students' Reading Room."

57 Belle da Costa Greene, "Questions for Mr. Morgan's decision," July 10, 1928, ARC 1216, 174:231.1. Copies of Jack Morgan's responses were sent to the Board of Trustees.

58 Ann Mosher, typed memorandum, September 13 (no year), ARC 3291, Box 31, Folder 13.

59 Greene to Berenson, May 28, 1930, Berenson Papers, Box 63, Folder 27.

60 *PML Review, 1924–29*, 8.

61 "The Pierpont Morgan Library" is typically cited as the corporate author of the report, but Belle da Costa Greene wrote and compiled the text; her name, however, does not appear on the title page. Alexander Marx of the Jewish Theological Seminary's library noted this discrepancy in his thank you letter: "although the expert knowledge of the charming author is evident all through the book, I was surprised that her name does not appear anywhere." Marx to Greene, December 11, 1930, ARC 3291, Box 86, Folder 1.

62 "The Bibliographer," *Boston Evening Transcript*, November 12, 1930, ARC 3291, Box 85, Folder 11.

63 Royal Cortissoz to Greene, October 2, 1930, and Herbert Putnam to Greene, October 22, 1930, ARC 3291, Box 86, Folder 1.

64 Ruth Granniss to Greene, October 3, 1930, ARC 3291, Box 86, Folder 1. Both Granniss and Greene were Honorary Founding members of the Hroswitha Club, the women's book collecting organization. They also corresponded about their respective libraries and formed a close professional relationship; see the Grolier Club's Institutional Records, Box 21, Folder 1.

65 Jae Jennifer Rossman, "Changing Attitudes toward Access to Special Collections," *Transactions of the American Philosophical Society* 110, no. 3 (2022): 127–50.

66 Mary Biggs, "Librarians and the 'Woman Question': An Inquiry into Conservatism," *Journal of Library History* 17, no. 4 (Fall 1982): 409–28.

67 Alexandra A. A. Orchard, Kristen Chinery, Alison Stankrauff, and Leslie Van Veen McRoberts, "The Archival Mystique," *American Archivist* 82, no. 1 (Spring/Summer 2019): 53–90.

68 Élise Vallier, "African American Womanhood: A Study of Women's Life Writings (1861–1910s)," *Transatlantica*, no. 2 (2017).

69 Rossman, "Changing Attitudes," 129.

70 Ibid.

71 Though the Pierpont Morgan Library had placed restrictions on researcher access to its collection, Belle Greene was clearly committed to striking a balance between access and preservation. She allowed graduate and undergraduate students to use the collection, regularly taught with books and manuscripts, and sent original material for scholars to consult outside of New York.

72 Ibid.

73 As mentioned in Anne-Marie Eze's essay in this volume, Greene did extensive work to unmask the "Spanish Forger." The correspondence preserved in ARC 3291 also shows Greene's support of research through extensive reference communication with scholars.

74 Rossman, "Changing Attitudes," 140.

75 Mary Biggs, "Librarians and the 'Woman Question,'" 413.

76 Greene, "'Pin Money' Workers Bitterly Condemned," quoted in *Democrat and Chronicle*, July 20, 1914.

77 Greene to Winifred Kennedy, February 7, 1943, ARC 3291, Box 29, Folder 12.

78 Violet Burnie Napier to Greene, June 23, 1938; Greene to Napier, June 28, 1938, ARC 3291, Box 18, Folder 22.

79 For correspondence between Belle Greene and Helen Franc, see ARC 3291, Box 36, Folder 9.

80
Greene to Mary Ann Farley Tully, April 5, 1946, ARC 3291, Box 28, Folder 6.

81
Greene to Dorothy Miner, April 3, 1948, ARC 3291, Box 71, Folder 1.

82
Miner to Greene, November 5, 1943, ARC 3291, Box 71, Folder 2.

83
Greene to Henry S. Morgan, March 1, 1932, ARC 3291, Box 106, Folder 12. Also relevant are letters from Harrsen to library staff while she was studying and working in Prague in August of 1936 (ARC 3291, Box 19, Folder 6).

84
Meta Harrsen to Katherine Quinn, August 4, 1936, ARC 3291, Box 19, Folder 6.

85
Harrsen to Greene, September 1946, ARC 3291, Box 13, Folder 2.

86
Multiple letters from Harrsen to Bernard Berenson, Berenson Papers, Box 68, Folders 2–7.

87
The photograph of Greene from 1941 was taken at the sale of Edward Newton's library, Parke-Bernet Galleries. The bibliographer Emily Millicent Sowerby, for whom Belle Greene was "a person that one is more than glad to have known, and would not have missed knowing for anything," described the scene in her memoir: "*Life Magazine* was taking photographs of everything that was going on and of all the personalities. A photographer to whom Miss Greene was unknown had been instructed to take her photograph, so he leaned over me, and said to her, 'Do you mind telling me who you are?' 'Not at all,' replied Miss Greene with dignity and politeness. 'I am Kate Smith, the radio star.' The photographer was completely floored." For Sowerby, Greene was "one of the most remarkable personalities" and "wittiest women" she had known. E. Millicent Sowerby, *Rare People and Rare Books* (London: Constable, 1966), 201–2.

88
The authors are indebted to Sidney Babcock, former Jeanette and Jonathan Rosen Curator and Department Head of Ancient Western Asian Seals and Tablets at the Morgan, for relating the story of his mentor, Edith Porada, as part of the recorded Zoom talk "The Women Who Made the Morgan," March 3, 2021, https://www.themorgan.org/videos/women-who-made-morgan.

89
Ibid.

90
Edith Porada to Greene, n.d. [before January 31, 1939], ARC 3291, Box 57, Folder 9.

91
Greene to Ferris J. Stephens, January 31, 1939; Stephens to Greene, February 2, 1939, ARC 3291, Box 57, Folder 9. Pierpont Morgan was the founding benefactor of Yale's Babylonian Collection. See Benjamin R. Foster, "Albert T. Clay and His Babylonian Collection," in *Beyond Hatti: A Tribute to Gary Beckman*, ed. Billie Jean Collins and Piotr Michalowski (Atlanta: Lockwood Press, 2013), 121–35.

92
Porada to Greene, February 27, 1940, ARC 3291, Box 57, Folder 9.

93
Porada to Greene, n.d. [1940?], ARC 3291, Box 57, Folder 9.

94
Babcock, "The Women Who Made the Morgan."

95
Helen Franc to Greene, July 30, 1942, ARC 3291, Box 36, Folder 9.

96
Ibid. The manuscript Franc describes is MS M.728 (see p. 127 in the present volume).

97
Oral History with Helen Franc, The Museum of Modern Art Oral History Program, April 16, 1991.

98
Greene to A. van de Put, October 26, 1939, ARC 3291, Box 29, Folder 8.

99
Greene to Tammaro De Marinis, 1945, ARC 3291, Box 8, Folder 8.

100
Ernest T. DeWald to Greene, November 14, 1943, ARC 3291, Box 9, Folder 12.

101
ARC 1310, B Badin, Ludovic; ARC 3291, Box 16, Folder 18.

102
H. Idris Bell to Jack Morgan, [July 1941], ARC 3291, Box 2, Folder 7. The folder labeled "Evacuation Measures-WWII" (ARC 3291, Box 80, Folder 17) documents Greene's discussions with the Met and NYPL.

103
Greene to Jane Morgan Nichols, April 21, 1944, ARC 3291, Box 108, Folder 1.

104
The Pierpont Morgan Library, *The Pierpont Morgan Library: Review of the Activities and Acquisitions of the Library from 1941 through 1948: A Summary of the Annual Reports of the Director to the Board of Trustees* (printed by Plantin Press, New York, 1949), 17. (Hereafter abbreviated as "*PML Review, 1941–48*.")

105
Ibid., 22–24. For "people laugh," see clipping of "Comic Art of the Past on Exhibition Here," *New York Times*, February 2, 1943, ARC 3291, Box 92, Folder 9.

106
Greene to Sergeant Bernard M. Peebles, April 6, 1945, ARC 3291, Box 96, Folder 5.

107
Greene to Martin E. Goldschmidt, December 28, 1944, ARC 3291, Box 38, Folder 5.

108
Greene to Erwin Panofsky, July 29, 1943, ARC 3291, Box 54, Folder 11.

109
Greene to Ada Thurston, March 19, 1943, ARC 3291, Box 96, Folder 5.

110
Greene to Edward Weeks, December 17, 1947, ARC 3291, Box 68, Folder 1.

111
William Makepeace Thackeray, *The Rose and the Ring: Reproduced in Facsimile from the Author's Original Illustrated Manuscript in the Pierpont Morgan Library* (New York: Pierpont Morgan Library, 1947).

112
PML Review, 1941–48, 13, 16.

113
Ibid., 8.

114
The Pierpont Morgan Library, *The Pierpont Morgan Library: Review of the Activities and Acquisitions of the Library from 1936 through 1940: A Summary of the Annual Reports of the Director to the Board of Trustees* (printed by Plantin Press, New York, 1941), xii. Greene to Jane Morgan Nichols, October 4, 1933, ARC 3291, Box 108, Folder 1.

115
Greene to Jane Morgan Nichols, March 25, 1943, ARC 3291, Box 108, Folder 1.

116
Nichols to Greene, April 22, 1945, ARC 3291, Box 108, Folder 1.

117
Nichols to Greene, n.d. [August 1943], ARC 3291, Box 108, Folder 1.

118
Greene to Nichols, October 1, 1943, ARC 3291, Box 108, Folder 1.

119
Greene to Nichols, June 12, 1945; Nichols to Greene, April 17, 1947, ARC 3291, Box 108, Folder 1.

120
"Things I Remember about Miss Greene," October 25, 1969, Unprocessed Director's Papers (Charles Ryskamp), ARC.

121
"Signed, Sealed, Delivered: Cylinder Seal Family Workshop," The Morgan Library & Museum website, November 13, 2022, https://www.themorgan.org/programs/signed-sealed-delivered-cylinder-seal-family-workshop.

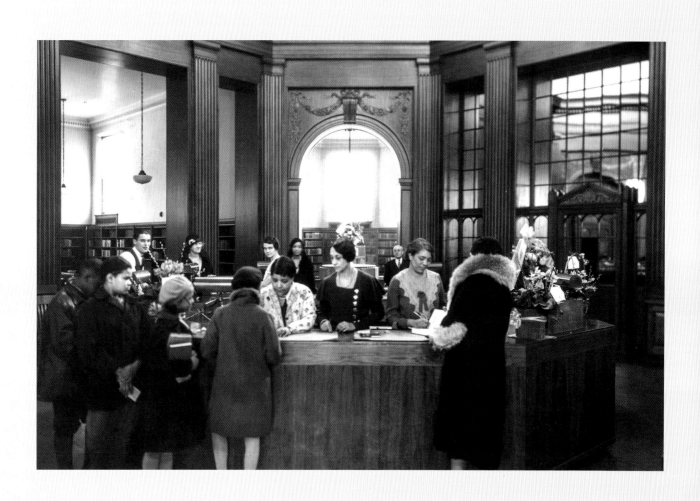

Opening day at the George Cleveland Hall Branch, Chicago, January 1932, with Vivian G. Harsh at center. George Cleveland Hall Branch Archives, Photo 084, Vivian G. Harsh Research Collection of Afro-American History and Literature, Chicago Public Library.

Rhonda Evans

BLACK LIBRARIANSHIP AND THE LEGACY OF BELLE DA COSTA GREENE

Belle da Costa Greene achieved unparalleled status as a library director, collector, and curator during her lifetime. As scholars continue to uncover the complex layers of Greene's life, two main aspects have risen to the forefront of her legacy—her position as the personal librarian of financier J. Pierpont Morgan, along with the luxuries and challenges this position provided, and her Black ancestry, complicated as it was by her decision to pass as white. Although these two points of interest have been the subject of scholarship and literature, there has hardly been any discussion of how these parts of her life intersected. A major obstacle in this regard is the limited documentation of Greene's specific views on race and racial equality. This essay endeavors to reach a fuller understanding of Greene's position by looking beyond the Morgan Library at the broader context of Black librarianship in the United States. Her career building Morgan's collection flourished in the early twentieth century, overlapping with the careers of Black librarians who were curating and stewarding important collections for the purpose of racial equality and Black liberation. How does the legacy of Belle da Costa Greene—a Black woman living as white and working as the director of one of the most revered research libraries in the world—fit into the history of the sociocultural work of pioneering Black librarians who were her contemporaries?

Librarianship in the United States has always been a predominately white profession. Even today, despite visible efforts to increase diversity and inclusivity within the profession, including having a Black woman as the executive director of the main professional organization, 82 percent of librarians in the

United States identify as white.¹ American libraries have a fraught racial past. Not only has the profession been an extremely difficult one for people of color to enter, significant obstacles have prevented Black people from accessing libraries—public and private—as patrons. In fact, one of the very first sit-in demonstrations in the United States was held for the purpose of integrating a public library.² Due to these inequities, the Black librarians of Greene's generation held the struggles of Black people as the foundation of their work. Therefore, the question arises, where does Belle da Costa Greene fit within the legacy of Black librarianship? To answer this question, it is necessary to understand what defines Black librarianship, specifically during the time frame of Greene's career at the Morgan Library. Also, who were some of Greene's Black contemporaries? What motivated them to join a profession that held so many barriers to entry? And how was the work of Black librarians unique within the larger field of librarianship?

EARLY BLACK LIBRARIANSHIP

In 1900 Edward Christopher Williams graduated with a master's degree in library science from the New York State Library School in Albany, making him the first African American with a professional degree in librarianship. However, Williams had been working as a librarian—trained through apprenticeships as was common at the time—since 1892.³ There are no specific dates that define "early Black librarianship," but we begin to see more visible representation within the field not long after Reconstruction. For decades Black librarians struggled to find a place for themselves and for Black library patrons.⁴ But the relevant period, from the turn of the twentieth century through the Harlem Renaissance, saw important early gains within the profession.

In studying the work of Black librarians during this period, the defining commonality—and what many could argue defines early Black librarianship—is a foundation in activism and Black liberation. These librarians were working within a framework where a large population of Black people were suffering the effects of a system that legally penalized Black literacy with extreme physical and mental abuse.⁵ Prior to the Civil War, with the exception of Tennessee, all Southern states had laws forbidding enslaved people (and even some free people of color) to read, learn to read, or teach other Black people to read.⁶ Therefore, "a direct result of these antebellum policies was that by 1900, over half of America's black population, 90% of whom had remained in the South after slavery ended, could not read or write."⁷ It was understood by both white and Black people that reading and writing were powerful tools that could be used in acts of resistance and liberation. This was so profoundly felt by enslaved people that even with the threat of severe punishment, they found ways to educate themselves and each other by creating spaces such as "pit schools" and "floating schools" as informal classrooms.⁸ Many early Black librarians were

only one or two generations removed from their enslaved ancestors and the illegality of Black literacy, including Greene.[9]

Under the doctrine born from the 1896 Supreme Court decision *Plessy v. Ferguson*, public libraries should have provided "separate but equal" services to their Black populations. However, even with some support by the Carnegie Corporation to construct library branches for Black citizens, this "separate but equal" rarely came to pass, and the vast majority of Black people received no public library services.[10] As Patterson Toby Graham writes in *A Right to Read* in regard to public libraries in Birmingham, Alabama, at the turn of the twentieth century, "while the library supporters spoke in universals, they had to admit that the 80,000 blacks in the city received nothing but sympathy in regard to library service."[11] In the early nineteen hundreds academic libraries at historically Black colleges and universities (HBCUs) did exist, the first opening in 1865 at Virginia Union University, but these still only provided limited access to the larger Black population.[12]

Leaders of the Black community at the turn of the twentieth century keenly understood the power of libraries and the important work of librarians. Activists and scholars such as W. E. B. Du Bois, Walter White, and Adam Clayton Powell Sr. and Jr. were advocates for public library access as well as access to the profession of librarianship.[13] Du Bois claimed, "Every argument which can be adduced to show the need of libraries for whites applies with redoubled force to the negroes."[14] Even Greene's father, Richard T. Greener, worked as a librarian at the University of South Carolina in addition to his professorship.[15]

Activism around library access continued in the 1920s during the Great Migration. This was also the height of the Harlem Renaissance, out of which came the idea of the "New Negro Reader."[16] It was during this time that Black librarianship was at its most visible, due to the significant increase in Black publications including newspapers, magazines, literature, and nonfiction that explored Black history and culture and featured prominent as well as emerging Black scholars, writers, collectors of history, and other thought leaders.

VINDICATING EVIDENCES

To understand Greene's place in early Black librarianship, it is important to look at her career in conversation with a few of the pioneering Black librarians who were her contemporaries, specifically Catherine Latimer, Vivian G. Harsh, and Daniel Murray.[17] Greene's place in early Black librarianship can be examined through the lens of two important aspects of library work—collecting and access.

In 1925 Arturo Alfonso Schomburg (fig. 1), the famed bibliophile and historian, published an essay in Alain Locke's anthology *The New Negro* titled "The Negro Digs Up His Past."[18] Of African descent and born in Puerto Rico, Schomburg dedicated his life to collecting an array of materials that documented the history of Black people globally.[19] Schomburg used the term "vin-

dicating evidences" to describe how the collecting and sharing of this history could counteract consistent negative stereotypes and correct the erasure of the historical contributions of Black people while instilling pride and curiosity in those who were exploring these concepts for the first time. Schomburg writes,

> The American Negro must remake his past in order to make his future. Though it is orthodox to think of America as the one country where it is unnecessary to have a past, what is a luxury for the nation as a whole becomes a prime social necessity for the Negro. For him, a group tradition must supply compensation for persecution, and pride of race the antidote for prejudice.[20]

One of the key tenets of Black librarianship in the early twentieth century was to collect and provide resources—historical and current—by and about Black people that demonstrated their place in the world from outside of the lens of whiteness.

In 1925, a year after Greene was officially named director of the Pierpont Morgan Library, Catherine Latimer (hired in 1920 as the New York Public Library's first Black librarian) was appointed as the head librarian of NYPL's Division of Negro Literature, History and Prints (fig. 2). This special division of the 135th Street Branch was established to house rare books, manuscripts, and other special collection items by and about people from the African diaspora. In 1926 the library purchased the impressive collection of Arturo Schomburg, which included thousands of rare books, manuscripts, pamphlets, and art—the "vindicating evidences" collected over his lifetime. Latimer served as the steward of this collection for twenty-five years and worked closely with Schomburg, who later became curator of the division.[21]

The parallel professional relationships between Belle Greene and J. Pierpont Morgan and between Latimer and Schomburg are compelling. Coincidentally, in 1934 the New York Public Library held two concurrent exhibitions from the collections of Morgan's son, Jack (an exhibition of his medieval manuscripts curated by Greene), and Schomburg. An article on the exhibitions published in the *Pittsburgh Courier* described the two collectors: "The first is J. Pierpont Morgan; and the other is Arthur Schomburg. One is white, the other colored. Yet immense as was the social and financial distance between them, both had in common a taste that is as rare as it is beneficial, namely, the preserving of records, written and pictorial, for the guidance and advancement of mankind.

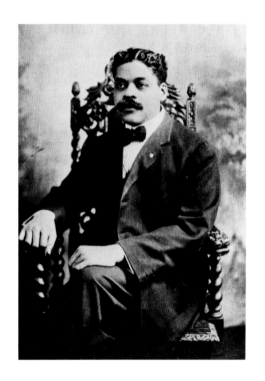

FIG. 1
Portrait of Arthur Alfonso Schomburg, Bibliophile, 1900–1935. Gelatin silver print; 10³⁄₁₆ × 8⁵⁄₁₆ in. (26 × 21 cm). New York Public Library, Schomburg Center for Research in Black Culture, Photographs and Prints Division; SC Photo Arthur Alfonso Schomburg Collection.

Without men of the type of Morgan and Schomburg, humanity would retrograde until it again reached cannibalism."[22]

While both Greene and Latimer worked under the shadow of these two titans, they carefully curated and developed the collections they managed while also forging their own professional connections and practices. Yet the values placed on these materials and the motivations behind the collecting differed greatly. Greene clearly expressed to Morgan, early in her career, that her aspiration was to make his library "pre-eminent, especially for incunabula, manuscripts, bindings and the classics."[23] Her collecting focus was Europe, and she traveled there often to purchase what was considered the most precious and valuable art and books in the world.[24]

Schomburg and Latimer collected for a different purpose, understanding early on the value in historical works not yet recognized by the rest of the field.

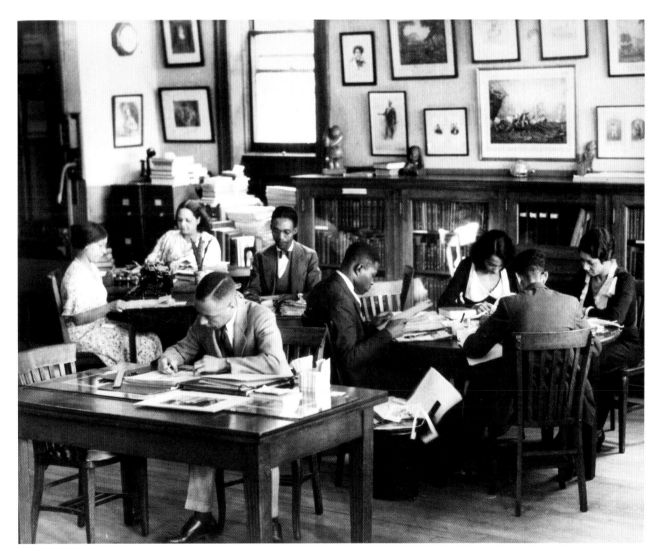

FIG. 2
Researchers using the Schomburg Collection when it was the 135th Street Branch Library Division of Negro Literature, History and Prints, with Catherine A. Latimer, reference librarian of the collection, in left background, 1938. New York Public Library, Schomburg Center for Research in Black Culture, Photographs and Prints Division; Box 5.

The goal was not to build up private wealth and status—although that was not the sole reason Morgan collected, and Greene claimed to have a great interest in rare manuscripts from early in her career.[25] Instead, they sought to document, through the collection of rare materials, the historical narrative of Black people and to provide free and open access to the collection. Although Schomburg, like Morgan, began collecting for his personal library, the fact that he sold his collection to the New York Public Library is significant.[26] The work of Schomburg and Latimer to house this collection in a space with few barriers to access aimed to dismantle the racist narratives that were widely believed and taught in early twentieth century America.

In an article Latimer wrote for *The Crisis* magazine in 1934, "Where Can I Get Material on the Negro," she describes many of the rare items that were in the Division of Negro Literature, History and Prints, including the first known published work by a Black author, Juan Latino, from 1573; eighteenth-century works by Jupiter Hammon, the first Black poet published in the United States; first-edition books by poet Phillis Wheatley; and an extensive collection of manuscripts from Haiti, including the "Proclamation and Address of Toussaint

FIG. 3
Vivian G. Harsh, 1920s. George Cleveland Hall Branch Archives, Box 10, Photo 087, Vivian G. Harsh Research Collection of Afro-American History and Literature, Chicago Public Library.

FIG. 4
Daniel A. P. Murray, n.d. Library of Congress, Manuscript Division; Daniel Alexander Payne Murray Papers, 1900–1970, MSS5741.

L'Ouverture (bearing his signature), that he delivered when he took command of the army in 1793."[27] Similar to Morgan, Schomburg also collected an impressive number of sixteenth- and seventeenth-century manuscripts, although they were exclusively works by Black authors or about Black people.[28] As Latimer explained, "there is in this wealth of material a virgin field along research lines and it is hoped in the future that these treasures may be more widely used and appreciated by all races."[29]

"Where Can I Get Material on the Negro" represents the chief principles of Black librarianship in the early twentieth century: to collect and document Black history while encouraging the public to explore and develop scholarship in order to promote understanding, equity, and Black liberation. To achieve this, other Black librarians had to do similar work, and there were many who were building and promoting collections similar to Latimer's. One example is Vivian G. Harsh (fig. 3).

In 1932, after having worked at the Chicago Public Library for twenty-three years, Harsh was appointed as the head of the George Cleveland Hall Branch Library (p. 248), which was built to serve the Black residents of Chicago.[30] There she opened the Special Negro Collection, which added great value to the already heavily used branch services and circulating collections by providing access to rare books, manuscripts, maps, and other materials.[31] Unlike Latimer and Greene, Harsh was not affiliated with any major collectors, but it was her mission to continue to build the Special Negro Collection. In 1934 Greene and Harsh were both traveling extensively in search of the most unique, rare, and important works for their libraries. As Greene traveled throughout Europe on a significant budget provided by the Morgans, Harsh traveled the United States on a grant from Julius Rosenwald to find books that were written on Black culture and by Black authors. She returned from her trip with first-edition volumes by authors such as Phillis Wheatley, W. E. B. Du Bois, George Washington Williams, and William Wells Brown.[32] Like many Black librarians at the time, Harsh also recognized the talents of those who were using the special collections for their own work, and she collected manuscripts from then-unknown writers, such as Richard Wright and Gwendolyn Brooks, and added them to the Special Negro Collection.[33]

Although not all of Greene's Black librarian contemporaries were working in libraries that served Black populations, many still directed their efforts to the collection, preservation, and use of materials related to Black history and culture. Daniel Alexander Payne Murray was an assistant librarian at the Library of Congress from 1881 to 1923, and very briefly served as chief of the Periodicals Division (fig. 4).[34] Murray devoted his career at the Library of Congress to building a collection of works written by Black authors. One of the most significant turning points of his career was the 1900 Paris Exhibition. As famed librarian Jessie Carney Smith recounted in a profile of Murray:

In 1899, as the nation prepared for the American Exposition to be displayed at the 1900 Paris Exhibition, Murray was asked to provide a special demonstration on "Negro Literature." He startled the literary world by compiling a bibliography of over 2,000 books and pamphlets written and published by blacks. For his work Murray was heralded worldwide, since, until then, no one knew the breadth of black works.[35]

These works became the Library of Congress Collection of Books by Colored Authors, later the Murray Collection.

Black librarians in the early twentieth century greatly valued the materials they were collecting when the rest of the world did not, as evidenced by the fact that Latimer and Murray, with significantly lower salaries than Greene, were able to amass significant personal collections of Black-related rare books, art, and manuscripts.[36] Interestingly, Greene held pieces of African art in her private collection, but openly expressed in letters that Black art was inferior. At one point during Latimer's career she went to great lengths to acquire a collection of African art, one that was also desired by the Museum of Natural History, while Greene referred to a book on African art as "Nigger art."[37] In her biography of Greene, Heidi Ardizzone describes an observation by one of Greene's closest friends, Agnes Ernst Meyer, who collected from various parts of the world. Meyer, she writes "had a strong interest in African art, especially wood carvings and masks, a taste she tried unsuccessfully to transfer to Belle. She once complained that Belle had no respect for 'Negro things.'"[38]

Latimer emphasized the values of Black librarianship in the conclusion of "Where Do I Get Material on the Negro," explaining: "The purpose for which this Division was established is gradually being realized. Race consciousness and race pride are being aroused and inspired through the preservation of these historical records."[39] Outwardly there was clearly a schism between Greene's values, goals, and mission and those that defined Black librarianship. However, her personal collection possibly suggested the opposite.

THE ART OF ACCESS

Most Black librarians worked in public libraries, many of them segregated, officially or unofficially, or at the libraries of historically Black colleges and universities. Although Morgan's library was built around a private collection, Greene was dedicated throughout her career to opening up the library for public use, claiming, "I care too much for the art of collecting to put rare books out of the reach of ordinary people."[40] This goal was eventually achieved with the opening of the Pierpont Morgan Library as a public institution in 1924. Also, under Greene's direction, the Library had no documented policies restricting access due to race, and there is currently no evidence that Greene prevented researchers from consulting the collections due to their race.[41]

FIG. 5
Carl Van Vechten (1880–1964), *Dorothy Porter Wesley*, May 23, 1951. Photographic print; 9½ × 7³⁄₁₆ in. (24 × 18.3 cm). Carl Van Vechten Papers Relating to African American Arts and Letters. James Weldon Johnson Collection in the Yale Collection of American Literature, Beinecke Rare Book and Manuscript Library; JWJ MSS 1050, Box 108, Folder 1977.

Public access presented a number of complex challenges for early Black librarianship. These librarians often worked in the only library spaces open to Black residents. Although one branch might serve the majority of the Black people in a city, as in Chicago, such branches often received significantly less funding and additional resources than the numerous other branches that served their white counterparts. As a result, Black librarians had to provide more diverse services to larger populations with fewer resources. Their branches were not just a place to consult library materials, but also served as meeting spaces, spaces to create, and spaces for intellectual activities and discussion.[42] The prime example is the New York Public Library's 135th Street Branch during the Harlem Renaissance, when theatrical performances and art lessons took place in the basement, and authors such as Langston Hughes, Alain Locke, Jessie Fauset, and Zora Neale Hurston used the library both as patrons and as a place to share their work.[43]

In addition to providing access to physical spaces of learning, the lasting legacy of many Black librarians are the collections that they put so much effort into building for public use. Latimer and Murray were prolific bibliographers, both working, at different points, on encyclopedias that documented the history of Black people. They both also published regularly on Black history and the related materials within their libraries.[44] This parallels Greene's important work as a bibliographer, developing catalogues of Morgan's collection for exhibitions.[45] Many Black librarians, most notably Dorothy Porter Wesley of Howard University, practiced "countercataloguing"—the practice of cataloguing library materials outside of traditional cataloguing systems such as Melvil Dewey's decimal system (fig. 5). As described by Laura E. Helton in her article "On Decimals, Catalogs, and Racial Imaginaries of Reading," in the Dewey system, "nearly every object relating to African American life and history—aside from those on slavery, suffrage, minstrelsy, education, or domestic labor—landed in a section of the library reserved for works about people foreign to the nation."[46] Black librarians took decisive action against this in order for their patrons to easily find books related to Black culture. As Helton explains, "Catherine Latimer removed books on Africa from the class for travel, where catalogers often placed them, and moved them to ethnology or history. These acts built on a tradition of countercataloging at black institutions, from Du Bois's turn-of-the-century bibliographies at Atlanta University to the filing systems developed at the Tuskegee and Hampton Institutes to organize black newspaper data."[47]

Greene had the privilege, with the blessing of Morgan, to serve as the one gatekeeper who could choose to open a private library to some or all of the public, while Black librarians were fighting for access on multiple fronts, working to provide easy entry to collections in both physical and intellectual spaces.

CONCLUSION: RACE, PASSING, AND BLACK LIBRARIANSHIP

In addition to a dedication to the profession of librarianship, Greene shared other important characteristics with the librarians highlighted in this essay. They all came from elite, highly educated, wealthy, light-complexioned African American families.[48] Latimer, Harsh, and Murray, if they had chosen, could easily have lived as white. Whether it was a legacy of activism and pride in their heritage, or fear that they would lose more than they gained, they all made the choice to live openly and proudly Black. Murray often addressed his mixed heritage. As Billie E. Walker writes in his profile, "Murray and other light-complexioned aristocrats believed their function was to serve as a 'natural bridge' between the black and white worlds, as racial and cultural brokers who spoke to

FIG. 6
Frederick Douglass (1818–1895), Autograph letter to J. D. Husbands, January 17, 1881. The Morgan Library & Museum, New York, purchased from P. Alloway, November 1947; MA 1221.

blacks and for blacks to whites."[49] However, in spite of their privilege these figures spent much of their careers fighting racial prejudice within the library profession, including demotions (in the case of Murray, because white colleagues refused to be supervised by a Black librarian) and being excluded from professional events.[50]

When trying to understand Greene's place in the history of Black librarianship, it is difficult to ignore that there are few documented instances where Greene mentions Blackness without degrading it in some form—using terms such as "darky," "slave," and the N-word.[51] This could be understood as an attempt to reaffirm her whiteness to others as opposed to a reflection of internalized racism. Regardless, this behavior is in direct contradiction with the work that Latimer, Harsh, Murray, and others were doing at the time. Black librarians during Reconstruction and Jim Crow aimed to liberate Black people by providing access to information and, more specifically, information that allowed understanding and appreciation of one's own history, culture, and achievements.

In 1947, toward the end of Greene's career as director of the Morgan Library, she made a purchase that did not fall in line with the illuminated manuscripts and other rare materials she had spent her career collecting. Greene added

FIG. 7
Accession book for the department of Literary and Historical Manuscripts, showing entries for MA 1201–1225, including the Frederick Douglass letter (MA 1221; see entry 21), 1944–47. The Morgan Library & Museum, New York.

to the Morgan's collection of literary and historical manuscripts an 1881 letter by Frederick Douglass (figs. 6, 7). Although there was already some Americana acquired by the Morgan Library, which included letters by Douglass, Greene had never specifically sought out individual items by Black Americans or documenting the Black experience.[52] The letter acquired by Greene is a letter from Douglass to J. D. Husbands discussing, in general, government appointments in regard to the administration of President-Elect General James A. Garfield. In the letter Douglass writes, "All that they have a right to ask of General Garfield is, that they shall not be discriminated against on account of race or color in his selection of the men to fill the offices under him."[53] This one letter raises many more questions than it answers. As her career was coming to an end, was Greene sending a message about her work as a librarian? Does her acquisition reflect a newfound desire to recognize and connect with her Black heritage, or was the desire always there but constrained by a fear that to speak positively of Blackness would risk her own being discovered? Did she believe, nearing the end of her career as director of the Morgan Library, that she was now free to make this choice without repercussion?

Greene, as a consequence of her efforts to live convincingly as a white woman, had to also claim white supremacy. Therefore, it is easy to state that she does not hold space within the legacy of Black librarianship. However, to be Black in America, especially during the height of Jim Crow, was to face the constant threat of physical and emotional racial violence, a fact that makes it understandable why living as white was a viable choice for some Black Americans. As Allyson Hobbs explains in her book *A Chosen Exile*, "Passing was a potent weapon against racial discrimination, but it was also a potential threat to personal and community integrity."[54] Therefore, categorically denying Greene's place within the legacy of Black librarianship overlooks and oversimplifies the racial complexities of a society that compels a person to make the choice to "pass." Greene's Black peers accomplished great things throughout their careers, but they were held back from even greater accomplishments due to racism and sexism. Is it possible that the Douglass letter provides a glimpse into what Greene would have done with her career if she lived in a society that did not constantly deny the intelligence and humanity of Black people?

NOTES

1
Tracie Hall led the American Library Association from 2020 until 2023. On her appointment, see American Library Association, "ALA Appoints Tracie D. Hall as Executive Director," press release, January, 15 2020, https://www.ala.org/news/press-releases/2020/01/ala-appoints-tracie-d-hall-executive-director; Department for Professional Employees AFL-CIO, "Library Professionals: Facts and Figures, 2023 Fact Sheet," April 16, 2023, https://www.dpeaflcio.org/factsheets/library-professionals-facts-and-figures.

2
See Brenda Mitchell-Powell, *Public in Name Only: The 1939 Alexandria Library Sit-In Demonstration* (Amherst: University of Massachusetts Press, 2022).

3
E. J. Josey, "Edward Christopher Williams: Librarian's Librarian," *Negro History Bulletin* 33, no. 3 (March 1970): 70–77.

4
Even through the 1960s many state library associations did not admit Black librarians. Renate L. Chancellor, *E. J. Josey: Transformational Leader of the Modern Library Profession* (London: Rowman & Littlefield, 2020), 126.

5
Birgit Brander Rasmussen, "'Attended with Great Inconveniences': Slave Literacy and the 1740 South Carolina Negro Act," *PMLA* 125, no. 1 (2010): 202, http://www.jstor.org/stable/25614450.

6
Debbie Johnson-Houston and Maurice B. Wheeler, "A Brief History of Library Service to African Americans," *American Libraries* 35, no. 2 (February 2004): 42; Rasmussen, "'Attended with Great Inconveniences,'" 202.

7
Johnson-Houston and Wheeler, "Brief History," 42.

8
Heather Andrea Williams, *Self-Taught: African American Education in Freedom and Slavery* (Chapel Hill: University of North Carolina Press, 2005), chapter 1; Dennis L. Durst, "The Reverend John Berry Meachum (1789–1854) of St. Louis: Prophet and Entrepreneurial Black Educator in Historiographical Perspective," *North Star: A Journal of African American Religious History* 7, no. 2 (Spring 2004): 6.

9
Heidi Ardizzone, *An Illuminated Life: Belle da Costa Greene's Journey from Prejudice to Privilege* (New York: W. W. Norton, 2007), 6.

10
Johnson-Houston and Wheeler, "Brief History," 42–43.

11
Patterson Toby Graham, *A Right to Read: Segregation and Civil Rights in Alabama's Public Libraries, 1900–1965* (Tuscaloosa: University of Alabama Press, 2002), 10.

12
Johnson-Houston and Wheeler, "Brief History," 44–45.

13
Rhonda Evans, "Libraries and the Color Line: Du Bois and the Matter of Representation," in *The Black Librarian in America: Reflections, Resistance, and Reawakening*, ed. Shauntee Burns-Simpson et al. (London: Rowman & Littlefield, 2022), 16.

14
W. E. B. Du Bois, "The Opening of the Library," *Bulletin of Atlanta University*, 1902.

15
Rebecca D. Hunt. "African American Leaders in the Library Profession: Little Known History," *Black History Bulletin* 76, no. 1 (2013): 16, http://www.jstor.org/stable/24759707. During the Civil War, the library at the University of South Carolina was transformed into a temporary hospital for the Confederate army. Greener was instrumental in revitalizing the library. Greener brought in a cataloguer, oversaw minor renovations, and reshelved thousands of books. Katherine Reynolds Chaddock, *Uncompromising Activist: Richard Greener, First Black Graduate of Harvard College* (Baltimore: Johns Hopkins University Press, 2017), 61.

16
Shawn Anthony Christian, *The Harlem Renaissance and the Idea of a New Negro Reader* (Amherst: University of Massachusetts Press, 2016), 3.

17
There were a number of trailblazing Black librarians who made significant contributions to the field of librarianship during the time that Greene was working, for example, Dorothy Porter Wesley at Howard University, and many who worked with Latimer at the New York Public Library's 135th Street Branch such as Regina Anderson Andrews and Augusta Baker. However, space prohibits an extensive discussion of the many pioneering Black librarians working in the early twentieth century.

18
Arthur A. Schomburg, "The Negro Digs Up His Past," in *The New Negro*, ed. Alain Locke (New York: Atheneum, 1970), 231–38.

19
Vanessa K. Valdés, *Diasporic Blackness: The Life and Times of Arturo Alfonso Schomburg* (Albany: State University of New York Press, 2018).

20
Schomburg, "The Negro Digs Up His Past," 231.

21
Rhonda Evans, "Catherine A. Latimer: Librarian of the Harlem Renaissance," *Libraries: Culture, History, and Society* 6, no. 1 (March 2022): 21–27.

22
J. A. Rogers, "Rogers Compares Lives of Morgan and Schomberg [sic] Whose Portraits Hang Side by Side," *Pittsburgh Courier*, January 1934.

23
Jean Strouse, *Morgan: American Financier* (New York: Random House, 1999), 510.

24
According to Strouse: "It all began nearly from the moment Belle stepped off the Oceania. Newspaper reporters recorded her arrival, estimating that she brought $30,000 worth of items back for the Morgan Library." Ibid., 211.

25
Ibid., 2.

26
Valdés, *Diasporic Blackness*, 3.

27
Catherine Allen Latimer, "Where Can I Get Material on the Negro," *The Crisis* 41 (June 1934): 164.

28
David Pullins and Vanessa K. Valdés, *Juan de Pareja: Afro-Hispanic Painter in the Age of Velázquez*, exh. cat. (New York: The Metropolitan Museum of Art, 2023), 51–60.

29
Latimer, "Material on the Negro," 164.

30
"Vivian Gordon Harsh," in *Contemporary Black Biography*, vol. 14 (Detroit: Gale, 1997), *Gale In Context: Biography*, accessed May 27, 2023, https://link-gale-com.i.ezproxy.nypl.org/apps/doc/K1606001130/BIC?u=nypl&sid=bookmark-BIC&xid=0d16ef1e.

31
Ibid.

32
Ardizzone, *Illuminated Life*, 434; "Vivian Harsh," in *Notable Black American Women* (Detroit: Gale, 1992), *Gale in Context: Biography*, accessed May 27, 2023, https://link-gale-com.i.ezproxy.nypl.org/apps/doc/K1623000185/BIC?u=nypl&sid=bookmark-BIC&xid=0d907249.

33
"Vivian Gordon Harsh," in *Contemporary Black Biography*.

34
Johnson-Houston and Wheeler, "Brief History," 44.

35
"Daniel Murray," in *Notable Black American Men, Book II*, ed. Jessie Carney Smith (Detroit: Gale, 1998), *Gale in Context: Biography*, accessed May 27, 2023, https://link-gale-com.i.ezproxy.nypl.org/apps/doc/K1622000334/BIC?u=nypl&sid=bookmark-BIC&xid=1d0ee738.

36
Evans, "Catherine A. Latimer," 36; Billie E. Walker, "Daniel Alexander Payne Murray (1852–1925), Forgotten Librarian, Bibliographer, and Historian," *Libraries and Culture* 40, no. 1 (Winter 2005): 34.

37
Evans, "Catherine A. Latimer," 35; Ardizzone, *Illuminated Life*, 164.

38 Ibid., 271. See Gail Levin's brief discussion in the present volume of Greene's thoughts on African art and the statues in her personal art collection.

39 Latimer, "Material on the Negro," 165.

40 "J. P. Morgan's Librarian Says High Book Prices Are Harmful," *New York Times*, April 30, 1911, 13.

41 There is a record of Alain Locke asking Greene if he can "include a photograph or print of Tintoretto's *Portrait of a Moor* in his book *The Negro in Art*," to which Greene agreed. Ardizzone, *Illuminated Life*, 446.

42 Cheryl Knott, *Not Free, Not for All: Public Libraries in the Age of Jim Crow* (Amherst: University of Massachusetts Press, 2016), 3.

43 Evans, "Catherine A. Latimer," 28.

44 Ibid., 33–34; Walker, "Daniel Alexander Payne Murray," 27–29, 31–34.

45 Ardizzone, *Illuminated Life*, 431.

46 Laura E. Helton, "On Decimals, Catalogs, and Racial Imaginaries of Reading," *PMLA* 134, no. 1 (2019): 103.

47 Ibid., 105.

48 Evans, "Catherine A. Latimer," 22–23; Adolph J. Slaughter, "Historian Who Never Wrote," *Chicago Defender*, August 29, 1960, http://ezproxy.nypl.org/login?url=https://www.proquest.com/historical-newspapers/historian-who-never-wrote/docview/493830456/se-2; Walker, "Daniel Alexander Payne Murray," 26–27.

49 Ibid., 30.

50 Johnson-Houston and Wheeler, "Brief History," 42–43; Evans, "Catherine A. Latimer," 29–43.

51 Ardizzone, *Illuminated Life*, 164, 225, 413.

52 J. Pierpont Morgan acquired several Frederick Douglass letters as part of large collections purchased en bloc, specifically the Ford Collection (1898) and an extra-illustrated, multivolume set (now broken up) of John G. Nicolay's biography of Abraham Lincoln.

53 Frederick Douglass to J. D. Husbands, January 17, 1881, Morgan Library & Museum, MA 1221.

54 Allyson Hobbs, *A Chosen Exile: A History of Racial Passing in American Life* (Cambridge, MA: Harvard University Press, 2014), 13.

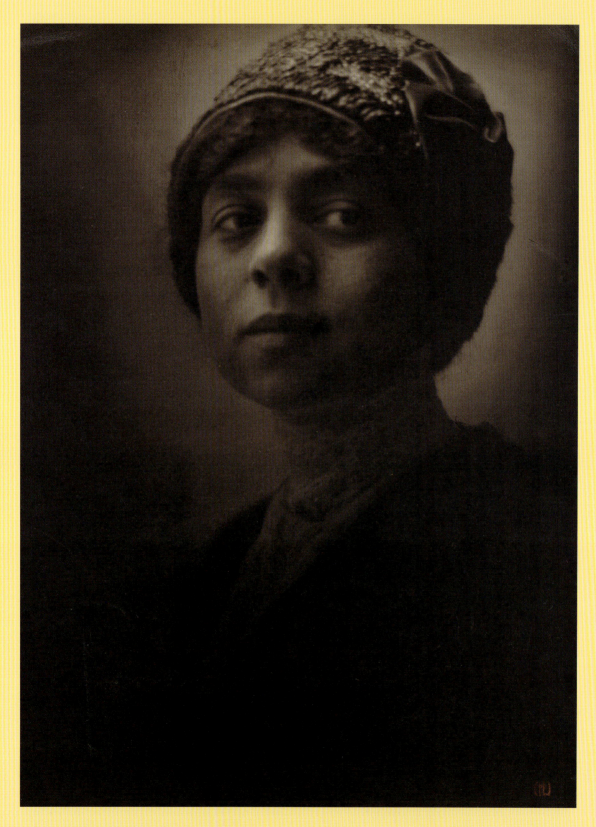

Clarence H. White (1871–1925), *Belle da Costa Greene*, 1911. Platinum print; 9 13/16 × 7 5/16 in. (24.9 × 18.5 cm). Biblioteca Berenson, I Tatti, the Harvard University Center for Italian Renaissance Studies; Bernard and Mary Berenson Papers, Personal Photographs, Box 12, Folder 37.

Philip S. Palmer

BELLE GREENE AS DIRECTOR:
ENDINGS

In the 1940s, global upheavals and the death of Jack Morgan no doubt had a great impact on Belle Greene's leadership of the Pierpont Morgan Library. But it was a series of personal deaths, between 1941 and 1945, that affected her the most. The first was that of Greene's mother, in March of 1941. Genevieve Ida Fleet Greener, who had been calling herself Genevieve Van Vliet Greene since 1903, lived with her daughter for most of her life. But surviving archival sources—most significantly Belle's letters to Bernard Berenson—provide only brief glimpses of Genevieve's life with her daughter. Genevieve traveled overseas with Belle on several occasions, most notably as a chaperone on her daughter's first trip abroad, in 1908.[1] When they first moved to Murray Hill from West 115th Street, in late 1910, Belle Greene lived at 138 East 40th and her mother in an adjoining apartment at 142 East 40th, though "to make it eminently respectable [she] cut an opening through the two drawing rooms so that it is virtually one apartment."[2] After Pierpont Morgan's death in 1913, Belle Greene noted of her inheritance that it "would take care of me personally and alone—but will not go far with a dependent mother, two sisters and a married sister and brother in law."[3] In 1914 Greene and her sisters threw Genevieve a birthday party, where they

> made Mother's life miserable by trying to learn her real age. We guessed all the way from 40 to 80 but she would not admit to anything. We all simply <u>busted</u> ourselves on presents to her. Ethel & Teddy combined gave her a lovely opera wrap, my sister a small diamond brooch and I, the diamond hair piece. We have all decided to go naked and hungry in consequence.[4]

A couple of months later, when Greene succumbed to "nervous prostration" one morning, it was her mother who called the doctor and Jack Morgan.[5]

There are fewer surviving references to Greene's mother from the 1920s onward, when Greene's correspondence with Berenson became less frequent. But one exception is an extraordinary letter sent to the Morgan in 2000 by Gertrude Tuxen, a Danish chambermaid who worked in Belle Greene's household from around May 1939 to April 1940, when she lived at 53 East 66th Street. Tuxen worked under Greene's housekeeper Elise Olsen, originally from Norway. In her letter Tuxen describes a luxury apartment filled with objects from Greene's personal collection: "She and her mother occupied the 7th floor which had its own elevator entrance. The home was a 'museum' with many items from Miss Greene's travels with JP Morgan, there were chairs you were not to sit on, and I was told that many things were museum bound eventually."[6] The ninety-year-old "Mrs. Greene," also "referred to as the 'old lady,'" seemed to live a fairly lonely life at the apartment, according to Tuxen: "no friends knew her then or came. The household staff was her sole companionship." Taking with them the household Pekingese dog, named "Hia Shua San," Tuxen and Olsen (along with Gertrude's aunt and uncle) one day took Genevieve for a picnic outing in the

FIG. 1
Genevieve Van Vliet Greene (left), Belle da Costa Greene's mother, on an outing in the Hudson River Valley near Bear Mountain, ca. 1939. Gelatin silver print; 3½ × 4⅝ in. (8.9 × 11.6 cm). The Morgan Library & Museum, New York; ARC 3297.1.

Hudson Valley near Bear Mountain State Park. Tuxen included with her letter several photographs, including one of this picnic outing (fig. 1).[7] In it Genevieve is seated at left in what Tuxen describes as a "very comfortable chair for the old lady." This is the only known photograph of Genevieve.

Given all of the archival gaps in the life of Belle's mother, it is telling that the only known image of her comes *not* from the expected repositories or in the expected contexts—a photograph from the college preparatory program she attended at Oberlin College, perhaps, or an image of the Fifteenth Street Presbyterian Church congregation—but rather from her daughter's chambermaid and at the end of her life. Tuxen worked under Greene for less than a year and the household staff only brought Genevieve on a day trip this one time. That she took a photograph of this outing, preserved it, and sent her letter to the Morgan sixty-one years later is almost hard to believe. And yet, this is the way the family's history comes down to us, through twists and turns.

What the photograph most powerfully captures and reveals is the visual logic of passing. Compared to the skin tone of her daughter Belle, Genevieve's complexion is quite light and she does not immediately appear to be a Black woman. The image of "Mrs. Greene" perhaps helps to explain how Genevieve Ida Fleet Greener could pass as Genevieve Van Vliet Greene, how she could fit into the colorist social world of the Fifteenth Street Presbyterian Church, how Grace Hoadley Dodge—Belle Greene's educational patron who corresponded with Genevieve about the Northfield Seminary for Young Ladies—could believe she was white, and why Belle Greene's younger sister Theodora looked almost indistinguishable from the white women in her Barnard College yearbook photo (fig. 2). Unlike Belle and Russell, Genevieve and Theodora did not need to employ "da Costa" as a cover, but could instead use the socially aspirant "Van Vliet" to align their assumed whiteness with old New York families of status. Genevieve's death certificate, which was signed by Belle Greene, documents both of the family's adopted middle names: rather than James H. Fleet, Genevieve's father is listed as Robert Van Vliet, and rather than Hermione Peters Fleet, her mother appears as Genevieve Dacosta.[8] After years of the family's names transforming in official records and city directories, Genevieve's death certificate attempts to settle the matter of Dutch and Portuguese ancestry once and for all in the eyes of the law.

That same year Belle Greene's longtime friend and colleague, the Coptic manuscript scholar Father Henri Hyvernat, died of cancer only a couple of months after her mother's death. But it was in the summer of 1943 that Greene suffered the greatest tragedy of her life, when she lost her nephew,

GENEVIEVE VAN V. GREENE
403 W. 115th Street, New York

Must I work?
Oh, what a waste of time!

FIG. 2
Yearbook photo of Genevieve "Teddy" Greene, Barnard College class of 1912, *Mortarboard* 18, 1911, 184. Barnard Archives and Special Collections, Mortarboard Collection, 1894–2023, carton 2; BC12.01.

Robert "Bobbie" MacKenzie Leveridge. Bobbie was born in 1919 to Greene's sister Theodora, whose husband was killed in action during the First World War, before Bobbie's birth. Despite the circumstances, Bobbie's arrival brought immense joy to his mother and doting aunt:

> I think that I wrote you that my small sister Teddy has an A.1—peach of a boy—He is a bit too blond to absolutely suit me as I'm not awfully keen about a blue eyed golden haired man—but as his eyelashes (too divinely long and curling) are black[,] I'm hoping that in time his hair will turn black also, when, believe me, he will be some beauty—Of course I'm quite crazy about him—not at all on account of his looks—which is what attracts everyone else—but because of his truly amazing intelligence.[9]

It was difficult for Theodora to afford childcare for her son as a single mother, and when she remarried in 1921, Bobbie came to New York City to live with Belle permanently and became her legal ward at age five.[10] He was effectively the child Belle never had, though Bobbie's stepfather was still involved in his upbringing, teaching him to swim, sharpen a stick to roast s'mores, and change a tire, as well as going on road trips with Theodora.[11] She paid for his schooling, took him on vacations to Europe, went horseback riding at Yellowstone, and introduced him to many of her professional colleagues.[12] Father Henri Hyvernat was particularly fond of Bobbie and often asked after him in correspondence with Greene. In one particularly amusing exchange, Greene sent Hyvernat a clipped photo of the bearded Russian psychologist Ivan Pavlov with an accompa-

FIG. 3
Robert "Bobbie" MacKenzie Leveridge, Belle Greene's nephew, can be seen in the second row from the bottom, second student from the left. St. Paul's School Choir, 1932–33. Archives of St. Paul's School.

FIG. 4
Robert "Bobbie" MacKenzie Leveridge at the Fountain Valley School of Colorado, standing in the courtyard of the Hacienda, early fall 1933. Archives of the Fountain Valley School.

nying note about her five-year-old nephew: "Bobbie cut this out of a magazine and brought it to me saying triumphantly 'Here's Father Hyvernat'—you see he loves and remembers you!"[13] Hyvernat replied a few days later, "Please tell little Bobbie that I am quite flattered at his remembering me so well. But I shall try to send him something that will help him not to confound me with any old whiskered Russian celebrity."[14]

Bobbie attended several prep schools during his adolescence. In 1932 he was enrolled at the Malcolm Gordon School in the Hudson Valley. There he progressed well and enjoyed "a general awakening of his sense of responsibility."[15] A year later he moved to the elite St. Paul's School in Concord, New Hampshire, where he was a student for the 1932–33 school year. There he sang treble and appeared in a group photograph of the school choir (fig. 3). The records of his academic performance in the St. Paul's "marks book" document a student of promise who did not always apply himself—"English: Good work, but could do better"; "Science: Superfluous talk, does pretty well"; "Remarks: Talks too much. Not to [sic] good attention but has a good mind. Nervous."[16]

After St. Paul's Bobbie continued his education in Colorado, at the Fountain Valley School, where he enrolled in November 1933 and graduated in June 1936. On his school application, filled out by his aunt, he is described as "inclined to head colds," and it seems Greene chose this school in part because a doctor had prescribed "a high, dry climate" for her nephew.[17] The application lists "Scientific" under "Chief interest in school work." Bobbie's preference for science emerges as a theme in one of the letters his aunt wrote to the Fountain Valley Head Master, Francis Mitchell Froelicher:

> Bob has a keen and alert intelligence, he is fairly well read, and is particularly interested in a scientific, medical or surgical career. From the age of ten, he has never swerved in his determination to pursue life-work along these lines, and has spent much of his free-from-school time in laboratory experiments and allied reading.[18]

The passage calls to mind a comment Greene made in a newspaper article, that she fostered an interest in her particular "life-work"—rare books and manuscripts—at the young age of twelve.[19] In her letters to Froelicher, Greene hopes that the school will help align Bobbie's physical and intellectual development, saying also that she wants "him to learn the underlying cause of this new era and to prepare himself to fit into it, if possible help carry it on a bit—and to forget the easy and careless times under which he was brought up" (fig. 4).[20]

Bobbie's academic performance at Fountain Valley initially showed promise but came to disappoint his aunt. During his first year both his German and medieval history were not up to the headmaster's standards, and his first report card of 1935 prompted Greene to send the school a letter of reproval—a missive she was "quite willing that Bob should read."[21] And yet there was much to commend about Bobbie. "The masters all feel that he is an unusually competent student," wrote Froelicher: "Among the younger boys he is something of a leader

and he will have more and more opportunity to use such latent leadership as he has as he goes through school."[22] His 1935–36 report describes him as "versatile and gifted...embarking most happily on his last year," with an interest in various extracurricular activities in the arts: "Glee Club, tenor; Thanksg. and Christmas Carols; Magazine: Amusing poem in fall issue; linoleum cut—nice one...The King in Henry IV."[23] Bobbie also performed in William Shakespeare's *Love's Labour's Lost*, where "he gave a very creditable and understanding performance of Holofernes" and was "generally admired."[24] With his interest in poetry, music, drama, art, and medicine, Bobbie seems to have distilled the collective passions of his family—from the musical talents of Genevieve and the Fleets to the medical acumen of her father James H. as well as the theatrical and literary facility of Richard T. Greener. In a letter largely about Bobbie's financial improvidence, the school secretary even reveals his bibliophilia: "Bob does buy more books than he needs and many in his own collection are in the school library. However, they are worth-while books as a rule and perhaps you do not want to discourage this particular extravagance."[25]

Fulfilling his and his aunt's ambition, Bobbie enrolled at Harvard College in 1936. That summer, before her nephew passed his entrance exams, Greene told the Harvard Byzantinist scholar Robert Pierpont Blake that her nephew was "much interested in the medical sciences, and at the age of ten had determined to be a doctor or surgeon. He plans to go from Harvard to the Harvard Medical School."[26] A letter Bobbie wrote to F. M. Froelicher in 1937 suggests he was finding the academics challenging: "We are all, I think, finding it a lot tougher here than we had expected, if only in regard to the amount and sheer mass of required study."[27]

In 1939, a year before graduating, Bobbie would leave Harvard and move to California, where he worked in various fields including journalism, public relations, aviation, and the film industry.[28] Destined to follow in his father's military footsteps, Bobbie enlisted in the US Army Air Corps in August 1941. In the wake of Pearl Harbor Bobbie moved from California to Florida, then to Maine, and finally to England, where he was stationed with the 92nd Bombardment Group (327th Bombardment Squadron) in August 1942.[29] According to his aunt he "flew a bomber in the Dieppe raid one week after he landed in England," but generally his activities during the war are not well known.[30]

Sadly, there is more documentation about the final months of Bobbie's service, which ended with his untimely death on August 3, 1943. Greene was told Bobbie "had been killed in action 'in the European area,'" and this was the cause of death she reported to the St. Paul's School alumni magazine, which reproduced a drawing of Bobbie in uniform (fig. 5).[31] But as Greene's biographer, Heidi Ardizzone, has noted, "the circumstances of Robert's death are rather mysterious, and what few details the Air Force had were almost certainly not communicated to the family."[32] According to military records, Bobbie was not killed in action but tragically died by suicide. His War Department Report of Death attributes the cause of his passing to "gunshot wounds self-inflicted while mentally

unsound," and a handwritten note on the first page of his Individual Deceased Personnel File from the US Army reads "Suicide, 8-3-43."[33] Ardizzone notes that "Leveridge's file contains no explanation of the circumstances of his death," but another file, a set of letters preserved at the Archives of American Art, sheds more light on the end of Bobbie's life (fig. 6).

The papers of the art conservator and historian Daniel "Dan" Varney Thompson, who had been a correspondent and friend of Greene's throughout the 1930s, contain a file of letters and documents "pertaining to the death of Robert Leveridge."[34] Thompson taught at the newly founded Courtauld Institute of Art in London and had been a trusted friend of Bobbie's for several years.[35] When Dan saw Bobbie in June 1943, the young airman gave him an envelope containing a handwritten letter from his fiancée, Nina "Tess" Taylor. Thompson documented this encounter, the last time he saw Bobbie alive, in a typed note included in his papers:

> R. L., at the moment of his departure from D. V. T.'s house in London after a brief leave between his periods of intense activity as a Bombardier in missions over the Continent, turned back and drew this letter from his breast pocket.
> "I want you to have this and keep it," he said.
> "I will put it in the safe for you," replied D. V. T.
> "No, I want you to read it," said R. L., and went away.
> Efforts to reach him by telephone were unsuccessful, and in August news of his death was received.[36]

Reading the letter was clearly a disturbing experience for Thompson, being such close friends with Bobbie, and it is a difficult read today for anyone

26 ALUMNI HORAE

ROBERT MacKENZIE LEVERIDGE, of the Form of 1937, Lieutenant, U.S.A.A.F., was killed in action August 3, 1943, in the European area.

Robert Leveridge came to S.P.S. in 1932, but remained there only one year. He entered Harvard in 1936 from the Fountain Valley School of Colorado. At college he took courses in preparation for the Medical School. He had been in England since 1942 and had taken part in many missions over the continent, when he was killed in action August 3, 1943.

Leveridge was the only child of Robert MacKenzie Leveridge, killed in France in July, 1918, while serving in an American Machine Gun Battalion. He is survived by his aunt and guardian, Miss Bella da Costa Greene.

FIG. 5
Notice of Bobbie's death. St. Paul's School, *Alumni Horae*, Spring 1944: 26. Archives of St. Paul's School.

who comes across the digitized file on the Archives of American Art website.[37] It continues a conversation Bobbie and Nina had begun the previous spring and summer, in 1942, when she had discovered (likely through an investigation conducted by her father) and divulged to Bobbie the truth of his family's ancestry. "I've heard it so often," she writes, "and from a number of different sources, some without malice." She continues: "this has bothered me off and on for a long time and I never mentioned it to you because I was afraid you might not know and if you didn't it would surely upset you dreadfully or if you did you must be very ashamed of it[,] loyal and devoted to her though you are."

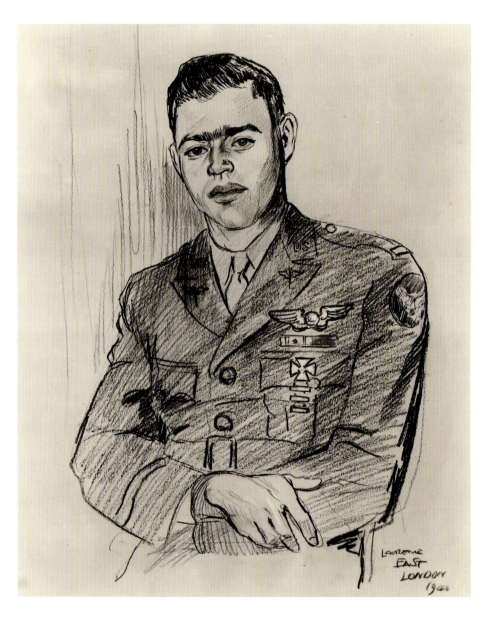

FIG. 6
Drawing of First Lieutenant Robert MacKenzie Leveridge,
ca. 1942. Photographic print; 9 × 7½ in. (23 × 19 cm).
Reproduced in St. Paul's School, *Alumni Horae*, Spring 1944,
26. Archives of St. Paul's School.

Writing at times in an seemingly embarrassed style full of circumspection and innuendo, Nina refers to this revelation as "the thing that has made life so difficult for us ever since," and proceeds to say that when she reaffirmed her engagement to Bobbie, she was doing so only to make him feel better: "If I spoke of marriage then it was because I was so worried about you. I was afraid of what might become of you if I left you then on top of all your other troubles. I didn't know what you might not turn into. I was even afraid you might shoot yourself." This sentiment is shocking in its prescience. Perhaps the most disturbing part of their conversation centers on the prospect of children, which, knowing of his Black ancestry, Nina resolutely refused to consider having with Bobbie. Their conversation the previous summer had at one point turned to forced sterilization, with Bobbie apparently broaching this possibility. Despite Nina's protestations, she tells Bobbie all the same that she "was overwhelmed by the sense of how fine and good and courageous you were when you suggested it yourself." But in the end she could not bring herself to marry such a man as him:

> If you ever marry anyone you'll have to do that, Darling, won't you? As long as you continue to believe as do I that you have no right to have children anyhow and I don't think that anything but weakness could ever shake our belief either yours or mine that it would be a very wicked thing for you to have a child. You must do it then regardless of me or else not marry at all.

The letter's second segment discusses "other things" that Nina characterizes as "much more trivial"—namely, the role of "society" and the perceived shame of social ostracism brought on by an interracial marriage. If the first part of the letter touches on the all-too-real physical violence of racism—its direct threat to the Black body in envisioning Bobbie's sterilization—the second part speaks to the arguably more insidious, subtler modes of systemic racism that by the 1940s had been deeply entrenched in American society for generations:

> I'm not going to pretend that society means nothing to me. It does. I should dislike being cut by many of my rather large acquaintance as well as by those whom I had thought to be friends. I should like my children to be able to go to the schools and belong to the clubs that they might normally be expected to. Any mother would. You more or less belong with one group, I with another.

There is a rhetoric of social entitlement here—refracted through the lens of motherhood—that in a strange way echoes aspects of passing's social logic: no doubt Genevieve, like "any mother," would wish the same sense of belonging for her children. And yet, through her anti-Black racist vitriol, Nina twists this logic into the letter's most infamous lines, repeating and endorsing some of the most spiteful rumors about Bobbie's beloved aunt:

> I shall quote a piece of a conversation which I think you will agree it would be very unfortunate for any child of ours to overhear.
> "I consider it an insult to be invited to meet Morgan's nigger whore."
> Imagine having to say to little Mac, yes, that is your Aunt Belle, dear.

One can perhaps imagine this "piece of conversation" originating with Nina's father, who had apparently badgered his daughter with questions about "liv[ing] on Mr. Morgan's money" if she married Bobbie. On the last page Nina channels her father again—giving voice to his hatred and fully articulating her own physical and social racism—in one of the letter's most symptomatic and deeply hurtful lines: "I am to be sent to a doctor now who is going to tell me what a fearful thing it would be for an octaroon [sic] to marry what Daddy calls a clean white girl."

Nina Taylor did not send Bobbie these eight closely written pages, begun on January 23 and completed on January 30, 1943, until Valentine's Day, enclosing a short explanatory note and signing it with her name and a doodle of an arrow-pierced heart enclosing the words "Be my valentine." That she waited until Valentine's Day to send Bobbie this letter—with all of its racist enmity expressed in cold, unfeeling language—is a truth almost too cruel to imagine. As Thompson wrote in a note to Belle Greene on the outside of an envelope containing the letter: "The contents of this envelope brought a noble boy to his death. It is not fair to brand him suicide: this letter killed him" (fig. 7).[38] It is unclear whether it was the truth of his ancestry, the prospect of a childless future, the dissolution of his engagement, or (most likely) a combination of all

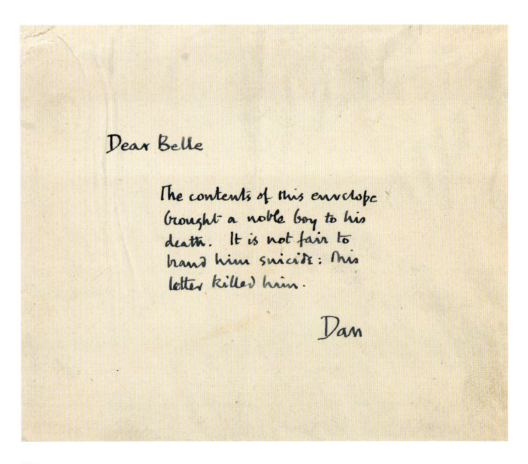

FIG. 7
Daniel Varney Thompson (1902–1980), Autograph note to Belle da Costa Greene, ca. 1944. Archives of American Art, Smithsonian Institution; Daniel Varney Thompson Papers.

three that led to Bobbie's death by suicide. What is abundantly clear, however, is that racism killed Robert MacKenzie Leveridge.

Daniel Varney Thompson documented the subsequent movements of the letter after he received it from Bobbie in June 1943. In January 1944, perhaps fearing it would fall into the wrong hands, Thompson sealed the letter (itself enclosed within Nina Taylor's original envelope sent to Bobbie) in a Courtauld Institute envelope, wrote on its front the short note to Belle Greene cited in the previous paragraph, and wrapped it inside of a larger piece of paper bearing a handwritten note added by himself. It indicated that, in the event of his death, the envelope and its contents should be hand-delivered to Belle da Costa Greene, but if she was already dead the envelope should be burned and its ashes scattered. Thompson then enclosed this packet of material in another sealed Courtauld Institute envelope, with "To be opened only by the hand of Miss Belle da Costa Greene" written on the front. What is curious, though, is that this note is crossed out and signed by Thompson with an additional note: "opened by D. Thompson himself. 16 April. 1948 [or 1944—the final number is indeterminate]."

A month after Thompson first sealed the letter, Greene wrote to her friend following a long silence, prompted no doubt by the shock of Bobbie's death:

> I have been laid low— first with a slight stroke on learning of Bobbie's death, which kept me in the hospital for six weeks.... When I said stroke I meant a sort of heart attack. You see I evidently am not in my "right mind" yet—It all has hit me so hard, and I just have not had the guts to take it as probably I should have.[39]

After discussing some family news, including the recent marriage of her niece Belle Greene Harvey, she turns to the matter of Bobbie, his fiancée, and the document Dan was keeping for her:

> Damn that Nina T. to h___l She writes me all the time— trash[.] Dan—Can you send me a copy of the document you say Bobby gave you, which you put in the vault at Daniel Varney Ltd.... I should like to know about it, and if sent to me at the above address, there is no one who would open it, but myself.[40]

Here Greene must be referencing a now-lost letter from Dan to her (or perhaps a phone conversation) in which he told her about the letter Bobbie entrusted him with safekeeping. If the date on the Courtauld Institute envelope does in fact read "1944" instead of "1948," it is possible that Thompson sent her the letter (or a copy of it) that spring of 1944, after opening the sealed envelopes. There is some evidence she knew of its contents. Later that summer, in anticipation of Thompson's imminent visit to New York, she invites him to stay in Bobbie's old room, while also hinting that there is something she would like to discuss in person: "Dear Dan There is lots I want to say to you—but not on paper."[41] There is no indication from their late correspondence (1945, 1947, and 1948) that they discussed the matter further, and the narrative suggested by these letters—combined with Thompson's signed unsealing of the precious

envelope—only provides circumstantial evidence that Belle Greene knew the full truth of her nephew's demise. Even if she did not read the letter Nina sent Bobbie, Greene certainly knew that he had given Dan Thompson an important document and she expressed an interest in reading it.

Alexandra Lapierre's well-researched historical novel *Belle Greene* begins and ends with the story of Bobbie's suicide and the letter from Nina Taylor. Though Lapierre is the first person to write about this letter and the contents of the Belle da Costa Greene subject file in Daniel Varney Thompson's papers, she was not the first scholar to read this file. Both Jean Strouse and Heidi Ardizzone read it as well, though neither included the story of Bobbie and Nina in their respective biographies of J. Pierpont Morgan and Belle da Costa Greene. Lapierre writes in her preface "that even the smallest details are based on documented evidence," but she does exercise poetic license in her book, especially when she modifies language purportedly quoted directly from Greene's letters.[42] This sort of liberality in altering the granular details of archival sources must, of course, be permitted to the historical novelist. And despite inventing the fanciful and dramatic scene of Bobbie confronting his aunt about his ancestry in May 1942, having just learned the truth from his fiancée, Lapierre is careful to hew close to her archival sources in telling the story of Bobbie, Dan Thompson, and the letter from Nina.[43] Yet Lapierre seems to ignore Belle Greene's 1944 letter to Thompson asking for a copy of Nina's letter, and does not account for the fact that Thompson opened the sealed envelopes in 1944 or 1948. She imagines that Thompson did not read Nina's letter until after Bobbie's 1943 death, and that Belle Greene never read the letter at all—"never received the key to the mystery of her adopted son's death."[44]

It is impossible to know for certain what really happened. Did Dan read Nina's letter before or after Bobbie's death by suicide? And did Belle ever read Nina's letter? Given Thompson's friendship with Greene and the serious approach he took with his custodianship of the letter from Bobbie, it seems unlikely he would unseal the envelopes during her lifetime unless she prompted him do so. It seems more than possible, then, that Greene either read the letter sealed in those envelopes or was given a summary of its contents, perhaps in person or over the telephone instead of through correspondence. If this was indeed the case, how does Greene's knowledge of the circumstances of Bobbie's death fit into the larger story of her life? In 1943 she was near the end of her long career at the Morgan Library, begun almost four decades prior. Whatever rumors had been circulating about her ethnicity could no longer threaten her illustrious position as one of the world's most accomplished cultural heritage executives. And yet, through the reality of Bobbie succumbing to the racism of white society, Belle Greene once again became vulnerable—exposed to the very prejudice she, her mother, and siblings thought they had left behind forever when crossing the color line. The story of Bobbie reveals this line to be porous and provisional for white-passing Black people. Despite the power of social status, career, money, and connections, such individuals can never truly escape

racism's violent logic. It was this logic that so terribly afflicted Bobbie in his final days, and that would deeply affect his aunt in the days to come.

As described in her February 1944 letter to Thompson, Bobbie's death devastated Belle Greene both emotionally and physically. Work, as she told F. M. Froelicher, was the only outlet for her grief:

> I am sorry to say that I have not "guts" enough to take it yet.... I try to remember that so many others are in the same position as myself—and that innumerable families are suffering—I accomplish it in the day-time, by working every second, from 8:30 to 7 p.m.— but the nights are unbearable.[45]

Nearly two years after his passing, in a letter she wrote to Eric Millar, Greene characterizes "Bobby's death...as an even greater blow to me personally" than Jack Morgan's: "the only way in which I can keep 'chin up' at all is to realize how many countless others have suffered similarly."[46] Her empathy for other young men who died in the war can be seen in her reaction to a 1941 poem titled "The Young Dead Soldiers Do Not Speak," written by her friend Archibald MacLeish, poet and Librarian of Congress, whom she had known for many years. (MacLeish had even recommended Bobbie for the Fountain Valley School in 1933.)[47] With its haunting refrain of "We were young. We have died. Remember us," the poem commemorates the life of a young soldier named Richard Herrick Myers, who, like Bobbie, died in 1943 as a first lieutenant in the Air Corps (fig. 8).[48] The poem appeared in various publications in the 1940s, and after reading it Belle Greene wrote MacLeish to request a copy of the manuscript. MacLeish responded by offering the manuscript itself to Greene—"The manuscript could only belong to you. I am proud to have you have it"— and she accepted it for the collection of the Pierpont Morgan Library: "I cannot tell you how much it means to me to have the manuscript of your tribute to 'The Young Dead

FIG. 8
Archibald MacLeish (1892–1982), "The Young Dead Soldiers," autograph manuscript, 1944. The Morgan Library & Museum, New York, gift of Archibald MacLeish, 1944; MA 1197.

Soldiers.' It is the finest poem on the subject I have read and means so much more than just grief, for a young dead soldier."[49] When Greene presented the acquisition to the Morgan's Board of Trustees in 1944, she noted that "this poem carries a message far wider than to those who have lost someone in this War."[50] She told MacLeish she would photograph the manuscript and place it next to photos of Bobbie and his father in her apartment.[51] A few years later, Alice Myers, Richard Myers's mother, wrote Greene about "the loss of [her] gallant nephew in this war." She hoped that they could meet one day to look at MacLeish's manuscript, which Greene described as "one of the finest and most important things... that I have read for many years."[52] Alice agreed about the poem's emotional power, asking, "What can be done to remind the living of their responsibility to be articulate for the soldiers and civilians who are now voiceless?"[53]

By 1945 Belle Greene was "all-in," as she often remarked, meaning "spent and exhausted." In a letter to Thompson from September of that year, she writes of the physical toll all of her losses in the 1940s had taken, with her sister Ethel's death being the most recent: "I am so badly crippled. I think that I wrote you why—rather from what. I have gone through too much to ever be the same old 'harridan' again. Added to it all, my sister Ethel, Mrs. Oakley died quite suddenly some months ago—she was my pet sister. I still miss Mr. Morgan terribly."[54] A year later her friend William Ivins, curator of prints at the Metropolitan Museum of Art, wrote to Berenson about Greene's 1943 stroke, noting that "the deaths of her mother and sister shocked her and then the loss of her nephew Bobbie in the war hurt her cruelly."[55] In the last five years of her life, Greene's health would continue to deteriorate. After retiring in 1948 she lived to see an exhibition mounted in her honor (1949) but passed away before enjoying the voluminous Festschrift edited by Dorothy Miner and dedicated to Greene's memory. Her final days are recounted with great emotion by her friend and mentee Meta Harrsen, who was there with Greene until the end, and wrote a moving letter describing her death and funeral (fig. 9):

> The attendance was about 200 friends who came from all over the East, Baltimore, Boston and Washington. It was just as she would have wished it.... Several of her friends spoke of her going as marking the end of an era; it is certainly the end of a brilliant era for this Library.... So, I feel there was great rejoicing in Heaven, when she met Bobbie and both Mr. Morgans and old Prof. Hyvernat and all the others.[56]

THE PIERPONT MORGAN LIBRARY
33 East Thirty-sixth Street
New York 16, N. Y. May 18, 1950.

Dear Mr. Berenson,

 Belle died on Wednesday May 10th at five minutes of eleven at night. The funeral service was held at St.Thomas Episcopal church, 5th Ave. and 53rd St. on Monday the 15th at 2 p.m. Knowing what she would have liked, I asked for the old Luther hymn, "Eine feste Burg ist unser Gott", the 23rd Psalm, and "Onward Christian Soldiers", with the regular Episcopal ritual. As the obituary notice had asked that no flowers be sent, there were only about fifteen beautiful pieces, quite enough to make the chapel dainty and Spring-like. A blanket of deep, very fresh crimson roses (from the Library) covered the coffin.

 The attendance was about 200 friends who came from all over the East, Baltimore, Boston and Washington. It was just as she would have wished it. But I suppose you will hear more from Rose Nichols. There was only one thing that troubled me, and the day after the funeral I had a note from Belle's nurse, and that gave me the consolation I had hoped for, I feel that it was a direct message from Belle. The nurse wrote;"I thought you would like to know that Miss Greene's death was entirely peaceful, she just quietly stopped breathing at five minutes to eleven". As the nurse was the only witness we can be sure it was so. Apparently the brother called the next morning and so the obituary notices read "May 11th", but it really was on the tenth.

 Several of her friends spoke of her going as marking the end of an era; it is certainly the end of a brilliant era for this Library.

 The book you sent her will be added to the Belle Greene collection here. Dorothy Miner has long planned to invest any proceeds from the sale of the Liber Amicorum in an illuminated manuscript to be given this Library in her memory.

 A large number of telegrams and letters have come to me, very few people in Belle's circle know the new Director, Mr. Adams, and he was not here anyway, he sailed the day before she died for a vacation in England and France. But both Junius and Henry Morgan attended the services, and I know how sincerely they mourn her. Mr. and Mrs. Robert Bliss, Bernard Baruch, F.H. Taylor of the Metropolitan, all Princeton (Institute for Advanced Stdudies and University) and of course, the contributors to the Liber Amicorum were there.

 So, I feel there was great rejoicing in Heaven, when she met Bobbie and both Mr. Morgans and old Prof. Hyvernat and all the others.

With kindest regards,

Sincerely yours,

Meta Harrsen

P.S. We expect fuller notices in periodicals and I shall see that you receive the best. Meta.

FIG. 9
Meta Harrsen (1891–1977), Typed letter to Bernard Berenson, May 18, 1950. Biblioteca Berenson, I Tatti, the Harvard University Center for Italian Renaissance Studies; Bernard and Mary Berenson Papers, Box 68, Folder 2.

NOTES

1. Heidi Ardizzone, *An Illuminated Life: Belle da Costa Greene's Journey from Prejudice to Privilege* (New York: W. W. Norton: 2007), 99.

2. Greene to Bernard Berenson, December 27, 1910, Bernard and Mary Berenson Papers, Box 60, Folder 12, Biblioteca Berenson, I Tatti, the Harvard University Center for Italian Renaissance Studies.

3. Greene to Berenson, April 29, 1913, Berenson Papers, Box 61, Folder 7.

4. Greene to Berenson, May 16, 1914, Berenson Papers, Box 62, Folder 2. Genevieve's birthday was on May 17, 1849, making her sixty-five in 1914. Her date of birth is listed in a typescript document titled "Notes re James H. Fleet," which cites legal documents in the DC Superior Court. "Fleet" folder, Peabody Room, Georgetown Library, District of Columbia Public Library.

5. Greene to Berenson, July 27, 1914, Berenson Papers, Box 62, Folder 4.

6. Gertrude Tuxen to the Pierpont Morgan Library, June 2000, Archives of the Morgan Library & Museum, ARC 3297. (Archives of the Morgan Library & Museum material hereafter cited as "ARC.")

7. The other photographs depict the dog as well as the view from Belle Greene's apartment, with an inscription (in Danish) on the back of the photograph that notes "from Mrs. Greene's window you have a good NEW YORK view," with vistas of the Empire State Building as well as rooftop gardens and sunbathers ("Fra Mrs Greenes Vindue har man et godt NEW YORK Billede"). The author is grateful to Inge Dupont for her translation from the Danish.

8. "Genevieve Van Vliet Greene, 1941" file, "New York, New York City Municipal Deaths, 1795–1949," FamilySearch database, accessed May 13, 2022, https://www.familysearch.org/ark:/61903/1:1:2WPK-RR4; Ardizzone, *Illuminated Life*, 538; Dorothy Miner and Anne Lyon Haight, "Greene, Belle da Costa," in *Notable American Women, 1607–1950* (Cambridge, MA: Belknap Press, 1971), 2:83.

9. Greene to Berenson, September 26, 1919, Berenson Papers, Box 63, Folder 2.

10. Ardizzone, *Illuminated Life*, 390–92; Greene to F. M. Froelicher, July 25, 1933, Archives of the Fountain Valley School.

11. Robert Leitner, Belle Greene's grand-nephew, in a phone call with the author, April 8, 2024.

12. For their trip to Switzerland and the south of France in 1928, see Ardizzone, *Illuminated Life*, 419; for their trip to Italy, ibid., 430; for their trip to Germany in 1936, ibid., 435; and for Yellowstone, Greene to Froelicher, August 29, 1933, Archives of the Fountain Valley School.

13. Greene to Henri Hyvernat, May 28, 1924, Henry Hyvernat Papers, ICOR / Semitics Library, Catholic University of America.

14. Hyvernat to Greene, July 4, 1924, Hyvernat Papers. Almost a year earlier, Greene told Jack Morgan about hosting Bobbie in New York and taking him shopping, where he insisted on acquiring an ax and saw so that he could help chop wood at the Morgan camp known as "Camp Uncas."

15. Meta Harrsen to Berenson, February 22, 1932, Berenson Papers, Box 68, Folder 2.

16. St. Paul's School marks book, 1932–33, Archives of St. Paul's School. The author thanks St. Paul's School Archivist Deanna Parsi for transcriptions from the marks book.

17. Application for Admission to the Fountain Valley School of Colorado, July 25, 1933; Greene to Froelicher, July 9, 1933, Archives of the Fountain Valley School.

18. Greene to Froelicher, July 9, 1933, Archives of the Fountain Valley School.

19. See the essay by Anne-Marie Eze in this volume.

20. Greene to Froelicher, July 25, 1933, Archives of the Fountain Valley School.

21. Froelicher to Greene, November 9, 1933; Greene to Froelicher, October 27, 1935, Archives of the Fountain Valley School.

22. Froelicher to Greene, May 11, 1934, Archives of the Fountain Valley School.

23. 1935–36 Report for Robert MacKenzie Leveridge, Archives of the Fountain Valley School.

24. Froelicher to Greene, May 5, 1935, Archives of the Fountain Valley School.

25. "Miss Becker" to Greene, June 14, 1935, Archives of the Fountain Valley School.

26. Greene to Robert P. Blake, July 8, 1936, ARC 3291, Box 13, Folder 5.

27. Leveridge to Froelicher, January 11, 1937, Archives of the Fountain Valley School.

28. Ardizzone, *Illuminated Life*, 444; Greene to Edgar Wind, September 21, 1942, ARC 3291, Box 30, Folder 16.

29. Ardizzone, *Illuminated Life*, 449–50.

30. Ibid., 450.

31. Greene to Edgar Wind, September 22, 1943, ARC 3291, Box 30, Folder 16; *Alumni Horae*, Spring 1944, 26. Greene sent a photograph of this drawing to St. Paul's School for reproduction in the article.

32. Ardizzone, *Illuminated Life*, 453.

33. US Army, Individual Deceased Personnel File, "Leveridge, Robert M.," National Archives.

34. "Greene, Belle da Costa," Daniel Varney Thompson Papers, Series 3 (Subject Files), Sub-series 1 (Personal and Professional, 1925–1979), Box 3, Folder 23, Archives of American Art, Smithsonian Institution.

35. Greene to Daniel Varney Thompson, February 13, 1944, Thompson Papers, Box 3, Folder 23: "How 100% right Bobbie was in his faith in, and <u>devotion to you</u>. He was unswerving in that."

36. Daniel Varney Thompson, typed note, ca. 1950s, Thompson Papers, Box 3, Folder 23.

37. Nina Taylor to Robert Leveridge, January 23 and 30, 1943, Thompson Papers, Box 3, Folder 23, https://www.aaa.si.edu/collections/daniel-varney-thompson-papers-9246/subseries-3-1/box-3-folder-23.

38. Thompson to Greene, [1944], Thompson Papers, Box 3, Folder 23.

39. Greene to Thompson, February 13, 1944, Thompson Papers, Box 3, Folder 23.

40. Ibid. In several unanswered letters to Thompson, also preserved with his papers, Nina mentioned writing Greene to no avail while trying to learn more about the circumstances of Bobbie's death.

41. Greene to Thompson, August 26, 1944, Thompson Papers, Box 3, Folder 23.

42. Alexandra Lapierre, *Belle Greene*, trans. Tina Kover (New York: Europa Editions, 2022), 16.

43. Ibid., 461–78.

44. Ibid., 480.

45 Greene to Froelicher, October 13, 1943, Archives of the Fountain Valley School.

46 Greene to Eric Millar, June 29, 1945, ARC 3291, Box 2, Folder 7.

47 Archibald MacLeish, telegram to Froelicher, June 16, 1933, Archives of the Fountain Valley School.

48 Ardizzone, *Illuminated Life*, 455–56.

49 MacLeish to Greene, May 19, 1944; Greene to MacLeish, June 2, 1944, MA 1197.

50 "Report of the Director to the Board of Trustees," June 19, 1944, ARC.

51 Greene to MacLeish, June 2, 1944, MA 1197.

52 Alice Myers to Greene, April 2, 1946; Greene to Myers, April 11, 1946, ARC 1310. See also Ardizzone, *Illuminated Life*, 455.

53 Myers to Greene, April 11, 1946, ARC 1310.

54 Greene to Thompson, September 9, 1945, Thompson Papers, Box 3, Folder 23.

55 William Ivins to Berenson, March 7, 1946, quoted in Ardizzone, *Illuminated Life*, 460.

56 Harrsen to Berenson, May 18, 1950, Berenson Papers, Box 68, Folder 2.

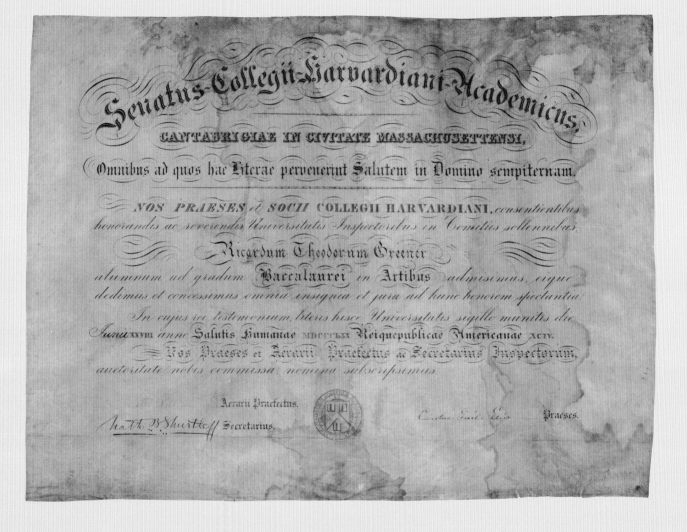

Richard T. Greener's Bachelor of Arts diploma, Harvard College, June 28, 1870. Acquired by Harvard University at the Hindman Fine Books and Manuscripts sale, August 6, 2014. Other materials discovered by Rufus McDonald, including Greener's law degree and license to practice law, were sold to the University of South Carolina.

Afterword

When the curatorial staff of the Morgan Library requested that I contribute to a publication about Belle da Costa Greene, I shared that I was not without judgment.

I began by imagining I were in a conversation with Belle. What would I say? We have so much in common. The thrill of the hunt for breathtaking finds of rare books and manuscripts. An understanding of the intersections of libraries and race. I adore glamour as much as the next person. The crisp silhouette of a well-tailored outfit is not lost on me.

However, when it comes to Belle and me, there is one significant difference. For me, Belle da Costa Greene represents a dilemma. The operational definition of a Black librarian, in my eyes, is one who is unapologetically Black. There is no relinquishment of my race from my identity.

If I were to have a conversation with Belle, would there be mutual respect or mutual toleration? What do I write about a Black woman and librarian who is so greatly admired in my profession, but whom I find to be the antithesis of what I stand for? What do I write about a Black woman and librarian whose influence on contemporary librarianship and the study of bibliography encompasses all that I aspire to? The very narrative—the stories, the myths—we wish to perpetuate that grants the Black woman her agency is both a blessing and misfortune that belies her legacy of purpose and service as a librarian.

I asked, Where does one begin?

I respond with understanding and acceptance.

My first encounter with Belle Marion Greener was in an unlikely space. In fact, she did not enter the picture at all. The encounter was not about her style. Such stationary considerations—of Belle's colorful tweeds, plumed hats, furs, the "Belle da Costa Greene" persona—indeed inform the preponderance of contemplations I hear about this great librarian, this great Black librarian who responded to a very white professional environment on her own terms. But such considerations dilute the texture and fabric of what made her a formidable curator of the Morgan collection. I refer to them as "stationary" because they keep her rigidly in place in a space focusing tamed, fashionable looks and not what matters to most who come to the Morgan, which is research, scholarship, and books.

The encounter concerned the absence of a father and how that absence, as it seems, makes a very strong woman surrounded by a kingdom of what saves us from ourselves—books. At the time, I served as the Executive Director of the Black Metropolis Research Consortium at the University of Chicago—a group of libraries, museums, and archives devoted to uncovering the hidden narratives of Black Chicago. I received a phone call related to a local story that had made national news about a steamer trunk found in an attic someplace in the predominantly Black Englewood neighborhood. The call was from a librarian in Boston acquainted with me through our mutual graduate study of library science at Simmons College. They explained to me that the found items were papers related to Richard T. Greener, Harvard's first African American graduate.

The response to the Greener papers' origin story was unsettling to me. I felt assaulted by a culmination of assumptions about the Black Chicago construction worker who had the good sense to save the contents of the trunk from demolition. From what I could ascertain, Rufus McDonald did not immediately understand the importance of Richard Greener, the man behind the documents he found within the walls of an abandoned Chicago home. He even less likely understood the importance of the connection of his discovery to Belle Marion Greener—the girl who transformed into the aesthetic icon of Belle da Costa Greene, the Pierpont Morgan Library director whose life of pulchritude and professional penchant for rare book and manuscript curation eclipsed all memories of Greener and effectively collapsed him into a footnote, as if hidden in a trunk, waiting to be uncovered. While his relational knowledge was fragmentary, Rufus was intelligent enough to make an emotional and historical connection to the materials and therefore sought the assistance of someone with experience in rare books and manuscripts.

For this, the how of where the Greener papers were found and the who of the humble but common man who discovered them, were equally problematic for the enormously privileged and biased community of rare books and manuscripts professionals. Those stricken with da Costa Greene fever embraced the discovery, the story. But we know that race complicates matters.

They did not embrace the messenger.

White man finds rare undiscovered documents.

White man seeks appraisal.

White man perceived as clever, is handsomely compensated for his find. Society views the transaction as the fullest expression of placing a piece of history back where it belongs.

Black man finds rare undiscovered documents.

Black man seeks appraisal.

Black man perceived as cunning, is either advised to "donate" the items or is offered lowest possible amount.

Any altruistic motives of the Black finder desiring a proper steward for the papers are met with doubt and suspicion. Why? Because he was seeking payment for merely being the very thing those who criticized and scoffed are...a manuscript dealer.

The story of Belle's origin, in ironic keeping with the tenacious collection-building that was at the center of her work at the Morgan, begins with a potential sale of a manuscript.

"This man has the diploma of the first African American graduate of Harvard. The father of Belle da Costa Greene. Now he won't give them to anyone without trying to make a killing and is trying to take advantage. How they came to be in that place is a mystery. You are of course familiar with the frenzy of King papers and Malcolm X. These Black collections have become such commodities nowadays. They are in the hands of people who just want to profit—family members with no income...You are in Chicago. Could you have a look at them? Tamar, perhaps try to speak some sense into him?"

As a Black woman librarian.

There are equally tangible parts of my profession that I love and loathe. Like Belle da Costa Greene, I worked as a librarian at Princeton Library. I worked as a librarian in New York City. I was educated as a librarian in Massachusetts. My chosen area of which to hone my curatorial expertise, like Belle, was early rare books and manuscripts. Incunable, recto, verso, frontispiece, folio, rubrication, woodcut.

Like Belle, I surrendered myself to it all. Like Belle, my biography as a librarian entails the absence of a father. Like Belle, my mother sought to teach me the art of reinvention to free me from an origin story that she feared would not hold me up, but back.

Her weapon of choice was the library. Libraries are free, unassuming, and can never turn us away—or so she believed. But we know that race complicates matters. With education in close companionship, a great deal felt possible for me as a librarian. But unlike Belle, my personal narrative includes a manicule with a long index finger that points to my exterior and tells the story of how I and many BIPOC women in this indispensable ecosphere of rare books, research, and knowledge are pieced together.

BLACK WOMAN LIBRARIAN.

My skin is an authentic response to my DNA. The cover of my book is not Moroccan leather or Portuguese silk. There are no exotic articulations of brown marbling. No self-imposed inflation of mystery.

The Black woman librarians I emulate are Dorothy Porter Wesley, Jean Blackwell Hutson, Eliza Atkins Gleason, Sadie Peterson Delaney, Mayme Agnew Clayton, Vivian G. Harsh. The themes of their identity as Black librarians are, for each, nonnegotiable. They left their mark on history with more answers than questions.

However, as you have all read in this tribute of essays, it is Belle da Costa Greene's negotiation with identity that intensifies her legacy as a personal librarian, a personal librarian whose relationship with herself was notably impersonal.

Which brings me back to the encounter that occasioned my first brush with Belle. An absent father found in Chicago.

Despite what we may try to escape from—whether our past, our actions, even our own skin, whatever we do not want to be—all confronts us and comes full circle through history.

I was uncomfortable sitting in the home of Rufus McDonald to view the Richard Greener papers. As a native Chicagoan, I was no stranger to the Englewood community. Like Belle, I had become estranged from my beginnings. The furnishings were sparse. The artificiality of the world I created for myself as a Black woman librarian in rare books and manuscripts inhabited my identity. I was not the homeless, fatherless Black girl from the West Side of Chicago. I was the child who received an education and avoided the common pitfalls of many others who grew up Black just like me. I was mentored into the finest libraries in Ivy League universities, where I learned the trade. In the home with Rufus, there was a woman who smiled at us with a look in her eyes suggesting hope. Every Black child has experienced the promise and weight of that look. This discovery of Greener's history brought the promise of Belle's world, the ease, the money, the freedom to their fingertips.

The striking juxtaposition of Greener's personal effects in that humble Chicago apartment provoked an interaction between Belle and me. The documents were arranged strategically. I remember the brittle edges of paper but also the sun coming in through the window. The diploma. A Harvard graduate. A Black first. The paradox I experienced between my wishing the idea of this Black man was my father and the mother of Belle extinguishing the idea that this Black man was her father.

Greener's photos carried a look of spirit and dignity. He was a father with a grand story. A lawyer. An activist. Teacher—a librarian. But he was absent from Belle's world, and for her own self-preservation she created an even grander story. Her legacy would never be uncovered in a demolished home but in a mystical place of books and magic now known as the Morgan Library & Museum.

This experience served as a neutralizing influence on my later understanding and critiques of Belle. Her identity was hers to choose. She was neither right nor wrong.

Looking down at the photos of Greener, I was considering the new interpretations of Belle that would emerge. But also, of the emptiness and loss—an unfinished entrance was now closed. Their discovery translated simultaneously into a narrative for Belle that was both simple and complex.

She was both the girl and the woman.

Despite the complexities, despite implications of her decision to be race ambiguous, she belongs in a long canon of Black women who interrogate our understanding of race and contemporary librarianship.

She privileged neither whiteness nor Blackness. She privileged the collections, which is what any sound curator is expected to do. Her curatorial hunger sought not for her past but rather her future and the result is timeless.

Rufus was constantly hovering over us as we looked at the Greener documents.

Satisfied with what I saw, "You have quite the find," I commented.

"They are trying to give me nothing," he said. "What do you think they are worth?"

"Everything you can possibly get, and you should settle for nothing less." I spoke softly...

Tamar Evangelestia-Dougherty
Director, Smithsonian Libraries and Archives

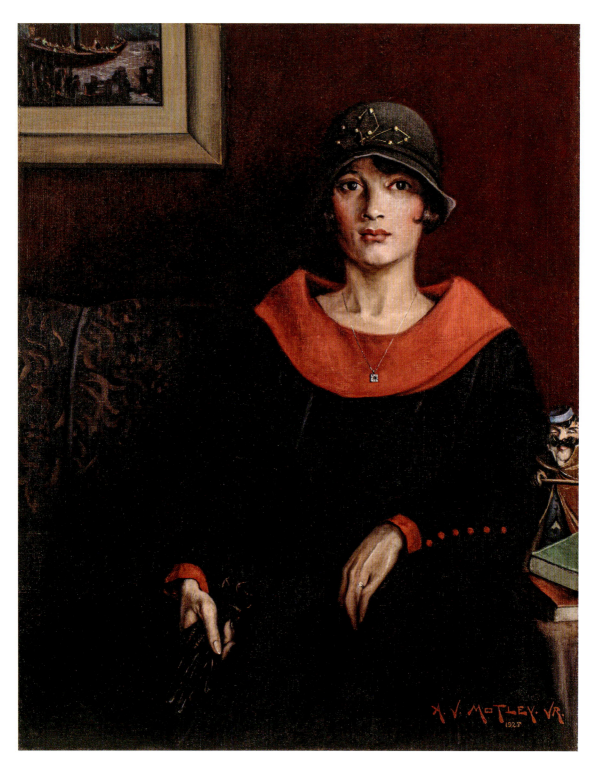

Archibald J. Motley Jr. (1891–1981). *The Octoroon Girl*, 1925. Oil on canvas; 38 × 30¼ in. (96.5 × 76.8 cm). Courtesy Michael Rosenfeld Gallery.

Checklist of the Exhibition

The following list is organized according to the exhibition's thematic sections and roughly follows the chronology of Belle da Costa Greene's life. It includes only select photographic reproductions, and folios for certain objects differ from those illustrated in the catalogue. The list is current as of the time of printing.

Clarence H. White (1871–1925), *Belle da Costa Greene*, 1911. Platinum print; 9 3/8 × 6 3/4 in. (23.8 × 17.1 cm). Princeton University Art Museum, The Clarence H. White Collection, assembled and organized by Professor Clarence H. White Jr., and given in memory of Lewis F. White, Dr. Maynard P. White Sr., and Clarence H. White Jr., the sons of Clarence H. White Sr. and Jane Felix White; x1983-447.
PAGE 16

A Family Identity

James H. Fleet, Page C. Dunlop, and Charles H. Webb, Letter to the Board of Managers of the American Colonization Society, October 7, 1833. Library of Congress, Manuscript Division; American Colonization Society Records, mm78010660.

Negro Churches—Presbyterian Church, Wash., D.C., 1899? Photographic print; 6 5/16 × 5 7/8 in. (16 × 15 cm). Library of Congress, Photographs and Prints Division; LOT 11303 [item] [P&P].
PAGE 24

15th Street Presbyterian Church, *The ladies of the 15th Street Presbyterian Church, Washington, D.C., will hold a fair, beginning December 22nd …* [Washington, DC, ca. 1880]. Library of Congress, Rare Book and Special Collections Division; Printed Ephemera Collection, Portfolio 207, Folder 4a.

Class Album, Harvard 1870, with photographs by George Kendall Warren (1834–1884) (Cambridge, MA: Harvard College, 1870). The Morgan Library & Museum, New York, purchased on the Horace W. Goldsmith Fund for Americana, 2021; ARC 3270.
PAGE 47

Harvard College (1780–), Bachelor of Arts diploma of Richard Theodore Greener, June 28, 1870. Harvard University Archives; HUM 201.
PAGE 282

Richard T. Greener (1844–1922), *Charles Sumner, the Idealist, Statesman and Scholar: An Address Delivered on Public Day, June 29, 1874, at the Request of the Faculty of the University of South Carolina* (Columbia, SC: Republican Printing Company, 1874). New-York Historical Society; Pamphlets E415.9.S9 G74 1874.

Marcus Tullius Cicero (106 BC–43 BC), *De Officiis*, Italy, around 1450. Houghton Library, Harvard University; MS Lat 177, fols. 59v–60r.
PAGE 137

George Washington Williams (1849–1891), *1862—Emancipation Day—1884: The Negro as a Political Problem* (Boston: A. Mudge & Son, 1884). New-York Historical Society, Main Collection; E29 .N3 Box 13 Non-circulating.

Richard T. Greener (1844–1922), Autograph letter signed to Arturo Schomburg, June 4, 1918. New York Public Library, Schomburg Center for Research in Black Culture, Manuscripts, Archives and Rare Books Division; Richard T. Greener Papers, Sc MG 107.
PAGE 48

The Crisis 13, no. 4 (February 1917). New York Public Library, Schomburg Center for Research in Black Culture, Jean Blackwell Hutson Research and Reference Division.
PAGE 72

Byron Company, *Seven African-American Men on the Steps of Grant's Tomb on Riverside Drive*, ca. 1903. Gelatin silver print; 8 × 10 in. (20.3 × 25.4 cm). Museum of the City of New York, Prints & Photographs collection; 93.1.1.7009.
PAGE 49

Martin Deschere (1848–1902), 58th Street between 8th and 9th Avenues, ca. 1880. Museum of the City of New York, Prints & Photographs collection; X2010.11.6103.

Distinguished Colored Men (New York: A. Muller & Co.; Chicago: Geo. F. Cram, ca. 1883).
Library of Congress, Prints and Photographs Division; PGA—Muller—Distinguished colored men (D size).
PAGE 26

An Empowering Education

Grace Hoadley Dodge (1856–1914), Autograph letter signed to Emma Charlotte Revell Moody, July 1, 1896. Northfield Mount Hermon Archives; Greene, File 2052N.

Lucetta Daniell (1867–1943), Autograph letter signed to the Secretary of Northfield Seminary, July 2, 1896. Northfield Mount Hermon Archives; Greene, File 2052N.

Belle da Costa Greene (1879–1950), Application for Admission to Northfield Seminary, June 1896. Northfield Mount Hermon Archives; Greene, File 2052N.
PAGES 50–51

A. French, Northfield Campus and East Hall, ca. 1890. Photographic print; 6 7/8 × 9 13/16 in. (17.5 × 25 cm). Northfield Mount Hermon Archives.
PAGE 54

Genevieve Ida Fleet Greener (1849–1941), Autograph letter signed to Evelyn S. Hall, June 27, 1896. Northfield Mount Hermon Archives; Greene, File 2052N.

Belle da Costa Greene (1879–1950), Autograph letter signed to Evelyn S. Hall, August 27, 1896. Northfield

Mount Hermon Archives; Greene, File 2052N.
PAGE 53

Amherst College Summer School, Fletcher Course in Library Economy, Class of 1900, 1900. Gelatin silver print; 9 × 11 in. (22.9 × 27.9 cm). Amherst College Archives and Special Collections.
PAGES 44, 58

Questioning the Color Line

Harry Willson Watrous (1857–1940), *The Drop Sinister—What Shall We Do with It?*, 1913. Oil on canvas; 37 × 50 1/4 in. (93.9 × 127.6 cm). Portland Museum of Art, gift of the artist; 1919.18.

Archibald Motley Jr. (1891–1981), *The Octoroon Girl*, 1925. Oil on canvas; 38 × 30 1/4 in. (96.5 × 76.8 cm). Michael Rosenfeld Gallery.
PAGE 286

Anita Hemmings, ca. 1890s. Reproduction of original photograph. Vassar College Special Collections, Vassar College Photograph Files; Folder 12.8 (OV3.110).

National Association for the Advancement of Colored People (1909–). Poster for the NAACP anti-lynching campaign, 1922. Collection of the Smithsonian National Museum of African American History and Culture; 2011.57.9.

Harriet Beecher Stowe (1811–1896), *Uncle Tom's Cabin* (London: John Cassell, 1852). The Morgan Library & Museum, New York, bequest of Julia P. Wightman; PML 150858.

National Association for the Advancement of Colored People (1909–). *Stop the Ku Klux Propaganda in New York*. [New York, NY]: Published by the National Association for the Advancement of Colored People, 70 Fifth Avenue, New York, [1921?]. The Morgan Library & Museum, New York, purchased on the Gordon N. Ray Fund, 2023; PML 199007.

The Crisis 19, no. 5 (March 1920). New York Public Library, Schomburg Center for Research in Black Culture, Jean Blackwell Hutson Research and Reference Division.

Ernest Walter Histed (1862–1947), *Belle da Costa Greene*, 1910. Gelatin silver print; 23 × 18 in. (58.4 × 45.7 cm). The Morgan Library & Museum, New York; ARC 2702.
PAGE 95

Alfred Stieglitz (1864–1946), *Jean Toomer*, 1925. Gelatin silver print; 3 9/16 × 4 5/8 in. (9.1 × 11.7 cm). National Gallery of Art, Alfred Stieglitz Collection; 1949.3.645.

Carl Van Vechten (1880–1964), *Fredi Washington*, December 8, 1938. Reproduction of original photograph. Yale University Beinecke Rare Book and Manuscript Library; JWJ MSS 1050, Box 107, Folder 1954.

Jessie Redmon Fauset (1882–1961), *Plum Bun* (London: Elkin Mathews & Marrot Limited, 1928). The Morgan Library & Museum, New York, the Carter Burden Collection of American Literature; PML 185103.

Wallace Thurman (1902–1934), *The Blacker the Berry: A Novel of Negro Life* (New York: Macaulay Company, 1929). The Morgan Library & Museum, New York, the Carter Burden Collection of American Literature; PML 187341.

Nella Larsen (1891–1964), *Passing* (New York: Alfred A. Knopf, 1929). The Morgan Library & Museum, New York, the Carter Burden Collection of American Literature; PML 185968.
PAGE 75

Carl Van Vechten (1880–1964), *Nella Larsen*, November 23, 1934. Reproduction of original photograph. Yale University Beinecke Rare Book and Manuscript Library; JWJ MSS 1050, Box 96, Folder 1706.
PAGE 75

"Why 'Passing' Is Passing Out," *Jet*, July 17, 1952. New York Public Library, Schomburg Center for Research in Black Culture, Jean Blackwell Hutson Research and Reference Division.

Clarence H. White (1871–1925), *Belle da Costa Greene*, 1911. Platinum print; 8 7/8 × 5 3/8 in. (22.5 × 13.7 cm). The Morgan Library & Museum, New York; ARC 2821.
PAGE 92

Clarence H. White (1871–1925), *Belle da Costa Greene*, 1911. Platinum print; 9 7/8 × 7 3/4 in. (25.1 × 19.7 cm). The Morgan Library & Museum, New York; ARC 2822.
PAGE 93

Pierre Jean de Béranger (1780–1857), *Songs from Béranger*, translated by Craven Langstroth Betts (New York: F. A. Stokes , 1893). Inscribed to "Belle da Costa Greene from Craven Langstroth Betts 1903." The Morgan Library & Museum, New York, gift of the Estate of Belle da Costa Greene; PML 45820.
PAGE 27

Princeton

Charlotte Martins, Autograph letter signed to Belle da Costa Greene, February 6, [1912]. The Morgan Library & Museum, New York; ARC 1310.

View from Northwest with Chancellor Green at left, ca. 1880–1900. Photographic print; 10 × 14 in. (25.4 × 35.7 cm). Princeton University Library Special Collections, Seeley G. Mudd Manuscript Library; Historical Photograph Collection, Grounds and Buildings Series, Box MP25, Item 606.

Pyne Library: Cataloguing Room, ca. 1920. Photographic print; 8 × 10 in. (20.3 × 25.4 cm). Princeton University Library Special Collections, Seeley G. Mudd Manuscript Library; Historical Photograph Collection, Grounds and Buildings Series, Box MP41, Item 1204.

Princeton University Library Accession Book 37, 1904–5. Princeton University Library Special Collections, Seeley G. Mudd Manuscript Library; Princeton University Library Records, AC123.

Salmon Portland Chase (1808–1873), *Speech of Salmon P. Chase in the Case of the Colored Woman, Matilda: Who Was Brought Before the Court of Common Pleas of Hamilton County, Ohio, by Writ of Habeas Corpus, March 11, 1837* (Cincinnati: Pugh & Dodd, 1837). Princeton University Library Special Collections; John Shaw Pierson Civil War Collection, W17.25Iq Oversize.

Gainsborough Studios, *Junius Spencer Morgan*, ca. 1900. Courtesy of Elisabeth Morgan.
PAGE 61

Junius Spencer Morgan, Chartres, 1921. Courtesy of Elisabeth Morgan.

Belle da Costa Greene, Librarian

Clarence H. White (1871–1925), *Belle da Costa Greene*, 1911. Platinum print; 9 3/8 × 7 5/8 in. (23.9 × 19.2 cm). Biblioteca Berenson, I Tatti, the Harvard University Center for Italian Renaissance Studies; Bernard and Mary Berenson Papers, Personal Photographs, Box 12, Folder 37.
PAGE 96

Edward Steichen (1879–1973), *Photographic Portrait of Pierpont Morgan*, 1903. Platinum print; 16 1/16 × 11 15/16 in. (40.8 × 29.7 cm). The Morgan Library & Museum, New York; AZ182.
PAGE 28

J. Pierpont Morgan (1837–1913), *Excelsior Daily Journal for 1905*, 1905. The Morgan Library & Museum, New York; ARC 1196, Box 28, Folder 3.

Tebbs & Knell, East Room of J. Pierpont Morgan's Library, between 1923 and ca. 1935. The Morgan Library & Museum, New York; ARC 1604.

J. Pierpont Morgan's Library (inscribed by Belle da Costa Greene), between 1905 and 1950. Photographic print; 11 3/4 × 14 1/8 in. (29.9 × 35.9 cm). The Morgan Library & Museum, New York; ARC 1637.

Edgar Allan Poe (1809–1849), Autograph letter to John Augustus Shea, February 3, 1845 (containing the earliest surviving fragment of "The Raven"). The Morgan Library & Museum, New York, purchased by J. Pierpont Morgan, 1909; MA 621.
PAGE 110

Alfred Launder (d. 1952), Bookbinding originally housing the earliest surviving fragment of Edgar Allan Poe's "The Raven," early twentieth century. The Morgan Library & Museum, New York, purchased by J. Pierpont Morgan, 1909; MA 621A.
PAGE 100

Photographer unknown, *Belle da Costa Greene*, ca. 1911. Reproduction of original photograph. The Rosenbach, Philadelphia; 2006.2218.

Theodore C. Marceau (1859–1922), *Belle da Costa Greene (reading)*, May 1911. Gelatin silver print; 14 15/16 × 10 7/8 in. (38 × 27.7 cm). Biblioteca Berenson, I Tatti, the Harvard University Center for Italian Renaissance Studies; Bernard and Mary Berenson Papers, Personal Photographs: Box 1 Friends (Large Format).
PAGE 86 (LEFT)

Theodore C. Marceau (1859–1922), *Belle da Costa Greene (leaning on chair)*, May 1911. Gelatin silver print; 14 15/16 × 10 7/8 in. (38 × 27.7 cm). Biblioteca Berenson, I Tatti, the Harvard University Center for Italian Renaissance Studies; Bernard and Mary Berenson Papers, Personal Photographs: Box 1 Friends (Large Format).
PAGE 87 (RIGHT)

Theodore C. Marceau (1859–1922), *Belle da Costa Greene (seated)*, May 1911. Gelatin silver print; 14 15/16 × 10 7/8 in. (38 × 27.7 cm). Biblioteca Berenson, I Tatti, the Harvard University Center for Italian Renaissance Studies; Bernard and Mary Berenson Papers, Personal Photographs: Box 1 Friends (Large Format).
PAGE 87 (LEFT)

Theodore C. Marceau (1859–1922), *Belle da Costa Greene (standing)*, May 1911. Gelatin silver print; 14 15/16 × 10 7/8 in. (38 × 27.7 cm). Biblioteca Berenson, I Tatti, the Harvard University Center for Italian Renaissance Studies; Bernard and Mary Berenson Papers, Personal Photographs: Box 1 Friends (Large Format).
PAGE 87 (RIGHT)

Bernard Berenson and Mary Berenson at Friday's Hill, 1901. Gelatin silver print; 8 × 5 7/8 in. (20.4 × 15.1 cm). Biblioteca Berenson, I Tatti, the Harvard University Center for Italian Renaissance Studies; Bernard and Mary Berenson Papers, Personal Photographs, Box 1, Folder 8.
PAGE 36

Belle da Costa Greene (1879–1950), Autograph letter to Bernard Berenson, February 23, 1909. Biblioteca Berenson, I Tatti, the Harvard University Center for Italian Renaissance Studies; Bernard and Mary Berenson Papers, Box 60, Folder 1.

Bernard Berenson holding photograph of an artwork, ca. 1909. Photographic print; 8 3/16 × 6 3/16 in. (20.8 × 15.8 cm). Biblioteca Berenson, I Tatti, the Harvard University Center for Italian Renaissance Studies; Bernard and Mary Berenson Papers, Personal Photographs, Box 2, Folder 1.
PAGE 102

René Piot (1869–1934), *Female Head*, 1908. Charcoal and white crayon on light brown paper; 10 3/16 × 9 11/16 in. (25.8 × 24.6 cm). I Tatti, the Harvard University Center for Italian Renaissance Studies; Berenson Art Collection.

Belle da Costa Greene (1879–1950), Autograph letter to Bernard Berenson, April 12, 1913. Biblioteca Berenson, I Tatti, the Harvard University Center for Italian Renaissance Studies; Bernard and Mary Berenson Papers, Box 61, Folder 7.

Preserved flowers from the day of the funeral of J. Pierpont Morgan, enclosed in a folded sheet of mourning stationery and envelope annotated by Belle da Costa Greene, April 14, 1913. The Morgan Library & Museum, New York; ARC 1196, Box 2, Folder 34.

"Young Woman Librarian Continues Work of Great Morgan Collection," *New York Herald*, August 3, 1913. With reproduction of a photograph by Adolph de Meyer (1868–1946). The Morgan Library & Museum, New York; ARC 3295.
PAGE 221

Adolph de Meyer (1868–1946), *Belle da Costa Greene*, 1912. Platinum print; 9 5/16 × 7 1/2 in. (23.6 × 19 cm). Biblioteca Berenson, I Tatti, the Harvard University Center for Italian Renaissance Studies; Bernard and Mary Berenson Papers, Personal Photographs, Box 12, Folder 37.
PAGE 88

Building a Library

Mirrour of the World. [Westminster]: [William Caxton], [1481, after August 12]. The Morgan Library & Museum, New York, purchased with the Amherst Collection, 1908; PML 776, sig. d5v–d6r.

Sir Thomas Malory (active fifteenth century), *Thus endeth thys noble and joyous book entytled le morte Darthur* (Westmestre: [William

Caxton], the last day of Juyl [*sic*] the yere of our lord /M/CCCC/lxxxv [July 31, 1485]). The Morgan Library & Museum, New York, purchased by J. Pierpont Morgan, 1911; PML 17560, fols. 49v–50r.
PAGE 30

Paul-César Helleu (1859–1927), *Portrait of Belle da Costa Greene*, 1913. Black, white, and red chalk; 26 9/16 × 21 in. (67.5 × 53.4 cm). The Morgan Library & Museum, New York; 1950.12.
PAGE 76

Rembrandt Harmenszoon van Rijn (1606–1669), *The Hundred Guilder Print*, ca. 1648. Etching, engraving, and drypoint; 11 1/8 × 15 5/8 in. (28.3 × 39.5 cm). The Morgan Library & Museum, New York, purchased, 1925; RvR 116.
PAGE 34

Elizabeth Barrett Browning (1806–1861), *Sonnets from the Portuguese*, autograph manuscript of Sonnet XX, ca. 1845–50. The Morgan Library & Museum, New York, purchased by J. P. Morgan Jr., 1917; MA 933.20.
PAGE 113

Dawson & Lewis, Bookbinding originally housing the *Sonnets from the Portuguese* manuscript. The Morgan Library & Museum, New York, purchased by J. P. Morgan Jr., 1917; MA 933.3-28A.
PAGE 112

Honoré de Balzac (1799–1850), *Eugénie Grandet*, autograph manuscript, 1833. The Morgan Library & Museum, New York, purchased by J. P. Morgan Jr., 1925; MA 1036.
PAGE 114

Clarence H. White (1871–1925), *Belle da Costa Greene*, 1911. Platinum print; 8 7/8 × 5 3/8 in. (22.5 × 13.7 cm). The Morgan Library & Museum, New York; ARC 3275.
PAGE 80

Building a Library: Medieval and Islamic Manuscripts

Cowtan & Sons, Desk and swivel chair used by Belle da Costa Greene, 1906–7. The Morgan Library & Museum, New York.
PAGE 11

Cowtan & Sons, Card catalogue cabinet from the North Room of J. Pierpont Morgan's Library, ca. 1907. The Morgan Library & Museum, New York.
PAGE 19

Belle da Costa Greene (1879–1950), Autograph catalogue cards, 1900s–1940s. The Morgan Library & Museum, New York.

Early accession book of medieval and Renaissance manuscripts, ca. 1900–1974. The Morgan Library & Museum, New York.
PAGES 118–19

Single leaf from the Winchester Bible, Winchester, England, between 1160 and 1180. The Morgan Library & Museum, New York, purchased by J. Pierpont Morgan, 1912; MS M.619, recto.
PAGE 20

Old Testament Miniatures, Paris, France, ca. 1244–54. The Morgan Library & Museum, New York, purchased by J. P. Morgan Jr., 1916; MS M.638, fols. 4v and 12r.
PAGES 120, 121

Judith of Flanders Gospels, England, 1051–64. The Morgan Library & Museum, New York, purchased by J. P. Morgan Jr., 1926; MS. M.708, front cover.

Miscellany on the Life of St. Edmund, Bury St. Edmunds, England, ca. 1130. The Morgan Library & Museum, New York, purchased by J. P. Morgan Jr., 1927; MS M.736, fols. 17v–18r.
PAGES 124–25

Hours of François I, Tours, France, ca. 1515. The Morgan Library & Museum, New York, purchased by J. P. Morgan Jr., 1927; MS M.732, fols. 31v–32r.
PAGE 126

Mont-Saint-Michel Sacramentary, Mont-Saint-Michel, France, ca. 1060. The Morgan Library & Museum, New York, purchased by J. P. Morgan Jr., 1919; MS M.641, fols. 142v–143r.
PAGE 122

Beatus of Liébana (d. 798), *Commentary on the Apocalypse*, San Salvador de Tábara, Spain, ca. 945. The Morgan Library & Museum, New York, purchased by J. P. Morgan Jr., 1919; MS M.644, fols. 117v–118r.
PAGES 32–33

Manuscripts Lent by the Pierpont Morgan Library to the New York Public Library MCMXXXIII (New York, ca. 1933). The Morgan Library & Museum, New York; ARC 3291, Box 91, Folder 4.

Exhibition of Illuminated Manuscripts Held at the New York Public Library: New York, November 1933 to April 1934 ([New York]: Pierpont Morgan Library, ca. 1934). The Morgan Library & Museum, New York; ARC 3298.

Lectern for displaying manuscripts, ca. 1920s–1930s. The Morgan Library & Museum, New York.

Visitor to the Pierpont Morgan Library's Exhibition of illuminated manuscripts, held at the New York Public Library, 1933–34. Photographic print; 9 × 7 1/8 in. (22.9 × 18.1 cm). The Morgan Library & Museum, New York; ARC 3291, Box 91, Folder 4.
PAGE 157

A Seated Courtier with His Pet Falcon, Afghanistan, ca. 1600. The Morgan Library & Museum, New York, purchased by J. Pierpont Morgan, 1911; MS M.386, fol. 1r.
PAGE 143

Ibrāhīm Adham of Balkh Served by Angels, Faizabad, Oudh, India, ca. 1750–75. The Morgan Library & Museum, New York, purchased by J. Pierpont Morgan, 1911; MS M.458, fol. 32r.
PAGE 143

Ausstellung München 1910: Ausstellung von Meisterwerken muhammedanischer Kunst; Musikfeste, Muster-Ausstellung von Musik-Instrumenten (Munich: Rudolf Mosse, 1910). The Morgan Library & Museum, New York, gift of Belle da Costa Greene, 1935; ARC 3299.

A Life of Her Own

Genevieve Van Vliet Greene, Belle da Costa Greene's mother, on an outing in the Hudson River Valley near Bear Mountain, ca. 1939. Gelatin silver print; 3 1/2 × 4 5/8 in. (8.9 × 11.6 cm). The Morgan Library & Museum, New York; ARC 3297.1.
PAGE 266

Laura Coombs Hills (1859–1952), *Belle da Costa Greene*, 1910. Watercolor on ivory; 5 3/4 × 4 1/4 in. (14.6 × 10.8 cm). The Morgan Library & Museum, New York, gift of the Estate of Belle da Costa Greene, 1950; AZ164.
PAGE 192

[Calligraphy], commissioned for Muḥammad Shāh Qājār and written by Asad-Allāh Shīrāzī, 1841. The Morgan Library & Museum, New York, gift of the Estate of Belle da Costa Greene, 1951; MS M.846.5.
PAGE 203

Turkish Qur'an by Pashāzāde, Turkey, probably Istanbul, 1832–33. The Morgan Library & Museum, New York, gift of the Estate of Belle da Costa Greene, 1950; MS M.835, fols. 2v–3r.
PAGES 144–45

Book of Hours, Rouen, France, ca. 1460–70. The Morgan Library & Museum, New York, Melvin R. Seiden Collection, 2007; MS M.1160, fols. 37v–38r.
PAGE 146

Lavinia Fontana (1552–1614), *Marriage Portrait of a Bolognese Noblewoman*, ca. 1580. Oil on canvas; 45 1/4 × 35 1/4 in. (114.9 × 89.5 cm). National Museum of Women in the Arts, Gift of Wallace and Wilhelmina Holladay; 1986.77.
PAGE 201

Head of a Bodhisattva (Mahāsthāmaprāpta), Northern China, Northern Qi dynasty, 550–77. Limestone with partial polychrome; 13 3/8 × 8 3/8 × 8 5/8 in. (34 × 21.2 × 21.9 cm). The Morgan Library & Museum, New York, gift of the Estate of Belle da Costa Greene, 1949; AZ075.
PAGE 207

Jean Pillement (1728–1808), *Chinoiserie: Fisherman with Two Nets*, eighteenth century. Colored chalks; 14 1/16 × 9 1/2 in. (35.7 × 24.1 cm). The Morgan Library & Museum, New York, gift of the Estate of Belle da Costa Greene, 1950; 1950.16.
PAGE 204

Albrecht Dürer (1471–1528), *Melencolia I*, 1514. Engraving; 9 7/16 × 7 5/16 in. (24 × 18.6 cm). The Morgan Library & Museum, New York, gift of the Estate of Belle da Costa Greene, 1950; 1950.33.
PAGE 196

A Belle da Costa Greene Bookshelf, various titles and years of publication. The Morgan Library & Museum, New York.
PAGES 216–17

Henri Matisse (1869–1954), *Nude*, 1912. Pen and ink on paper; 12 3/8 × 8 3/4 in. (31.4 × 22.2 cm). The Morgan Library & Museum, New York, gift of the Estate of Belle da Costa Greene, 1950; 1950.14.
PAGE 176

Belle da Costa Greene (1879–1950), "291," *Camera Work*, no. 48 (July 1914): 64. The Morgan Library & Museum, New York, gift of Mrs. Herbert J. Seligmann, 1986; PML 78904.
PAGE 183

Alfred Stieglitz (1864–1946), Typed letter to Belle da Costa Greene, July 10, 1914. The Morgan Library & Museum, New York; ARC 1310.
PAGE 182

Clara Tice (1888–1973), *Anteater*, twentieth century. Opaque watercolor over graphite; 11 × 16 in. (28 × 40.5 cm). The Morgan Library & Museum, New York, gift of the Estate of Belle da Costa Greene, 1950; 1950.35.
PAGE 215

Arthur B. Davies (1862–1928), *Reclining Female Nude with Hand under Her Chin*, nineteenth century. Pastel with graphite; 6 1/2 × 12 1/2 in. (16.5 × 31.8 cm). The Morgan Library & Museum, New York, gift of the Estate of Belle da Costa Greene, 1950; 1950.32.
PAGE 214

Abraham Walkowitz (1880–1965), *Human Abstract*, ca. 1913. Graphite; 17 1/16 × 11 in. (43.3 × 27.9 cm). The Morgan Library & Museum, New York, gift of the Estate of Belle da Costa Greene, 1950; 1950.22.
PAGE 184

William Rothenstein (1872–1945), *Belle da Costa Greene*, 1912. Red and black chalk; 12 1/4 × 9 7/16 in. (31.1 × 24 cm). The Morgan Library & Museum, New York, gift of Frederick B. Adams Jr., 1956; 1956.5.
PAGE 185

Marius de Zayas (1880–1961), *Belle da Costa Greene*, 1913. Charcoal and graphite on paper; 23 5/8 × 17 1/2 in. (60 × 44.5 cm). The Metropolitan Museum of Art, New York, Alfred Stieglitz Collection, 1949; 49.70.188.
PAGE 178

Benedetto Pistrucci (1784–1855), *Head of Medusa*, 1840–50 (cameo), ca. 1860 (mount). Red jasper mounted in gold with white enamel; 2 11/16 × 2 11/16 in. (6.8 × 6.8 cm). The Metropolitan Museum of Art, New York, purchase, Assunta Sommella Peluso, Ada Peluso, and Romano I. Peluso Gift, in memory of Ignazio Peluso, 2003; 2003.431.
PAGE 212

Pair of Earrings with Pearls, Sapphires, and Gold Globules, early fifth century. Gold and gems; 2 3/4 in. (7 cm). Dumbarton Oaks Research Library and Collection, purchased from the Pierpont Morgan Library, 1952; BZ.1952.7.1-2.
PAGE 213

Adolf Hohenstein (1854–1928), *La Bohême, quattro quadri di G. Giocosa e L. Illica. musica di G. Puccini* ([Milan]: [Officine Grafiche Ricordi], [1895]). The Morgan Library & Museum, New York, James Fuld Collection.

Belle DeAcosta Green [sic] – *Alice Carpenter* – *Kath. Davis* – *Maude Wetmore*, September 12, 1916, from Bain News Service. Photographic print; 3 7/8 × 5 7/8 in. (10 × 15.2 cm). Library of Congress, Photographs and Prints Division; BIOG FILE [item] [P&P].

Members of the Women's Roosevelt League for Hughes. Left to right: Mrs. Jos G. Deune, Sec'y., Miss Alice Carpenter, Pres., Miss Belle Greene, Treas., ca. 1916. Photographic print; 5 × 4 in. (12.7 × 10.2 cm). Library of Congress, Photographs and Prints Division; BIOG FILE [item] [P&P].
PAGE 37

National Hughes Alliance, Women's Committee, *Women in National Politics* (New York: Women's Committee National Hughes Alliance, 1916). Library of Congress, General Collections; JK2357 1916 .N3.

Babies' Hospital (New York, NY), *Lewis Carroll anniversary: January 27, 1932, January 27, 1832, years 100: To provide a child's library for a child's hospital* ([New York]: [Babies' Hospital], [1932]). The Morgan Library & Museum, New York, purchased

on the Drue Heinz Fund for Twentieth-Century Literature, 2023; ARC 3303.

Belle da Costa Greene, Director

Minutes of the Pierpont Morgan Library Board of Trustees, 1924. The Morgan Library & Museum, New York; ARC 3294, Box 1425, v. 1.

"The Story of the Great Morgan Treasures," *New York Herald*, February 17, 1924. The Morgan Library & Museum, New York; ARC 3291, Box 91, Folder 12.
PAGE 226

Frank Owen Salisbury (1874–1962), *J. Pierpont Morgan Seated, Half-Length*, 1928. Charcoal and white chalk with fixative; 22 5/16 × 19 in. (59.7 × 48.5 cm). The Morgan Library & Museum, New York, purchased on the Acquisitions Fund; 1973.8:3.
PAGE 35

Pierpont Morgan Library, *The Board of Trustees of The Pierpont Morgan Library has established the following rules for the use and regulation of the Library*, ca. 1933. The Morgan Library & Museum, New York; ARC 3291, Box 81, Folder 3.

Pierpont Morgan Library, Library card issued by the Pierpont Morgan Library to Harold Strong Gulliver, 1934. The Morgan Library & Museum, New York; ARC 3291, Box 77, Folder 7.
PAGE 37

"Morgan Library Art Treasures Used as Textbooks for Lecture," *New York Herald*, February 16, 1935. The Morgan Library & Museum, New York; ARC 3291, Box 90, Folder 10.

Catholic Church, Missal, France, probably Troyes, ca. 1400. The Morgan Library & Museum, New York, purchased by J. Pierpont Morgan, 1907; MS M.331, fols. 186v–187r.

Schedule for a series of lectures on Art and the Book, February to May, 1924, at the Library School of the New York Public Library, 1923. The Morgan Library & Museum, New York; ARC 1310.

Spanish Forger, *Betrothal of St. Ursula*, late nineteenth / early twentieth century. Oil on panel; 30 1/2 × 24 1/2 in. (77.5 × 62.3 cm). The Morgan Library & Museum, New York, gift of Martin Cooper; 1988.125.
PAGE 148

After Sandro Botticelli (1444/45–1510), *Madonna of the Magnificat*, Florence, Italy, ca. 1490. Oil on panel; 37 3/8 in. (94.9 cm) diameter. The Morgan Library & Museum, New York, purchased by J. Pierpont Morgan, 1911; AZ014.

Thomas Gainsborough (1727–1788), *Lady Walking in a Garden*, ca. 1785. Black and white chalks with smudging, worked wet and dry, watercolor; 19 1/2 × 12 1/4 in. (49.5 × 31.2 cm). The Morgan Library & Museum, New York, acquired from the Estate of J. P. Morgan Jr., 1943; III, 63b.
PAGE 240

Anne Boleyn, Queen, consort of Henry VIII, King of England (1507–1536), Letter to the dean and canons of Exeter Cathedral, March 26, [1536]. The Morgan Library & Museum, New York, purchased in 1936; MA 1131.
PAGE 128

Jacques Louis David (1748–1825), *Maximilien Robespierre on the Day of His Execution*, eighteenth century. Graphite; 7 1/4 × 7 7/8 in. (18.4 × 20 cm). The Morgan Library & Museum, New York, purchased in 1928; MA 1059.6.
PAGE 129

Charles Dickens (1812–1870), *Our Mutual Friend*, autograph manuscript, September 2, 1865. The Morgan Library & Museum, New York, purchased, 1944; MA 1202–1203.
PAGE 131

Gospel Book, Sis, Cilicia, 1274. The Morgan Library & Museum, New York, purchased in 1928; MS M.740, fols. 4v–5r.
PAGE 150

John Keats (1795–1821), "On First Looking into Chapman's Homer," autograph manuscript, n.d. [October 1816 or later]. The Morgan Library & Museum, New York, purchased by J. P. Morgan Jr., 1915; MA 214.3.
PAGE 130

Houghton Library, Harvard University, *The Librarian of The Houghton Library requests the pleasure of your company at a talk by Helen Vendler[:] Amy Lowell: A Ouija Board for a Dead Song*, ca. 1950s–1960s. The Morgan Library & Museum, New York; MA 4098.

New York World's Fair (1939–40), The Trylon and Perisphere illuminated at night at the 1939 World's Fair, October 28, 1940. Gelatin silver print; 14 × 10 1/2 in. (35.5 × 26.7 cm). Museum of the City of New York, 91.69.39.

William Blake (1757–1827), *The Lord Answering Job out of the Whirlwind*, eighteenth century. Pen and black and gray ink, gray wash, and watercolor, over faint indications in pencil; 9 1/16 × 10 9/16 in. (23 × 26.8 cm). The Morgan Library & Museum, New York, purchased by J. Pierpont Morgan, 1909; 2001.75.

Rembrandt Harmenszoon van Rijn (1606–1669), *Woman with a Child Descending a Staircase*, ca. 1636. Pen and brown ink and wash; 7 3/8 × 5 3/16 in. (18.7 × 13.2 cm). The Morgan Library & Museum, New York, purchased by J. Pierpont Morgan, 1909; I, 191.

British Museum, *Air Raid Precautions in Museums, Picture Galleries and Libraries* ([London]: printed by Order of the Trustees, the British Museum, 1939). The Morgan Library & Museum, New York; ARC 3291, Box 80, Folder 15.
PAGE 238

Society of American Archivists, *The Care of Records in a National Emergency* (Washington, DC: National Archives of the United States, 1941). The Morgan Library & Museum, New York; ARC 3291, Box 80, Folder 15.
PAGE 238

Helen Franc (1908–2006), Typed letter to Belle da Costa Greene, July 30, 1942. The Morgan Library & Museum, New York; ARC 3291, Box 36, Folder 9.
PAGE 237

Pierpont Morgan Library, *The Written Word* ([New York], [1944]). The Morgan Library & Museum, New York; ARC 3291, Box 89, Folder 10.
PAGE 239

Gradual cutting, Trinity Sunday, Florence, Italy, 1392–99. The Morgan Library & Museum, New York, purchased by J. Pierpont Morgan, 1909; MS M.653.2.

Edith Porada (1912–1994), *Die Rollsiegel der Akkadzeit: Dissertation zur Erlangung der Doktorwurde an er Philosophischen Fakultat der Universitat Wien* [part two, plates], ca. 1934. The Morgan Library & Museum, New York; ARC 3304.
PAGE 235

Passport issued to Edith Porada, Vienna, September 14, 1938. The Morgan Library & Museum, New York, Edith Porada Papers; Box 8-1.
PAGE 235

Edith Porada (1912–1994), Autograph letter signed to Belle da Costa Greene, n.d. [1940?]. The Morgan Library & Museum, New York; ARC 3291, Box 57, Folder 9.

Edith Porada, [1950s?]. Photographic print; 8 1/2 × 6 1/2 in. (21.6 × 16.5 cm). The Morgan Library & Museum, New York, Edith Porada Papers; Box 8-1.

Tree on Mountain beside Three Shoots and Stag, between 1300 BC and 1200 BC. Milky chalcedony; 1 3/16 × 3/8 in. (3 × 1 cm). The Morgan Library & Museum, New York, acquired by J. Pierpont Morgan sometime between 1885 and 1908; Morgan Seal 601.

Portrait of J. P. Morgan Jr. aboard *S. S. Mauretania* upon his arrival from the Paris Reparations meeting, 1929. Photographic print; 10 × 8 1/8 in. (25.4 × 20.6 cm). The Morgan Library & Museum, New York, gift of Henry S. Morgan, 1955; ARC 2690.2.
PAGE 220

William Makepeace Thackeray (1811–1863), *The Rose and the Ring*, autograph manuscript, 1853. The Morgan Library & Museum, New York, purchased by J. P. Morgan Jr., 1915; MA 926.
PAGE 241

Lord Byron's gimmel ring, ca. 1813. Yellow gold; 7/8 in. (2.3 cm) diameter. The Morgan Library & Museum, New York, gift of J. P. Morgan Jr.; AZ122.

St. Paul's School, St. Paul's School Choir, 1932–33. Photographic print; 7 11/16 × 9 13/16 in. (19.5 × 25 cm). Archives of St. Paul's School.
PAGE 268

Robert "Bobbie" MacKenzie Leveridge at the Fountain Valley School of Colorado, standing in the courtyard of the Hacienda, early fall 1933. Archives of the Fountain Valley School.
PAGE 268

Belle da Costa Greene (1879–1950), Autograph letter signed to F. M. Froelicher, August 29, 1933. Archives of the Fountain Valley School.

St. Paul's School, *Alumni Horae*, Spring 1944, 26. Archives of St. Paul's School.
PAGE 271

Drawing of First Lieutenant Robert MacKenzie Leveridge, ca. 1942. Photographic print; 9 × 7 1/2 in. (23 × 19 cm). Reproduced in St. Paul's School, *Alumni Horae*, Spring 1944, 26. Archives of St. Paul's School.
PAGE 272

Daniel Varney Thompson (1902–1980), Autograph note to Belle da Costa Greene, ca. 1944. Archives of American Art, Smithsonian Institution; Daniel Varney Thompson Papers.
PAGE 274

Black Librarianship

Winold Reiss (1886–1953), *The Librarian*, 1925. Pastel and tempera on Whatman board; 30 × 22 in. (76.2 × 55.9 cm). Fisk University Museum of Art, Nashville, TN.
PAGE 79

Mattie Edwards Hewitt (1869–1956), Belle da Costa Greene, 1929, for Bain News Service. Reproduction of original photograph. Library of Congress, Prints & Photographs Division, George Grantham Bain Collection; LC-USZ62-93225.
PAGE 78

View of researchers using the Schomburg Collection when it was the 135th Street Branch Library Division of Negro Literature, History and Prints, with Catherine A. Latimer, reference librarian of the collection, in left background, 1938. Reproduction of original photograph. New York Public Library, Schomburg Center for Research in Black Culture, Photographs and Prints Division; Box 5.
PAGE 253

Carl Van Vechten (1880–1964), *Dorothy Porter Wesley*, May 23, 1951. Reproduction of original photograph. Carl Van Vechten Papers Relating to African American Arts and Letters. James Weldon Johnson Collection in the Yale Collection of American Literature, Beinecke Rare Book and Manuscript Library; JWJ MSS 1050, Box 108, Folder 1977.
PAGE 257

Regina Andrews (Seated) with Librarian Edna Law, 1940. Gelatin silver print; 7 1/16 × 5 1/8 in. (18 × 13 cm). New York Public Library, Schomburg Center for Research in Black Culture, Photographs and Prints Division; SC Photo Regina Andrews Collection.

A Legacy Remembered

Clarence H. White (1871–1925), *Belle da Costa Greene*, 1911. Platinum print; 9 1/2 × 7 in. (24.2 × 17.8 cm). Biblioteca Berenson, I Tatti, the Harvard University Center for Italian Renaissance Studies; Bernard and Mary Berenson Papers, Personal Photographs, Box 12, Folder 37.
PAGE 172

Clarence H. White (1871–1925), *Belle da Costa Greene*, 1911. Platinum print; 9 1/2 × 5 1/2 in. (24.2 × 14 cm). Biblioteca Berenson, I Tatti, the Harvard University Center for Italian Renaissance Studies; Bernard and Mary Berenson Papers, Personal Photographs, Box 12, Folder 37.
PAGE 68

Clarence H. White (1871–1925), *Belle da Costa Greene*, 1911. Platinum print; 9 13/16 × 7 5/16 in. (24.9 × 18.5 cm). Biblioteca Berenson, I Tatti, the Harvard University Center for Italian Renaissance Studies; Bernard and Mary Berenson Papers, Personal Photographs, Box 12, Folder 37.
PAGE 264

Gospel Book (Anhalt-Morgan Gospels), possibly St. Bertin, France, or at St. Vaast in Arras, Belgium, late tenth century. The Morgan Library & Museum, New York, purchased on the Lewis Cass Ledyard Fund, 1948; MS M.827, fols. 17v–18r.
PAGE 163

Pierpont Morgan Library, *The First Quarter Century of the Pierpont Morgan Library* ([New York], [1949]). The Morgan Library & Museum, New York; ARC 3291, Box 82, Folder 1.

Gospel Book, Reims, France, ca. 870s. The Morgan Library & Museum, New York, purchased, 1927; MS M.728, fols. 14v–15r.
PAGE 127

Zir Ganela Gospels, commissioned by Princess Zir Ganela, Ethiopia, 1400–1401. 14 5/16 × 9 7/8 in. (36.2 × 25.1 cm). The Morgan Library & Museum, New York, purchased on the Lewis Cass Ledyard Fund, 1948; MS M.828, fols. 4v–5r.
PAGES 152–53

Frederick Douglass (1818–1895), Autograph letter to J. D. Husbands, January 17, 1881. The Morgan Library & Museum, New York, purchased from P. Alloway, November 1947; MA 1221.
PAGE 259

Meta Harrsen (1891–1977), Typed letter to Bernard Berenson, May 18, 1950. Biblioteca Berenson, I Tatti, the Harvard University Center for Italian Renaissance Studies; Bernard and Mary Berenson Papers, Box 68, Folder 2.
PAGE 279

Index

Page numbers in italics indicate illustrations. Belle da Costa Greene is abbreviated as "BG."

African art/culture, 179–83, 256
Amherst College Summer School, 27, *44*, 58–59, *58*, 60, 138
Ardizzone, Heidi, *An Illuminated Life: Belle da Costa Greene's Journey from Prejudice to Privilege*, 22, 89, 94, 164, 256, 270–71, 276
Austen, Jane, 110, 241; *Lady Susan* manuscript, 114
Balzac, Honoré de: *Balzac, Towards the Light, Midnight* (Edward J. Steichen, photographic print of Rodin sculpture), 174, *175*; *Eugénie Grandet*, autograph manuscript, 113, *114*
Béranger, Pierre Jean de, *Songs from Béranger*, 27, *27*
Berenson, Bernard, 35, *36*, 102, 186; correspondence with BG, 34, 36–37, 71, 81, 101, *102–3*, 103, *105*, 106, 109–11, 184, 197, 222–23, 265; letters to/from Meta Harrsen, 234, *279*; modern art, views on, 174–75, 180; relationship with BG, 36–37, 91, 101–7, 141, 143
Berenson, Mary, 36, *36*
Bishop, William Warner, 62
Black librarians/librarianship, 39, 283, 285–87; BG place within, 261, 283–87; collection/provision of Black resources, 251–54, 256; countercataloguing, 258; early Black librarianship, 250–51; Harsh, Vivian G., 39, *248*, *254*, 255, 259; Latimer, Catherine, 39, 252–54, *253*, 256, 258–59; Murray, Daniel Alexander Payne, *254*, 255–56, 258–59; public access to collections, 258, 260; Wesley, Dorothy Porter, 39, *257*, 258
bookbindings, 63, *100*, 112
books: *Alice's Adventures in Wonderland* (Lewis Carroll), 101; *The Autobiography of an Ex-Colored Man* (James Weldon Johnson), 188; *Gargantua and Pantagruel* (Rabelais), 101; *The House Behind the Cedars* (Charles W. Chesnutt), 73, *73*; *Le Morte d'Arthur* (Sir Thomas Malory), 30–31, *30*; *Passing* (Nella Larsen), 75, *75*, 85; *Prancing Nigger* (Ronald Firbank), 108; Qur'an, 144–45, 147, *198*; *The Rose and the Ring* (William Makepeace Thackeray), 241, *241*; *Songs from Béranger* (Pierre Jean de Béranger), inscribed to BG, 27, *27*; *The Thousand and One Nights*, 19, 102–4; *Vita Nuova di Dante Alighieri* (Dante Alighieri), 104–7, *106*. *See also* Books of Hours; Gospel Books; incunabula; literature; manuscripts
Books of Hours: Hours of François I, *126*; manuscript owned by BG, *146*, 147
Browning, Elizabeth Barrett, 110–13; bookbinding, *Sonnets from the Portuguese*, manuscript (Dawson & Lewis), *112*; *Last Poems*, 242, 243; *Sonnets from the Portuguese*, 110–12, *113*
Bruce, Blanche K., 21, *26*, 46
Chesnutt, Charles W., 8, 73, 74; *The House Behind the Cedars*, 73, *73*; "The Wife of His Youth," 69
churches: Fifteenth Street Presbyterian Church, Washington, DC, 21, 24–25, *24*, 45–46, 267; West End Presbyterian Church, New York, 52
Cicero, Marcus Tullius, *De Officiis*, 48, 137, *137*
Cockerell, Sir Sydney, 18, 35, 39, *257*, 258
Daniell, Lucetta, 52
Dante Alighieri, *Vita Nuova di Dante Alighieri*, 104–7, *106*
Der Nersessian, Sirarpie, 150–51, 154, 164
Dickens, Charles, *Our Mutual Friend*, autograph manuscript, 113–14, *131*
Dodge, Grace Hoadley, 52–53, 56, 188, 267
Douglass, Frederick, *26*, 48, 72; letter to J. D. Husbands, *259–60*, 261
drawings: *Anteater* (Clara Tice), *215*; *Belle da Costa Greene* (Marius de Zayas), 178, *178*; *Belle da Costa Greene* (William Rothenstein), *185*; *Chinoiserie: Fisherman with Two Nets* (Jean Pillement), *204*, 205; First Lieutenant Robert MacKenzie Leveridge, *272*; *Human Abstract* (Abraham Walkowitz), 184, *184*; *John Pierpont Morgan* (Frank Owen Salisbury), *35*; *Lady Walking in a Garden* (Thomas Gainsborough), *240*, 241; *The Librarian* (Winold Reiss), 77, *79*; *Male Figure Approaching a Ruler, in a Courtyard* (Anonymous, Italian School), *208*; *Maximilien Robespierre on the Day of His Execution* (Jacques Louis David), *129*; *Nude* (Henri Matisse), 37, *176*; *Portrait of Belle da Costa Greene* (Paul-César Helleu), 76, 77; *Reclining Female Nude Seen from the Back* (Everett Shinn), *214*; *Reclining Female Nude with Hand under Her Chin* (Arthur B. Davies), 214. *See also* works on paper
Duncan, Isadora, 183–84
Dürer, Albrecht, *Melencolia I*, *196*, 197
Ettinghausen, Richard, 151
exhibitions: New York Public Library, 157–58, *157*, 233, 228; Pierpont Morgan Library, 22–23, 38, 113–14, 147, 151, 154, 155–56, 158, 161–62, 228, 237, 239, *239*, 243, 278
Farley, Mary Ann, 154–55, 232
Firbank, Ronald, *Prancing Nigger*, 108
Fleet, Genevieve Ida (Van Vliet), 23–24, 45–47, 265–67, *266*; family residence, Georgetown, *24*, 25; "passing," 27, 49, 52, 73, 267
Fleet family, background, 24–25, 46–47
Fontana, Lavinia, *Marriage Portrait of a Bolognese Noblewoman*, 200, *201*
Franc, Helen M., 154, 232; letter to BG, 236–37, *237*
Freud, Sigmund, 102, 180
Gainsborough, Thomas, *Lady Walking in a Garden*, *240*, 241
George Cleveland Hall Branch Library, Chicago, IL, *248*, 255
Gilpin, Charles Sidney, 107–8, *107*
Global Middle Ages, 149–51, 154, 167. *See also* medieval interests of BG
Gospel Books: Anhalt-Morgan Gospels, 161, *163*; Armenian, from Sis, Cilicia, 150, *150*; Judith of Flanders, inside front cover, 139, *140*; Quedlinburg Gospels, *38*; Reims Gospels, *127*, 237; Zir Ganela Gospels, 39, 151, *152–53*
Granniss, Ruth, 229–30
Greene, Belle da Costa: acquisitions for the Morgan Library, 30–34, 38–39, 109–14, 117–31, 141, 143, 149–54, 161–62, 223–25, 241–43, 260–61; autograph letters, *53*, *102–3*, *105* (*see also* Berenson, Bernard, correspondence with BG); bequest from J. Pierpont Morgan, 35, 185; birth certificate, *46*; death, 39, 278, *279*; drawings, 76, 178,

185; early employment, 52, 138; early life, 23–25; education, 27, *44*, 45, 49, 52–59, *58*, 138; Festschrift, *Studies in Art and Literature for Belle da Costa Greene*, 163–64, 278; hiring of by J. Pierpont Morgan, 28, 62, 139; Hroswitha Club, 154–55, 163–64, 194; inscriptions in books, 106, *106*, 108; librarianship, 17–19, 27–28, 39, 230–32, 253; mentorship, 232–38; newspaper/magazine articles concerning, *18*, *31*, *81*, *88*, 89, 89–90, *221*; obituary, 162–63; paintings, *192*; "passing," 21, 27, *27*, 71–73, 81–82, 188, 261; peer tributes, 161–64; personal collection of art and books, 103, 105–6, 192–217; perspectives on race, 107–8, 260–61; photographs, *16*, *37*, *44*, *58*, *68*, *78*, *80*, *84*, *86–88*, *92–93*, *95–96*, *132*, *162*, *172*, *218*, *234*, *264*; political activity, 37, 184–86, *186*; Princeton University, 27–28, 59–63, 79, 138; published writing, 55–56, *57*, 173, 183, *183*, 229, 233, 245; quotes, 17, 18, 34, 35, 39, 55, 56, 59, 60, 63, 73, 77, 88, 101, 103, 104, 105, 108, 109, 111, 113, 120, 136, 139, 141, 146, 155, 158, 173–74, 176, 179, 182, 197, 200, 202, 206, 209, 219–20, 222–25, 227, 229, 231–32, 238–43, 256, 260, 265–66, 268–70, 275, 277, 278; racial identity, 19, 21, 25, 70–72, 81, 283–87; sculptures, *12*; self-presentation, 77, 85, 88–89, 91, 94, 97–98; signatures, *106*, *231*; will, 193–94; writings about, 22, 164

Greene, Ethel, 27, 49, 56, 278

Greene, Genevieve Theodora ("Teddy"), 27, 49, 193, 267–68, *267*

Greene, Mary Louise, 27, 49

Greene, Russell da Costa, 27, 49, 53, 193, 267

Greener, Richard Theodore, 17, 25, 26, 45–49, *47*, 52–53, 72–73, 251, 270, 284–86; Bachelor of Arts diploma, Harvard University, *282*, 284–86; letter to Arturo Schomburg, *48*; rare books/documents collection, 136–37

Grimké, Rev. Francis J., 21, *21*, 45–46

Haight, Anne Lyon, 18, 164

Harrsen, Meta P., 18, 39, 154–55, 157, 232–34, 278; letter to Bernard Berenson, *279*

Harsh, Vivian G., 39, *248*, 254, 255, 259–60

Hartmann, Sadakichi, 177–78

Helleu, Paul-César, *Portrait of Belle da Costa Greene*, *76*, 77

Histed, Ernest Walter, 85, 88; photograph of BG, 94, *95*

Husselman, Elinor Mullett, 155

Hyvernat, Fr. Henri, 150, 267–69

incunabula, 30–31, 141

Ivins Jr., William M., 140, 205, 278

jewelry: *Head of Medusa* (Benedetto Pistrucci), 211, *212*; *German Pendant with a Personification of Fortitude*, 210, 211; *Pair of Earrings with Pearls, Sapphires, and Gold Globules*, 211, *213*

Johnson, James Weldon, 49; *The Autobiography of an Ex-Colored Man*, 188

Keats, John: Lowell, Amy, Keats collection given to Harvard, 130; "On First Looking into Chapman's Homer," *130*

Lapierre, Alexandra, *Belle Greene*, 22, 276

Larsen, Nella, 75, *75*; *Passing*, 74–75, *75*, 85

Latimer, Catherine, 39, 252–56, *253*, 258–59

letters: Anne Boleyn, Queen of England, *128*; Austen, Jane, 110, 241; autograph letter from Frederick Douglass, *259*, 261; autograph letters from BG, *53*, 102–3, *105*. *See also* Berenson, Bernard, correspondence with BG

Leveridge, Robert "Bobbie" MacKenzie, 267–69, *268*; death, 270–71, *274*, 277; drawings, *271*, *272*; education, 268–70; letter from N. Taylor, 271–76; military service 270

librarianship, 19, 230–31, 249–51. *See also* Black librarians/librarianship

Life magazine: articles on Pierpont Morgan Library exhibition (1945), 158; "On the Head of a Pin," advertisement (J. Walter Thompson Company), 158, *159*

literature: BG and personal reading, 30, 34, 101, 108; literary allusions in BG letters, 102–4, 107, 109. *See also* books

MacLeish, Archibald, "The Young Dead Soldiers," 277–78, *277*

Malory, Sir Thomas, *Le Morte d'Arthur*, 30–31, *30*

manuscripts: *De Officiis* (Marcus Tullius Cicero), 48, *137*; display of in New York Public Library (1933–34), *157*; *Eugénie Grandet* (Honoré de Balzac), 113, *114*; *Homily on Gilead*, *149*; *Lady Susan* (Jane Austen), 114; *Last Poems* (Elizabeth Barrett Browning), 242, 243; literary manuscripts collected by J. Pierpont Morgan, 109; medieval (*see* medieval manuscripts); *Our Mutual Friend* (Charles Dickens), 114, *131*; "The Raven" (Edgar Allan Poe), (fragment), 109–10, *110*; *Sonnets from the Portuguese* (Elizabeth Barrett Browning), 110–12, *113*; "The Young Dead Soldiers" (Archibald MacLeish), 277–78, *277*

maps, *The National Capital, Washington, D.C.*, *23*

Marceau, Theodore C., 85, 88; photographs of BG, *86–87*

Martins, Charlotte, 60–62

Matisse, Henri, 174–76; *Nude*, 37, *176*

Medieval Academy of America: BG legacy, 164–67; creation, 135; induction of BG as Fellow, 160–61; *Speculum*, memoir of BG, 164

medieval interests of BG, 134–36; early education in medievalism, 138; European trips, 140–41, 143; female medievalist network, 154–55; influence on apartment interiors, 146–47; study of forgeries, 147; transatlantic network, 139–40; use of experts to assess manuscripts, 149–51

medieval manuscripts, 30, 34, 109, *118–19*, 149; Armenian manuscripts, 150–51, *150*; Berry Apocalypse manuscript, 158, *159*; *The Commentary on the Apocalypse* (Beatus of Liébana), *32–33*; Coptic manuscripts/bindings, 149–50, *149*; Islamic book art, 143, *143*; *Martyrology and Miscellaneous Texts* (Usuard), *123*; *Miscellany on the Life of St. Edmund*, *124–25*; *Mont-Saint-Michel Sacramentary*, *122*; Winchester Bible leaf, *20*. *See also* Books of Hours; Gospel Books; miniatures

Meyer, Adolph de, photographs of BG, *88*, 89, *218*, *221*

Meyer, Agnes Ernst, 177, *179*, 256

Miner, Dorothy, 155, *155*, 163–64, 211, 232–33, 278; letter to BG, *233*

miniatures: Old Testament, *120–21*, 223–24; Arabic, Indo-Persian, *143*, 202, *203*

Morgan, J. Pierpont, 28; BG relationship with, 34, 55, 63; collecting of books/manuscripts by, 109–10, 139; death, 219; drawings, *35*; hiring of BG, 28, 62, 139

Morgan, J. Pierpont, Jr. ("Jack"), *220*; antisemitism, 186–87; BG relationship with, 35, 219, 222–25; death, 241–42; purchase of collection items, 110, 112, 161, 223–25, 241

Morgan, Junius Spencer, 28, *61*, 63, 138–39, 197; BG relationship with, 35, 60, 219

J. Pierpont Morgan's Library (1906–1924), *29*, 161, *162*; access to, 227, 256; accession books, *118–19*, 260; acquisitions, 117–31 (*see also under* individual medium); card catalogue cabinet, *19*; collection, sale/dispersal of following death of J. Pierpont Morgan, 220–21; collection development, 28–29, 34, 38–39, 110–11, 139; creation, 28, 35; desk and swivel chair used by BG, *11*; East Room, *6*; transition from private collection to public institution, 135, 225. *See also* The Morgan Library & Museum; Pierpont Morgan Library

The Morgan Library & Museum (2006–present): BG Curatorial Fellowships, 166. *See also* J. Pierpont Morgan's Library; Pierpont Morgan Library

Pierpont Morgan Library (1924–2006): access to, 227–28, 256; accession books, *118–19*, 260; acquisitions, 117–31, 241 (*see also under* individual medium); appointment of BG as director, 225, *226*; Board of Directors, 225, 227, 242; creation of from J. Pierpont Morgan's Library, 38, 135, 225, 227; exhibitions (*see under* exhibitions); expansion of, 228–29; gifts/bequests from BG and BG estate, 147, 166, *196*, 204, 205, *207–8*; leadership of BG during WWII, 238–40; library card, *37*; *Life* magazine article (1945), 158; loan of collection items, 156–57, *157*; *New York Herald* article, *226*; photographic department, 158, 160; public engagement, 156–57, *156*; safety/evacuation of collection items during WWII, *238*, 239; reports, 229. *See also* J. Pierpont Morgan's Library; The Morgan Library & Museum

Morrow, Epiphany ("Big Piph"), 133–34, *167*

Murray, Daniel, Alexander Payne, *254*, 255–56, 258–60

Napier, Violet Burnie, 232

New York Herald: article on BG, *221*; article on Morgan collection, *226*

New York Public Library: 135th Street Branch, Division of Negro Literature, History and Prints, 252, *253*, 254–55, 258; exhibitions of Morgan collection, 157–58, *157*, 233, 228

New York Times: article on BG, 89, *89*; article on New York Public Library exhibition of Morgan collection, 228; quote on BG, 69–70

Nichols, Jane Morgan, 242–43

Northfield Seminary for Young Ladies, MA, 53–56, *54*, 138; application by BG, *50–51*, 52–53; *The Hermonite*, *57*; letter from BG, *53*; letters of recommendation for BG, 52–53

paintings: *Belle da Costa Greene* (Laura Coombs Hills), *192*, 193; *Betrothal of St. Ursula* (Spanish Forger), *147*, *148*; *Madonna and Child Enthroned with Saints John Gualbertus, John the Baptist, Francis and Nicholas* (Bernardo Daddi), *209*; *Marriage Portrait of a Bolognese Noblewoman* (Lavinia Fontana), 200, *201*; *The Octoroon Girl* (Archibald J. Motley), *286*

Panofsky, Erwin, 157, 240

"passing," 98, 261, 276; *The Autobiography of an Ex-Colored Man* (James Weldon Johnson), 188; BG, 21, 27, *27*, 71–73, 81–82, 188, 261; Greene family, 27, 49, 52, 73, 267; novels, 73–74; *Passing* (Nella Larsen), 74–75, *75*, 85

personal collection of BG, 146–47, 151, 191–216; *A Native Woman (bhīl) Playing a Vina*, *199*; African art, 179–80, 183, 256; *Anteater* (Clara Tice), *215*; *Belle da Costa Greene* (Laura Coombs Hills), *192*, 193; Book of Hours, *146*; books, 216–17; calligraphic leaf (Asad-Allāh Shīrāzī), 202, *203*; *Chinoiserie: Fisherman with Two Nets* (Jean Pillement), *204*, 205; *German Pendant with a Personification of Fortitude*, 210, *211*; Head of a Bodhisattva (Mahāsthāmaprāpta), 206, *207*; *Head of Medusa* (Benedetto Pistrucci), *212*; illuminated initial H from 15th century Italian choir book, *195*; *Madonna and Child Enthroned with Saints John Gualbertus, John the Baptist, Francis and Nicholas* (Bernardo Daddi), *209*; *Male Figure Approaching a Ruler, in a Courtyard* (Anonymous, Italian School), *208*; *Marriage Portrait of a Bolognese Noblewoman* (Lavinia Fontana), 200, *201*; *Melencolia I* (Albrecht Dürer), *196*, 197; *Nude* (Henri Matisse), *37*, *176*; *Pair of Earrings with Pearls, Sapphires, and Gold Globules*, *213*; Qur'an, *144–45*, 147, *198*; *Reclining Female Nude Seen from the Back* (Everett Shinn), *214*; *Reclining Female Nude with Hand under Her Chin* (Arthur B. Davies), *214*

photography: portrayal of women, 88, 94; self-presentation of BG, 85, 88–89, 91, 94, 97–98; use of for educational purposes, 158, 160

Picasso, Pablo, 178–79, 182

Poe, Edgar Allan: bookbinding, "The Raven" manuscript fragment (Alfred Launder), *100*; "The Raven," manuscript fragment, 109, *110*

Porada, Edith, 234, *235–36*, 236, 243

Quaritch, Bernard Alfred, 30, 112

racial inequality in US, 72–74, 82, 165, 250–51; antisemitism, 186–87; legal status of Black Americans, 27, 72; racial tensions in early 20th century, 21, 184–87, *186*

Read, Charles Hercules, 18, 141, 143, 149, 151, 179, 202

Reiss, Winold, *The Librarian*, 77, *79*

Rembrandt Harmenszoon van Rijn, *The Hundred Guilder Print*, 34

Richardson, Ernest Cushing, 59–60, 62–63, 138

Rosenbach, A. S. W., 224

Schomburg, Arthur Alfonso, 49, 251, *252*; letter from Richard T. Greener, 48, *48*

Schomburg Collection, 252–55; researchers using, *253*

sculptures: Head of a Bodhisattva (Mahāsthāmaprāpta), 206, *207*; *Belle da Costa Greene* (Jo Davidson), *12*

Seligmann, Herbert J., 187–88

Steichen, Edward J., 173–74, 177, 184; *Balzac, Towards the Light, Midnight*, 174, *175*; *Photographic Portrait of Pierpont Morgan*, *28*, 173–74

Stein, Gertrude, 175–77

Stieglitz, Alfred, 173, 181–82, 185, 188; letter to BG, *182*

Stieglitz circle/291 gallery: BG involvement, 173–74, 177, 181–84, *182–83*, 188; *Camera Work*, 174, 176, 182, 185, 187–88; *Exhibition of Sculpture—The First in America—and Recent Drawings by Henri Matisse* (1912, exhibition), 175; *Statuary in Wood by African Savages—the Root of Modern Art* (1914, exhibition), 180–81

Strouse, Jean: *Morgan: American Financier*, 22, 81, 276; "The Unknown J. P. Morgan" (*New Yorker* article), 164

Sumner, Charles, 47–48, 136–38, *137*

Terrell, Mary Church, 74

Thackeray, William Makepeace, *The Rose and the Ring*, 241–42, *241*

Thompson, Daniel Varney, 271, 274–75, *274*, 278

Thompson, Paul, *Belle Da Costa Greene*, 132

Thurston, Ada ("Thursty"), 154, 232, 241

Van Vechten, Carl, *75*, 106, 108, *257*

Van Vliet, Genevieve Ida, *see* Fleet, Genevieve Ida (Van Vliet)

Walkowitz, Abraham, 184, 188; *Human Abstract*, 184

Wesley, Dorothy Porter, 39, *257*, 258

White, Clarence H., 85, 88; photographs of BG, *4*, *16*, *68*, *80*, *84*, *92–93*, 94, *96*, *172*, *264*

Women's Roosevelt League for Hughes, 37, *37*

works on paper: *Ausstellung München 1910, Meisterwerke Muhammedanischer Kunst—Musik-Feste* (Julius Diez), *142*; calligraphic leaf (Asad-Allāh Shīrāzī), 202, *203*; *Distinguished Colored Men*, *26*; *The Hundred Guilder Print* (Rembrandt Harmenszoon van Rijn), *34*; *Ibrāhīm Adham of Balkh Served by Angels*, *143*; *Melencolia I* (Albrecht Dürer), *196*, 197; *Native Woman (bhīl) Playing a Vina, A*, *199*; *A Seated Courtier with His Pet Falcon*, *143*. *See also* drawings; manuscripts

Wroth, Lawrence C., 18–19, 119, 162

Zayas, Marius de, 177–78, 180–82; *Belle da Costa Greene*, *178*

Contributors

Colin B. Bailey is the Katharine J. Rayner Director of the Morgan Library & Museum. A scholar of eighteenth- and nineteenth-century French art, he is a specialist of Pierre-Auguste Renoir and has been responsible for many publications and exhibitions. Among the initiatives Bailey has spearheaded at the Morgan is the inauguration of the Belle da Costa Greene Curatorial Fellowships, created for promising scholars from historically underrepresented communities in the curatorial and special collections fields.

Julia S. Charles-Linen is an Associate Professor in the School of Social Transformation at Arizona State University whose teaching and research focuses on African American literature and culture. She is the author of *That Middle World: Race, Performance, and the Politics of Passing* (2020) and is currently working on a biography of Jessie Redmon Fauset, titled *Finding Fauset*.

Erica Ciallela is Exhibition Project Curator for *Belle da Costa Greene: A Librarian's Legacy* at the Morgan Library & Museum. A public historian and archivist with a research background in nineteenth- and early twentieth-century African American women's history and education, she began at the Morgan as a Belle da Costa Greene Curatorial Fellow, and processed the professional papers of Belle da Costa Greene. She previously worked at the Prudence Crandall Museum, a National Historic Landmark in Canterbury, CT.

Tamar Evangelestia-Dougherty is Director of the Smithsonian Libraries and Archives. Prior to joining the Smithsonian, she was an Associate Librarian at Cornell University and Director of Collections and Services at New York Public Library's Schomburg Center for Research in Black Culture. Evangelestia-Dougherty holds a Master of Science in Information Science and a Doctor of Library and Information Science, Honoris Causa, from Simmons University in Boston.

Rhonda Evans is Director of the LuEsther T. Mertz Library, New York Botanical Garden. Previously she held various roles at the New York Public Library, including Assistant Chief Librarian at the Schomburg Center for Research in Black Culture. Evans has written for multiple library publications, including *The Black Librarian in America: Reflections, Resistance, and Reawakening* (2022). She currently serves on the board of the Museums Council of New York City.

Anne-Marie Eze is Associate Librarian of Houghton Library at Harvard University. She previously served as the library's Associate Librarian for Collections and Programs, and before that its Director of Scholarly and Public Programs. Prior to joining Harvard, Eze was Associate Curator of the Collection at the Isabella Stewart Gardner Museum, Boston, where she co-curated *Beyond Words: Italian Renaissance Books*. She holds degrees from the University of London, including a doctorate from the Courtauld Institute of Art.

Daria Rose Foner is Assistant Vice President, Specialist, in Sotheby's Old Master Paintings Department. She was previously the Research Associate to the Director at the Morgan Library & Museum, where she served as the co-founder and co-director of "The Letters of Belle da Costa Greene to Bernard Berenson" digital project. Foner received her PhD at Columbia University, where her dissertation, "Collaborative Endeavors in the Career of Andrea del Sarto," focused on the creative practices of sixteenth-century Florentine visual and performing artists.

Gail Levin is Distinguished Professor of art history, American studies, and women's studies at Baruch College and the Graduate Center, the City University of New York. An authority on the American painter Edward Hopper, she has curated landmark exhibitions and written many books, including Hopper's catalogue raisonné; definitive biographies of Hopper, Lee Krasner, and Judy Chicago; and studies on Aaron Copland, synchromism, and Abstract Expressionism.

Philip S. Palmer is the Robert H. Taylor Curator and Department Head of Literary and Historical Manuscripts at the Morgan Library & Museum. He holds a PhD in English literature from the University of Massachusetts, Amherst. At the Morgan he has curated exhibitions on Woody Guthrie, James Joyce, *The Little Prince*, and Beatrix Potter. He is co-curator of *Belle da Costa Greene: A Librarian's Legacy*, as well as co-founder and director of "The Letters of Belle da Costa Greene to Bernard Berenson" digital project.

Deborah Parker is Professor of Italian at the University of Virginia. Her publications include *Commentary and Ideology: Dante in the Renaissance* (1992), *Bronzino: Renaissance Painter as Poet* (2000), and *Michelangelo and the Art of Letter Writing* (2011). Her new book *Becoming Belle da Costa Greene: A Visionary Librarian through Her Letters* is forthcoming in 2024.

Deborah Willis, PhD, is University Professor and chair of the Department of Photography and Imaging at the Tisch School of the Arts at New York University. A recipient of MacArthur and Guggenheim fellowships and a member of the American Academy of Arts and Sciences, she is the author of *The Black Civil War Soldier: A Visual History of Conflict and Citizenship* (2021) and *Posing Beauty: African American Images from the 1890s to the Present* (2009).

The Morgan Library & Museum Staff and Volunteers

Administration

Colin B. Bailey
Katherine Delaney
Sarah Lees
Jessica Ludwig
Lydia Shaw
Kristina W. Stillman

Collection Information Systems

Sandra Carpenter
Robert Decandido
Lenge Hong
Maria Oldal

Communications and Marketing

Noreen Khalid Ahmad
Christina Ludgood
Chie Xu

Development

Mirabelle Cohen
Eileen Curran
Annie Gamez
Molly Hermes
Hannah Lowe
Caroline Mierins
Hadassah Penn
Lauren Stakias
Kirsten Teasdale
Stacy Welkowitz

Drawings and Prints

Esther Levy
Sarah Mallory
John Marciari
Jennifer Tonkovich
Daniel Tsai

Education

Mary Hogan Camp
Esme Hurlburt
Jennifer Kalter
Kat Kiernan
Nicole Leist
Jessica Pastore

Exhibition and Collection Management

Elizabeth Abbarno
Sholto Ainslie
Nicholas Bastis
Alex Félix
Walsh Hansen
Erika Hernandez Lomas
Anne Reilly-Manalo

Facilities

Esperanza Ayala
Monica Barker-Browne
Jean-Luc Bigord
Beverly Bonnick
Ricardo Browne
Glenvet Cassaberry
Josean Colon
Gerard Dengel
Wilson Gonzalez
Melbourne Green
Eric Grimes
Rodney Grimes
Cortez Hackett
Raheem Johnson
Andrew LeeLam
James McCollough
Marina Mugnano
Gilbert Parrilla
Sonny Patrick
Vernon Pulliam
Javier Rivera
Lidia Rodriguez
Jonathan Scales
David Shim
Bromley Synmoie
Janeth Tenempaguay
Pedro Tejada
Noel Thomas
Catherine Torres
Benjamin Ubiera
Francis White
Cory Williams

Finance Services

Nicholas Danisi
Carmen Mui
Faiyad Islam
Thomas Mercurio
Natalie Molloy
Mary Schlitzer

Human Resources

Niekeda Bourgeois
Dorian Lewis-Hood
Eden Solomon

Imaging and Rights

Janny Chiu
Carmen González Fraile
Kaitlyn Krieg
Marilyn Palmeri
Eva Soos
Min Tian

Literary and Historical Manuscripts

Erica Ciallela
Jathan Martin
Philip Palmer
Sarah Robinson

Management Information Systems

Josh Feldman
Dani Frank
Daniel Friedman
Adrian Giannini

Medieval and Renaissance Manuscripts

Deirdre Jackson
Emerald Lucas
Joshua O'Driscoll
Roger Wieck

Merchandising Services

Sherifa Ali-Daniel
Pedro Anlas
Samantha Eberhardt
Aubrey Herr
Alana Hollins
Mahogany Johnson
Michelle Macias
Maya Manaligod
Emily Pritykin
Heloise Robertson
Layla Williams
Stephany Zuleta

Modern and Contemporary Drawings

Emily Roz

Music Manuscripts and Printed Music

Robinson McClellan

Photography

Olivia McCall
Joel Smith

Printed Books and Bindings

Sheelagh Bevan
Jesse Erickson
John McQuillen
Samantha Mohite

Publications

Karen Banks
Yuri Chong
Michael Ferut
Ryan Newbanks

Reading Room

Katherine Graves
Sylvie Merian
María Isabel Molestina
Victoria Stratis

Reference Collection

Peter Gammie
Alaina Poppiti
Sima Prutkovsky

Thaw Conservation Center

Michael Caines
Maria Fredericks
Elizabeth Gralton
Jonathan Johansen
Rebecca Pollak
Yungjin Shin
Reba Fishman Snyder
Francisco Trujillo
Ian Umlauf

Visitor Services

Afra Annan
Aidan Carroll
Simon Cooper
Mae Cote
Laura Fowler
Britney Franco
Tendajie Leon
Leah Marangos
Yvette Mugnano
Elliot Nuss
William Pardoe
Sabrina Rivera
Michelle Volpe

Part-Time Educators

Gema Alava-Crisostomo
William Ambler
Azadeh Amiri Sahameh
Lauren Ball
Dina Gerasia
Nadja Hansen
Rukhshan Haque
Sarah Harris Weiss
Catherine Hernandez
Helen Lee
Mary-Linda Lipsett
Emily Long
Deborah Lutz
Belbelin Mojica
Benjamin Moore
Luned Palmer
Klara Seddon
Walter Srebnick
Maria Yoon

Temporary Art Handlers and Registrars

Fidel Alleyne
Batja Bell
Lauren Clark
James Cullinane
Storm Harper
Junichiro Ishida
Thomas Kotik
Christopher Lesnewski
Meghan Magee
Dustin McBride
Kate McKenzie
Travis Molkenbur
Carolyn Morris
Gary Olson
Yoshinari Oshiro
Beverly Parsons
David Peterson
Anibal Rodriguez
James Sheehan

Volunteers

Sidney Babcock
Grace Brodsky
Mitchell Cohn
Deb Freeman
Judith Hill
Lois Hoffman
Cynthia Johnson
Liz Kaufman
Dede Kessler
Richard Kutner
Sara Lishinsky
Wendy Luftig
Fanette Pollack
Rick Mathews
Cathleen McLoughlin
Joseph Mendez
Carissa Montgomery
Dominique Picon
Pat Pilkonis
Susan Price
Leili Saber
Jacqueline Topche
Jean Vezeris
William Voelkle
Miryam Wasserman
Christie Yang

Current as of January 1, 2024

Image Credits

The following credits, which are keyed to page numbers, apply to photographic reproductions and the institutional ownership of works illustrated. Every effort has been made to trace copyright owners and photographers. The Morgan apologizes for any unintentional omissions and would be pleased to add an acknowledgment in future editions.

Amherst College Archives and Special Collections: 44, 58; Archives of American Art, Smithsonian Institution, Daniel Varney Thompson papers, 1848–1979, bulk 1923–1979: 274; photo Jerry Atnip: 79; courtesy Barnard Archives and Special Collections: 267; The Bernard and Mary Berenson Papers, Biblioteca Berenson I Tatti—The Harvard University Center for Italian Renaissance Studies: 2, 36, 68, 86–87, 88 (fig. 6), 96, 102–3, 105, 162, 172, 264, 279; Bettmann / Getty Images: back cover, 132; Brooklyn Museum Libraries and Archive: 88 (fig. 5); Chicago Public Library: 90; Chicago Public Library, George Cleveland Hall Branch Archives, Box 10, Photo 087, Vivian G. Harsh Research Collection of Afro-American History and Literature: 248, 254 (fig. 3); photo Janny Chiu: 11, 27, 32–33, 122–23, 129–30, 148, 150, 159, 163, 183–84, 198–99, 203, 216–17, 231, 242; photo Steven H. Crossot: 196, 204, 208, 240; Department of State, Trenton, New Jersey: 72 (fig. 2); © Dumbarton Oaks Research Library and Collection, Washington, DC: 213; Fisk University Galleries, Nashville, TN. Gift of the artist in honor of his pupil, Aaron Douglas, 1952.3.4 (T): 79; Fountain Valley School of Colorado: 268 (fig. 4); photo Carmen González Fraile: 19, 35, 37 (fig. 19), 73, 75 (fig. 5), 100, 112–14, 118–19, 126, 128, 131, 146, 149, 152–53, 182, 195, 221, 226, 233, 235, 237–39, 241, 259–60, 277; photo Graham S. Haber: endpapers, 6, 12, 20, 30, 34, 38, 75, 110, 120–21, 124–25, 127, 140, 143 (fig. 40), 144–45, 185, 192, 207, 214–15; Harvard University, Houghton Library: 106, 137, 282; Library of Congress: 21, 23, 24 (fig. 7), 26, 37 (fig. 18), 78, 186; Library of Congress, Daniel Alexander Payne Murray papers, Manuscript Division: 254 (fig. 4); Library of Congress, Historic American Buildings Survey, Creator, Andrew Ross, William P. Thompson, Ellen J Schwartz, William P Thompson, and Sponsor U.S. Commission Of Fine Arts, Alexander, J, and Jet Lowe, photographer. Andrew Ross Tenant House I, 30th Street Northwest, Washington, District of Columbia, 1933: 24 (fig. 6); image copyright © The Metropolitan Museum of Art. Image source: Art Resource, NY © Marius de Zayas. Permission courtesy of Rodrigo de Zayas: 178; image copyright © The Metropolitan Museum of Art. Image source: Art Resource, NY, © 2024 The Estate of Edward Steichen / Artists Rights Society (ARS), New York: 175; Collection of Elisabeth Morgan, Digital image courtesy of The Morgan Library & Museum: 61; The Morgan Library & Museum: front cover, 12, 19–20, 27–30, 32–35, 37 (fig. 19), 38, 47, 73, 75 (fig. 4), 76, 80, 92–93, 95, 100, 110, 112–14, 118–31, 140, 143–46, 148–50, 152–53, 155–57, 159, 163, 182–85, 192, 195–96, 198–99, 203–4, 207–8, 214, 216–18, 220–21, 226, 231, 233, 235–42, 259–60, 266, 277; © The Morgan Library & Museum: endpapers, 6, 11; The Morgan Library & Museum, bequest of Belle da Costa Greene, 1950, 1950.35. Used with permission of the Clara Tice family and Francesca Mancino: 215; The Morgan Library & Museum © Eastman Kodak Company: 159 (fig. 17); The Morgan Library & Museum, gift of the Estate of Belle da Costa Greene, 1950, 1950.14 © 2024 Succession H. Matisse / Artists Rights Society (ARS), New York: 176; The Morgan Library & Museum, PML 199107: 73; Münchner Stadtmuseum, Sammlung Reklamekunst © Julius Diez or legal succession: 142; Museum of the City of New York, 93.1.1.7009: 49; National Museum of Women in the Arts, Washington, DC, Gift of Wallace and Wilhelmina Holladay, Funding for the frame generously provided by the Texas State Committee: 201; photo Christine Nelson: 167; New Jersey State Library: 18, 81; New York Public Library: 48, 72 (fig. 1), 252–53; New York Times Archives: 89; Archives of Northfield Mount Hermon School: 50–51, 53–54, 57; The Norton Simon Foundation: 209; The Office of Public Records, District of Columbia Archives: 46; Pacific & Atlantic Photos, Inc: 220; Princeton University Art Museum: 16, 84; courtesy of Michael Rosenfeld Gallery LLC, New York, NY © Estate of Archibald John Motley Jr. All reserved rights 2024 / Bridgeman Images: 286; St. Paul's School Archives, Concord, NH: 268 (fig. 3), 271–72; photo Lee Stalsworth: 201; The Walters Art Museum: 210; Wikimedia: 107; Yale Collection of American Literature, Beinecke Rare Book and Manuscript Library © Van Vechten Trust: 75 (fig. 5), 257.

Published to accompany an exhibition at the Morgan Library & Museum, New York, October 25, 2024–May 4, 2025

Belle da Costa Greene: A Librarian's Legacy is made possible by lead support from Agnes Gund. Major support is provided by the Ford Foundation; Mr. and Mrs. Benjamin M. Rosen; Katharine J. Rayner; Denise Littlefield Sobel; the Lucy Ricciardi Family Exhibition Fund; Desiree and Olivier Berggruen; Gregory Annenberg Weingarten, GRoW @ Annenberg; and by a grant from the National Endowment for the Humanities: Democracy demands wisdom. Assistance is provided by the Franklin Jasper Walls Lecture Fund, the Friends of Princeton University Library, Elizabeth A. R. and Ralph S. Brown Jr., and the Cowles Charitable Trust.

Any views, findings, conclusions, or recommendations expressed in this exhibition do not necessarily represent those of the National Endowment for the Humanities.

Published in 2024 by the Morgan Library & Museum and DelMonico Books · D.A.P.

The Morgan Library & Museum 100

The Morgan Library & Museum
225 Madison Avenue
New York, NY 10016
themorgan.org

DelMonico Books

DelMonico Books available through
ARTBOOK | D.A.P.
75 Broad Street, Suite 630
New York, NY 10004
artbook.com
delmonicobooks.com

© 2024 The Morgan Library & Museum

Big Piph, "The Ballad of Belle da Costa Greene"
© I Am Not Them, LLC

All rights reserved. No part of this book may be reproduced or transmitted in any form or by any means, electronic or mechanical, including photocopy, recording, or any other information storage and retrieval system, or otherwise without written permission from the publishers.

For the Morgan Library & Museum
Publications Manager: Karen Banks
Editor: Ryan Newbanks
Assistant Editor: Yuri Chong
Director of Imaging & Rights: Marilyn Palmeri
Manager of Imaging & Rights: Eva Soos
Special Projects Assistant: Min Tian
Photographer: Janny Chiu
Assistant Photographer: Carmen González Fraile
Graham S. Haber Intern: Jessica Micolta

For DelMonico Books
Production Director: Karen Farquhar

Separations by Altaimage, London and New York

Designed by Barbara Glauber, Heavy Meta

Printed and bound in China
ISBN: 978-1-63681-135-2

Front cover: Ernest Walter Histed, *Belle da Costa Greene*, 1910 (p. 95).
Back cover: Paul Thompson, *Belle da Costa Greene [...]*, ca. 1915 (p. 132)
Page 1: Impression from stamp used by Belle da Costa Greene.*
Frontispiece: Clarence H. White, *Belle da Costa Greene*, 1911 (p. 96).

*Belle da Costa Greene often applied this stylized "Belle" stamp to her personal correspondence. The stamp appears in green ink on her letters as late as 1930, though she used it more frequently in the 1910s.

Library of Congress Cataloging-in-Publication Data

Names: Ciallela, Erica, editor. | Palmer, Philip S., 1983– editor.
Title: Belle da Costa Greene : a librarian's legacy.
Description: New York : The Morgan Library & Museum ; DelMonico Books/D.A.P., 2024. | Includes bibliographical references and index.
Identifiers: LCCN 2024021711 | ISBN 9781636811352 (hardcover)
Subjects: LCSH: Greene, Belle da Costa—Exhibitions. | African American librarians—New York (State)—New York—Biography—Exhibitions. | Women library administrators—New York (State)—New York—Biography—Exhibitions. | Pierpont Morgan Library—History—Exhibitions. | Manuscripts—Collectors and collecting—New York (State)—New York—History—Exhibitions. | Art—Collectors and collecting—New York (State)—New York—History—Exhibitions. | LCGFT: Exhibition catalogs. | Biographies.
Classification: LCC Z720.G83 B45 2025 | DDC 020.92 [B]—dc23/eng/20240521
LC record available at https://lccn.loc.gov/2024021711